ART IN *CRISIS*

ART IN *CRISIS*
W. E. B. DU BOIS AND THE STRUGGLE FOR AFRICAN AMERICAN IDENTITY AND MEMORY

Amy Helene Kirschke

INDIANA UNIVERSITY PRESS
Bloomington and Indianapolis

This book is a publication of

Indiana University Press
601 North Morton Street
Bloomington, Indiana 47404-3797 USA

http://iupress.indiana.edu

Telephone orders 800-842-6796
Fax orders 812-855-7931
Orders by e-mail iuporder@indiana.edu

The paper used in this publication meets the minimum requirements
of American National Standard for Information Sciences—Perma-
nence of Paper for Printed Library Materials, ANSI Z39.48-1984.

Manufactured in the United States of America

Library of Congress Cataloging-in-Publication Data

Kirschke, Amy Helene.
 Art in crisis : W.E.B. Du Bois and the struggle for African
American identity and memory
/ Amy Helene Kirschke.
 p. cm.
 Includes bibliographical references and index.
 ISBN-13: 978-0-253-34674-2 (cloth)
 ISBN-10: 0-253-34674-6 (cloth)
 ISBN-13: 978-0-253-21813-1 (pbk.)
 ISBN-10: 0-253-21813-6 (pbk.)
 1. African American art. 2. African American artists—History
and criticism. 3. African Americans—Race identity. 4. Art criticism
—United States—History—20th century. 5. Du Bois, W. E. B.
(William Edward Burghardt), 1868-1963—Knowledge—African
American arts. I. Title.
 N6538.N5K57 2007
 704.03'96073—dc22
 2006032190
1 2 3 4 5 12 11 10 09 08 07

For my family: My sister, Melissa, my mother and father,

and for my daughters, Helene, Genevieve, and Marigny, who fill my life with humor, adventure, and joy!

CONTENTS

Acknowledgments

Many colleagues helped me through the years of research and writing this book with their professional support, including Clarence Mohr, Jessie Poesch, Robert Holyer, Raymond Barry, Marty Keenan, and Beth Howse and Mrs. Tabitha Williams, both at Fisk University. Carolyn Reid-Wallace, the former president of Fisk, gave me inspiration to work harder. Genevieve Fabre at the University of Paris read various parts of this project and offered editorial advice. Stephanie Cassidy, Archivist at the Art Students League in New York, and Nancy Cricco, Archivist of the special collections at New York University, were very helpful. Tammi Lawson at the Schomburg Center has always been a great supporter. Christy Cunningham-Adams and George Adams gave me a new insight into the creation of art. The members of the Art Department at University of North Carolina, Wilmington, have given me the greatest support and care of my career. My colleagues, Tom Schmid and Nelson Reid have been particularly supportive. Marshall Eakin served as my mentor through the politics of academia, and I have the utmost respect for him. Jimmie Franklin and Sam Mc-Seveney offered me endless guidance and friendship. Leonard Folgarait, Barbara Tsakirgis, Tracy Miller, Don Evans, Susan DeMay and especially Michael Aurbach and Carlton Wilkinson were great colleagues in the Art Department at Vanderbilt University. Anne Hill, Fay Renardson, John Powers and Joanne Rathman were also most helpful.

Theresa Leininger-Miller continues to give me her support and guidance in our field and is a valued friend too. Dolan Hubbard was one of the primary inspirations for this project when he encouraged me to research Du Bois and visual imagery. His patience and commitment to his work are a tribute to him. I will never be able to fully thank Cary Wintz for his careful review of my manuscript, countless hours of painstaking help, and unbelievable generosity as a scholar. I couldn't have finished it without his help. David Driskell has given me

support and insight into my work for many years, and I am eternally in his debt. David Levering Lewis's amazing work on Du Bois made this work a possibility for me, his constant encouragement of scholars working on Du Bois and his generous help on this and other projects will always be so much appreciated. The writings of David Blight on memory and identity provided tremendous support for this project. Kate Babbitt's copyediting skills were a tremendous help.

This book would not have been possible without the support of many dear friends through the years, including Sean O'Rourke, Diane Doolittle, Lin Walker, Susie Maitland, Kathleen Madigan, Cathy Lee, Odette Bonnet, Elizabeth McCleave, Michael Fossett, Helene Marchadour LaTour, Amy Metteer, Stephanie King, Catherine Kast, Kindra Clyne Steenerson, Pam Greenough, Bob Russell, Dan and Judith Friedenreich, Tim Betbeze, and Terry Utterback. Will and Hazel and Dorothy kept me company while I wrote.

Dr. Eddie Hamilton kept my children healthy, Mercedes Carrera has always been my inspiration as my first art history professor, and Father Tony Lehman will always be in my heart, guiding me. Simonne Fisher gave me the city of Paris which will always be a home to me and my family.

Valena Minor Williams must have special recognition in this book. She is my mentor and my friend; she gives me advice on my scholarship, on life, and on motherhood. She is a journalist, an adventurer, a scholar, an activist, a great supporter of the arts, a mother of four daughters, and a committed and involved grandmother. She has encouraged me at every turn since I met her in 1990. I consider it my great fortune to count her as my dear friend.

My family has always been a great encouragement and source of strength, including my Aunt Eugenie and Uncle Richard Watson, and my step-sister Bonnie Bruce, my father Harry Kirschke who gave me his sense of humor, my mother, Jane Bruce, who is the greatest mom in the world, my sister Melissa Kirschke Stockdale, who is the greatest sister and friend you could ever wish for, my nephew Nic Stockdale whom I love like my own child, my brother-in-law Tom Stockdale, and my husband, Tom Schwartz, whose patience and painstaking editorial help made this book possible. Most especially, I thank my three daughters Helene, Genevieve, and Marigny who fill my life with love.

ART IN *CRISIS*

Introduction

W. E. B. Du Bois, the towering intellectual leader of African Americans in the early twentieth century, has been the subject of countless books, articles, and monographs, including two Pulitzer Prize–winning biographies. Although Du Bois's ideas and political activities have become a veritable academic cottage industry, there is as yet no study of the art, drawings, cartoons, and photography—the visual vocabulary—he used as editor of *The Crisis* magazine. The first significant national African American magazine, *The Crisis* was an organ of the National Association for the Advancement of Colored People (NAACP) and an integral part of the struggle to combat American racism. Du Bois, who helped found the NAACP, came to New York in the summer of 1910 to take the position of director of publicity and research for the organization and to assume the role of editor for the journal, which debuted in November. Du Bois had previous experience; he had edited the journals *Moon* and *Horizon* between 1906 and 1910. But this endeavor would be different. Du Bois intended to make *The Crisis* the principal crusading voice for civil rights on a national scale. Created at the height of the Jim Crow era, the magazine would speak to black Americans who had been disenfranchised and were struggling to improve their marginalized status. Southern blacks were still largely relegated to agricultural and service positions and had limited opportunities to receive an adequate education. Black Americans lived in a land plagued by white terror; lynchings were still common in the South and racial discrimination was the pattern throughout the United States.

African Americans needed a new venue to discuss the most salient issues of the day, including opportunities and advancements in education, labor, women's rights, military service, and the injustices of lynching and racial prejudice. Du Bois wanted to provide such a venue on the pages of *The Crisis* and address the inequitable society in which blacks lived. As a scholar, he could study and exam-

ine the past and how it had been analyzed by historians and the population as a whole. He could evaluate as well how African Americans related to their African heritage. Du Bois outlined his goals in the first issue of *The Crisis*:

> It will first and foremost be a newspaper: it will record important happenings and movements in the world which bear on the great problem of inter-racial relations, and especially those which affect the Negro-American.
>
> Secondly, it will be a review of opinion and literature, recording briefly books, articles, and important expressions of opinion in the white and colored press on the race problem.
>
> Thirdly, it will publish a few short articles.
>
> Finally, its editorial page will stand for the rights of men, irrespective of color or race, for the highest ideals of American democracy, and for reasonable but earnest and persistent attempts to gain these rights and realize these ideals. The magazine will be the organ of no clique or party and will avoid personal rancor of all sorts. In the absence of proof to the contrary it will assume honesty of purpose on the part of all men, North and South, white and black.[1]

Du Bois did not mention visuals or the importance of art for the magazine, but it soon became clear that art was central to his agenda. Relatively little is known about the reasoning behind Du Bois's selection of art or the criteria he used to select the artists and pay them. But art was a powerful tool for political expression, and Du Bois and his staff were committed to a magazine that would include both the written word and art to explore the issues of the day. *The Crisis* became a principal patron of the visual arts in a time of limited opportunity for black artists.

As editor of *The Crisis*, Du Bois would attempt to use the journal as a means of racial uplift—celebrating the joys and hopes of African American culture and life—and as a tool to address the injustices black Americans experienced—the sorrows of persistent discrimination and racial terror, especially the crime of lynching. The written word was not sufficient—visual imagery was central to bringing the message to the homes of readers and emphasizing the importance of the cause.

Du Bois placed political cartoons, drawings, photographs, and prints on the cover and through the pages of *The Crisis*. But they were different from images of African Americans in other magazines. The images Du Bois used were generated from a black perspective; they were almost entirely created by black artists who were connected to the importance of the causes addressed in the journal. The art was dignified and respectful and exuded race pride. The more tragic images were direct and graphic in their ability to express the violence African Americans faced in daily life. Du Bois was always interested in issues of African American identity, but how would visuals aid in the development of a

stronger black identity? And how could visuals in *The Crisis* help define a collective memory for his black readership, a memory that Du Bois believed had been seized and largely shaped by a white-dominated culture? This study will examine the process whereby visual imagery came to be an important factor in shaping identity and helping define a collective memory.

Who were these artists? Did their work represent their ideas and political leanings, or was the work chosen to express Du Bois's own view of black life? What were the iconographic prototypes utilized by these artists? How do they fit into the history of American political cartoons, and what place do they have in the history of African American art and of the social realist movement in the United States, a movement which emphasized the realities of struggles in Depression America?

This book is an extended exploration of how W. E. B. Du Bois used the visual arts to define a new collective identity and historical identity for African Americans. Chapter 1 looks at the background for Du Bois's efforts, his early days at the magazine, and the relationship of his views to those of famed abolitionist and former slave Frederick Douglass. Chapter 2 turns our attention to the history of black cartoons and the black artists Du Bois recruited for his attempt to influence the memory and identity of the race. Chapter 3 examines in detail the terror of lynching and the manner in which Du Bois used visual images of these crimes in *The Crisis* to unite the African American community and mobilize it to demand an end to this barbaric practice. Chapter 4 examines the theoretical aspects of Du Bois's view of art and his changing views of a black aesthetic. Chapter 5 explores Du Bois's conscious efforts to use visuals to forge a positive connection between black Americans and their ancestral home of Africa. Chapter 6 examines the remaining significant issues explored by visual artists in *The Crisis*, including war, women and families, and education.

During the era when Du Bois was editor of *The Crisis*, most white Americans accepted a racist version of their recent history, a version of history that denigrated black achievement and celebrated the failure of Reconstruction after the Civil War. (After all, Woodrow Wilson provided an introduction to D.W. Griffith's *Birth of a Nation*, the highly popular movie of 1915 that cemented a racist view of the postwar South.)[2] In this argument over history, there were few black players to represent the African American perspective. Historian David Blight notes that Du Bois was a "self-conscious creator of black counter-memory" who spent "much of his career as a scholar and an artist trying to dislodge history from its racist moorings."[3] How could Du Bois's endeavor in *The Crisis*, the written and the visual, address the myths of a white-recorded past and rewrite history for the present and future? Du Bois spoke of his use of both history and social science as weapons to confront a white version of American his-

tory. How would visuals fit into this equation on the pages of *The Crisis?* How would art aid him in confronting the effects of slavery and the inability of whites to grasp the effects of the institution and embrace a different historical consciousness or develop moral foresight? Du Bois knew the plight of the artist: "If a colored man wants to publish a book, he has got to get a white publisher and a white newspaper to say it is great, and then you and I say so."[4] Black artists needed their own voice. Du Bois believed that the Negro race had to determine for itself what kind of art and literature it wanted to promote,[5] and *The Crisis,* with his careful direction, could do just that.

1. W. E. B. Du Bois and African American Memory and Identity

Martin Luther King, Jr., noted in a 1968 speech that W. E. B. Du Bois's "singular greatness" was his "unique zeal" which "rescued for all of us a heritage whose loss would have profoundly impoverished us." King noted that before Du Bois the "collective mind of America became poisoned with racism and stunted with myths."[1]

Much of Du Bois's work addressed the need to reclaim a lost history; thus, he dealt directly with issues of identity and memory. Du Bois realized that visuals could greatly aid him in the development of his audience and in better expressing the political and social issues of the day. He used original artwork, cartoons, drawings, and photography to support editorials and essays on the questions of his day: lynching, war, education, women and children, labor, racism and prejudice, and a new relationship to Africa. He used the covers of *The Crisis* to entice readers to open the issue and explore the contents; visuals could tell a more poignant story to his audience. In 1903, Du Bois stated that the Negro race (like all races) "is going to be saved by its exceptional men. . . . Can the masses of the Negro people be in any way more quickly raised than by the effort and example of this aristocracy of talent and character? Was there ever a nation on God's fair earth civilized from the bottom upward? Never; it is, ever was and ever will be from the top downward that culture filters."[2] Du Bois believed that only the best and the brightest of the race could and should lead the race into the twentieth century, the "Talented Tenth," and that part of its duty was to propagate high culture. Art in *The Crisis* was a part of that process, part of the expression of the "Talented Tenth," serving to educate from the top down with images of politics, social history, and the history of Negro culture.

From the beginning of his career, W. E. B. Du Bois used visual images to illustrate the most important aspects of black life in America. At first with his

work on *Moon* and then *Horizon* magazines, and then as editor of *The Crisis,* Du Bois wanted to use art to illustrate the major issues of the day for his readers. He understood that much of the identity of the African American had been altered by a history riddled with tragedy and racism and that African Americans had been largely excluded from any part in the collective American identity. It would be a matter of reconstructing the past in the context of a renewed sense of community rather than reproducing that past.[3] The collective traumatic past of African Americans could serve to unify the race. Black Americans did not have the luxury of ignoring history, it was something that they had to struggle against to achieve a sense of dignity. History had been dominated and told by white culture and was skewed in its perspective. White power was maintained by telling history through white historical memory.[4] For Du Bois, *The Crisis* could retell history, a black history that had often been orally transmitted in the black community, through essays and visuals. *The Crisis* could carry on the traditions of "advocacy journalism" that was established with *Freedom's Journal,* "the first newspaper published by Africans in North America," and continued through William Lloyd Garrison's *Liberator* and Frederick Douglass's *North Star,* finally to T. Thomas Fortune's *New York Globe,* a paper Du Bois had greatly admired as a young man.[5]

Du Bois was born to Albert and Mary Salvina Du Bois in Great Barrington, Massachusetts, where his first published piece appeared in the local newspaper when he was fourteen years old. His father, a barber (among many other professions), was a mulatto with some social standing and wealth in his background. But he abandoned his family when "Willie" was only two years old. His mother had been a domestic worker and had given birth to a child out of wedlock two years before the birth of Du Bois. Although Du Bois remembers his childhood as almost idyllic, he was quite poor and was given a tremendous amount of responsibility by his mother. She strongly encouraged him to excel academically; he soon realized this was his ticket to a better life.[6] After graduating from Fisk University, Du Bois attended Harvard, where he obtained another B.A. (his Fisk degree was not recognized by Harvard) and was accepted into the graduate program. He won a Slater Fund fellowship to attend the University of Berlin for two years. A residency requirement kept him from obtaining a Ph.D. in economics in Germany, and he returned to Harvard to complete a doctorate. This experience, and his Ph.D. in history from Harvard—he was the first black man at Harvard to receive a doctorate—prepared him for leadership. Du Bois would spend time as a professor at Wilberforce University, University of Pennsylvania (where he was required to live in segregated quarters), and Atlanta University. During these years Du Bois did not restrict himself to academia. He was prolific in his writings and became a political activist. He was

involved in the Niagara Movement, a group of progressive African American leaders and scholars which was established to discuss civil rights in 1905 and led to the establishment of the NAACP. He also attended the first Pan-African Congress in 1900. While his involvement was minimal in 1900, he "came to personify the Pan-African movement,"[7] and he would assist in the organization of subsequent conferences intermittently for the next forty-five years.

Despite his elite education and extraordinary abilities, Du Bois experienced the impact of racism throughout his life. Some of these experiences are chronicled in his famous 1903 collection of essays, *The Souls of Black Folk,* which includes references to the inferior education available to blacks, the lack of economic opportunities, and the racism blacks experienced personally in daily life. He believed that America's self-definition was constructed in racist terms, including ideas about freedom and constitutional rights, and that the country's moral authority would be stunted as long as such ideas dominated mainstream thought.[8] Du Bois understood that many white Americans did not consider African Americans to be a part of the collective American identity. From the crafting of the U.S. Constitution, African Americans had been considered property, and little had changed in the white perspective since that time, despite emancipation and the constitutional amendment giving black men the vote. The effects of the Civil War and the subsequent development of the Jim Crow South were keenly felt in the daily life of African Americans. In Du Bois's 1890 commencement address at Harvard he told his audience: "You whose nation was founded on the loftiest ideals and who many times forget those ideals with a strange forgetfulness, have more than a sentimental interest, more than a sentimental duty. You owe a debt to humanity for this Ethiopia of outstretched Arm, who has made her beauty, patience, and her grandeur law." Du Bois announced one of the principal aims of all of his future historical work: to forge a history that might help solve or transcend the race problem.[9] Du Bois's 1896 dissertation, "Suppression of the African Slave Trade" involved prodigious and careful research. It is more than likely that he had an awareness of the visuals that are associated with slavery, posters announcing slave auctions with woodblock images of enslaved Africans, and posters announcing runaway slaves, which were often accompanied by crude images of shackled men and women. They were the earliest images of African peoples in America and were part of the wealth of research available on the African slave trade. As a man who had traveled extensively in Europe and who was familiar with the visual arts, Du Bois had some understanding of the power of visuals, even though images of African Americans had been greatly underrepresented and respectful images of African Americans were not readily available.[10] He stated "What is true of literature is true of art: here with a tenth of us colored, we see a colored face in an il-

lustration, a painting or a bronze, on the stage or in a movie but rarely, and then usually in obvious caricature."[11] He wanted to change how African peoples were viewed, using accurate representation to create a new and authentic written and visual historical memory. In 1900, Du Bois won a gold medal for his work at the Paris Exposition, which featured an exhibit he curated, the Exposition des Nègres dAmérique (Exhibit of American Negroes). It included photos of ordinary black Americans in their daily lives as well as sociological data that included charts and maps with facts about American blacks. More than 50 million visitors attended the exposition. David Levering Lewis described the exposition as "resolutely upbeat, racially triumphalist and progressive."[12] In her study of the Du Bois photographs of the Paris exposition, historian Shawn Michelle Smith argued that Du Bois "utilized the tools of visual representation both to problematize racist propaganda and to envision a New Negro at the turn of the century."[13] Du Bois was already using art, in the form of photographs, to dispel white stereotypes of blacks as ignorant or lazy and to affirm a more positive, dignified view that stressed their accomplishments.

This desire to use art was established early on, in Du Bois's theories of the role and importance of beauty, truth, and goodness. As David Levering Lewis writes, "The author of *The Souls of Black Folk* comforted himself as the avatar of a race whose traveled fate he was predestined to *interpret* and direct."[14] *The Crisis* had a predominantly black readership, but white liberals read the journal too. Du Bois was well aware of this fact. He could influence both races with this magazine, which was largely written by blacks. Publications such as the radical *New Masses* had written about blacks, its editors believing white progressives could preserve the integrity of ethnic cultures. Political parties had ignored blacks; even the Socialist Party and its leader Eugene B. Debs had ignored them. The need was there. While some of his readers would be members of the "Talented Tenth," many others would be less well educated, less literate. The power of an image, be it cartoon, drawing, or photograph was even more important for this audience than it would be for a more privileged group. A publication such as *The Crisis* could use art address the needs of this marginalized black society and question traditional white constructs of authority and power.

While he sought the opinion of prominent whites on issues concerning black Americans, he wanted blacks to be involved in the writing of their own history. White radicals had appropriated blacks as a cultural symbol and wanted them to remain exotic and uncivilized. Writers such as Carl Van Vechten were fascinated by what they saw as the fabulous sexuality and spontaneity of blacks but failed to see their oppression and deprivation in a white-dominated world. In Harlem, white radicals openly exploited blacks for the exotic thrills of

Harlem's nightclubs, white writers saw only one side of black life. White illustrators depicted blacks as Sambos or savages, just as writers did.[15] *The Crisis* could attack both of these notions of black life.

DU BOIS AND THE *VOICE OF THE NEGRO*

One of the precursors of *The Crisis,* the Atlanta-based *Voice of the Negro,* had an impact on Du Bois, and he in turn influenced this journal. Its editor, John Bowen, was the second African American in the United States after Du Bois to receive a Ph.D. At the turn of the century, Atlanta was becoming a center of black protest, with Du Bois and his colleagues at Atlanta University at the center of the movement. John Bowen and the more militant Jesse Max Barber were intimately involved in creating *Voice of the Negro,* which wrote about the lives of the "Talented Tenth" as its dominant voice, including articles on literature, European travel, higher education, business, women's clubs, politics, and history. It also promoted the social and cultural development of the Talented Tenth.[16] The *Voice* expressed the triumph over slavery as a source of pride, and like *The Crisis* after it, included both literature and visuals including cover art and some political illustrations to express its viewpoint. Bowen, Barber, and Du Bois had reason to embrace their roles as editors. In the early decades of the twentieth century, Georgia experienced an increase in lynchings; the infamous lynching of Samuel Hose in 1899 had a radical effect on Du Bois. Jesse Barber was also interested in protest and was moved to comment on the Statesboro lynchings of 1904.[17]

Voice of the Negro proclaimed that little progress had been made since slavery, and reminded its readers of the history of slavery as a means of protesting the current situation.[18] The journal featured Du Bois on its cover in January 1905, where he was depicted as a genie emerging in smoke from a lantern, presumably a symbol of hope or a wish for a better future (fig. 1). Future *Crisis* artist John Henry Adams provided the illustration and a biographical sketch of Du Bois.[19] Although he was by birth a northerner and did not share the slave past of some of his colleagues, Du Bois nevertheless believed that blacks had to "grasp the Negro problem," and he and others urged racial solidarity in confronting that historical legacy. John Henry Adams portrayed Du Bois as an ideal example of someone who embraced opportunity rather than succumbing to a debilitating legacy. He learned from the past instead of being crushed by it.[20] In April of 1906, John Henry Adams published his own poem questioning why black men should be anything less than proud, accompanied by his illustration of a partially clad black man who appears to be thoughtful and uncertain of his place. In addition to these types of contributions, *Voice of the Negro* included

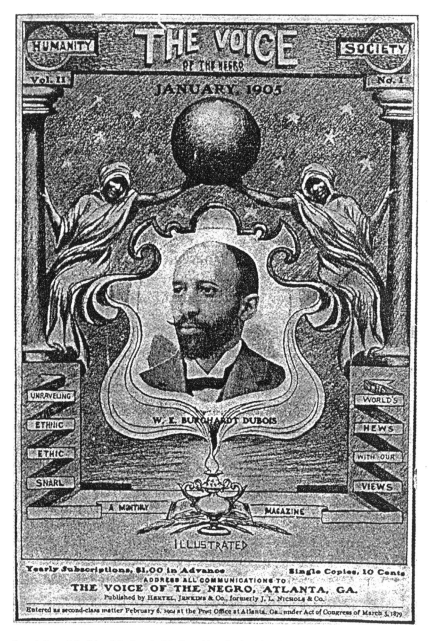

Figure 1. Cover of *The Voice of the Negro,* by John Henry Adams. Reprinted from *The Voice of the Negro,* January 1905.

inspirational photographs of prominent blacks. *Voice of the Negro* provided, on a smaller scale, an example of the type of journal Du Bois would lead. Du Bois's experience as a leader in Atlanta, a city deeply entrenched in Jim Crow laws, helped prepare him for his work as editor of *Crisis* in the relative safety of New York City.

Du Bois also edited *The Moon Illustrated Weekly*, which debuted in Memphis in late 1905. He also worked on *The Horizon: A Journal of the Color Line*, which had a greater circulation and covered both domestic and international issues important to African Americans. Du Bois's other professional and personal experiences, including academic positions and substantial experience as a writer, prepared him for the editorship of *The Crisis*. He accepted the position while he was working at Atlanta University, where he had become familiar with the idea of memory as a cultural struggle.[21]

THE EARLY DAYS OF *THE CRISIS* (1910–1913)

Creating a new magazine and successfully publishing it every months was a difficult undertaking. *The Moon* had closed, *The Horizon* was failing. While the NAACP did not have funds to commit to the venture, Oswald Garrison Villard provided offices and public support. Several NAACP board members strongly objected to an idea they considered impractical.[22]

The name *Crisis* came from either NAACP board member William English Walling, or northern reformer, activist, and board member Mary White Ovington when the first discussions of the magazine were held. The idea came from the poem "The Present Crisis" by activist James Russell Lowell, which captured the idea that America's racial problem was *the* crisis of the hour. Ovington recalled the discussion of the title in the August 1914 issue of *Crisis*:

> "There is a poem of Lowell's," I said, "that means more to me today than any other poem in the world—'The Present Crisis.'" Mr. Walling looked up. "'The Crisis,'" he said. "There is the name for your magazine, 'The Crisis.'" And if we had a creed to which our members, black and white, our branches, North and South and East and West, our college societies, our children's circle, should all subscribe, it should be the lines of Lowell's noble verse, lines that are true today as when they were written seventy years ago.[23]

The Present Crisis

Once to every man and nation comes the moment to decide,
In the strife of Truth with Falsehood for the good or evil side;
Some great Cause, God's New Messiah, offering each the bloom or blight,
Parts the goats upon the left hand, and the sheep upon the right,
And the choice goes by forever 'twixt darkness and that light.

Then to side with Truth is noble when we share her wretched crust.
Ere her cause bring fame and profit, and 'tis prosperous to be just;
Then it is the brave man chooses, while the coward stands aside,
Doubting in his abject spirit, till his Lord is crucified,
And the multitude make virtue of the faith they had denied.
 (James Russell Lowell)

While Du Bois may not have given the magazine its name, his imprint and goals were present from the first day, and he certainly recognized that this was a time of crisis for black Americans. The first issue of *The Crisis* appeared in November 1910 (Fig. 2). Du Bois was asked to submit his work to a board of directors, which consisted of two white men, one white woman, and three black men.[24] In the introduction to the first issue, Du Bois stated he would set forth "those facts and arguments which show the danger of race prejudice."[25] He established the format of *The Crisis* early on: "Along the Color Line," would discuss politics, education, social uplift, organizations and meetings, science and art, opinions, editorials; "The Burden" would cover civil, economic, and political injustices against African Americans; and "What to Read" would review the latest in literature. "Talks about Women" and "Man of the Month" were added in December 1910 and May 1911, respectively. The cover of the inaugural issue was the blurred image of a black child who was holding a hoop in the right hand and a stick in the other (fig. 3).[26] Du Bois or his daughter Yolande did this first unskilled drawing, and it is clear that *The Crisis* needed more established artists for future covers. Most visuals in this early issue were advertisements.

Within one month, the length of *The Crisis* doubled, which increased the number of its visual images. The early issues featured unpolished cover sketches by amateur artists. By 1911, the anniversary issue's cover was graced by the work of a professional photographer, George Scurlock, who "specialized in posed Talented Tenth Women,"[27] and inside the issue, drawings by New York artist Louise Latimer were reproduced. By April 1912 circulation had grown to 22,500.[28]

Du Bois quickly realized that *The Crisis* could be used to make the NAACP more effective. He believed that men who would join these ranks needed to be educated and *The Crisis* could help train them, not simply with the written word, but in its manner, its pictures, its conception of life, its subsidiary enterprises. He believed that this important work could be done if circulation figures could reach 100,000.[29]

The "work" Du Bois meant was the creation of an African American legacy, something he had campaigned for over much of his life. "Your restless eye may easily overlook the corner where sits the scientist seeking the truth that shall make us free, or the other, where the artist dies that there may live a poem or painting or a thought." Earlier in his life he had expressed similar thoughts in an

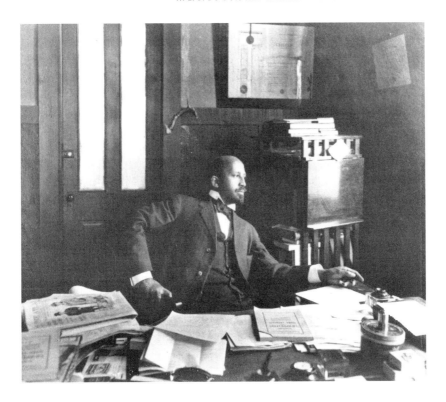

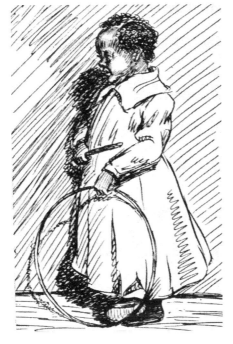

Figure 2. W. E. B. Du Bois in his office at *The Crisis*. Courtesy the Schomburg Center for Research in Black Culture, New York Public Library.

Figure 3. Art from the inaugural cover of *The Crisis*. Reprinted from *The Crisis*, November 1910.

address he delivered to Fisk University students and alumni in Nashville. At his alma mater, the famed historically black university founded in 1866, he encouraged the students to consider not so much "what you want to do as what wants to be done; . . . it is the duty of the Negro to serve his blood and lineage, and so working, each for each, and all for each, we will realize the goal of each for all." Du Bois asked the students to ask themselves, "What part can I best take in the striving of the eight million men and women who are bound to me by a common sorrow and a common hope, that through the striving of the Negro people this land of our fathers may live and thrive?" One of many more practical options he offered these students, even in 1898, was the role of the artist. He suggested, "Finally, I come to the field of the scientist and the artist—of the men who seek to know and create. . . . [T]he man who enters here must expect long journeys, poor and unknown and often discouraged. . . . [H]ere the young Negro so often forgets that 'art is long, and time is fleeting' . . . [F]or the man who will work, and dig, and starve, there is a chance to do here incalculable good for the Negro race; for the woman in whose soul the divine music of our fathers has touched some answering chord of genius, there is . . .a chance to gain listeners who will know no color line."[30]

In 1903, in *Booklovers' Magazine,* Du Bois had lamented the belief held by most white Americans that blacks contributed practically nothing of importance to American civilization. He wrote "[T]he average American, accustomed to regarding black men as the outer edge of humanity, not only easily misses seeing the colored men who have accomplished something in the world common to both races, but also misses entirely the work of the men who are developing the dark and isolated world of the black man."[31] In particular Du Bois understood the plight of creative blacks of mixed blood. Whites considered them to be comic, a joke to laugh about, but if they created successfully, "'That is due to his mixed blood,' cry the same men."[32] From a very early point he decided to use *The Crisis* to provide a place for the achievements of blacks in the arts, including poets, writers, and visual artists. *The Crisis* would eventually provide a way, in Du Bois's mind, to educate both blacks and whites about *all* issues of the times and the talents of black Americans.

Du Bois believed that the Negro had made his greatest contribution to American culture in art and in labor. He concluded that the only real, or truly authentic American art was "Negroid" and, consequently, was not highly regarded by most Americans. Visual arts still needed to develop. "We are already beginning to see the beauty of Negro Art in American literature, in music and dancing, and such social ideals as good will and sacrifice. . . . [W]e can, therefore, well think of the Negro element in America as an integral part of American life and as having made a permanent contribution to American civiliza-

tion."[33] Du Bois spoke of the talent of a multitude of Negro writers, but he referred to painter Henry O. Tanner as the best example of a black visual artist. In 1913, he wrote of Tanner: "Outside of literature the American Negro has distinguished himself in other lines of art. One need only mention Henry O. Tanner whose pictures hang in the great galleries of the world, including the Luxembourg."[34]

Du Bois hoped that *The Crisis* could help change the place of the Negro in American culture, by providing access, helping to build an audience, and educating. He wrote in 1921 of the Negro as an outsider in American culture. "The place of the Negro in American culture is not that of a contributor, but rather of a passive victim or brute fact." At least that was the assumption of most white Americans. True, the Negro had contributed to labor, but the greater contribution of his toil has been "his gift to art in America."[35] Once again he cited the contributions of Henry O. Tanner, and this time he added sculptor Edmonia Lewis to the list of accomplished black artists. He also noted the writing of Natalie Curtis Burlin, who had stated that the Negro was equally important in his role of contributor to culture: "[H]is presence among us may be a powerful stimulus to the art, music, letters and drama of the American continent."[36]

Through *The Crisis* magazine, Du Bois and his readers could form a collective memory about their legitimate past and their identity.[37] Art could assist them in this task and express the contributions the race had made as Americans. It could remind readers of traditions and myths from the past, something even the radical left had been woefully inconsistent in doing—journals such as the *New Masses* vacillated between depicting African Americans as sources of humor and depicting them as dignified equals with whites. The image of blacks was too malleable in the early decades of the twentieth century, and too often it was used for exploitive purposes. There was a need for a new and more consistent art.

For Du Bois, art provided an immediate reference point and could help underlay the importance of an issue. He believed that the power of single, poetic images, events, or moments could give substance to cultural memory.[38] What was symbolized in a nation's history was as important as what was not symbolized, and much of the history and iconography of the contributions of black Americans had been left out or distorted.

Historian David Blight has argued that the study of historical memory is the study of cultural struggle, of "contested truths," of moments, events, or even texts in history that depict rival versions of the past and which are in turn put to the service of the present. Memory aids in the construction of a collective identity; it is how a culture and groups use, construct, or try to "own" the past in order to win power or place in the present. Du Bois wanted to win place and

power for black Americans in U.S. society and therefore repeatedly addressed issues of identity and memory in *The Crisis*. Visuals were important tools to achieve this goal.

Du Bois contended that history must be explored and felt in order to know the responsibilities of the present.[39] Past and present met in the imagery of *The Crisis* with frightful intensity. His writings such as *Black Reconstruction* also addressed the past; he knew that equality could not be won in the present unless the past was revisited through a different lens.[40] But Du Bois made a gradual but persistent turn away from the scientific empiricism in which he was trained to the poetic sensibilities that characterized so much of his writing after he left Atlanta to edit *The Crisis* in 1910.[41] Du Bois's efforts to forge an African American countermemory should be understood in the context of this turn in his work from social science toward art. Later Du Bois wrote that he used history and the other social sciences as weapons to be sharpened and applied through research and writing. So too Du Bois used art as a means of trying to establish a new memory of the black American experience. In doing so, he hoped to define the identity of the black middle class as both American and African.

Du Bois understood that black and white society saw the same events differently and recalled them differently. Slavery, the Civil War, and emancipation were all part of America's unaltered past, but in the half-century since the end of the war, the two races had become increasingly divided. Race remained a powerful division in society. Where northern and southern whites were reconciled by looking back to the past, there was no such reconciliation for blacks, there was no similar counterpart.[42] One such event was the Blue-Gray Reunion, a celebration held to mark the fiftieth anniversary of the battle of Gettysburg that brought 53,000 Civil War veterans from both North and South to the Gettysburg site. No black veterans were included; all of the veterans were white. Blight has argued that white supremacy was emphasized at the Gettysburg reunion of 1913. At a time when lynching had developed into a social ritual in the South and when American apartheid in the form of Jim Crow laws had become fully entrenched, black opinion leaders found the "sectional love-feast" at Gettysburg to be more than they could bear. The *Baltimore Afro-American* wrote, "Today the South is in the saddle, and with the single exception of slavery, everything it fought for during the days of the Civil War, it has gained by repression of the Negro within its borders. And the North has quietly allowed it to have its own way."[43] The blood of black soldiers and lynched citizens was "crying from the ground" in the South, unheard and strangely unknown at the white-controlled Blue-Gray Reunion. Du Bois recognized that the "problem of the 20th century is the problem of the color line,"[44] and this Civil War semi-centennial celebration was no exception. How could black Americans look back, and then for-

ward, with pride and inspiration? How could they declare their history in the South when they were dealing with the harsh realities of segregation, poverty, and Jim Crow in their daily lives?

American whites had the luxury of revising their past, reinventing their Civil War history and memories of African American enslavement. Blacks did not have the same luxury. Their history of oppression was part of who they were, and they needed to remember the past if they were to change the future. Du Bois used the pages of *The Crisis* to fight against white distortions of the history of the Old South. He reported on celebrations of the anniversary of the Emancipation Proclamation with irony and disgust and followed the debates surrounding these with great interest. Du Bois used both the written work and illustrations in *The Crisis* to inform blacks of how whites saw this anniversary. Within the black community, the perspectives on emancipation varied, depending on region, education, generation, experience, and political and social outlook.[45] *The Crisis* sought to provide a unified accounting of such events and inform the readership of any progress made in representing the black point of view, a viewpoint that had been almost entirely erased. "Jeremiadic" memories that use commemorative movements as occasions for bitter appeals against injustice, past and present, were useful to Du Bois as he relayed his point of view on the state of race relations in the United States. Here he could counter the idea of the "happy darkie," the predominant image in the southern recollection of the master-slave relationship. He wanted to dispel the enduring picture of the Old South as full of contented and loyal black folk.[46]

Du Bois's revisioning of history can be seen in the January 1913 issue. Frequent contributor Laura Wheeler drew the cover, a thoughtful and well-executed portrait of a dignified and humble elderly man with his head slightly bowed (fig. 4). The portrait of the man, presumably representing a former slave now in old age, was paired with a reminder from Du Bois of what had really taken place in the last fifty years and how the black man was perceived by whites in America. Inside the issue, Du Bois offered his readers an editorial on "emancipation" to mark the fiftieth anniversary of the event. He told his audiences that the American people had not freed the slaves "deliberately and with lofty purpose" but had done so in a war to "destroy the power of the South." He reminded his readers that bringing full civil and political rights to the freedmen was a "task of awful proportions" and that the action had finally "faltered, quibbled" and had done an about face, away from responsibility. Americans had "built barriers to decent human intercourse and understanding between the races that today few white men dare call a Negro friend." Far too many whites in both the North and the South, Du Bois lamented, "would greet the death of every black man in the world with a sigh of relief."[47] This comment illus-

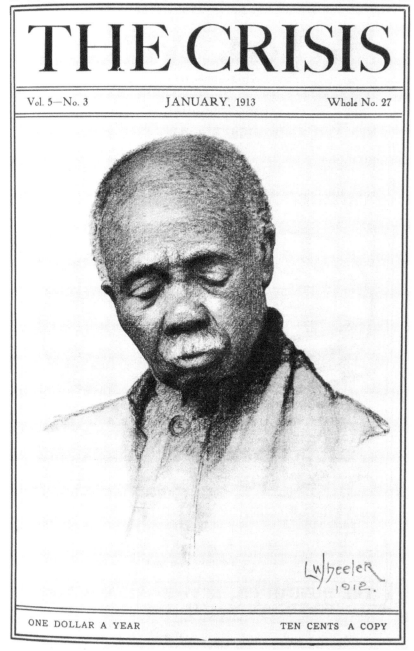

EMANCIPATION NUMBER

THE CRISIS

Vol. 5—No. 3 JANUARY, 1913 Whole No. 27

ONE DOLLAR A YEAR TEN CENTS A COPY

Figure 4. Untitled man, by Laura Wheeler. Reprinted from *The Crisis,* January 1913, cover.

trates the level of Du Bois's pessimism and cynicism regarding the position of blacks in America in the early years of *Crisis*. Du Bois would not allow his readers to forget how a celebration of "emancipation day" should be gauged in black America. Memory had to be preserved, and Du Bois employed essays, poems, satire, and visuals to bring about a memory of a past that must not be forgotten.[48]

Du Bois understood that African Americans were an important part of the American nation; they carried a rich American and African heritage. *The Crisis* could aid in stating and establishing the role of African Americans in the collective American identity. Du Bois did not want their past, their history, to be lost. But he wanted to *choose* those memories through essays and visuals which expressed the most important issues in history and current events. Through *The Crisis* Du Bois could select and interpret memories to serve the changing needs of African Americans.[49] African Americans could then develop a shared identity by identifying, exploring, and agreeing on memories. African Americans had to be empowered with their own history to use their political rights and gain access to political power, which would ultimately lead to economic and educational advantage.

In effect, Du Bois posed the question, If history is the reconstruction of what is no longer, who is to recall the history of a people? History is always "problematic and incomplete."[50] Du Bois never gave up believing in an ethical basis for history, and he fully understood and eloquently warned against the problem of domination in historical memory. "With sufficient general agreement among the dominant classes, the truth of history may be utterly distorted and contradicted and changed to any convenient fairy tale that the masters of men wish," he wrote in *Black Reconstruction*.[51] Freeing history from the control of whites would also free the spirit from domination.[52] African Americans needed to search for sources of common memory because they were a people from varied religious, tribal, and linguistic backgrounds.[53]

Du Bois's goal of helping his community remember its past took place in a social environment that was hostile to that project. As Mitch Kachun has noted, "During the generation after the 1870s, black Americans concerned with the race's historical memory grew increasingly frustrated by their inability to alter white America's racial ideology or whites' refusal to acknowledge the black presence in the nation's history and culture."[54] Yet Du Bois knew that keeping memory of the past, including that of the Civil War, alive within the black community and among progressive whites was a primary tool in the fight against racism and oppression. Du Bois did not want the pain of the past to overshadow hope for the future; he wanted the lessons of the past to be applied to the harsh realities of the present. *The Crisis* was the primary tool for such an endeavor.

SEARCH FOR IDENTITY: THE STRUGGLE WITH "TWONESS"

Du Bois knew that his identity as a black man was inseparable from the history of his people. How could he aid in defining the race by articulating the past when a racist South and an at best apathetic country claimed a different history? Du Bois articulated the struggle in *The Souls of Black Folk:*

> One ever feels his twoness,—an American, a Negro: two souls, two thoughts, two unreconciled strivings; two warring ideals in one dark body, whose dogged strength alone keeps it from being torn asunder. The history of the American Negro is the history of this strife—this longing to attain self-conscious manhood, to merge his double self into a better and truer self. In this merging he wishes neither of the older selves to be lost. . . . He simply wishes to make it possible for a man to be both a Negro and an American.[55]

Du Bois hoped to show the importance of the black experience, to put it into context as a part of the national history. Du Bois implied that America's collective memory awaited new voices, new scholars and storytellers whose "strivings" might liberate it from the misconceptions and false constructions. *The Souls of Black Folk* told a story in prose with "beauty and pain"; Du Bois would use *The Crisis* to tell a story of joy and sorrow with art.[56]

The writer William James once asked Du Bois why *The Souls of Black Folk* was so negative. Du Bois answered that he wanted to tell the *other* American experience. As Blight comments, "This endless dialectic between the beauty and the pain in American history is just what Du Bois sought to capture by bringing the black experience to the center of the story." Du Bois wanted the veil lifted, but it first had to be remembered, analyzed, and understood.[57]

To right the wrong of a forgotten and revised history, Du Bois saw his duty as a historian to reclaim the historical past of African Americans.[58] Du Bois could not accept anything less than an honest appraisal of both past and present. African Americans had to define both an individual and collective memory that took into account their rights as American citizens and their unique experience as a race of people who shared a history of oppression. As Kachun writes, "More specific to the question of collective memory, blacks had to balance the need to preserve, interpret and disseminate the positive elements in their history with the desire to eradicate many of the more painful and degrading aspects of that history. These tensions—between American-ness and distinctiveness, between constructive memory and selective amnesia, lay at the crux of African Americans often ambivalent relationship with historical memory."[59] As any hope of change after the Civil War era faded, this sense of distinctiveness rooted in racial identity and shared oppression grew. At the same time, how-

ever, separateness coexisted uneasily with the equally intense assertion by many African Americans, including Du Bois, that they were, most fundamentally, American.[60]

DU BOIS, FREDERICK DOUGLASS, AND THE HISTORY AND MEANING OF THE CIVIL WAR

Despite their occasional disagreements, W. E. B. Du Bois was profoundly affected by Frederick Douglass and Douglass's interest in historical memory as a way to construct a collective national identity for African Americans. Douglass needed to rely on his own version of events to create a memory which "privileged liberty and equality for black people."[61] David Blight has shown that historical memory is not "merely an entity altered by the passage of time; it [is] the prize in a struggle between rival versions of the past, a question of will, of power, of persuasion. The historical memory of any transforming or controversial event emerges from cultural and political competition, from the choice to confront the past and to debate and manipulate its meaning."[62] Art served a role in this competition. "Commemorative rituals can inspire decidedly different interpretations; sometimes it depends simply on whether one is on the creating or the receiving end of historical memory. Sometimes it depends simply on whether a construction of social memory is to be used to sustain the social order, or to critique and dislodge it."[63] Douglass, like Du Bois, wanted to forge enduring historical myths that could help win battles in the present. His quest was to preserve the memory of the Civil War; he believed blacks and the nation should remember it.[64] Douglass explained: "Man is said to be an animal looking before and after. To him alone is given the prophetic vision, enabling him to discern the outline of his future through the mists of the past."[65] "Memory was given to man for some wise purpose. The past is . . . the mirror in which we may discern the dim outlines of the future and by which we may make them more symmetrical."[66]

The deepest cultural myths—ideas and stories drawn from history that, through symbolic power, transcend generations—are the mechanisms of historical memory. Such myths are born of divergent experiences and provide the cultural weapons with which rival memories contest for hegemony.[67] African Americans needed a usable past. As Douglass said, "[T]he evil as well as the good that men do lives after them."[68] Du Bois, looking back in *Black Reconstruction* (1935), also warned that the truth had to be preserved. "We fell under the leadership of those who would compromise with a truth in the past in order to make peace in the present and guide policy in the future."[69] At stake in *The Souls of Black Folk* was the spiritual and psychological well-being of blacks in the age

of segregation; at stake in *Black Reconstruction* was the collective national memory and the struggle over the nature of history itself.

Du Bois saw five basic flaws in American historiography which *The Crisis* could address. The first was that American historians avoided emphasizing conflict in the American past, especially conflict over racial questions. The second flaw was the unwillingness of historians to make moral judgments or assess responsibility for the wrongs of the past. The third flaw was the failure of historians to confront slavery forthrightly. The fourth was their ignorance of the active role of blacks in the U.S. past, and the fifth was the highly developed "hideous mistake" thesis about Reconstruction that was rooted in false assumptions and popular racism.[70] Du Bois hoped to raise questions about the tenets of history and change how history would be recorded. Unless the tragedies of the past were remembered, the past could repeat itself. Lynchings were increasing in number and the reasons why they still occurred had to be addressed.

Both Douglass and Du Bois understood that there were competing versions of the history of the Civil War. While whites proclaimed reconciliation in Civil War reunions, the deep significance of race in the coming of the Civil War and its conclusion was suppressed.[71] White northerners who voted against black suffrage shared a bond of white supremacy with southerners.[72] There really were relatively few differences in attitudes toward African Americans between the two regions, but both were willing to allow black life in the Old South to be romanticized with stories about a genteel and romantic southern past. This romanticized version of the Civil War and Reconstruction was found in the work of the Dunning school of historians (and W. A. Dunning's *Reconstruction* of 1907) and in the film *Birth of a Nation* in 1915. In a version of history that was later epitomized in the myths perpetuated in the film *Gone with the Wind,* the plantations of the Old South plantation were peopled with happy black servants working side by side with their masters, surrounded by music and laughter. History was in danger of being forgotten.

Du Bois was shocked at the way historians had suppressed the significance of slavery and the black struggle for freedom in the literature on the Civil War and Reconstruction era. As he stated in *Black Reconstruction,* "[o]ne is astonished in the study of history at the recurrence of the idea that evil must be forgotten, distorted, skimmed over. . . . The difficulty, of course, with this philosophy is that history loses its value as an incentive and example; it paints perfect men and noble nations, but it does not tell the truth."[73] Just as Frederick Douglass's effort to preserve the memory of the Civil War was "a quest to save the freedom of his people and the meaning of his own life,"[74] Du Bois had dedicated his life to disseminating the truth, his version of the truth, on the pages of

The Crisis, to use history as incentive and example through visuals and the written word. Both were extremely powerful weapons. Cartoons and illustrations could help forge a new black realism in art, a unique way of demonstrating how the issues of the day were intimately tied to the past. For Douglass and Du Bois, history was something living and useful.

THE BLACK AESTHETIC: AFRICAN OR AMERICAN?

In his essay "The Seventh Son," Du Bois traced African American art back to the African artisan. He wrote of the traditions of creating textiles, sculpture and pottery in Africa. Talented artists were stripped of the cultural context for their creativity when they were taken into slavery, but they still created.[75] Du Bois's commitment to African art as an ancestral legacy would appear in the pages of *The Crisis*, which featured African-inspired drawings, reproductions of original African art, and even political cartoons about Africa. Du Bois realized that knowledge of the rich cultural heritage of Africa had to be created.

In 1913 Du Bois wrote of the inspiration that the Negro could find in life and in art. In "The Negro in Literature and Art" he proclaimed that "the Negro is primarily an artist." Others might speak "disdainfully of his sensuous nature," but the Negro, who had held at bay the life-destroying forces of the tropics, had gained in some slight compensation a sense of beauty, particularly for "sound and color, which characterizes the race." He noted the contribution of the Negro to art in Egypt, where "Negro blood flowed in the veins of many of the mightiest of the pharaohs."[76] Du Bois hoped to build on the ideas of men like Martin R. Delany. Delany was a former slave, a Harvard-educated doctor who came to work with Frederick Douglass. Later as a soldier in the Civil War and an employee of the Freedmen's Bureau, Delany worked diligently to change the fact that whites had granted Africans "only the most debased roles in world history."[77] Delany, who initially advocated a return to Africa, was more extreme in his solutions to the race problem than Du Bois. They both understood that to white Americans, African-Americans did not seem to deserve citizenship because the "African" side of the hyphen would always undercut the perceived merits of the "American" half.[78] In America, it was believed that the Negro could only bring his music, but in Du Bois's view, the only authentic American music was that of the Negro American. Here was the key to the success of the Negro in the arts: having experienced tragedy beyond comprehension of white people, the Negro race's expression of life's experiences was unique.

Du Bois also addressed the social origins of the African American. He questioned if any artistic expression could be fairly called "American Negro art?"

Du Bois recognized that there had been a great many American artists of Negro descent, pointing to Henry O. Tanner as an example of "our great painter." But then, for the first time, he criticized Tanner, because he "has in no sense contributed to American Negro art. He is a painter of biblical subjects, a great American painter, or more truly, he ought to be classed as a great French painter or a cosmopolite."[79] "There are pictures and sculptures meant to portray Negro features and characteristics . . . Whence did this art come? The art instinct is naturally and primarily individualistic. It is the cry of some caged soul yearning for expression and this individual impulse is, of course, back of Negro art . . . That social compulsion in this case was built on the sorrow and strain inherent in American slavery, on the difficulties that sprang from emancipation, on the feelings of revenge, despair, aspiration, and hatred which arose as the Negro struggled and fought his way upward."[80]

Art had the unique ability to show blacks something that whites tried to deny them, that they were "people like anyone else, that they are contributors to culture, that they are the same." "The fact that there is, therefore, a real Negro art expressing the thoughts, experiences, and aspirations of the 12,000,000 colored people in the United States is not nearly as extraordinary as it would be if no such self-expression had arisen." The suffering of the Negro was part of their unique contribution. Du Bois noted, "If the drama of the transportation of the millions of Africans to the United States and their emancipation could have been accomplished without a gift of emotion and beauty to the world, it would have been an eternal proof that the Negro was different from other human beings . . . Already this art expression is showing its peculiarities, its unique content." In music the Negro "has given the world new music, new rhythm, new melody and poignant, even terrible expressions of joy, sorrow, and despair. The world dances and weeps at the beating of the black man's baton."[81]

Du Bois, ever the pan-Africanist, encouraged artists to turn to Africa for inspiration in art. In 1926, Du Bois wrote in *What Is Civilization?*[82] of the beauty of African art. "The sense of beauty is the last and best gift of Africa to the world and the true essence of the black man's soul . . . We have long known of the African artist . . . rich centers of African art were brought to European knowledge on the African western coast. It was long customary to think of this art first as imitation, secondly as inexpressibly crude and funny; but to-day more recent interpretations show the primitive art of Africa is one of the greatest expressions of the humans soul in all time, 'that black men invented art as they invented fire' . . . All this Africa has given the modern world together with its suffering and its woe."[83]

Artists like the sculptor Elizabeth Prophet, whom Du Bois spotlighted in *The Crisis* December 1929 issue, had sacrificed their own wealth and health for

the good of these goals, to make a black art for a black audience.[84] Du Bois hoped to inspire other artists with stories like Prophet's, who continued to work despite the worst circumstances, creating against all odds. Prophet continued to sculpt against the wishes of her family. Because of her race, she was often excluded from attending exhibitions where her work was shown. Leaving for Europe in 1922, she found greater freedom in France, where she was admitted "without question" to the Beaux Arts. She refused to do anything that would stand in the way of her becoming a great sculptor. She had "scarcely begun" her work, Du Bois explained to his audience. Her excellence as a top sculptor should be an inspiration to every American artist, who is "handicapped by color, is turned aside by poverty and prejudice." Du Bois noted that Prophet never made excuses for herself, never whined or complained. "She did not submit to patronage, cringe to the great, or beg of the small. She just worked."[85] Upon her return to the United States in 1934, Du Bois encouraged Prophet to take his Sociology 471 class which had been studying race problems. He felt she would add to the class as a "colored person" especially teaching other students about the French attitude towards Negroes. But Du Bois also believed that Prophet could benefit from such an education, which could stimulate her own work and artistic imagination.[86]

For too long, Du Bois believed, blacks had laughed at themselves. Now, a more straightforward style of art was emerging, one that he felt was imperative. Du Bois paid tribute to "a thoughtful, clear-eyed artist," Frank Walts, who had done a number of "striking portraits" for *The Crisis.* Walts' main subject matter was "black faces," including his thoughtful portrait of a bright-eyed boy, Harry Elam. However, when Du Bois published Walts' work, he received numerous protests from "colored" sources. Why did the audience laugh at this work? Because they were too black? White people never complained that their work was too white . . . neither do "we complain if we are photographed a shade 'light'." Du Bois felt the black audience should not be ashamed of their color and blood, but they were instinctively and almost unconsciously ashamed of the depictions of their darker shades. The problem of color within the race was a problem unique to the black audience, an audience that Du Bois hoped to develop and educate through the pages of *The Crisis.* "Black is caricature in our half-conscious thought and we shun in print and paint that which we love in life. How good a dark face looks to us in a strange white city!"[87]

Du Bois rejoiced that a "mighty and swelling human consciousness" was leading the black race back, joyously, to embrace the darker world. Yet his readers remained afraid of black pictures because they were the cruel reminders of the crimes of Sunday "comics" and "nigger" minstrels. Again, he addressed issues of identity and memory. He ended his essay with words of inspiration and

enthusiasm. "Off with these thought-chains and inchoate soul-shrinkings, and let us train ourselves to see beauty in black!"[88] The black audience could be made less afraid, and more familiar, through the workings of *The Crisis*. When *The Crisis* published the respectful black portraits of Roland Hayes by white artist Winold Reiss, or the works of Aaron Douglas or Laura Wheeler, the audience was becoming more familiar with, and more accepting of, positive, respectful representations of black Americans. African Americans were beginning to re-assert their own identity. *The Crisis* was an educator of beauty, and therefore of truth, and finally, of positive propaganda which revealed the truth. Whites did not look for respectful portrayals of blacks. "The themes on which Negro writers naturally write best, with deepest knowledge and clearest understanding, are precisely the themes most editors do not want treated . . .White Americans are willing to read about Negroes, but they prefer to read about Negroes who are fools, clowns, prostitutes, or in any rate, in despair and contemplating suicide. Other sorts of Negroes do not interest them because, as they say, they are 'just like white folks.' But their interest in white folks, we notice, continues."[89]

Du Bois wrote: "We are segregated, apart, hammered into a separate unit by spiritual intolerance and legal sanction backed by mob law . . . that this separation is growing in strength and fixation; that is worse today than a half-century ago and that no character, address, culture, or desert is going to change it in one day or for centuries to come." The black must recognize that "he is a Negro, not just an American. Segregation was a fact of life, and therefore, Negroes must "carefully plan and guide our segregated life, organize in industry and politics to protect it and expand it and above all to give it unhampered spiritual expression in art and literature."[90]

Through *The Crisis,* Du Bois hoped his essays would interpret to the world the "hindrances and aspirations of American Negroes."[91] The art he published in *The Crisis* would underline his agenda. *The Crisis* was the right kind of propaganda, a tool to illuminate the truth of a race, and to address the history of a people altered by white domination. "With this organ of propaganda and defense we were able to organize one of the most effective assaults of liberalism upon reaction that the modern world has seen." Du Bois noted, with typical "confidence" that *The Crisis* could not have possibly attained its popularity and effectiveness, if it had not been in a sense a personal organ and the "expression of myself."

Du Bois, as a historian, was concerned with social, and therefore collective forms of memory. He understood that individuals depend on other members of their own groups for independent confirmation of the content of their memo-

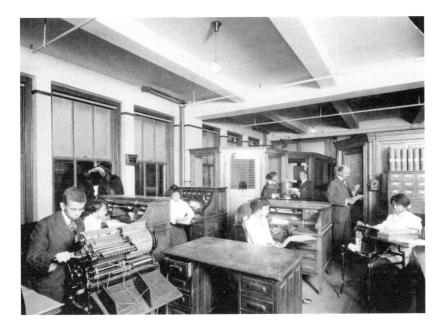

Figure 5. *The Crisis* staff. Courtesy the Schomburg Center for Research in Black Culture, New York Public Library.

ries. Du Bois, as artist-historian, made narratives a mixture of the scholarly and literary dimensions of history, and used images to enhance and illustrate the most fundamental issues.[92]

Frederick Douglass made the timeless definition of racism as "diseased imagination." Du Bois understood how deeply embedded the problem of racism was in American historical narratives, as well as how much those narratives continued to shape the future.

2. A History of Black Political Cartoons and Illustrations: The Artists

Through his employment of young African American illustrators, W. E. B. Du Bois became one of the important patrons of the Harlem Renaissance. His role in the development of African American art is significant.

THE DEVELOPMENT OF AMERICAN POLITICAL CARTOONS

Cartoonists and illustrators, artists who have the power to situate a perplexing issue in a small, distinct image, have enticed Americans throughout the country's history. The style of cartoons or illustrations has changed, from crowded woodcuts and engravings to simple pen-and-ink drawings, but the use of certain symbols and the powerful juxtaposition of image and text have remained fairly consistent from the early days of cartooning. Cartoons and illustrations can summarize painful or powerful ideas, events, or emotions in an instant, and they often serve to attack an evil or injustice.

Political cartooning developed as a symbolic art. As early as 1754, Benjamin Franklin depicted a serpent drawn into eight pieces, with "Join, or Die" written at the base of the drawing. The image of Uncle Sam appeared during the War of 1812 and was immediately used as a symbol of American values. In 1828, lithography came to the United States, coinciding with Andrew Jackson's election to the presidency. Lithography, drawing directly on a stone which was inked and printed, provided affordable art for Americans and an easy way to reproduce images. The Civil War provided a new reason for an influx of political cartoons, including caricatures of Abraham Lincoln, images for abolitionist literature, and sketches covering the Civil War for *Harper's Weekly*.

After the Civil War, the art of illustration became much more sophisticated, and caricature developed as a political tool in the United States. Two national

magazines, *Harper's Weekly* and *Leslie's Weekly*, thrived during this period, providing work for artists. By the beginning of the twentieth century, cartoonists had come into their own as celebrities and interpreters of social norms and culture. By 1900, every newspaper, even small-town papers, had a cartoonist.[1] Illustration also became a vital part of advertising, which would replace income from subscriptions as the chief source of revenue.

IMAGES OF BLACKS IN CARTOONS IN THE EIGHTEENTH AND NINETEENTH CENTURIES

The image or representation of African peoples by Euro-Americans has a long history. Blacks had appeared in European art since medieval times, when they were often represented as one of the three magi. Black figures appeared as allegories of Africa in the late eighteenth century. These images invariably placed African peoples in positions of servitude. Erasmus Darwin's "The Botanic Garden. A Poem in Two Parts" of 1798 featured an almost nude slave at the bottom of the frontispiece. The slave states, "Am I not a man and a brother?" The image was meant to appeal to a viewer's empathy and had a subtext of equality. The German-language publication *Sklaven-Handel* (slave trade) carefully illustrated Africans as shackled slaves. Pain, suffering, violence, and the separation of families provided the stories for the illustrations in this anti-slavery text. Sir William Elford's "Plan of an African Ship on the Lower Deck," published in 1789, included an illustration of 300 Africans on a slave ship, crammed together with no room to move or breathe. The illustration made a powerful impact. Elford describes humans "almost like herrings in a barrel, and reduced nearly to the state of being buried alive, with just air enough to preserve a degree of life, sufficient to make them sensible of all the horrors of their situation."[2] Finally, Noah Webster's *Little Reader's Assistant*,[3] a children's book, described the treatment of Africans, including torture and family separation, and illustrated it with shackled slaves, small and bent over, dominated by their white master.

The earliest illustrations of black Americans in what became the United States date to the end of the eighteenth century. Blacks appeared in drawings and woodblock prints in several venues, often accompanied by physical descriptions. Those venues include travel literature, advertisements for slave markets and runaway slave notices, portraits, Protestant tracts, and images of blacks in major historical events. One thing is clear: very few of these images were drawn from the African American perspective.[4]

Advertisements for slaves were often accompanied by very detailed descriptions of the individuals. Certain symbols often appeared in these depictions. A

1769 advertisement for a female slave who had just arrived from Africa shows her with her child in order to indicate her fertility. Posters announcing runaway slaves pictured slaves only partially clad, often running and often carrying a walking stick, a reference to African heritage. Sometimes a piece of clothing symbolizing Africa, such as a headdress, was featured on the figure. As much detail as possible accompanied these drawings, largely to help the slaveowner recover his property. Showing slaves as only partially clad or in seminudity emphasized what whites viewed as their barbarism as well as their sensuality.[5]

But even during this period, another image of blacks was possible. Paul Revere's engraving "Bloody Massacre" of 1770 featured one black, "Crispus Attucks" who lost his life in the Boston massacre. He is depicted lying at the feet of British soldiers.

Some depictions of blacks in the colonies appeared in travel books and brochures written by traders, explorers, and missionaries that were reprinted in America. Publications such as James Cook's 1795 *Captain Cook's Third and Last Voyage to the Pacific Ocean* depicted indigenous peoples, who were depicted as people of color, welcoming Europeans in foreign lands.

African Americans who contemplated illustrating their own people faced a history of caricature-like depictions of blacks that included distorted physical traits, cruel stereotypes, and huge exaggeration. Thomas Worth's "Darktown" series done for Currier and Ives in the late nineteenth century provides an illuminating example of this genre. While these images were considered good-natured fun by some, they ridiculed African Americans mercilessly, showing them as clowns and buffoons, lacking in common sense and the ability to feel or reason.[6] For a short time Thomas Nast drew sympathetic images of blacks and their quest for freedom in *Harper's Weekly,* including "Patience on a Monument" of October 10, 1868, a tribute to black forbearance. But his commitment to the cause waned when Republican concern for black rights diminished, and he soon followed with unflattering portraits of black voters. *Harper's* featured the work of caricaturist Sol Eytinge Jun, whose Blackville cartoons ridiculed more wealthy African Americans, by exaggerating their features with wide eyes and protruding lips.[7] Illustrator Thomas Worth created a racist depiction of a black lady liberty with exaggerated features to symbolize the corruption of Tammany Hall and the abuse of immigrants as they entered New York harbor. The drawing, made for Currier and Ives in 1884, was meant to show sympathy for immigrants but ridiculed blacks in the process.[8]

In the late-nineteenth- and early-twentieth-century South, blacks were the chief source of comedic figures in white newspapers and journals. Many of these were minstrel figures, whites making gross parodies of black life in blackface,

"comics under cork."[9] Positive images of black figures appeared in the comics and political cartoons very rarely. Just as poor white farmers discriminated against blacks to make themselves feel superior, so too black figures in cartoons helped the white working class assert its authority and superiority. Even the rare black illustrator, such as E. Simms Campbell, one of the first mainstream black cartoonists, made his black porter a comedic figure, in his 1937 strip, *Hoiman*.[10]

Du Bois surely would have been familiar with these images of African Americans as he was completing his research for his dissertation in 1896 at Harvard University, "Suppression of the African Slave Trade." These early images of black Americans in positions of servitude, partially clad, shackled, often bent over, like not fully developed humans, must have influenced his desire to reconstruct the image of the African American on the pages of *The Crisis* and helped develop his understanding of the power of imagery when accompanied by text.

Du Bois would also have been familiar with positive images through portraiture, such as the 1773 portrait of poet Phyllis Wheatley by black artist Scipio Morehead, which was reproduced as a frontispiece in Wheatley's first published book of poetry. Wheatley is depicted as intelligent and thoughtful. She is caught in the act of writing, quill in hand, inkwell at her side; her head rests in a pensive pose. Her status as property of her owner, Mr. John Wheatley, literally circles the engraving. Early portraits of blacks stood alone; they were usually not placed in context. How could a black person be depicted in an appropriate social setting when there was no such appropriate setting?[11] Such images illustrated both the power of the image of the enslaved and the power of the respectful and intelligent portrait of Wheatley, points Du Bois clearly appreciated and used in his work.

THE MAGNIFYING GLASS IN THE TWENTIETH CENTURY

Illustrations provide clues into how groups see themselves and how others see them as well. In them we see a society's values, interests, and beliefs, and they can be considered a magnifying glass of the dilemmas of the day.[12]

Radical or "progressive" publications often provide examples of the magnifying glass. One of the most radical publications of the early twentieth century was *The Masses*, which was founded by socialist Piet Vlag and published in Greenwich Village from 1911 to 1917 with an average circulation of 12,000. Painter John Sloan was its first art editor; the magazine featured important social realist artists such as Stuart Davis, George Bellows, and Robert Henri, all of whom admired the work of French political satirist Honoré Daumier.[13] *The*

Masses gave artists a free environment in which they could express themselves. While the publication dealt with the major issues of the day, including women's issues, labor unrest, and tenement life, it did not feature African Americans in any consistent or dignified manner. African Americans were shown with respect one month and as grotesque caricatures the next, sometimes in quite vicious images.[14] One issue might have a mammy in a caricature, the next, a biting criticism of lynching accompanied by an effective cartoon. Stuart Davis was fascinated with jazz, but his fascination centered on what he considered to be the "exotic" and "lurid" details of black life. Despite its political radicalism, *The Masses* did not rise above the prevailing prejudices of the era. These contradictions between racism and social conscience, as art historian Rebecca Zurier has noted, were typical of the period.[15] White artists, even in journals sympathetic to issues in the black community, did not treat African Americans with respect. Only a black journal could do that.

Most comic strips in the early twentieth century tended to portray a lily-white world, a homogenous world free of people of color. The first black protagonist was not introduced into the comics until R. F. Outcault created "Li'l Mose" in 1901. African Americans in cartoons were confined to the position of maids, pickaninnies, manservants, n'er-do-wells, stable boys, porters, and valets. "Sambo" of *Sambo and His Funny Noises* appeared in 1907, a caricature of a young black child with bulbous features.

Only with the black migration to northern cities during and after World War I and the development of a black middle class does one see a new vocabulary of visual images of blacks. The 1930s saw a growth of the independent black press that served cities with large black populations, these newspapers included the *Chicago Defender,* the *Pittsburgh Courier,* and New York's *Amsterdam News.* The black-drawn comic strip *Bungleton Green,* originally drawn by Leslie Rogers, which debuted in the *Chicago Defender* in 1920, chronicled the unfair treatment of black Americans until 1968. In the 1930s, Zelda Ormes created *Torchy Brown,* which addressed women's issues, including gender discrimination and sexual violence. On the pages of *The Crisis* and in these newspapers, stereotypical images of blacks were counteracted and authentic black characters emerged.

As a monthly magazine, *The Crisis* did not have to meet the grueling schedule of dailies. Editors had time to think about illustrations and to commission pieces to accompany editorials and essays. Illustrators for *The Crisis* frequently employed familiar symbols whose iconography was firmly established in U.S. culture. Cartoonists for the magazine used the Statue of Liberty, for example, to exemplify the vast divide between American ideals and the reality of black life. Men such as cartoonist Ollie Harrington developed black characters in cartoon

form, such as "Bootsie," the black community's own humorous figure. Harrington used Bootsie to speak out against government apathy toward lynching, among other issues.[16]

The art in *The Crisis* was largely political. In contrast, most white cartoonists focused on humor. A 1940s book on drawing comics explained why African Americans were good subjects for ridicule:

> The coloured people are good subjects for action pictures, they are natural born humorists and will often assume ridiculous attitudes or say side-splitting things with no apparent intention of being funny. The cartoonist usually plays on the colored man's love of loud clothes, watermelon, chicken, crap-shooting, fear of ghosts, etc.[17]

As with animation and the film industry, there were few opportunities for black cartoonists in American media, and most of those were demeaning. This would not change until after World War II.[18]

THE ARTISTS

Very little is known about the artists who illustrated *The Crisis* magazine. NAACP records contain almost no documentation of transactions between Du Bois and his staff and the visual artists, and there are virtually no extant examples of original art. Usually the actual date a piece of art was created is unknown; only the publication date can be determined. Many of the artists who appeared most frequently on the pages of *The Crisis* have left nothing behind. The best records about them can be found in the papers of the Harmon Foundation, a high-profile philanthropic organization which supported the creative work of African Americans. The foundation provided strong support for visual artists, including prizes accompanied by cash awards and traveling exhibitions which provided a venue for audience development, sales, and greater visibility for the artists. Several of *The Crisis* artists applied for Guggenheim fellowships, and their applications provide more biographical information. These artists embodied Du Bois's ideal of Talented Tenth. Several of *The Crisis* artists trained at the same institutions, partly because they were the leading institutions in the country and partly because they were among the few places which offered opportunities to black artists.

Albert Alex Smith

Albert Alex Smith was one of the more frequent and interesting contributors to the art of *The Crisis.* He was born in New York City in 1896 and was trained in art at the Ethical Culture Art School, to which he won a scholarship as the only "Negro competitor." He also attended the National Academy of De-

sign in New York and later attended the Academie des Beaux-Arts in Liege, Belgium, where he spent a year and received special instruction in etchings. Smith had also been accepted at the Art Students League but was later refused admission because of his race.[19] A musician before he was an artist, he joined the 807th Pioneer Band and went abroad with a Negro regiment in the American Expeditionary Force during World War I. He served as a cartoonist for First Army Headquarters for five months and visited France and Belgium while accepting small contracts to earn money to travel. After his service, Smith decided to relocate to Paris and took an apartment on Rue La-marck in the heart of the artists' district of Montmartre. He also earned money for travel by working as a jazz musician and singer. His exhibition record and awards are numerous, including awards from the Harmon Foundation, an Amy Spingarn prize in *The Crisis* in 1925, a Henry. O. Tanner gold medal, and others.[20] Smith earned a place in seven annual exhibitions with the Harmon Foundation and was admitted to the prestigious Paris Salon in 1921. Smith also regularly exhibited in Europe, notably in Paris, Cannes, and Brussels. He also exhibited in New York and Boston.[21] His work received positive notices, including in the French journal *La Revue Moderne,* which described his compositions as vigorous, finely colored, luminous, and optimistic. The article noted Smith's independent spirit and his interesting images of his voyages across the world.[22] After a brief return to the United States, Smith decided to go back to Paris in 1927 to work as a musician. He performed in cabarets and clubs in Paris and, after traveling to Spain, quickly learned to play the banjo when he realized it would gain him more employment. He wrote to his parents of his budding musical career: "I am popularly called Bing Crosby. Lots of women have told me that they come especially to hear me croon. And I can croon if I have to say so myself. I have tried to develop a style of singing that is more or less my own and people seem to like it."[23]

Arthur Schomburg, president of the American Negro Academy, wrote a letter of support for a Harmon Gold Award for Smith in 1929. Schomburg praised the skill in Smith's intricate etchings but also noted that he had been "beset with difficulties." Schomburg added that he knew of "no other person who has served his state and his people, and was worthy of your consideration" more than Smith.[24]

Smith dealt with the most important issues concerning his race, and his works appeared regularly in both *The Crisis* and *Opportunity,* the Urban League's journal that debuted in 1923.[25] He dealt very directly with even the most disturbing issues facing black Americans, but he did so from the distance and safety of Paris. Smith's father described one of his son's pieces which dealt with lynching in a letter to George Haynes of the Harmon Foundation:

I have a picture that I have not exhibited, I was thinking of sending it to the Harmon Foundation, but I have changed my mind, I am afraid that the picture might do harm, Now I would love for you to see the picture, this is the picture, A colored boy has just been lynched, he is lying in his Mother's lap, with a piece of rope around his neck, his hands are at the back of his head tied with a piece of rope, and the colored lady, his Mother[,] a very respectable looking lady, has nothing but sorrow in her face, Now I think that the picture is too heavy, that is a question? Why Albert painted a picture like that I don't know, This is it, an Artist just painted what it had in his mind, to HELL with what any one thought.[26]

Most of the images Smith submitted to *The Crisis* were pen-and-ink drawings, and the originals do not survive. Smith died in Paris in 1940 at the very young age of forty-four of a blood clot to the brain. In one of many obituaries, one writer described Smith's work as "not stemming from the African primitive tradition or belonging to any of the modern American schools" but having a "power of its own." The writer continued: "Perhaps through his long years of residence abroad, during which he lost a good deal of contact with his native America, he came to think of himself not first as a Negro or an American, but as an artist, and an artist who wished to contribute what he had to express to the world at large, and to the achievement of the Negro race in the field of the arts."[27] Smith was a true artist of the diaspora, a member of the Black Atlantic whose life was shaped by the events of slavery and discrimination but who commented on black life from Paris as an expatriate. This allowed him to see the United States with a clearer eye.

Cornelius Johnson

Relatively little is known about Cornelius Johnson, who provided Du Bois with a substantial number of political cartoons. Johnson was the son of a postal worker and seamstress, born in Texas and reared in Chicago. He attended the Mechanic Arts High School in Chicago and spent three years at the Art Institute of Chicago and three months at the Art Students League in New York. Johnson was known for his posters, greeting cards, and portrait work. In an application for the Harmon Foundation's traveling show, Johnson noted that one of his special recognitions as an artist was that he was "one of the few colored students to be permitted to practice-teach in the Saturday classes" of the Chicago Art Institute. He explained in his application that lack of finances had made it impossible for him to complete his training at the teacher training department of the Institute.[28] *The Crisis* was Johnson's main venue for his art, which he called "free lance magazine work," and he considered his connection to the magazine to be one of his most important achievements. He received two prizes for his work there, including a second prize and honorable mention in the

Crisis Magazine Cover Design Contest of 1927–38 and first prize in a *Crisis* national contest for a cartoon "relative to Negro Business, finance, etc."[29]

Laura Wheeler Waring

Waring, born Laura Wheeler in Hartford, Connecticut, was Du Bois's most frequently featured woman artist on the pages of *The Crisis.* The daughter and granddaughter of ministers, Waring recalled that even as a young child she delighted in visiting the art galleries of Hartford, not only for the joy of an outing but also because she loved the painting, the color, the beauty of the galleries. She always loved to paint and draw, and her parents often joined their children in these activities. Both her parents, especially her mother, had some artistic talent. Waring was dedicated to becoming the best artist she could possibly be and pursued that dream tenaciously. She received teacher training at the Cheyney Training School for Teachers at the State Normal School in Cheyney, Pennsylvania.[30] When the family fell on hard times, Laura took responsibility for the younger children. She needed to work and this took away from her chance to paint. Summers were spent studying "the teaching of drawing" at Harvard and Columbia, among other places.

In 1924 Waring made her second trip of three to Europe and went to France to study painting with Boutet de Monvel and Prinet at the well-respected Academie de la Grand Chaumiere in Paris. Waring called this the "only period of uninterrupted life as an artist with an environment and associates that were a constant stimulus and inspiration."[31] She kept in contact with Du Bois while studying in Europe, and one letter to him indicates her dissatisfaction with the low pay (and even no pay) for her work that she sent back to *The Crisis* from Paris. She even met Du Bois for dinner once while he visited Paris.[32] Upon her return, she studied under Henry McCarty at the Pennsylvania Academy of Fine Arts. After six months of studying at the academy, Waring won a Cresson Traveling Scholarship, which allowed her to spend three months in Paris to "study in the great galleries of Europe."[33] In 1927, at the urging of friends, she submitted her work to the Harmon Foundation for an award and listed Henry O. Tanner as a reference on her application. She won a first place Harmon Foundation medal and a prize award of $400 that year, followed by a bronze medal from the Harmon Foundation in 1930. Waring wrote to a supporter that this was the busiest time of her life. For six months, she studied and worked on her art at the Pennsylvania Academy of Fine Arts, usually seven days a week.

Waring was interested in furthering the chances of other artists to receive support and patronage from organizations such as the Harmon Foundation. She wrote to William E. Harmon in January 1928 to express her deep gratitude

for the chance she had been given by the foundation. She emphasized the important impact these awards had on the artists and explained that she was writing him "only to testify that these results are real." She explained to Harmon that she had had spent so much time teaching to support herself that she had little opportunity to devote herself to her art. But the Harmon Foundation award had given her "this stamp of approval on my work. I have the assurance to decide to give up nearly all of my teaching next year and devote the major part of my time to painting." Waring reassured Harmon that she planned to make a record of "interesting characters of the American Negro in paint" and that she had been invited to bring the exhibit to Paris when it was finished. She hoped to use the exhibit to "create more interest in inter-racial identity."[34] Waring's work was exhibited in such notable locations as the New York Water Color Club, the Corcoran Gallery of Art in Washington, the Chicago Art Institute, the Pennsylvania Academy of Fine Arts, and at numerous private venues.

Waring faced the same problems that all African American artists encountered in the United States during this decades, that of finding funding and patronage to support her training and work. In a reference letter for a Guggenheim Fellowship, supporter Dr. George Haynes wrote that Waring had "become more enthusiastic about the idea of devoting more time and attention to the searching out and portrayal of Negro types" after winning the Harmon Gold Award. Haynes explained to the committee that Waring's main handicap was the fact that she had to spend most of her time teaching. "I believe a year or two with freedom to travel and see various Negro types, with time to devote her undivided time and energy to painting them, would give outlet to her ambition in this direction and doubtless result in some permanent contribution to the Fine Arts."[35]

Waring's work appeared frequently on the pages of *The Crisis* during Du Bois's years, often in the form of portraits of women or children and drawings of African life. Her art accompanied the writings of Georgia Douglas Johnson, James Weldon Johnson, and Jessie Fauset, among others. Waring did not create political cartoons for the journal.

Elmer Simms Campbell

Elmer Simms Campbell was one of the younger artists to debut on the pages of *The Crisis*. His first piece appeared in March 1923, when he was a sixteen-year-old senior in high school at Englewood High in Chicago. *The Crisis* reprinted a war cartoon, "We Won Buddy," for which he won first prize at the third annual convention of the Central Interscholastic Press Association. With over 12,000 high school magazines from across the country entering the competition, it was a notable award. Campbell, the son of high school teachers, went

on to win several other awards, including the *St. Louis Post-Dispatch*'s first prize for drawing. Campbell studied at University of Chicago and graduated, after two and a half years of further study, from the Chicago Art Institute. Chicago cartoonist Ed Graham encouraged Campbell to continue his studies at the Art Students League in New York, and he spent 1932–1933 there studying under George Grosz. He was employed as a commercial artist in the Chicago area. In addition to his commercial work, Campbell briefly taught high school in St. Louis.

Campbell won an NAACP Christmas Seal contest in 1931. The image he created was described in an NAACP press release as "a sharp black figure of a man who has broken the chains which held him captive." The seal bore the simple inscription, "For Justice."[36] The seals were sold in books of 200 for $2, as "silent pleas for justice." The NAACP press release noted that the work of the "famous young colored illustrator" had appeared in *Judge, Life, Ballyhoo, College Humor,* and *The Chicagoan* and had been reprinted in German, French, and English periodicals.

Campbell chose to spend fourteen years living and working in Switzerland and became a regular contributor to *Esquire* magazine, for which he created Eski, the "pop-eyed, bulbous nosed connoisseur of female beauty" who appeared on numerous *Esquire* covers. He was a frequent contributor from the time the magazine debuted in 1933.[37] *The Crisis* was just one of many places where his art appeared. He would later sell his work to *Playboy, The New Yorker, Life, Judge, Collier's,* and the *Saturday Evening Post.* He also illustrated children's books and wrote about jazz. In his world travels, he took part in United Service Organizations shows after World War II in Japan, Germany, and France.

Campbell noted that his profession was not an easy one. "Turning out cartoons is hard work, a little like ditch-digging, except when you're digging a ditch you're out in the open and can get some fresh air," he said.[38] Campbell fought racism not only in his cartoons but also in his personal life. Campbell went to the New York Supreme Court to try to compel mortgage trustees to sell him property which he contended they refused to sell to him because of his race.[39]

Charles Dawson

Charles Dawson studied at the Art Students League in New York and the Art Institute in Chicago. He worked as a staff artist on a newspaper and as a freelance illustrator. He also worked on the New Deal Public Works of Art Project and worked in the National Youth Administration as the "Painter, Illustrator and Supervisor in charge of Negro Affairs, 3rd District, Chicago."[40] In his work for the Public Works of Art Project, he executed a series of watercolors

and pencil drawings, mostly of "Negro child life" and one large historical water-color of "Pershing inspecting Negro Troops in France."[41]

Dawson provided one of the more interesting covers for *The Crisis*; it cele-brated education and showed a strong sense of racial pride and the influence of a connection to Africa. He won a *Crisis* Krigwa Award for his efforts.[42] Dawson would use his talents in teaching positions at Howard University and Columbia University and exhibitions at the Harmon Foundation (1933) and the Negro Exposition of Progress in Birmingham (1940). He was also included in the "Art of the American Negro" exhibit at the American Negro Exposition in Chicago (1940). He exhibited at the Chicago Art League's World's Fair show which opened in August of 1934; the *Chicago Daily News* categorized Dawson's series of black-genre scenes as work that would "induce a pause."[43] Dawson had com-missions from the Chicago Urban League, the National Urban League, and Wilberforce University and for book illustrations.

In his Harmon Foundation application, Dawson was asked what was the most significant and interesting development in art today; he replied that the Negro Salon of Roosevelt High School, in Gary, Indiana, demonstrated a "very practical . . . art appreciation and pride of race" with their inclusion of an art gallery in the new school, which was staffed by an entirely black faculty. The gallery was filled with art that was secured by a faculty initiative to purchase art in 1932, during the heart of the Depression. They wanted the Negro Salon to consist principally of the works of "outstanding Negro Artists" who were cho-sen carefully so the works would inspire and encourage young black artists in the community. The works purchased for the gallery included the art of Charles Dawson and William Scott, who had also illustrated for *The Crisis*. Dawson considered the effort a "most inspiring and practical example of intelligent study of art appreciation" because the gallery would result in a love of art and would give a "most vital stimulation to the artists of their race."[44] Dawson viewed the art in the Negro Salon as both a source of pride and inspiration to the black faculty and student body and a source of "very desirable enlight-enment" to the white students and public of Gary who visited the novel art gallery. Dawson hoped that every black high school, college, and university in America would follow in the footsteps of Roosevelt High; he knew such an ef-fort would result in a "stimulation of Negro artists and Negro art beyond esti-mation."

Aaron Douglas

Aaron Douglas was born Topeka, Kansas, in 1899. He received his B.F.A. at the University of Nebraska, Lincoln, in 1922 and studied under Bavarian art-ist Winold Reiss in New York from 1925 to 1927. Douglas spent a year as the

first black fellow at the Barnes Foundation in 1930. He received his M.A. from Columbia University Teachers College in New York in 1944. Douglas is considered the leading visual artist of the Harlem Renaissance. Within weeks of his arrival in Harlem in 1925, Douglas was recruited by Du Bois and Charles S. Johnson, the editor of the Urban League's magazine *Opportunity,* to create illustrations to accompany their editorials on lynching, segregation, theatre, jazz, poems, and stories about political issues. Douglas, a Kansas City high school teacher, had chosen to join the young artists of the Harlem Renaissance after viewing the *Survey Graphic*'s special issue devoted to Harlem; Winold Reiss created the cover for the magazine. Douglas was impressed by the dignity and forthright manner with which Reiss portrayed blacks. He exhibited at D'Caz-Delbo Gallery in New York, Howard University, Fisk University, Newark Museum, and the Studio Museum in Harlem.

Du Bois hired Douglas to create a visual message for a public that had grown dramatically with the increase of black migration to the North during World War I. Douglas sought to follow Du Bois's injunction to create art with a message by crafting a new, positive African-influenced black image for his audience. Before Douglas, some American artists had begun to include African art in their work but none used it on a regular basis. Tired of the white man's depictions of blacks, Douglas believed his work could touch the black audience in a unique way. He explained in a 1925 letter to Alta Sawyer, his future wife: "We are possessed, you know, with the idea that it is necessary to be white, to be beautiful. Nine times out of ten it is just the reverse. It takes lots of training or a tremendous effort to down the idea that thin lips and a straight nose is the apogee of beauty. But once free you can look back with a sigh of relief and wonder how anyone could be so deluded."[45] Douglas's language of African art reached a growing black middle class in the North with a message of racial pride.

Douglas's growth and experimentation as an artist come through in his *Crisis* illustrations, where he created some of his most forceful and interesting works and evolved his artistic language. No artist before him had brought the language of African art to his or her work in quite the way Douglas did. The images are clean and bold, often just a few simple figures that illustrate a basic idea or show images of African Americans.

Douglas provided illustrations for numerous books and journals, including *The Crisis, Opportunity,* and *Theatre Arts Monthly,* and book illustrations for Locke's *New Negro* and for poet Langston Hughes. He also received a number of mural and portrait commissions. Douglas created a particularly innovative cover for the radical black publication *Fire!!,* edited by Wallace Thurman. *Fire!!* attempted to break from the confines of the traditional leaders of the Harlem

Renaissance and create a new artistic voice. In addition to the cover and three interior drawings for *Fire!!*, Douglas penned the artistic statement for the group.

Aaron Douglas was commissioned by Fisk University in 1930 to execute murals for its library. The cycle was to represent a panorama of the history of black people in the New World. He began with life in Africa, then depicted slavery, emancipation, and freedom, which he symbolized by Fisk's Jubilee Hall. The mural project was extensive, and Douglas hoped to make Fisk students realize the important contributions black Americans had made in the building of America. The final cycle of the murals (which were recently restored and returned to their original beauty) represents life in Africa, enslavement, the Middle Passage, and freedom through education. The mural cycle was the most ambitious project of his lifetime. Douglas repainted the entire cycle when he was asked to restore it in the late 1960s, using a brighter, bolder palette. He had learned a great deal about color in the years since it was created.

Many of the Harlem Renaissance artists made a sojourn to Paris, and Douglas was no exception. He lived and studied in Paris at the Academie Scandinave for one year, in 1931, following a one-year fellowship at the Barnes Foundation in Merion, Pennsylvania.

In 1934, Douglas executed what many have called his masterpiece, *Aspects of Negro Life,* his Marxist-inspired Works Progress Administration murals now at the Schomburg Center in Harlem. Douglas's large murals chronicled the struggle of the black man and woman from Africa through slavery, emancipation, and their roles as workers in the machine age. Douglas was determined to awaken the black middle class to the important issues of the time. The Great Depression's impact on the black middle class, which was more severe than on its white counterpart, radicalized both Douglas and his audience. The murals appealed directly to a public suffering from the harsh conditions of unemployment and poverty.

One of his most important contributions was his role as founder and chairman of the art department at Fisk University, Du Bois's alma mater, in 1937. He remained chair until his retirement in 1966.

Douglas remains unique in his efforts, providing crucial links with the literary figures of the Harlem Renaissance, its ideas about Africa, and the thinking of blacks throughout the world. He was the first black artist in the United States to consistently create racial art and as an illustrator was able to reach a large readership through black magazines.[46] Douglas works were filled with pride, unity, strength, dignity, and self-awareness. He was a pioneer in American art, breaking away from the traditions of such famous white artists as Robert Henri, Reginald Marsh, and Ben Shahn to create unique, sophisticated works that interpreted modernism in a new light.

Bernie Robynson

Bernie Robynson provided illustrations for *The Crisis* that included images of progress, education, and labor. Robynson had a high school education and studied for one year at Knoxville College in Tennessee. He also trained at the National Academy of Design, the Associated Art School, and the Art Students League. He was employed by the Consolidated Gas Company of New York as a messenger: the company frequently published his drawings in their advertisements in black newspapers. The company noted that he showed exceptional ability in portraying the subjects he knew best, "the life of his people." He was a resident of Harlem, which gave him easy access to the offices of *The Crisis.*

Robynson applied for a Guggenheim fellowship in 1929 and a Harmon Foundation award in 1931. His recommenders admired his pen-and-ink drawings and saw him as an illustrator who did not "scorn racial themes" but was "fully cognizant of the wealth of his racial heritage." One reference noted that he was still doing menial work yet was able to create art that was beautiful, original, and artistic. In Robynson's Guggenheim application, he proposed a series of drawings to be used as greeting cards depicting "Negro Folk Life" in the Old South. He hoped to show "in a sociological way" the universality and brotherhood of man and to inspire other artists to "do something better." Robynson's ultimate purpose as an artist was to portray literary incidents in a pleasing and dexterous manner and to use his talent for "any social cause that I deem just, to meet interesting people and be of service in my small way."[47]

Robynson often provided illustrations for the black newspaper *New York Amsterdam News* and worked regularly as a commercial artist in New York City. As one recommender noted, "If Mr. Robinson [*sic*] had been of any race except the Negro he would have received a position of prominence in one of the largest commercial Art Institutions." He exhibited at the 135th Street Library and instructed students there. Robynson was described as courageous, gentlemanly, a natural-born artist with a strong work ethic. He provided illustrations for several books, including Carter G. Woodson's *The Negro in Our History,* and his drawings were syndicated by the Associated Negro Press between 1928 and 1932.

James Lesesne Wells

James Lesesne Wells was born on the campus of Clark University in Atlanta in 1902. His father was a Baptist minister and his mother a university dean. Members of his family had held various political offices during Reconstruction. His interest in art developed early on, and he won his first art contest at age thirteen. He attended Lincoln University and received his B.S. from Co-

lumbia University. He studied lithography at the National Academy of Design and then spent three summers at Columbia receiving further training. He also trained at the Metropolitan Museum of Art, where he worked as a copyist. He received the Harmon Gold Award in Fine Arts in 1931 and the George E. Haynes prize for Best Work in Black and White.[48] Two of his students were chosen as Public Works Administration artists. Wells served as the first director of the Harlem Art Workshop in 1933. He designed book jackets and book illustrations and block prints for Negro History Week in Washington, D.C. Wells provided the cover design for Carter Woodson's *Rural Negro* and his works appeared in *The Survey* magazine and *New Masses*. His illustrations were included in exhibitions at the New York Public Library, the Smithsonian Institution, at the American Print Makers Society in New York, and at the Print Club of Philadelphia. Wells was the embodiment of the Talented Tenth artist and fit into Du Bois's idea of the well-trained artist who exhibited excellence in his work. He served as an art instructor at Howard University, where he spent the majority of his career. He directed the art club there, which featured regular exhibitions.

Wells's work was purchased by Howard University, Lincoln University, The Corcoran, Hampton Institute, and the Phillips Gallery in Washington, among others, and was featured in a variety of other prominent collections. Writing for the journal *The International Studio,* critic Washburn Freund said, "Wells has the rhythmical feeling of his race that makes him create spontaneously in old Negro forms. His art, therefore, combines individual naivete with the accumulated wisdom of an old and ripe tradition." Freund noted that his woodcuts and linoleum prints showed an African influence.[49]

Vivian Schuyler Key

Vivian Schuyler Key was born in Hempstead, Long Island, in 1905 and graduated high school with honors, as one of two black graduates, in 1923. She attended Pratt Institute for art training at the considerable sacrifice of her family. Key recalled her three years at the Pratt Institute, where she commuted from Hempstead to Brooklyn every morning: "They were very difficult years, years which I will never forget. I was the only colored person and the poorest one in my class. I was too conscious of my poor clothes and empty pocketbook. I had to forego many lunches for a brush or tube of paint. I was very retiring and very lonely. I loved the work however and did well in my classes, so I never once thought of quitting. I was encouraged by most of my instructors to keep going."[50] Evenings after school were spent doing her homework by oil lamp, drawing and painting at the big dining-room table. Vivian spent so many sleepless nights working in the cold house that she contracted a series of colds and one

severe case of bronchitis from which she never fully recovered. Schuyler married her husband, William Key, in 1929. She had little opportunity to paint, although she did design textiles. She contributed several drawings and covers for *The Crisis* and won the Amy Spingarn Art Award in *The Crisis* and exhibited at the Harmon Foundation. Her husband's lack of support and the duties of motherhood made her desire to paint an even greater challenge. Du Bois saw her work after being introduced to her by musician Minnie Brown and artist Aaron Douglas.

Key hoped to exhibit at the International House annual exhibition in 1930 and thus applied for a Harmon Award for distinguished achievement, hoping it might improve her chances.[51] She noted in her International House application letter that she might not appear to be distinguished but that she was capable of doing something "very great." Her need to make a living, her modest upbringing, and the limits in her training had hampered her efforts, but she was determined to continue. She faced discrimination against her gender and lamented that it was her "misfortune to be born a girl, a thing which I have regretted even though I have recently married." She and her sisters were excellent students; her sister Elizabeth was the first African American to graduate from Adelphi College in Brooklyn, where she was the only black. Her other sister, who wanted to be a doctor, became a nurse due to lack of funding for medical school. She noted that she and her sisters were not known and that they had "worked too hard to spare the time to make ourselves known and we have done the kind of work through which no one ever becomes known." Her greatest desire was to please her hardworking mother and to become a success in her mother's eyes. While Key was never famous, she was a respected artist among the small circle of illustrators working for *The Crisis.*

Romare Bearden

Romare Bearden, one of the most celebrated African American artists of the twentieth century, contributed some of his most interesting work to the pages of *The Crisis.*[52] Although Bearden was born in Charlotte, North Carolina, in 1914, his family moved to Harlem while he was still an infant. His parents socialized with many of the leaders of the Harlem Renaissance, including Langston Hughes and painters Aaron Douglas and Charles Alston. He met Du Bois in his parents' Harlem home. Bearden spent his high school years in Pittsburgh with his grandmother and graduated from Peabody High in 1929. He then attended Boston University for two years, where he illustrated for the student magazine *Beanpot,* and he spent his final two years of college at New York University, graduating with a bachelor of science in education in 1935. He started drawing cartoons in college and became the art editor of the New York

University student magazine *Medley* and the school newspaper's principal cartoonist. Bearden was part of a relatively new and small group of black cartoonists that was forging new territory in illustration. The work of E. Simms Campbell (who he met in Boston), Ollie Harrington, Miguel Covarrubias, Honoré Daumier, Jean-Louis Forain, and Käthe Kollwitz would greatly influence him. His early cartoons, along with those he did for the magazine *College Humor,* established Bearden's lifelong interest in social realism and social commentary through art. He also contributed cartoons to the nationally circulated *Baltimore Afro-American,* the Urban League's *Opportunity* magazine, and *Collier's.* His early published comic strips included *Dobby Hicks* (which has been compared to the strip *Henry*), which was followed by *Dusty Dixon,* a more evolved strip. He felt neither strip was the ideal place for his social commentary and sought a better way to communicate his view of the black condition. His developing interest in identity, in his southern heritage, and in the issues of the people of the black diaspora, which became a dominant theme of his work, found their early expressions in his political cartoons of *The Crisis.* These political cartoons led him to pursue a career as a politically engaged artist.

When Bearden entered the Art Students League in August of 1933, he came under the tutelage of George Grosz, whose work was strongly expressive of his own political ideology and had strong social implications. Grosz, who considered himself a propagandist of Marxism, had a profound impact on the young Bearden. As a German Expressionist who was also associated with the Dada movement, he graphically depicted victims of World War I—the disabled, crippled, and mutilated—and portrayed the collapse of capitalist society and its values. Grosz's World War II–era line drawings show his mastery of caricature, which would influence Bearden. In a portfolio of prints, Grosz ridiculed Hitler by dressing him in a bearskin to look like a caveman, a swastika tattooed on his left arm.[53] Such biting social commentary would provide Bearden an ideal source of inspiration for his own cartoons. Both artists were interested in issues of identity and memory.

Bearden was also clearly influenced by cartoonist William Gropper, whose work appeared in the *New York Call, New Masses,* and *The Liberator.* Gropper's political cartoons looked almost "sprayed" or "splattered" with tiny dots of black and Bearden would develop this technique as well, as is evident in his cartoons for *The Crisis.* William Gropper had an established reputation as a political satirist and was one of George Grosz's biggest admirers. The white political cartoonist Herblock worked in a similar style. He was featured in the October 1935 issue of *Crisis.*

Bearden's job as a case worker in the New York City Department of Social Work, which he started in 1938, would eventually provide him endless topics

for his art. At this time he also become associated with the 306 Group in Harlem, which included members such as Gwendolyn Bennett, Robert Blackburn, Norman Lewis, and Jacob Lawrence. Stuart Davis greatly influenced Bearden as well and inspired his interest in the connection between art and jazz.

Early in his career, Bearden stated that painting and art were supposed to be *about* something, namely the reality around him. "My works represent a consolidation of memories of certain direct experiences from my childhood into the present."[54] Bearden's work had a strong connection to the blues, the music of the Black diaspora. Bearden used art to register his own protests, first in his political cartoons and later in his paintings and collages, showing figures who are downtrodden, sorrowful, depressed, or abused, thereby registering a profound protest against their conditions.

In December 1934, Bearden's "The Negro Artist and Modern Art" was published in *Opportunity.* He tried to express his concerns about African Americans as artists and even criticized organizations that sponsored the works solely of African American artists, including the Harmon Foundation. Bearden found the Harmon Foundation's attitude toward black artists to be of a "coddling and patronizing nature" which encouraged them to pursue art before their level of expertise was ready for exhibition. He wrote, "However praiseworthy may have been the spirit of the founders, the effect upon the Negro artist has been disastrous."[55] Bearden believed art should be judged without notice of race. He did not want his fellow black artists to look at art through the eyes of white artists and re-create it but rather to paint what they knew, to search their own world for inspiration. He considered the ideal artists of the time to be the Mexican social realist muralists Diego Rivera and José Clemente Orozco, who absorbed the influences of their masters yet created something new and unique as individuals.

Romare Bearden had a long and prolific career as an artist who dealt directly with issues of personal and group memory, the identity of the black American (which he often tied to Africa), and the political scene. He is renowned for his collage works, his politically charged pieces of the 1940s, 1950s, and 1960s. His commitment to the political issues of the day, to painting what he saw and experienced and what moved him deeply, developed early in his career as an college arts editor, a cartoonist at New York University, and an illustrator for the *Afro-American* and *The Crisis.* He developed a visual vocabulary of political protest in these early cartoons and dealt directly with the issues of segregation, labor, war, prejudice, and lynching.

His early cartoons in *The Crisis* and the *Baltimore Afro-American* were extremely important to the development of his persona as a political artist and indeed were the foundation of his work, which dealt with the joys and sorrows of everyday black life in America. Bearden's political cartoons were simple and

straightforward; they gave an immediate message which supported essays and editorials offered to the readers by *The Crisis*. His use of visuals to support text and even sometimes to act as text was strongly influenced by W. E. B. Du Bois.[56]

As African American illustrators in the first third of the twentieth century, the artists of *The Crisis* faced very similar struggles, although their stories differ. They struggled financially, and those financial concerns put limits on their abilities to train, exhibit, and travel. They strove to receive the best education and training possible, even though they were limited by lack of finances, racism, and lack of opportunity for African Americans at many educational institutions. They had little support from patrons and foundations and few opportunities to exhibit their work. They struggled to find patrons in both the black middle class and among wealthy whites to buy their work and support their art. *The Crisis* provided these artists with a national venue for their work and created a community, if only on paper, of artists striving to express the human condition. These artists attempted to strengthen their own sense of a black identity and visualize the need for political action.

3. The "Crime" of Blackness: Lynching Imagery in *The Crisis*

The crime of lynching exposed the second-class status of black Americans and highlighted their oppression and victimization. The incidence of lynching had actually declined from the 1890s, when the annual number of victims—both black and white—was often in the hundreds. But the practice of lynching assumed a more exclusively racial character as the number of whites subjected to this violence decreased much more rapidly than the decrease in the number of blacks.[1] Although the NAACP's campaign against lynching led to further declines during this second decade of the new century, the number of black victims still remained appallingly high, and the fear created by each lynching magnified the issue well beyond the smaller number of victims. By the end of the decade, even southern-born President Woodrow Wilson was prepared to declare lynching a national disgrace. The flagrant injustice and outrageous brutality of lynching and the deep sorrow it created within the African American community created an issue around which African Americans could mobilize.

What was the source of Du Bois's commitment to publicizing the ongoing horrors of lynching? Two violent events had a profound effect on Du Bois and brought him ultimately to help found the NAACP and edit *The Crisis*. Both happened while Du Bois was living in Atlanta between 1897 and 1910. Although Du Bois had encountered prejudice, racism, and fear in Nashville while attending Fisk, he did not encounter the racial violence there that he would confront in Atlanta. In 1897 he was appointed a professor at Atlanta University, the sole black professor on an all-white faculty. Life in Atlanta reminded him of his status as a black man every day. One lynching, the April 1899 assault on

Sam Hose, had a powerful impact on Du Bois. A poor farmer, Hose was accused of murdering his white employer, Alfred Cranford. Cranford's wife stated that Hose murdered her husband with an ax, robbed them, raped her, and terrorized her children. Public hysteria ensued, fueled by Atlanta's five daily newspapers, including the *Atlanta Constitution*. As a result, Hose was hunted down, tortured, and lynched. The mob fought over pieces of his body. His knuckles were displayed at a small grocery story as evidence of the successfully hunted "prey" on the very street where Du Bois was walking when he heard of Hose's death. The event "shook him to his core."[2] Hose's torture included castration, a common practice in lynchings, and burning. Pieces of Hose's liver and heart were cooked and sold for ten cents, while bones went for a quarter. One special and two regular trains carried "nearly 4,000 people" to witness the burning or to visit the scene of the lynching.[3] For Du Bois the message was clear: "One could not be a calm, cool and detached scientist while Negroes were lynched, murdered and starved; and secondly, there was no such definite demand for scientific work of the sort that I was doing, as I had confidently assumed would be easily forthcoming." Du Bois had believed that "the world wanted to learn the truth, and if the truth were sought with even approximate accuracy and painstaking devotion, the world would gladly support the effort. This was, of course, but a young man's idealism, not by any means false, but also never universally true."[4]

Georgia's governor blamed blacks for not properly uplifting their own people and connected the lynching of Sam Hose to black participation in politics.[5] At first Du Bois refuted this argument and fought the attempt to disenfranchise blacks in the Hardwick Bill of 1899, a proposal by the Georgia legislature to restrict the franchise of blacks, even those that held property or were educated. But Du Bois soon decided to distance himself from lower-class blacks such as Hose, betraying a class bias shared by many of the Talented Tenth.[6] This was echoed in the white newspapers of Atlanta, which predictably expressed the moral superiority of whites and vilified the victims. Within weeks of Hose's lynching, Du Bois's eighteen-month-old son Burghardt died of diphtheria. The lynching of Hose and the death of his first born completely overwhelmed him. His grief was extreme and profound.

The second violent event which had an impact on Du Bois occurred seven years later. Du Bois had been instrumental in the creation of the Niagara Movement in 1904.[7] This movement took a different path than Booker T. Washington's program of accommodation, which stressed acceptance of segregation and emphasized learning a skilled trade rather than pursuing higher education.[8] Among other concerns, the twenty-nine men at the initial meeting of the new movement discussed economic issues, religion, black suffrage, and federal sub-

sidies for black schools. In the Niagara Movement, Du Bois was challenging Booker T. Washington and his followers, providing an alternative to their leadership in the black community. Du Bois left Atlanta in early 1906 to conduct a study on peonage in Lowndes County, Alabama, that was commissioned by the federal government. While in Alabama he heard of the terrible Atlanta race riots which began on the evening of September 22, 1906. His wife and daughter were in Atlanta, alone.

The riots resulted from reports in the newspaper *The Evening News* of several cases of alleged black rape against white victims. A mob of 10,000 men, women, and children took to the streets of Atlanta and beat or killed every black they encountered, including children.[9] Du Bois returned to Atlanta and for the first time purchased a shotgun for protection. "I bought a Winchester double-barreled shotgun and two dozen rounds of shells filled with buckshot. If a white mob had stepped on the campus where I lived I would without hesitation have sprayed their guts over the grass. They did not come."[10] Du Bois could hear the shots and screams from the campus of Atlanta University, although he did not personally experience the terror, which lasted several days.[11] For the first time, perhaps, Du Bois could feel some of the vulnerability that working-class blacks experienced.

Du Bois's initial absence from Atlanta and his failure to return quickly gave Booker T. Washington and his supporters a reason to criticize him. By accusing Du Bois of cowardice, Washington was both manipulating the situation and maligning him and the Niagara Movement. Yet Du Bois froze and failed to become an outspoken critic against the mob violence. This mistake cost him dearly, as support in the African American community shifted to Washington. Du Bois returned to his Alabama research project just days after the riots, leaving his wife and child alone again. Although some branded him a coward, Du Bois later complained privately that he was opposed by members of the community when he acted as a lone voice, "willing to speak out." Finally, he could not overcome his own class bias to contradict the racist claim that black criminal behavior had caused the white violence. Du Bois thought that blacks could be divided into groups of decent and less-decent individuals. He recognized that during riots, sometimes fairly good working-class black men joined the criminal element and committed crimes by which all the black middle class was judged.[12] Du Bois felt very much a failure, and this event, coupled with the Hose lynching and his son's death, led him to seek medical treatment for his depression; he later said that he had come close to a nervous breakdown.[13]

These events in Atlanta gave Du Bois a more personal connection to mob violence. Du Bois felt his blackness in a new way; he related more now to his black mother, not just to his father's whiteness. He began to see himself as a

black man who was largely African, part French, and a little Dutch but "thank God! No 'Anglo Saxon.'"[14] He felt the possibilities of racial violence, the realities of it around him, quite personally.

Two years later, in Springfield, Illinois, another brutal riot occurred. This began a chain of events that led to the establishment of the NAACP, which Du Bois helped organize. Du Bois finally decided to leave Atlanta to accept his position at the NAACP. He was free to speak in New York and used *The Crisis* as his tool. Here he could publish all the facts on mob violence and address it head on. He came to understand the immorality of southern whites and expressed his views on that issue on the pages of *The Crisis*. He later said that every lynching scarred his soul, and surely the Atlanta race riots, and the humiliation he suffered as a result of his silence, also weighed heavily on him.[15] When violence was involved, mere theories of race progress would not help bring about significant change, for there was no truth involved, no justice, no social order for his oppressed race. The events of Atlanta and the lynching of Hose forced Du Bois to realize that his idealistic views would not stand up to irrational white prejudice and brutality. Resounding in his ears was South Carolina congressman Ben Tillman's 1907 speech in Congress to support violence against blacks, a speech so vile and extreme that it symbolized the depravity of lynching:

> White women of the South are in a state of siege. . . . Some lurking demon who has watched for the opportunity seizes her; she is choked or beaten into insensibility and ravished, her body prostituted, her purity destroyed, her chastity taken from her. . . . [S]hall men . . . demand for [the demon] the right to have a fair trial and be punished in the regular course of justice? So far as I am concerned he has put himself outside the pale of the law, human and divine. . . . Civilization peels off us . . . and we revert to the impulses . . . to "kill! kill! kill!"[16]

Du Bois could not let such hate speech stand without a response.

THE FIRST YEARS OF *THE CRISIS* AND THE CAMPAIGN AGAINST LYNCHING

Before Du Bois brought lynching to the forefront on the pages of *The Crisis*, it was largely a taboo subject within the black community. As Daisy Lampkin, the field secretary of the NAACP, once stated, "We were so ashamed that whites could do that to *us*, that we hardly wanted to talk about it publicly."[17] However, Du Bois believed that the only way to end lynching was to attack it head on.

During his first decade as editor, Du Bois campaigned incessantly against lynching, using the magazine to document the violence in graphic detail, ex-

plain its origins and purposes, and compile an accurate number of the victims. He published accounts of lynchings, eyewitness descriptions, and photographs of lynching victims. Political cartoons in the magazine depicted the horrors of lynching. Du Bois also used the outbreak of war in Europe and the subsequent American intervention to protect "democracy" as a tool to focus attention on the extraordinary contradiction between American ideals and practices. The impact of his experiences in Atlanta eventually radicalized him and called him to action. He experienced a "permanent transformation from organizational leader to race propagandist."[18] Du Bois believed that lynchings were used by whites to control the black population and to reaffirm the values of the southern traditional order. Even the threat of a lynching was a way of asserting power and dominance over blacks and excluding them from the community.[19] American identity was reserved for white males, and lynching supported this.

The term "lynch law" is an oxymoron since the practice was not just extra-legal, it was anti-legal. The term developed from the concept that whites could take the law into their own hands. James Cutler wrote in his 1905 study on lynching that "the verb lynch was occasionally used to include capital punishment, but . . . 'to lynch' had not then undergone a change in meaning and acquired the sense of 'to put to death.' . . . It was not until a time subsequent to the Civil War that the verb lynch came to carry the idea of putting to death."[20] And it was not until the 1890s that lynching became an act almost exclusively focused on controlling African Americans.

In his study of lynching in Georgia and Virginia, historian Fitzhugh Brundage has classified every lynching as one of four types: mass mob, in which victims were killed in public in actions that were legitimized by widespread public participation; posse, in which a criminal suspect was captured by an ad hoc group and often lynched before the suspect was brought to law enforcement officials; terrorist, in which racial violence was committed by persons belonging to organized groups such as the Ku Klux Klan; or private, lynchings that were done secretly by small groups.[21] Historian Vincent Vinikas defines lynching as an event which required "a minimum party of four—at least three perpetrators and a victim. Whether or not a part of the public record, a lynching is by definition a public event."[22] The meaning of the word "lynching" actually became a point of contention between rival anti-lynching groups.[23] The definition of lynching mattered because it could further the strategies used to combat it. The NAACP defined lynching as community-sanctioned murder,[24] and this was the focus of the artwork and accounts in *The Crisis.* Du Bois wanted to make certain that these memories would be preserved forever; they were memories that needed to be used by African Americans to bring about change, to make sure that the victims had not died in vain.

However confusing the evidence or incomplete the records of lynchings were, what was noteworthy for Du Bois was their extralegal character, that they were acts of terrorism against black citizens. This made visual imagery all the more important. Newspaper accounts usually provide the best evidence for the modern historian, although some lynchings did not garner much attention. As Mary Church Terrell wrote in 1904, "Hanging, shooting and burning black men, women and children in the United States have become so common that such occurrences create but little sensation and evoke but slight comment now."[25] At times, accounts make it difficult to determine the method by which a black victim died. Usually, however, southern papers engaged in a form of sensational journalism that did not shy away from all the grisly details. Most newspapers identified the victim as black and asserted that the victim was guilty of the crime and therefore deserved the penalty.[26] Journalists often proved most helpful to those who supported mob violence, as they excused lynchings by publishing graphic details of supposed black crime. Such details could sell papers, and crime attracted an audience. Even the *New York Times* and the *Chicago Tribune* demonstrated bias in their treatment of lynchings, usually by assuming black guilt and the tendency toward rape of "Southern Negroes."[27]

Du Bois wanted to educate a new audience about the horrors of lynching. He was angry with the one-sided, racist coverage of lynchings in the mainstream press and turned to the pages of *The Crisis* to set the record straight and demand involvement from his readers. Du Bois had read the southern press, where he saw blacks referred to in lynching accounts as "fiends," "wretches" and "desperadoes"; such coverage always assumed the victim's guilt. Newspapers falsely emphasized "rape" as a reason for lynching. The white liberal press had failed him too. With the exception of Ray Stannard Baker, who exposed the realities of lynching in *McClure's* in 1905 and in a 1908 book called *Following the Color Line,* Du Bois had little help from whites in his campaign to expose lynching.

Lynching statistics were kept beginning in 1882 by the Tuskegee Institute, which recorded at least 3,442 lynchings from 1882 to the 1950s. It has been estimated that between 1890 and 1919, 1,748 black men, women, and children were lynched by whites, roughly one every six days.[28] (No one is sure how many blacks were killed before 1881; the records are incomplete.) During the same time period, 1,294 whites were lynched, mostly in the West. (Until 1868, the majority of recorded lynching victims were white men usually accused of stealing livestock or committing murder.) Over 1,200 lynchings occurred in the Deep South alone between 1882 and 1930; one scholar places the number of victims at 2,500 in ten southern states during those decades.[29] Lynchings were less frequent in Tennessee, Kentucky, and North Carolina, states that were

closer to the North, and were more common in the Black Belt states, where whites felt threatened by the black majority.[30] Between 1889 and 1918, 85 percent of recorded lynchings were done to black victims; 88 percent of these crimes took place in the South.[31] Some studies show that as much as 95 percent of lynchings took place in former slave states.[32] Since many lynchings were secret affairs and lynching records are often missing, accurate statistics are difficult to determine. What was clear was that whites used terror and extraordinary savagery and sadism to exercise their absolute power over African Americans.

Ida B. Wells, the renowned anti-lynching crusader and black journalist, fought against the characterization of blacks as villains in the southern white press. Wells used statistics as her primary weapon, as did several other activists, including Monroe N. Work, an African American sociologist at the Tuskegee Institute who compiled information on lynching for Tuskegee's Department of Records and Research. Work offered his statistics without commentary to white southern newspapers in order to encourage them to publish the figures. Because they were from an independent source, newspapers could avoid citing another newspaper as their primary source. His statistics were so widely respected that even the NAACP used his reports and considered them accurate.[33] The NAACP did, however, compile its own statistics, which were often published on the pages of *The Crisis.*[34]

Du Bois knew that despite class distinctions, whites generally agreed on matters of race and were united in their culture of white supremacy. It was in the interest of all classes of whites to continue the terrorism. For white landowners, it prevented any coalition of poor whites and blacks, while for poor whites, it reinforced the "southern caste line" and established superiority of poor whites over blacks.[35] Most statistics indicate that economic concerns or threats were often at the root of lynching and that lynching was more prevalent in locations where white economic power was challenged.[36] Du Bois also knew that the courts had not helped black Americans fight this terrorism. As he wrote in 1903, "Negroes came to look upon courts as instruments of injustice and oppression and upon those convicted in them as martyrs and victims."[37]

Lynchings reminded African Americans that they had almost as little protection under the law as citizens than they had had as slaves, a fact that was corroborated as violence against blacks continued year after year. Du Bois knew that few lynchers were ever brought to trial, and those few that were were rarely convicted. The few that were convicted served short jail terms or paid small fines. Southern police officers resisted intervening in lynchings, worried that their own personal authority as "the law" would be compromised. In fact, they were often collaborators in lynchings by offering little or no protection for black

prisoners in their care or by actually participating in them.[38] Fewer than 1 percent of the lynchings before 1940 were followed by a conviction of those responsible.[39]

The random aspect of lynchings was particularly disturbing and kept the black population in fear for their lives. When blacks heard of a nearby lynching, they were reminded of their extreme vulnerability.[40] Lynching generally did not occur in the same counties year after year—in other words, the violence circulated throughout the Deep South, never staying long in one place but always leaving a powerful impact. Often people who were associated with the accused were lynched as well, and women were victims too. Many female lynching victims were never suspected of a crime; they died in place of a male target, such as a husband, father, or brother.[41] Women and children suffered by witnessing the lynching of their male relatives; they were often forced to watch by the excited mob. Lynchings were a constant reminder to survivors that they too could be the next victims of this "officially encouraged but ultimately invisible brutality."[42] As Brundage explains, "The crippling dogma of white supremacy, the autonomy of county governments, and the weakness of state institutions all worked to frustrate opponents of mob violence."[43] There are accounts of resistance to lynchings, including armed resistance. But there was no systematic or effective way to fight a lynch mob. Author Richard Wright wrote years later that just the *threat* of violence modified his behavior. "The things that influenced my conduct as a Negro did not have to happen to me directly; I needed but to hear of them to feel their full effects in the deepest layers of my consciousness. Indeed, the white brutality that I had not seen was a more effective control of my behavior than that which I knew."[44]

Du Bois had tried presenting facts, but it was time to summon support through political activism and visual images. The NAACP hoped to nationalize the movement against lynching, and *The Crisis* was the ideal venue to do so. The NAACP had its own symbolic visual statement: it hung a black flag outside its offices on 5th Avenue every time a new lynching took place. The Urban League was involved in the fight against lynching too, eventually using *Opportunity* magazine as a vehicle for protest and education.[45]

Du Bois understood that in order for blacks to be tortured and murdered at the hands of the mob, white Americans had to rationalize their behavior by viewing blacks as subhuman, animal-like creatures and that extreme defamation of "Negro character" was a part of this process.[46] It was this fact that Du Bois couldn't deny: how whites ultimately saw blacks, no matter what their education, upbringing, or tone of skin. Southern whites believed that blacks were becoming "increasingly degenerate," which contributed to the public acceptance of lynchings. They believed that without the "civilizing effect" of slavery, blacks

were prone to savagery. Jim Crow laws were brought about to protect whites from the threat of black violence, including the fear of rape.[47]

The lynching imagery in *The Crisis* can be divided into three categories: religious, patriotic, and concepts of civilization. Religious imagery was particularly effective to show the paradox of lynching in a Christian context. Lynching was, in effect, anti-Christian. African Americans could be considered Christ-like in their suffering and martyrdom at the hands of the mob. This imagery was in direct contrast to the idea of blacks as "devils," the view of whites who supported lynching. This imagery also tied into the strong traditions of Christianity within the black community and could produce an immediate sense of recognition and identification.

The second-most-prevalent imagery was based on images of patriotism and symbols of American ideals to show the paradox and hypocrisy of lynching in America. Lynching was essentially anti-American—it put the rule of the mob over the rule of law. Furthermore, blacks who opposed lynching were true patriots. By using symbols of America, including the flag, the Statue of Liberty, and Uncle Sam, to underline lynching's anti-patriotic character, blacks placed themselves in the position of being better Americans than southern whites.

Finally, cartoons and photos often used the concept of "civilization" to attack lynching. This imagery turned the tables on southern whites. Whites justified lynching because they considered blacks to be "uncivilized," yet the very practice of lynching showed how barbaric white southern society was. African Americans, in this imagery, are the "civilized" victims of this uncivilized practice.

The very first issue of *The Crisis* in November 1910 addressed lynching. Du Bois wrote an editorial about the lynching of two Italians in Florida, expressing his indignation at the extralegal event. He looked beyond race at the barbaric character of lynching in a civilized society. The next month *The Crisis* published a cartoon from the Paris journal *L'Assiette au Beurre* with the caption "Illustrating the life of Mr. Roosevelt, shows something of prevailing European opinion of America" (fig. 6). The drawing was of a young man strung up by a rope, arms and legs bound, wearing cutoff "country clothes." He appears in blackface, his eyes bulge out in caricature, and his lips are white and heavily exaggerated. His tongue hangs out of his mouth. A white man, the lyncher, stands in the background; crowds appear behind him. The artist was showing that the audience didn't see him as a living being but rather as a comedic buffoon. Seeing the victim this way allowed the "sport" to continue. Below the image, this quote was included in *L'Assiette au Beurre*: "I was born October 27, 1858 in the midst of indescribable enthusiasm. A great banquet was given. Each guest brought a present of ale, whisky, mutton chops, ginger ale, or corned beef. The poor people

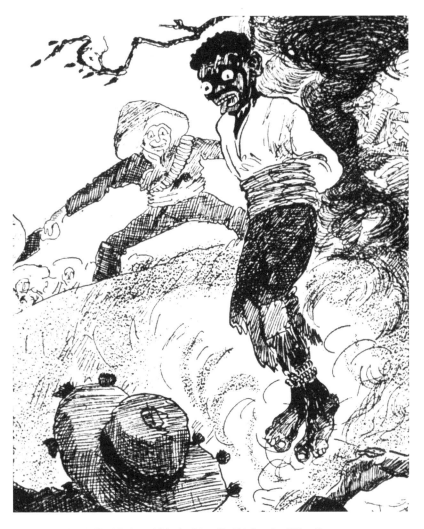

Figure 6. "Illustrating the life of Mr. Roosevelt." Reprinted from *The Crisis,* November 1910, p. 15.

having nothing of this sort to offer decided to burn a Negro alive under our windows."[48] The clear implication was that this was the only "gift" the poor people could offer the new baby—a man burned alive, a gift of "entertainment."

A January 1911 cartoon called "The National Pastime" by John Henry Adams is particularly moving. It features a grieving black woman, her head down on the desk, holding a newspaper, with the headlines, "Negro Lynched:

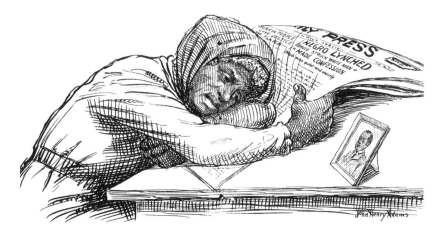

Figure 7. "The National Pastime," by John Henry Adams. Reprinted from *The Crisis,* January 1911, pp. 17–18.

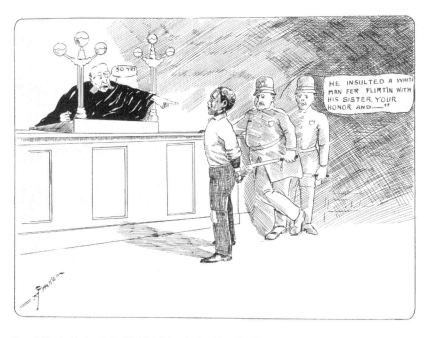

Figure 8. "Fiat Justitia, Ruat Coelum!" by W. C. Hokem. Reprinted from *The Crisis,* May 1914, p. 42.

Brute Struck White Man, Made Confession" and "American People Love Justice and Fair Play" (fig. 7). Her hair is wrapped in a kerchief or mantle, making her more vulnerable, even tying her to the image of Mary, the mother of Jesus. Within the cartoon, positioned next to the woman, is the framed portrait of a respectable black man, dressed in coat and tie as the image of an upstanding and fine citizen. The caption below reads: "Seventy-five per cent. of Negroes Lynched have not even been accused of rape." This was a reference to the research of Ida B. Wells, who had made it her life's work to prove that in fact, lynchers rarely accused their victims of rape, even though rape and alleged violence against women was one of the primary excuses for a lynching. Booker T. Washington often cited this as well in his attacks on lynching. Wells demanded in 1892 that the white press stop printing "the old threadbare lie that Negro men rape white women."[49] Wells noted that innocent people were often marked for lynching because they were related to another lynching victim or because of race alone.[50] The NAACP's 1919 study, *Thirty Years of Lynching in the United States, 1889–1918,* reaffirmed Wells's conclusions.

Historian Joel Williamson notes the "radical and devastating change in white thinking about black people" in the South between 1889 and 1915. Whites thought of blacks freed from the stringent controls of slavery as "retrogressing" to their natural state of savagery, which they felt was evidenced in what they saw as "a strikingly rapid increase in black criminality, the dissolution of the black family," rising rates of venereal disease, and "the key indicator . . . the frightful increase in rapes or attempted rapes by black men on white women." White people saw black men as "beasts" that had been held in check by slavery. White politicians, ministers, teachers, journalists, and community leaders echoed this point of view. Williamson interpreted race lynching and rioting by whites "as a vital part of the process by which the white elite transferred the base of their power from the mass of black people held in slavery . . . to the mass of white people. . . . [T]he changeover from a black base to a white base of power by the white elite was virtually a tri-generational process."[51] Black men were seen as "supersexual creatures, uninhibited and possessed by large, almost insatiable appetites. In particular black men were considered to have freakishly large sexual organs and lust for white women. There was therefore a fear—only rarely stated—that white women lusted after black men."[52] White men wanted to believe that white women would never willingly engage in sexual relations with a black man, that only rape could bring about such a union. Such a union could, of course, produce mixed and therefore "unclean offspring." Williamson raises the question if this was really a gender war more to do with relations between white men and women than with relations between blacks and whites

and concludes that perhaps "the ending of race lynching and rioting in the turn-of-the-century mode had more to do with a gender truce than a racial one."[53]

This theme of the assumed interest of the black man in the white woman appears in many different ways on the pages of *The Crisis*. In "Fiat Justitia, Ruat Coelum!" (fig. 8), a black man dressed in simple attire is brought in front of a judge. His hands are bound, and he stands in silence. The two white policemen, who hold billy clubs, explain (one of them leaning casually on the judge's desk), "He insulted a white man fer flirtin' with his sister, your honor and . . ." Before the policeman could finish or the accused could speak, the judge, an older white man, points his hand at the accused, slams down his fist, and proclaims, "30 Yrs!"

Lynching was the ultimate, final answer to this problem. Historian Trudier Harris states that there is a "symbolic transfer of sexual power at the point of the executions. The black man is stripped of his prowess, but the very act of stripping brings symbolic power to the white man. His actions suggest that, subconsciously, he craves the very thing he is forced to destroy. Yet he destroys it as an indication of the political (sexual) power he has."[54] In the castration and death of the black male, the lyncher asserts his power and the perceived denial of his masculinity. Harris calls lynching "communal rape."[55]

The February 1911 issue of *The Crisis* has a cartoon by John Henry Adams that shows a young couple working together; he dictates to her, she types (fig. 9). The caption reads, "1900: The colored man who saves his money and buys a brick house will be universally respected by his white neighbors." The couple are dressed in proper middle-class clothes: a modest dress for the woman, coat and tie for the man. A portrait of Abraham Lincoln hangs behind the man. In the next box, we see "1910: New and dangerous species of Negro criminal lately discovered in Baltimore. He will be segregated in order to avoid lynching." It shows another well-dressed man, who has just deposited money into his bank account, walking away from the teller (who is flanked by two white men, one watching the black man with suspicion) as he innocently puts his bankbook into his jacket pocket (fig. 10). The message is clear. The white public feared the successful black businessman, even though mainstream culture extolled the value of hard work. The black man was in danger of being lynched not because he was a real "criminal" but because he was feared as a potential equal and an economic threat. Du Bois observed the connection between the issues of labor and lynching. He saw the significance of the exclusion of black laborers in the agricultural South, where, he noted, "the Negro has theoretically the largest opportunity" to achieve success. White control of access to land was connected with the continued terrorism of lynching in the South; both were attempts to control the degrees to which blacks could achieve economic success.[56]

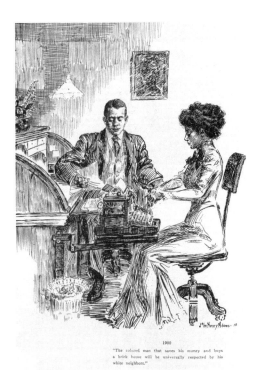

1900

"The colored man that saves his money and buys a brick house will be universally respected by his white neighbors."

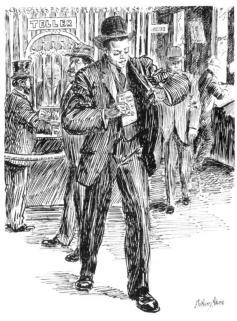

1910

"New and dangerous species of Negro criminal lately discovered in Baltimore. He will be segregated in order to avoid lynching."

Figures 9 and 10. "1900" and "1910," by John Henry Adams. Reprinted from *The Crisis*, February 1911, pp. 18–19.

Figure 11. "The Finger of Scorn," by E. A. Rogare. Reprinted from *The Crisis*, September 1911, p. 185.

Du Bois knew that lynching continued despite the occasional pious pronouncements of white leaders. He wrote in 1911: "The mob spirit in America is far from dead. Time and time again the disappearance of lynching has been confidently announced. Still this species of murder and lawlessness flourishes blithely. Its sickening details in the last few weeks have been as bad as could be imagined. The cause of this is obvious: a disrespect for law and a growing cheapness of human life. . . . [I]t is difficult to punish a rich murderer and extremely difficult for a black suspect to escape lynching. . . . [T]hey are not worth

it. They can be bought for fifty cents a day. Thus we despise life. The result is mob and murder. The result is barbarism and cruelty. The result is human hatred. Come, Americans who love America, is it not time to rub our eyes and awake and act?"[57] Du Bois criticized Americans for seeing blacks only as cheap labor, part of the masses. Whites cared nothing about the thoughts, feelings, and pain of black Americans. How could such people care about lynching?

In the September 1911 *Crisis,* Du Bois discussed a lynching in Coatesville, Pennsylvania. "The man was pursued and attempted suicide. He was brought wounded to town and placed in the hospital. Thence he was taken by a mob led by a policeman, dragged, chained to his cot, several miles, tortured and burned to death in the presence of a large concourse, including women. His bones and the chain with which he was bound were distributed as souvenirs."[58] The description was accompanied by a cartoon reprinted from the *New York Herald,* "The Finger of Scorn" (fig. 11). The cartoon shows a burning black hand emerging out of flames. The hand points accusingly at Lady Liberty, who observes the figure burning but looks in surprise at the accusation, pointing to herself as if to ask, "You're pointing at me?" She represents the culpability of all Americans in the contradiction of American ideals such racial terrorism represented.

In the same issue Du Bois's editorial was called "Triumph," but as David Levering Lewis has noted, it might be called, "Let the Eagle Scream" for the numerous times that phrase appeared in his text. Du Bois discussed the lynching of a "deranged black man" and the fact that the lynching had nothing to do with black "barbarism" and everything to do with white supremacy. Du Bois described the thousands of whites pouring out of the churches and converging on the butchered victim's "smoking pyre."[59] "Men and women poked the ashes and a shout of glee would signalize the finding of a blackened tooth or mere portions of unrecognizable bones." Du Bois told his readers that the victim had been a drunkard who had killed someone without premeditation. "The point is he was black. Blackness must be punished. Blackness is the crime of crimes. . . . It is therefore necessary, as every white scoundrel in the nation knows, to let slip no opportunity of punishing this crime of crimes." The essay concluded: "But let every black American gird up his loins. The great day is coming. We have crawled and pleaded for justice and we have been cheerfully spit upon and murdered and burned. We will not endure it forever. If we must die, in God's name let us perish like men and not like bales of hay."[60]

Du Bois tried to bring the reader to the site of the lynching with photographs and with a dramatization of the event: "Ah, the splendor of that Sunday night dance. The flames beat and curled against the moonlit sky. The church bells chimed. The scorched and crooked thing, self-wounded and chained to his

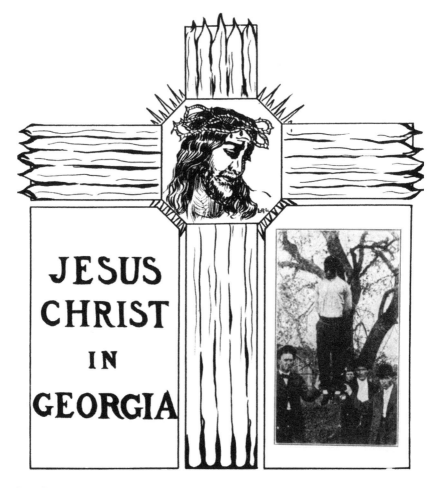

Figure 12. "Jesus Christ in Georgia." Reprinted from *The Crisis,* December 1911, p. 70.

cot, crawled to the edge of the ash with a stifled groan, but the brave and sturdy farmers pricked him back with the bloody pitchforks until the deed was done. Let the eagle scream! Civilization is again safe!"[61]

In December of that year, *The Crisis* featured a short fictional story of a lynching, "Jesus Christ in Georgia" (fig. 12), accompanied by a drawing of Christ's image on a cross of flames, his face, crowned with thorns and full of sorrow, looking down at the right quadrant of the page, under the arm of the cross, where a photograph of a lynching victim was featured. By using Christian im-

THE "CRIME" OF BLACKNESS

agery to attack the actions of "Christians," Du Bois undermined whatever religious sanction might exist for lynching. The image served to introduce a story by Du Bois with the same title as the cartoon.[62] In the tale, Du Bois equates Christ with all black men. Christ in the form of "the stranger" comes into a Georgia town and meets a variety of people, including a convict. The convict is finally given a job on a farm from a farmer who wants to hold him in servitude. The convict eventually steals the farmer's silver watch. He returns the watch because of his meeting with "the stranger" (Christ), who has encouraged him to do good. The farmer's wife has spoken with the stranger; she is drawn to him, but she is repulsed when she realizes he is a black man or mulatto. The convict later seeks the stranger again to speak to him and literally runs into the wife of the farmer as he runs down a path, knocking the wind out of the woman. The farmer accuses him of attacking her, and as he is seized by the mob, the woman does nothing to save him. After he is lynched, the farmer's wife looks into the sky. She sees a fiery cross and the image of the stranger crucified on the cross, looking with sorrowful eyes toward the lynched convict. She hears him say "This day thou shalt be with me in Paradise." She realizes that the stranger was Christ. To introduce Du Bois's story, the cartoon shows the image of a sorrowful Christ looking at the photograph of an actual lynching victim, a reference to the biblical story of Christ's words to the good thief on the cross.

In January 1912, Du Bois revealed more about lynching by putting the gritty truth in front of his readers. *The Crisis* reproduced a postcard, complete with stamp and postmark, which had been sent to John H. Holmes, pastor of the Unitarian Church in New York City (fig. 13). The caption, "A reply to Mr. Holmes from Alabama" was a chilling reply to Holmes's protests against lynching. The card, printed in Germany, included on the front a photograph of a lynching in Andalusa, Alabama, with the body in the foreground, the mob surrounding him. Such mementos of lynchings were common. *The Crisis* reported that hundreds of cameras would click all morning at the scene of a lynching. People in automobiles and carriages came from miles around to view the corpse dangling from the end of a rope. Sometimes portable printing plants were installed in the vicinity of the lynching in order to mass produce the cards as quickly as possible. There was plenty of money to be made at a lynching, through the sale of commemorative photographs and through the sale of body parts, a more "valuable" memento. One lynching was even recorded, to be used as an advertising ploy in the marketing of Thomas Edison's "talking machine" at country fairs in 1896.[63] Employers allowed their workers time off and children would skip school to view such events. Postcards such as the one sent to Holmes were meant to serve as both a brazen statement in support of lynching and a threat against those who wanted the practice stopped. The mob faced the cam-

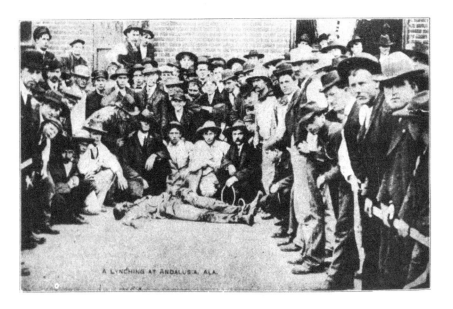

This Space For Writing Messages

Printed in Germany.

This is the way we do them
down here. The last lynching has not
been put on card yet.
Will put you on on our regular mail
ing list. Expect one a month on
the average.

A 15718

POST CARD

U.S. POSTAGE
ONE CENT

DAL.
8 AM
ALA.
1911

Rev. John H. Holmes,
Pastor Unitarian Church
New York City.

28 Garden Place
Bklyn N.Y.

This side for the Address Only.

A LYNCHING AT ANDALUSIA, ALA.

Figure 13. "A Reply to Mr. Holmes from Alabama." Reprinted from *The Crisis*, January 1912, p. 110.

era without shame and without fear of prosecution. They knew they would be safe from the law: the law supported them, the law was *among* them. Through the photographs and postcards, the moment of the lynching could be revisited, and relished, long after it was over. Although the postmaster general forbade the sending of lynching cards through the mail in 1908, the law was largely ignored. If necessary, an envelope was purchased to cover the card. The postcards served as souvenirs and supported the notion of lynching as a sport or "modern spectacle."[64]

Holmes received this taunting message: "This is the way we do them down here. The last lynching has not been put on card yet. Will put you on our regular mailing list. Expect one a month on the average." Published in its entirety, the card showed the "sport" of lynching and the somber, proud crowd standing by the body. The image was making a political statement and at the same time making the image, in the minds of the lynchers, an acceptable one in modern visual culture.[65] By the early 1900s, sending postcards of monuments, important community figures, and tourist attractions had become quite common. Why not a lynching too as a statement that proudly asserted the community's commitment to the "sport"?

The postcard in *The Crisis* was accompanied by an essay, "Holmes on Lynching," in the NAACP's monthly column. John Holmes's article was passionate. "This whole crime of lynching, to my mind, can never be solved by half-way measures. Men must have strength and courage. Poets must sing. Prophets must speak. An Emancipation Proclamation must be written."[66] Why would the editor include such a horrific image, one that surely must have been repugnant to his readers? It gave them, especially readers outside the South, insight into the realities of terrorism, into the place and the time and the people who carried out such acts. Du Bois believed that artists needed to create images and photographers needed to provide evidence to remind the world that lynching was not something that would be ended without a concerted effort by an informed and enraged public.

In January 1912, *The Crisis* also featured two images of lynching victims in Durant, Oklahoma. One was a painting in which the victim lay dead, slain "by a person or persons unknown"—a typical phrase used in articles describing lynchings. The other was a photo which showed the victim dangling from the tree and featured a mob member touching the victim's leg like a hunter presenting his "catch," surrounded by "prominent citizens" in the community (fig. 14).

In March 1912, Du Bois published the statistics on lynching: 1,521 lynchings had taken place between 1885 and 1911. His editorial, paired with a photo of a lynching victim, stated that although the NAACP listed 63 lynchings in 1911, "*The Crisis* believes that at least 100 colored people were lynched during

THE CRISIS

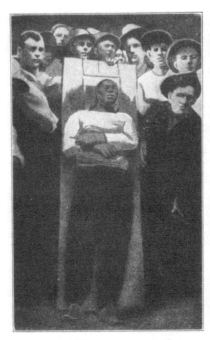

IN DURANT, OKLAHOMA: "BY A PERSON
OR PERSONS UNKNOWN"

Vision of a Lyncher

[Written for THE CRISIS and dedicated
to His Excellency, the Governor of South
Carolina.]

Once looked I into hell—'twas in a
 trance

Throughout a horrid night of soul-
 wrought pain;

Down through the pit I saw the
 burning plain,

Where writhed the tortured swarm,
 without one glance

Upward to earth or God. There in
 advance

Of all the rest was one with lips
 profane

And murderous, bloody hands,
 marked to be slain

By peers that would not bear him
 countenance.

"God," cried I in my dream, "what
 soul is he

Doomed thus to drain the utmost
 cup of fate,

That even the cursed of Tartarus
 expel?"

And the great Voice replied: "The
 chastity

Of dear, confiding Law he raped;
 now Hate,

His own begotten, drives him forth
 from hell."

LESLIE PINCKNEY HILL.

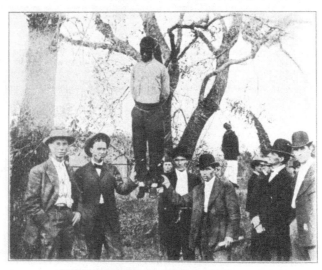

"A FRENZIED MOB OF PROMINENT CITIZENS"

Figure 14. Photo of lynching. Reprinted from *The Crisis*, January 1912, p. 122.

the year 1911, and therefore, we shall, in 1912, keep a careful list ourselves."[67] Thus began regular lynching reports in *The Crisis*. A reader also wrote that she had purchased an entire lot of postcards like the one featured in the January 1912 issue. The reader stated that she bought up all the cards "with the purpose of enlisting your aid in preventing the publication of such cards. I don't know how to begin this work, but with the co-operation of such men as you, we must accomplish something."[68] The letter reflected Du Bois's already-acknowledged role as a leader in the anti-lynching crusade.

Du Bois questioned the tactics in place to stop lynching. "We do not blame the people of the United States for being ashamed of lynching, but we have serious doubts if recent methods of curing the evil are going to be really efficacious. We do not refer now to the unjust and dangerous hastening of the trials of accused persons, nor even to the proposed lessening of the penalty for mob murder; but rather to an attempt, deliberate or unintentional, to suppress the truth concerning the present extent of lynching in this land."[69] Du Bois continued to use *The Crisis* to keep a record of the actual numbers of victims but found himself facing increasing difficulties. "God knows *The Crisis* is not anxious to increase the red record nor to revel in the spread of this most disgraceful blot upon our civilization," he lamented. But he now found much difficulty in determining just the number of lynchings. Du Bois accused southern newspapers, news agencies, and journalists of suppressing the news about lynchings to hide what he thought was an increase. He concluded that he would be only too glad to have his results disproved but doubted that that would happen any time soon.[70]

Under the heading "The Lynching Industry," the magazine listed every victim's name from the year 1914, the month they were murdered, and the state in which they were lynched. The article published a count of lynchings month by month, the number of lynchings by (alleged) crimes committed for that year, and the number of all lynchings by year from 1885 to 1914. The essay opened with typical Du Boisian sarcasm: "*The Crisis* is interested to report that the standard American industry of lynching colored men has flourished during the year 1914. . . . These lynchings produce the usual little pleasantries with which the American nation is so familiar."[71] Du Bois continued with particular cases:

> The chivalry of southern white manhood toward colored women has been particularly conspicuous this season. Two men raped a colored girl in Oklahoma. One was killed by her brother and their friends thereupon *lynched the girl!* . . . All this goes to show how peculiarly fitted the United States is for moral leadership of the world: for putting to shame the dreadful people who are fighting in Europe and seem quite lost to decency.

Du Bois continued, "It is a fine thing to have under these circumstances the stern cool leadership of President Wilson," who, as he bitterly concluded, had

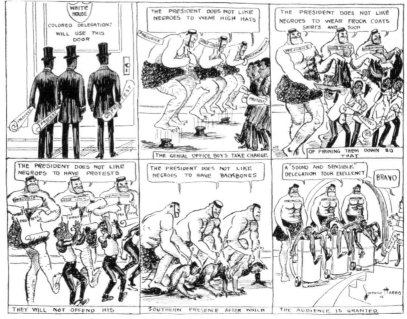

Figure 15 "The Next Colored Delegation to the White House," by Lorenzo Harris. Reprinted from *The Crisis,* June 1915, p. 96.

recently told that the South that they must "know the needs of the Negro and sympathetically help him in every way that is possible for his good and for our good."[72]

Du Bois found it hard to stomach Woodrow Wilson's claim to the moral leadership of the United States. Reference to Wilson's desire to silence black Americans can be seen in Lorenzo Harris's "The Next Colored Delegation to the White House" (fig. 15). The cartoon shows three black men, formally attired with top hats, who are greeted at the "colored door" by three thugs: "Prejudice," "Judge Lynch" and "Discrimination." The thugs destroy the men's clothing (including their hats), put lynching chains around their necks, remove their backbones ("the president does not like negroes to have backbones"), and finally present the three men, in garbage cans, to President Wilson, with the words "[a] 'sound and sensible' delegation[,] your excellency." Wilson receives them, clapping and exclaiming "Bravo!"[73]

The president was not the only symbol of leadership Du Bois attacked. He mocked the dearest principles of nationhood when *The Crisis* ran a political car-

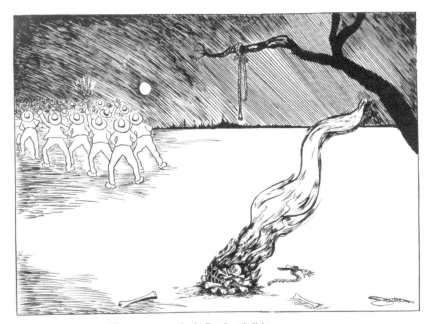

"O say, can you see by the Dawn's early light,
What so proudly we hailed at the Twilight's last gleaming!"

Figure 16. "O say, can you see . . ," by Jackson. Reprinted from *The Crisis*, February 1915, p. 197.

toon with the words of the national anthem (fig. 16). The cartoon depicts the limb of a tree with a lynching rope hanging from it, the charred bones of a victim smoldering below while a mob runs off in the background to the next lynching. In the cartoon, the moon is low on the horizon, and the first two lines of the national anthem are the only text: "O say, can you see by the Dawn's early light, What so proudly we hailed at the Twilight's last gleaming!"[74] The pride shown in this twilight is that of the mob, confident of their actions, sure, proud, and ready to find another victim.

In 1914, *The Crisis* reprinted evidence from the white press that the debate about lynching had become international. First Du Bois recounted a program for "success" for African Americans that was first published in *Leslie's Weekly*, which Du Bois warned was a magazine that "has never been top-heavy with brains." The journal intoned: "Let not the Negro imagine because of lynching and minor discriminations here and there that every man's hand is raised against him. The Negro must help himself. He must win a place for himself. Whenever he does this he possesses self-respect and receives also the respect of others!"[75]

Not all white popular magazines were so blind to the racial injustice, though: Du Bois recorded that the *London Spectator* insisted that President Wilson's first and largest duty was to "[s]top the disgrace of lynching." The correspondent suggested a new amendment to end lynching. "We shall of course, be told that such an amendment is absolutely hopeless. To which we reply—not if the people of the United States are in earnest in the desire to stop burning Negroes alive. When in earnest they can and do change the Constitution—witness the existing amendments."[76]

The Crisis intensified its coverage of lynching throughout 1916. The January issue was particularly graphic; it included the photograph of a victim crucified at Temple, Texas, and a man who was burned alive in Fort Worth as a crowd watched that included "many women standing on men's shoulders to witness the gruesome sight. All along the route the Negro fought savagely and was kicked and beaten by the mob" (fig. 17).[77] This photo was available for sale for ten cents on the streets of Fort Worth. The April issue featured a full-page photo of a lynching which took place in Lee County, Georgia, on January 20: five bodies were hung from one tree (fig. 18). A white man in suit, tie, and hat stands impassively to the side in the photo. The victims were taken from the Worth County jail, "rushed into the adjoining county in automobiles, and hanged and shot."[78] The photo was taken by a "colored servant" of a prominent white man, who took it while his employer was at lunch and handed it to a *Crisis* agent, who had it quickly copied. In his editorial, Du Bois explained that the five men were killed for defending themselves from arrest for being in arrears. In this case, Du Bois considered the case of the lynching to be a result of peonage, a system that followed slavery. In three nearby counties, there were 18,000 whites and 31,000 blacks and the whites needed black labor to raise cotton. Du Bois included a letter from a white southerner that explained that harsh overseers were necessary to get the proper amount of labor out of the black labor force. If cotton plantations were turned over to the Negro, the man explained, much less cotton would be produced. The anonymous letter-writer was brutally frank: "[A]s much as possible to prevent the Negroes from taking revenge it is absolutely necessary that they should always be kept in mind of swift and terrible penalties which wait not for the slow movements of the law but stand ever ready to strike them. . . . There must be extra-legal means always in reach and this extra-legal means is the mob, always ready to inflict capital punishment upon Negroes violating that code which arises upon the relations of blacks and whites in the black belt."[79] Du Bois understood that the political power and economic interests of those who supported the lynch law were so strong and their racial prejudice so deeply ingrained in society at every level that only an all-out national assault against lynching could destroy it. He wrote: "There you

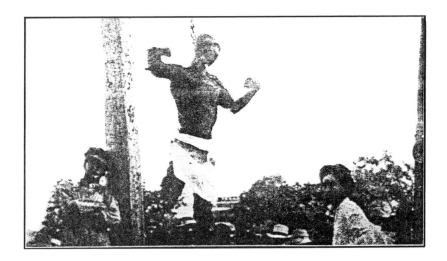

Figure 17. Lynching photo, Temple, Texas. Reprinted from *The Crisis,* January 1916, p. 145.

Figure 18. Lynching of five victims from Lee County, Georgia, January 1916. Reprinted from *The Crisis,* April 1916, p. 303.

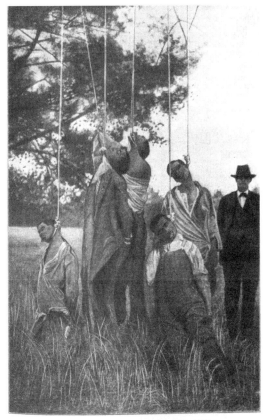

THE LYNCHING IN LEE COUNTY, GA., JAN. 20, 1916
(From an actual photograph)

have the whole modern government of the black belt with the South in its naked nastiness. Small wonder that the President of the United States is 'protesting" against the Armenian atrocities of the Turks."[80] Given these vested interests, Du Bois recognized that it was "easier" for Wilson to protest the Turkish genocide of Armenians than to comment on lynchings at home.

In July 1916 issue of *The Crisis* included one of its most extensive lynching accounts, a special supplement entitled "The Waco Horror." A special NAACP investigator was sent to record the facts of the lynching, indicating its significance. The magazine provided a lengthy and graphic description of the lynching of Jesse Washington and ten photos of the setting. The final photo, captioned "Finis," shows the brutal aftermath of the act. (Readers were shocked, as were some members of the NAACP board of directors, by the choice of this image: "The ghastly, burnt-cork husk of Jesse Washington suspended by chain from a tree.") Washington had confessed to a murder (and possible rape) under duress. Finding him guilty, the crowd ultimately lynched him, even though he would have been hung the next day. The judge did nothing to stop them. Washington, who was mentally retarded, was tortured, attached to a car and dragged, mutilated and castrated, burned while still alive (he was forced to light his own fire), and lynched. *The Crisis* reported statements by participants in the lynching party.

An undercover NAACP investigator reported: "While a fire was being prepared of boxes, the naked boy was stabbed and the chain put over the tree. He tried to get away, but could not. He reached up to grab the chain and they cut off his fingers. The big man struck the boy on the back of the neck with a knife just as they were pulling him up on the tree. . . . He was lowered into the fire several times by means of the chain around his neck. Someone said they would estimate the boy had about twenty-five stab wounds, none of them death-dealing."[81] Du Bois placed multiple photographs of the setting and the victim next to several pages of text that read like a horrifying novel. The substantial detail and graphic images enabled readers to experience the lynching and the circumstances surrounding the horror almost as if they had witnessed the event themselves. Du Bois believed that a photograph and a brief editorial were no longer enough. His readers needed to know every detail of lynchings and to know the victim, too, through photographs of the body from several vantage points.[82] He summed up the Waco horror: "This is an account of one lynching. It is horrible, but it is matched in horror by scores of others in the last thirty years, and in its illegal, law-defying, race-hating aspect it is matched by 2,842 other lynchings which have taken place between January1, 1885, and June 1, 1916." As he listed the lynchings by year, he pleaded, "What are we going to do about this record? The civilization of America is at stake. The sincerity of Christianity is chal-

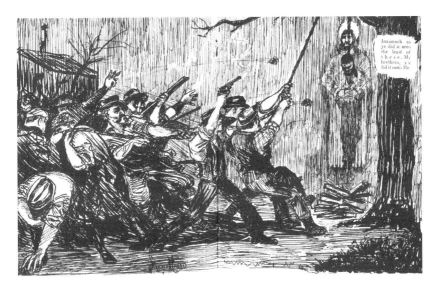

Figure 19. "Christmas in Georgia, A.D., 1916," by Lorenzo Harris. Reprinted from *The Crisis*, December 1916, pp. 78–79.

lenged." He then announced a special fund to start a crusade against "this modern barbarism" and listed an address for contributions.[83]

In response to what had proven to be a horrible year in lynching, *The Crisis* published one of the most moving images in cartoon imagery in December 1916 (fig. 19). Lorenzo Harris, one of Du Bois's favorite cartoonists, created "Christmas in Georgia, A.D. 1916." Harris showed a frenzied, rock-throwing mob with clubs and guns pulling the body of a victim up on a rope that was strung over the limb of a tree. Logs below the victim were ready for the burning. Their stark white arms and large hands emphasize their power over the victim. The crowd, dressed in vests, hats, and shirts with sleeves pushed up for action, stands in front of a simple house, presumably the victim's. One member of the mob, radically foreshortened, reaches toward the viewer to grab another rock, we only see the top of his hat. He serves to pull the viewer into the image, to make the viewer feel he is a part of the crowd, a witness to the event, even a participant. This was a technique often used in Christian imagery; by placing figures with their backs to the viewer, the artist encourages the viewer to experience the act first hand. Many European and American artists used this technique and had been doing so for more than 600 years, since the time of Giotto.[84] The victim's head drops limply, but his body is surrounded by the haloed Christ, who wraps the victim in his arms and supports his limp body.

Christ faces the crowd head on with sorrow. Christ is being lynched with the victim. The crowd continues, not thinking of their actions or the consequences. The image is horrifying and loving at the same time, reminding the reader with the passage from the biblical account of judgment day posted on the lynching tree, "Inasmuch as ye did it unto the least of these, My brethren, ye did it unto Me." This is the "celebration" of Christmas in Georgia, a reminder that Southern lynchers claimed to be Christians, but they made sure their victims suffered slow and painful deaths.

In the same issue, Du Bois noted that many of his readers asked if it was really possible to put a stop to lynching in the South and asked how it could be done. He responded that many people would be willing to help raise money if they clearly saw a method of stopping lynchings. While there was no "royal road to social reform," Du Bois proposed the following five paths, neither "spectacular nor sudden," to eliminate the savagery in the South: use of publicity, better administration of present laws, legal action in all possible instances, new legislation, and federal intervention. For Du Bois, the greatest hope lay in publicity:

> We place frankly our greatest reliance in publicity. We propose to let the facts concerning lynching to be known. Today, they are not fully known; they are partially suppressed; they are lied about and twisted. . . . We propose, then, first of all, to let the people of the United States, and of the world, know WHAT is taking place. Then we shall try to convict lynchers in the courts; we shall endeavor to get better sheriffs and pledged governors; we shall seek to push laws which will fix the responsibility for mob outbreaks, or for the failure to suppress them; and we shall ask the national government to take cognizance of this national crime.[85]

White publications used Christian imagery to fight lynching as well, including the radical *New Masses*. This publication included essays by anti-lynching writers, including NAACP cofounder Mary White Ovington. Cartoonist Robert Minor, who illustrated regularly for *The Masses*, provided the cover art for the August 1915 issue that bore the caption "In Georgia: The Southern Gentleman Demonstrates His Superiority" (fig. 20). The cover brought attention to Jews as well as southern blacks as victims of lynching. A white southerner is cropped in the lower right hand of the drawing as he leaves the site of the lynching, demonstrating no emotion. Behind him, a Jew hangs on the cross in the foreground. (This was a reference to the infamous Leo Frank lynching. Frank, a Jewish factory owner living in Atlanta, had been accused of murdering a young white woman employee and was found guilty and sentenced to life in prison. A mob seized him and lynched him. Frank was eventually proven innocent years after his death.) A black man behind the first figure is crucified as

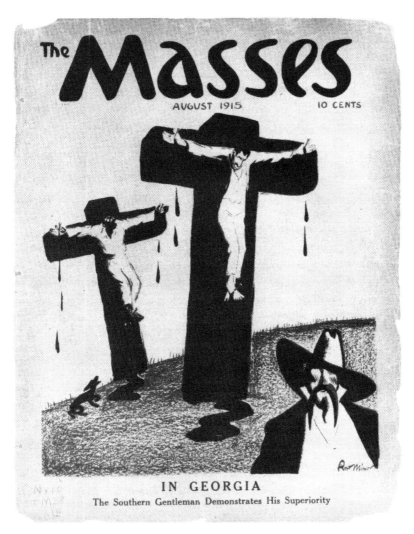

Figure 20. "In Georgia: The Southern Gentleman Demonstrates His Superiority," by Robert Minor. Reprinted from *The Masses*, August 1915, cover.

well; both have blood dripping from their bodies, forming pools below them. A dog barks at the dead black man.

The lynching of Ell Persons dramatized the point that lynchings were continuing with little effort to stop them. The lynching took place on May 22, 1917; *The Crisis* drew its coverage from "the Memphis white daily papers." Per-

sons was accused of killing a young girl and was lynched without benefit of trial in front of a crowd of 15,000. Persons never spoke; the sheriff spoke for him. He was doused with gasoline and a young black boy was forced to observe the burning with the words "Take a good look, boy . . . we want you to remember this the longest day you live. This is what happens to niggers who molest white women." Persons was burned, writhing in agony. His ears were hacked off as he burned. Several members of the crowd were dismayed that he burned too fast and felt that gasoline should not have been used, as it hastened the event. Members of the crowd fought over bits of his body, his clothing, and the rope. Du Bois included a photo of Persons' limp body next to newspaper coverage of the event by leading journals, including the nationally prominent *New Republic. The San Francisco Bulletin* drew a connection between the lynching and U.S. entry into the world war the previous month: "It is particularly unfortunate that the more civilized people in the South, who probably form a majority, do not put a stop to this degrading communal sport, at least during the period of a war which is being fought in the interests of higher civilization. The Tennessee community should be exempted from conscription. Men who burn human beings alive cannot be trusted to go abroad as representatives of the American cause."[86]

The Crisis continued its discussion of the Persons case in the August 1917 issue. The facts behind the case were discussed, including the "alleged confession" of the victim of the lynching.[87] The magazine raised serious doubts about Ell Persons' guilt, noting that "[a]ll the facts furnish a doubt so strong that the most humane form of lynching could not be looked upon as excusable." This was a crime that did not bear the earmarks of a "Negro" crime. "Negroes guilty of the most lustful crimes are known never to mutilate their victims . . . this was not a crime of primitive lust, but of over-civilized degeneracy."[88] (Ironically enough, this reveals a paradox in Du Bois, even demonstrating some of his class bias. While he supports Persons' innocence, he also implicitly accepts that there is such a thing as "a Negro crime" of "primitive lust.")

Whatever paradox might have existed for Du Bois in the Persons case, the July massacre of East St. Louis exemplified white evil and viciousness. *The Crisis* provided extensive coverage, including graphic photographs. Between one and two hundred persons who were black had been shot, burned, or hung or some combination of the three. Du Bois and white social worker Martha Gruening penned "The Massacre of East St. Louis," twenty-four pages of vivid accounts of the violence. Du Bois and Gruening spent a week in St. Louis with a group of volunteers and paid staff, compiling the data for the coverage. This coverage helped bring *The Crisis*'s circulation to almost 50,000.[89]

The East St. Louis violence began as a result of lengthy labor disputes and white fear that black newcomers would take their jobs. When a car full of plain-

clothes policeman was fired upon by African Americans, who may have assumed the carload were returning for another chance to shoot at black laborers, the city exploded the next morning.[90]

Personal testimonies of witnesses to the massacre were included, as were photographs of maimed survivors and the dead. The account, through interviews with victims and photographs, told of the carnage, the death, and the destruction of property and dreams of a decent future. This was investigative reporting with documentary photography, designed to incite anger and emotion at the needless slaughtering of innocent people, the destruction of property, the humiliation of a race. Du Bois wrote: "Awake! Put on thy strength, America—put on thy beautiful robes. . . . Russia has abolished the ghetto—shall we restore it? India is overthrowing caste—shall we upbuild it? China is establishing democracy—shall we strengthen our Southern oligarchy? No land that loves to lynch 'niggers' can lead the hosts of Almighty God."[91] *The Crisis* would follow with careful coverage of the August 1917 Houston riots in the October 1917 issue.

Lorenzo Harris remained a Du Bois favorite for his anti-lynching work. In the March 1918 issue Harris contributed "The Funny Page," which shows three barbarous brutes, two of them labeled "Lynch Law" and "Discrimination" (fig. 21). They are laughing as they read the Constitution of the United States, in particular the Fourteenth and Fifteenth Amendments, which they obviously considered to be a joke. They have huge muscular bodies and are attired in caveman clothes, indicating their undeveloped state as unevolved men. Their primitive rough faces and bald heads show them to be crude and hard-hearted. Their hands drip with blood and mark the pages of the Constitution with their bloody fingerprints. A lynching rope is slung over the shoulder of one of the men.

Another Harris cartoon depicted a devil with the caption: "On Certain Advantages in Being a Large, Well-Developed Devil" (fig. 22). It featured a giant serpent-like devil covered in scales in the middle of the composition with the words "Prejudice & Lynch Law Devil" written on his chest. Surrounding him are other "devils" of the era, the gambling devil, the dance devil, and the booze devil, the church devil, and "this devil and that devil" among them. These devils have all been knocked down by a running figure with a club, "Billy Sunday," who says "Bring on your dirty wobble-kneed, cock-eyed devil." They are small and cannot withstand assault. But the prejudice/lynch law devil is big and strong and mocks Sunday with the words "Never even touched me." As a large and well-developed form of evil, he can withstand attack, survive, and flourish. The cartoon represents the evils that evangelical preachers, represented by the famous evangelist Billy Sunday, wanted to fight, including temperance, dancing, and gambling, while they ignored or even endorsed racial prejudice. Preju-

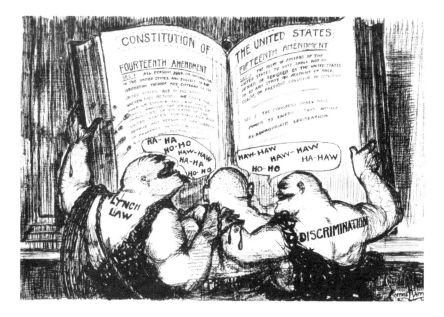

Figure 21. "The Funny Page," by Lorenzo Harris. Reprinted from *The Crisis*, March 1918, p. 241.

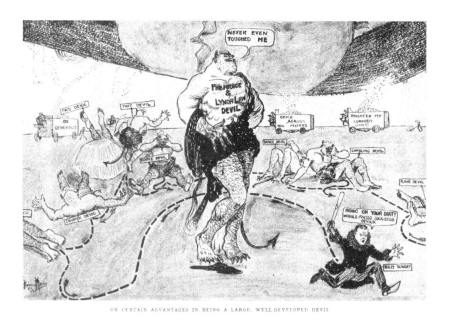

Figure 22. " . . . Well-Developed Devil," by Lorenzo Harris. Reprinted from *The Crisis*, April 1918, p. 285.

dice and lynch law were too strong for such campaigns and continued in their viciousness. Much of this terrorism was connected to the Ku Klux Klan, which based itself in "Christian" values. The Klan was united by its desire to support Prohibition. It wanted to eliminate bars, alcohol, and dance halls, symbolic sources of immorality and corruption, which it believed led to adultery and pre-marital sex. It supported the traditional values of family, God, and hard work, and its members considered themselves to be great patriots. Protestant churches, especially Methodists, Baptists, and Disciples of Christ, had their fair share of Klan members. Klansmen asserted their obligation to protect white Protestant women from all that degraded their purity.[92] Lynching was one effective means to assert their power.

Following the massacre in East Saint Louis, *The Crisis* continued to cover and expose individual lynchings. In Dyersburg, Tennessee, a mob burned Ligon Scott to death, one of the 224 such cases in 1917. The May 1918 issue included a photograph postcard of George McNeel, lynched in Monroe, Louisiana, in March 1918. The postcard was sold on the streets "to white people" at 25 cents and included a photo of the lynchers with their victim. Yet the grand jury in Monroe found "no information sufficient to indict" the lynchers. In the September issue, *The Crisis* reported the brutal murder of Mary Turner, who was eight months pregnant when she was lynched, her baby cut out of her body and the live child stomped to death in front of her. Her crime: "She would have warrants sworn out against the men who had lynched her husband."[93]

In the midst of such unparalleled horror, there emerged hope—*The Crisis* reported a military anti-lynching measure "[t]o punish the crime of lynching in so far as such crimes tend to prevent the success of the United States in war." President Wilson, a son of the South, finally committed himself firmly against lynching. The glaring contradiction between his crusade to make the world "safe for democracy" and the mob rule of lynching helped convert the president, who proclaimed: "I say plainly that every American who takes part in the action of a mob or gives any sort of countenance is no true son of this great democracy, but its betrayer, and does more to discredit her by that single disloyalty to her standards of law and right than the words of her statesmen or sacrifices of her heroic soldiers in the trenches can do to make a suffering people believe in her, their savior."[94] In the wake of this federal support, the anti-lynching campaign accelerated its efforts and dramatically increased its visibility. As historian Robert Zangrando notes, "The antilynching drive had an urgency, a public vis-ibility, and a dramatic quality that no other civil rights activity quite matched. It was through the antilynching struggles that the NAACP gained much of its stability and recognition, learned how to deal with the complex problems of race in America, and placed itself simultaneously in the vanguard of black activists

and at the center of national affairs."[95] The May 1919 issue announced a major anti-lynching conference in New York. The June issue reported that 119 distinguished black and white citizens attended, including governors, judges, college presidents, congressmen, and authors, all of whom called for an end to lynching. That year the NAACP published *Thirty Years of Lynching in the United States, 1888–1918* and linked the anti-lynching campaign to the vote: "a vote for every Negro man and woman on the same terms as for white men and women." African American men had the vote, at least on paper, but were prevented from exercising their right in the South. African American women had never had the vote; this support for women's suffrage came just at the decades-long campaign was about to bear fruit.[96]

The Dyer Anti-Lynching Bill was introduced in Congress in 1918.[97] Conceived by Leonidas C. Dyer, a Republican congressman from Missouri, and Merrill Moores of Indiana, the bill considered a lynch mob to be "three or more persons" and promised to protect the lives of American citizens denied protection by their states, disciplined state officials who refused to protect citizens, and fined entire counties or cities where lynchings occurred.[98] In other words, it supported collective responsibility. Although the bill would ultimately fail, the NAACP believed that the attention the bill garnered helped drastically reduce the number of lynchings in the following decades by awakening the people of the southern states to the need to take action to stop these crimes against blacks.

The Crisis continued to serve at the forefront of the battle against this terrorism. The efforts of *The Crisis* and the NAACP to expose lynching were not appreciated in many venues. *The Dublin Courier Herald* (Georgia) remarked that "the best thing . . . [the NAACP] can do for the betterment of Negroes of the country is to shut its filthy mouthpiece and organs of racial equality and die in a grave filled with hogs slops."[99]

THE 1920S: DECADE OF HOPE AND HATRED

Du Bois's efforts to keep lynching on the pages of the magazine were supported by James Weldon Johnson, who became secretary of the NAACP in 1920. At the same time, the Ku Klux Klan was strengthening and expanding its organization.[100] In an unpublished speech in 1921, Du Bois reflected: "Remember that in the lynching like that at Athens, Georgia, of the six or seven thousand people, nine-tenths are church members in good standing, Masons, Elks, Odd Fellows, business men, and even philanthropists. There is not, there cannot be today in Athens a single white man of prominence who cannot put his hand upon a murderer, or who would refuse to shake hands and recognize socially that same murderer. This is the real lynching problem."[101]

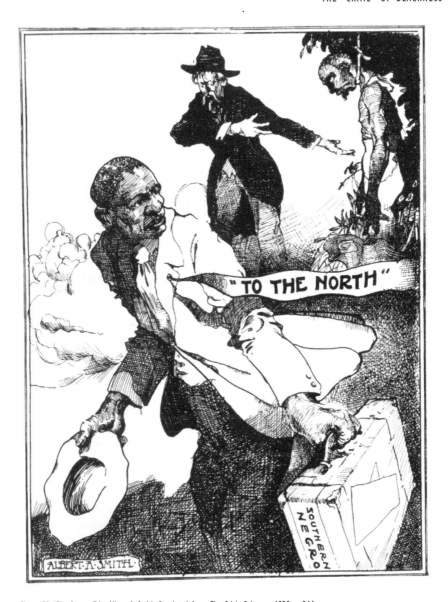

Figure 23. "The Reason," by Albert A. Smith. Reprinted from *The Crisis*, February 1920, p. 264.

Despite the resurgence of the KKK, lynching declined in absolute numbers during the 1920s. However, the smaller numbers did not lead Du Bois to lessen his efforts, and in many respects he made *The Crisis* even more outspoken in its denunciation of the barbaric practice. His editorial pages continued to beat the drum for anti-lynching legislation. He argued that lynching was a contributing cause to one of the great population movements of the time: the migration of large numbers of African Americans from the rural South to the urban North. Du Bois even used the greater role the United States was playing on the international stage—its leadership in disarmament conferences at Washington and Geneva—to continue to underline the hypocrisy and contradictions between America's new world role and the grim reality of lynching.

Cartoons continued to be an effective way of conveying Du Bois's anti-lynching message. Along with a map of 1919 lynchings, the February 1920 *Crisis* featured a political cartoon by Albert Alex Smith. Smith's cartoon, "The Reason," which accompanied the essay "Northerners Don't Understand the Negro," sought to answer in one quick glance the question "Why leave?" (fig. 23). Smith drew a concerned, well-dressed, middle-aged black man holding a suitcase with "Southern Negro" on the side of it. He is looking over his shoulder, holding a white hat in his hand as the words "To the North" stream from the lapel of his bright white jacket. An elderly white man, clad in black suit and hat, shows us, without a hint of remorse, the lifeless body of a lynching victim dangling from a tree. His white hand contrasts with his black ensemble. The black man fleeing north realizes that it is just a matter of time before he could face the same fate. Migration is the answer, the only way to escape the reign of terror.

Albert Alex Smith proved to be one of the most important artists working for *The Crisis.* Du Bois recognized the high quality of his work and saw his insightful cartoons as critical to the visual appeal of the magazine. Ironically enough, Smith's perspective on the plight of African Americans came as he lived in Paris, enjoying the freedom of life in the French capital and receiving the best training available for an artist. In helping Du Bois define a new African American identity, Smith understood the lives of American blacks, but by choice he did not *live* their lives.

Smith's visuals accompanied Du Bois's "The Social Equality of Whites and Blacks" (fig. 24).[102] The reference to the distorted justice system which was intimately tied to the issue of "legal lynching" was effectively illustrated in Smith's "They have ears but they hear not," a quote from the Old Testament Psalms. Black defendants were often bound and silent. Smith shows a black male defendant, shackled and chained, who appears before figures representing a white jury, white prosecuting attorney, white judge, and the white law (who is asleep).

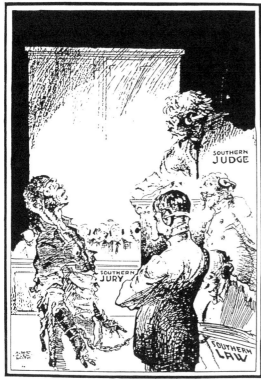

THEY HAVE EARS BUT THEY HEAR NOT Psalms CXXX-17.

Figure 24. "They Have Ears but
They Hear Not," by Albert A. Smith.
Reprinted from *The Crisis*,
November 1920, p. 17.

Figure 25. "Uncle Sam Is Tremendously
Interested in Disarmament," by
Lorenzo Harris. Reprinted from
The Crisis, January 1922, p. 124.

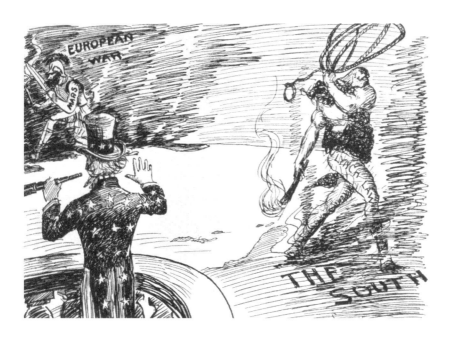

All these figures, although some of them look at the defendant, are wearing ear-muffs which will prevent them from hearing anything the black defendant has to say. Smith's realistic style, with his figures heavily modeled in the foreground, adds to the drama of the scene. He places the defendant in profile, his anguished face highlighted by the silhouette effect created by the plain background, which emphasizes that he is alone in every way.

The cartoonists at *The Crisis* continued to exploit the contradictions created by the persistence of lynching in the postwar era. The January 1922 cartoon by Lorenzo Harris, "Uncle Sam Is Tremendously Interested in Disarmament," brings back a familiar argument (fig. 25). This cartoon was created during the International Conference on Naval Limitation (commonly known as the Washington Conference), during which the United States assumed the moral high ground and demanded naval arms reductions from the other great powers. It shows the United States, represented by Uncle Sam, standing on a balcony representing the White House, looking at the European war (symbolized by Mars, the god of war) with his looking glass. He holds up his hand to caution Mars to stop. At the same time Uncle Sam ignores a barbaric, monstrous image of "The South" with "Lynch Law" written on his leg who is ready to take action with his swinging rope and burning club.[103]

The Crisis also provided extensive coverage of the NAACP's thirteenth annual conference, including a photo of the anti-lynching parade in Washington, D.C., and coverage of a parade in Newark held in conjunction with the NAACP's annual meeting. Marchers carried signs which included an image of a group of boys with the text "We are Fifteen Years Old. A Boy of Our Age Was Roasted Alive Recently." Other signs said "Liberty Holds Her Torch Aloft to Light Men's Funeral Pyres" and "Savages Eat Human Beings Without Cooking—Americans Cook Human Beings Without Eating." The conference focused on the need to pass the Dyer Anti-Lynching Bill. Prominent lawyer Moorfield Storey, who spoke at the conference and had written extensively on lynching as president of the American Anti-Imperialist League, appealed to the conscience of the American people: "If they will not stand by their colored fellow citizens in this crisis; if they will not resolve that in this day of civilization the torture and murder of human beings by lawless mobs must cease, the future of the country is darkened and calamity is sure to follow."[104]

This issue of *The Crisis* included a special section entitled "The Shame of America." It listed state-by-state lynching statistics for 1922 as well as statistics about the means of violent death for African Americans other than lynching (burnings, beatings, shootings, torture, drownings) complete with graphic photographs of several lynchings. These were placed next to a cartoon with a moving image of the crucifixion (fig. 26).[105] It features a black Christ figure with

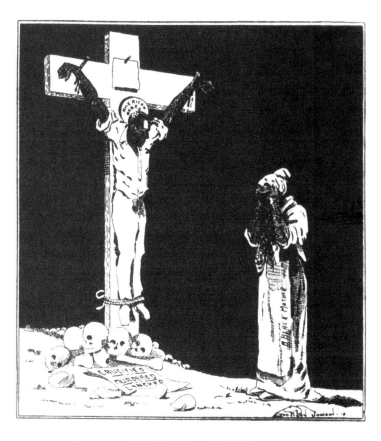

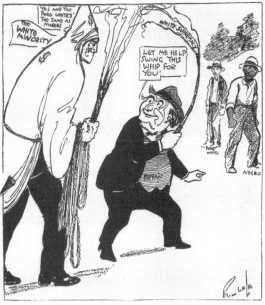

Figure 26. "3,496 Crucified!," by H. Johnson. Reprinted from *The Crisis*, February 1923, p. 168.

Figure 27. "Mr. Bryan Lends a Hand," by Ryan Walker. Reprinted from *The Crisis*, May 1923, p. 37.

"American Negro" written inside the halo over his head. At his feet many skeletons are piled up, with the words "Crucified, Murdered, Lynched" next to them. A woman covers her face in sorrow and horror, like Mary, the mother of Jesus, but this time she is "A Black Mother," as the words on the side of her apron inform us. The Christian iconography was familiar and recognizable, reinterpreted to connect lynching to the death of Christ and to the actions of "Christians."[106] This imagery worked on many levels. It connected the crime of lynching to a central truth of Christianity, merging African American identity and religiosity together. It also painfully underlined the horror of lynching to sympathetic white Christians, again affirming the power of imagery over simple text. The issue included a full-page statement in support of the Dyer Anti-Lynching Bill.

The Crisis sometimes bought art from other sources, reprinting pieces from other prominent journals and newspapers. Ryan Walker from the *New York Call* provided a cartoon called "Mr. Bryan Lends a Hand" in the May 1923 issue (fig. 27). A thug figure ("The White Minority") is hooded like a Klansman. Dollar signs decorate his robe, and a lynching rope is slung over his arm. William Jennings Bryan, holding a whip ("White Supremacy"), says to the hooded figure, "Let me help swing this whip for you." Walker is referring to the resurgence of the KKK in the early 1920s, to which Bryan, the great Populist figure, had given his tacit support. In the background of the cartoon stand two tired and dejected figures (a Negro and a poor white). Below the cartoon, an unsigned *New York Call* editorial on Bryan's political views quotes the perennial presidential candidate as rather cluelessly saying, "The colored people . . . live under the laws that the white people make for themselves as well as for the colored people." The editorial criticized Bryan as a supporter of class rule and the exploitation of laborers, both white and black, who "sweated for the pleasure of a minority."[107]

From his Paris vantage point, Albert Alex Smith contributed a more striking cartoon for the February 1924 issue of *The Crisis*, which included the complete text of the Dyer Anti-Lynching Bill. Smith's cartoon captured in one image what the Dyer Bill sought to confront. "Lords of Lynching" (fig. 28) shows two masked men with smirks on their faces, sitting and resting in the dark of night under the limb of a tree. The figure on the left has "Ku Klux Klan" on his shirt. The words "License," "Intimidation to the Negro," "Murder," and "Rapine" appear below on the grass. The Klansman holds a rope and a stick in his hands. The horses of these two will carry them through the countryside to the next night's "entertainment," an entertainment only the Dyer Bill could stop.[108] The cover of the issue was dedicated to the memory of lynching victims. Laura Wheeler provided "Lest We Forget" (fig. 29). The title flanks either side of the illustration, and the lettering is meant to resemble woodblock letters in

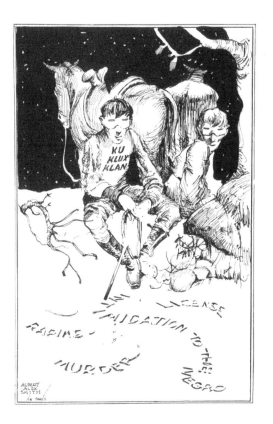

Figure 28. "Lords of Lynching," by Albert A. Smith. Reprinted from *The Crisis*, February 1924, p. 169.

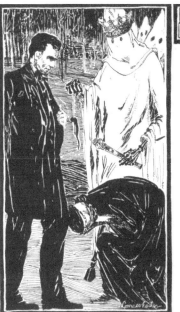

Figure 29. "Lest We Forget," by Laura Wheeler. Reprinted from *The Crisis*, February 1924, cover.

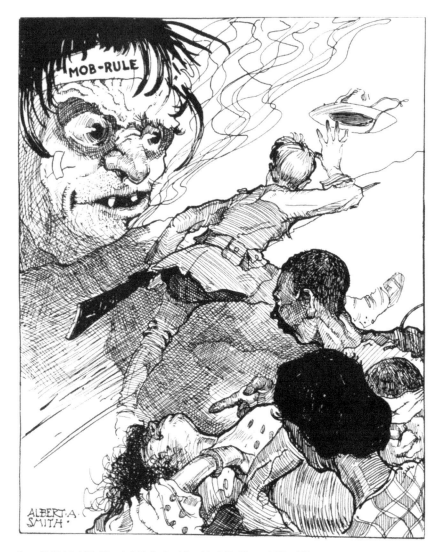

Figure 30. "Mob Rule," by Albert A. Smith. Reprinted from *The Crisis*, February 1927, p. 180.

the arts and crafts style. The illustration is framed in a simple black outline and contains the image of Abraham Lincoln in silhouette, shown deep in thought. Lincoln faces several Klansmen, including a crowned Ku Klux Klan member whose skeleton hands reach from his long white robe. This Klansman holds a scepter in his left hand and a small figure of a lynched black man dangles from

his right hand. A woman in a black robe bends in half, overcome with grief, at the feet of Lincoln.[109]

Albert Alex Smith's "Mob Rule" in the February 1927 issue (fig. 30) included a dead black figure in the lower right corner. As three other figures point to the body or tend to it, a horrible toothless, monster-like head with the words "Mob-Rule" on his forehead looms in the background. A white soldier or police officer stands between the black figures and the monster; he does nothing to prevent terror.[110] In the same issue Du Bois warned that thirty-four lynchings had occurred in the United States in 1926, nearly twice as many as 1925. He ascribed the increase to the failure of Congress to pass the Dyer Bill, which "removed [fear] from the minds of the murderers."[111] The indifference of white authority to the terror also played an important role.

Artist Cornelius Johnson created his own vision of "Prejudice" for the March 1927 issue (Fig. 31). A terrifying horned and fanged devil holds a smoking gun, his claw-like hands clasping a lynching rope. The figure emerges from a completely black background, which heightens the hellishness of his features. He is the embodiment of hatred and evil; the image is a striking use of religious imagery in the lynching debate.

The terror and murdering of blacks was illustrated in "The Black Prometheus Bound" in July 1927 (fig. 32). Uncle Sam states: "Behold my eaglets!" Truth, staring accusingly from the skies with rays of sun emanating from its head states: "Eaglets, forsooth!" Instead, they are vultures, gorging themselves on human hearts which, as the captions informs us, dare to aspire "Up from Slavery to that fire of freedom, which the Souls of Black Folk brought down from heaven!"[112] The caption alludes to the best-known works of rival black leaders Booker T. Washington and Du Bois, perhaps suggesting that whatever their differences, the vultures treated them with the same contempt. The vultures—Texas, Missouri, Mississippi, Georgia, Alabama, and Arkansas—pick at the body of a dead black man, who is strewn nude across a bed of thorns. Blood drips from their beaks. A cabin burns below, part of the reign of terror. The eagle, Uncle Sam, stands proudly by, ignoring the slaughter, again demonstrating the contradiction between professed American ideals and the terror practiced in the South.

Despite these powerful visual images and cartoons, Du Bois believed that apathy toward lynching remained widespread. In August 1927, he wrote, "The recent horrible lynchings in the United States, even the almost incredible burning of human beings alive, have raised not a ripple of interest, not a single protest from the United States Government, scarcely a word from the pulpit and not a syllable of horror or suggestion from the Defenders of the Republic, the 100% Americans, or the propagandists of the army and navy. . . . [A]nd yet

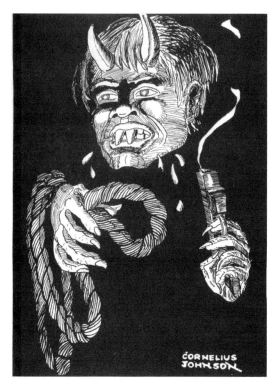

Figure 31. "Prejudice," by Cornelius Johnson. Reprinted from *The Crisis*, March 1927, p. 4.

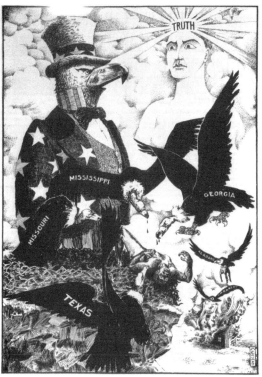

Figure 32. "The Black Prometheus Bound," by M. Crump. Reprinted from *The Crisis*, July 1927, p. 148.

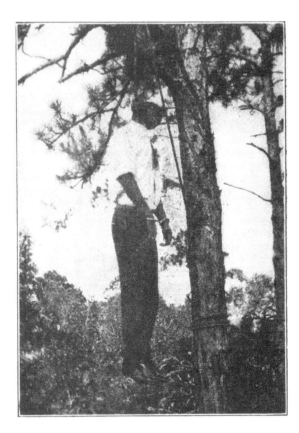

Figure 33. Photo of lynching in Alabama, February or March 1928. Reprinted from *The Crisis,* September 1928, p. 312.

hiding and concealing this barbarism by every resource of American silence, we are sitting in council at Geneva and Peking and trying to make the world believe that we are a civilized nation."[113]

He redoubled his efforts to publicize the issue. A photo in September 1928 shows a man lynched in February or the early part of March of that year. The text reads: "The snapshot was taken by a traveling salesman who had the film developed at Melbourne, Alabama, and then gave a copy to a colored police officer. We have been able to get no further information. We do not know what the name of the man who was lynched was or of what he was accused. He is evidently a well-dressed person and the hand-cuffs on his wrists show that he was in the custody of the officers of the law when murdered" (fig. 33).[114] This photograph was so powerful that it was used at least four more times in *The Crisis* over the next two years, and in the 1930s, the magazine used it in its advertisements to encourage readers to participate in the NAACP's anti-lynching cam-

paign. The text "My Country 'Tis of Thee, Sweet Land of Liberty—" was placed above the photo, and below it, the words "This is a picture of what happens in America—and *no other place on earth!*" Du Bois was again employing his civilization argument to appeal to the public to end lynching.

Du Bois continued to stress the violence lynching had done to American symbols and values. He commissioned Lorenzo Harris to provide a cartoon called "Vandals!" in March 1929 (fig. 34). It shows three thugs with monstrous pig-faces going through the gallery hall of a museum. The vandals bear the names "Lynch Law," "Negro Hater," and "Prejudice"; they hold clubs and are dressed in black suits and hats. They have crushed and destroyed precious works of art, including a statue named *Liberty and Justice.* A portrait of Abraham Lincoln is slashed. Three figures sleep on a nearby couch: "Police," Uncle Sam, and "The Courts." No one will stop the slaughter.

The Crisis highlighted Walter White's 1929 book *Rope and Faggot,* whose cover had an image of a lynching from a lithograph by white artist George Bellows. Walter White's work greatly aided the accounts published by the NAACP and in *The Crisis.* White, who was the NAACP's assistant secretary, conducted many lynching investigations. As a light-skinned man with blond hair and blue eyes, he was able to go undercover—at considerable personal risk—to expose some of the most horrific lynchings.[115] White's book used cold statistics to reveal the horrors of lynching, including numbers of victims burned alive and those burned after death. He tried to ascertain the psyche of lynchers, discussing their stunted mental growth which had been passed down from generation to generation. Like *The Crisis,* he associated lynching with practicing Christians. He wrote: "It is exceedingly doubtful if lynching could possibly exist under any other religion than Christianity. Not only through tacit approval and acquiescence has the Christian Church indirectly given its approval to lynch-law and other forms of race prejudice, but the evangelical Christian denominations have done much towards creation of the particular fanaticism which finds an outlet in lynching."[116] White hoped to change the overall structure of southern society, an indication of the radical nature of the NAACP's stance.[117] He noted that "the more Baptists and Methodists there were in a given state as a percentage of its 'total church population' the greater incidence of mob murder."[118]

THE 1930S: LYNCHING AND THE DEPRESSION

The Great Depression brought an upsurge in lynching, strengthening Du Bois's belief in the economic roots of the violence. He chronicled the increase and joined with new allies in the campaign against lynching. *The Crisis* docu-

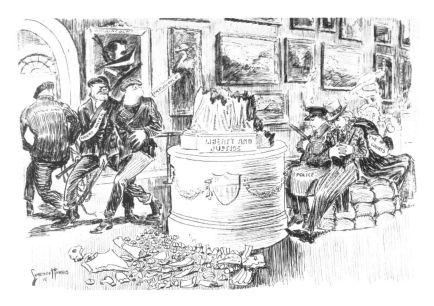

Figure 34. "Vandals!," by Lorenzo Harris. Reprinted from The Crisis, March 1929, p. 78.

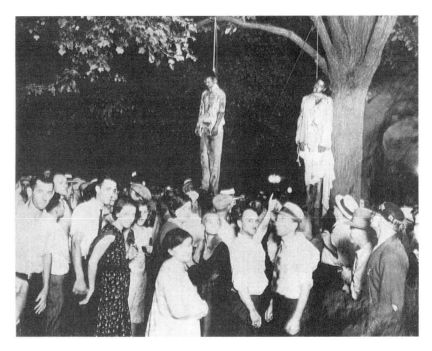

Figure 35. Photo of lynching in Marion, Indiana, August 1930, by Lawrence Beiter. Reprinted from *The Crisis,* October 1930, p. 348. Courtesy Indiana Historical Society.

mented the founding of the Southern Commission on the Study of Lynching under the direction of Dr. Arthur A. Raper. The Communist Party of the United States of America and its legal arm, the International Labor Defense, joined the anti-lynching campaign, criticizing the tactics employed by the NAACP as not radical enough to end lynching. Du Bois continued to make uncomfortable comparisons for Americans, connecting lynching with the advent of Nazi persecution of the Jews. The campaign finally brought results. There was a dramatic decline in lynching in the second half of the 1930s. The struggle was hardly over, but much was achieved.

The importance of visual images of lynching is demonstrated well in a case in August of 1930 in Marion, Indiana. The October 1930 issue of *The Crisis* ran a graphic photo of the lynching, with Du Bois's sarcastic caption, "Civilization in the United States, 1930" (fig. 35). In Marion, three young black men were accused of raping a white woman and shooting and killing the white man she was with. Two of the three accused men were taken by a mob from the jail and lynched, while the third suspect narrowly escaped. The men were not adequately protected by the local sheriff, a fact that gave the mob easy access to the jail. It later turned out that there was much more to the case. Walter White, who investigated the case within a week of the event, discovered that Mary Ball, the woman who claimed to be raped, was an associate of the black men and may have been working in collusion with them to help rob her white "dates" on lovers' lane. Nevertheless, the members of the lynch mob were eventually acquitted.[119]

White photographer Lawrence Beiter recorded the actual lynching and sold copies of his photos for 50 cents after the event. Postcards made from the photo were sold in other cities, too. The photo features the two victims hanging from the tree while a large crowd of well-dressed observers points to the victims and smiles for the camera; in effect, the lynching is an evening's entertainment. The crowd includes a young man holding his date's hand, a pregnant woman, and an older woman in a fur-collared coat. One man points to the victim to bring the viewer into the scene. Several branches of the tree were sawed off to provide a better view. A young boy had turned the bodies of the victims toward the camera to allow better photos of the scene.[120] Both victims have blood on their clothes, while the victim on the right has a cloth wrapped around his lower half to hide his naked body. His pants have been removed.

The white press coverage of the event shows why publications such as *The Crisis* were necessary to ensure that an accurate memory of this event was preserved. On August 8th, the *Marion Chronicle-Tribune* claimed that the "lynching was done not by men of violent and lawless dispositions"; rather, "these men are ordinary good citizens, but they were stung to the quick by an atrocious

crime and spurred on to their violent act by a want of confidence in the processes of the courts."[121] *The Crisis* and other black journals, including the *Chicago Defender,* offered a different rationale for the lynchings. White's report in *The Crisis* highlighted the questionable aspects of Mary Ball's character and argued that "[f]or generations, we black folks have been the sexual scapegoats for white American filth in literature and lynching." The lies that make black men into "wild beasts" of "filthy lust" are "deliberately nailed to every possible Negro crime and broadcast." Why was it, White asked, that there were two white rapists in the Grant County jail on August 7th who were not sought by the mob?[122] In contrast to coverage of the event by black newspapers and journals, white newspapers soon purged from memory the names of the lynching victims, referring to them only as Negroes or as criminals. The white *Marion Chronicle-Tribune* did not print Beiter's photograph, claiming that it was "too violent, too graphic, and too close to home."[123] Some black journals also cropped parts of the photo, showing only the victims or only the crowd.

The photo of the Marion lynching reprinted in *The Crisis* may have provided the inspiration for Abel Meeropol's famous poem "Strange Fruit," written later in the decade.[124] Meeropol was a Jewish teacher living in New York City in the 1930s and said that a lynching photo he saw in a journal haunted him and inspired his poem. The poem later became a hit song recorded by Billie Holiday in 1939. Even though this lynching did not occur in the South, the Meeropol poem captured the atmosphere of what was still an all-too-commonplace event in that region.

Strange Fruit

Southern trees bear a strange fruit,
Blood on the leaves and blood at the root,
Black body swinging in the Southern breeze,
Strange fruit hanging from the poplar trees.

Pastoral scene of the gallant South,
The bulging eyes and the twisted mouth,
Scent of magnolia sweet and fresh,
And the sudden smell of burning flesh!

Here is a fruit for the crows to pluck,
For the rain to gather, for the wind to suck,
For the sun to rot, for a tree to drop,
Here is a strange and bitter crop.[125]

Beider's photo was reproduced repeatedly over the years, twice in the year 1994 by *Newsweek* magazine. James Cameron, the third accused man who narrowly escaped lynching, wrote a book on the subject and was even decades later interviewed by news agencies across the world. At the execution of a black

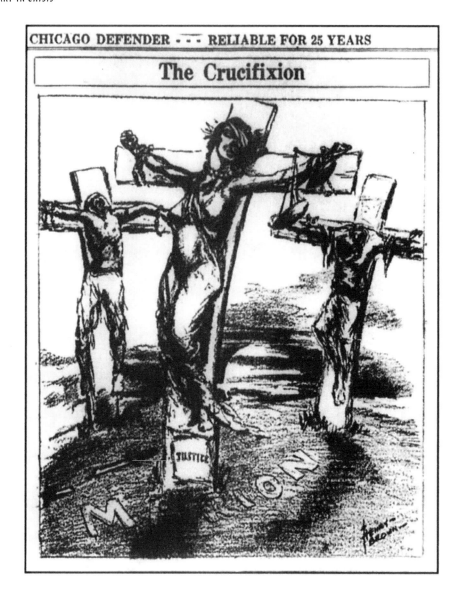

Figure 36. "The Crucifixion," by Henry Brown. Reprinted from the *Chicago Defender*, August 23, 1930. Courtesy *Chicago Defender*.

death-row inmate in Indiana in 1994, protestors held up copies of the famous 1930 lynching photo, preserving the memory of the event, using it as a reminder lest more mistakes be made. Documentaries were made about the event, featuring Cameron's accounts of that harrowing night, including one by independent filmmaker Joel Katz in 1999.[126] The memory of the lynching, preserved in photos and printed for the world to see in the national press, became a symbol of the crime of lynching and, for some, the symbol of government-sanctioned death. Some wanted such memories to be forgotten. As late as 1988, the executive editor of the *Marion Chronicle-Tribune* expressed the sentiments that "it is one chapter in the community's history that everyone, black or white, would just as soon forget about."[127] While some members of the black community (and the white community) did not want to recall the event vividly, James Cameron would state in an interview in the 1990s, "To remember is salvation . . . to forget, is exile."[128] Du Bois also believed that even sorrowful memory could be used to good purpose. The Marion lynching story and photograph resulted in coverage that included two political cartoons originally published in the *Chicago Defender.* One was another crucifixion scene (fig. 36). It featured three crucified bodies, the two in the back represent Marion lynching victims Shipp and Smith. The other, a woman called "Justice," is blindfolded, her scales of justice nailed to the cross as well. She is in the center in the position usually reserved for Christ. "Marion" is written on the ground below her.

The lynching in Marion and the photo that documented it would provide inspiration for another piece of political art in *The Crisis* the following March. The idea of the "sport" of lynching was brought to Du Bois's readers again in March 1931 in Lorenzo Harris's "Civilization in America, 1931. One of Our Major Sports" (fig. 37). The title deliberately echoes the one Du Bois used for the Marion photo and acknowledges the importance of spectator sports in the United States during this period. In Harris's scene, a dead man dangles from a tree while two men try to stab his lifeless body with a knife and a pitchfork; another with a hatchet appears in silhouette. A woman cuts off his toes, a particularly shocking image, providing a "souvenir" of the event, a common practice. A blond girl, the quintessential white child, collects the toes in a bowl. A wholesome-looking young man in a university-letter sweater, the ironic figure of the white sports hero, adds wood to the fire. He looks ready to "play" at a sport. Cans of gasoline and kindling are brought to the body for burning by a respectable older man who seems gentle and unthreatening, someone's grandfather. Another gas can is cropped at the bottom of the composition and leads us into the scene—we are there, witnessing the event. A small child is held up by his mother for a better view of the event. Women,

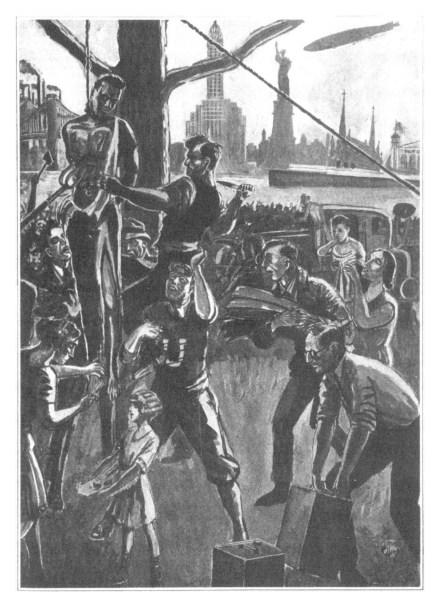

Figure 37. "Civilization in America, 1931. One of Our Major Sports," by Lorenzo Harris. Reprinted from *The Crisis*, March 1931, p. 95.

children, and older men participate—no one is excluded from this sport. In the background is evidence of modern society: a dirigible, a skyscraper, smoke-stacks, a barge floating on the water. The huge lynching tree pierces the entire composition. Across the expanse of water, the American flag, the steeple of a church topped by a cross, and the Statue of Liberty are silhouetted as symbols of peace, order, and harmony. The water shows the huge gulf between the ideals of American society and the realities of life for black Americans. These are ordinary Christian Americans participating in the unthinkable, part of "civilization in America."

During the 1930s the campaign against lynching gained new allies, which *The Crisis* reported with much satisfaction. Du Bois eagerly noted the conclusions of the Southern Commission on the Study of Lynching: "Only one in every six of the persons lynched had been even accused of rape; and naturally, not all of those accused were guilty."[129] Du Bois had been making the same point for more than twenty years in the pages of *The Crisis,* echoing the earlier findings of Ida B. Wells. The report recognized "that white men have disguised themselves to impersonate Negroes and fasten crime upon them. . . . [F]ew lynchers have been punished or even indicted. . . . [I]n numbers of cases the members of the mob were unmasked and perfectly well-known." [thereby contradicting the typical line "Lynched by parties unknown] . . . [W]omen and Children were often in the mobs." The report, as summarized by *The Crisis,* concluded, "Lynching can and will be eliminated in proportion as all elements of the population are provided opportunities for development and are accorded fundamental human rights. . . . For, fundamentally, lynching is an expression of a basic lack of respect both for human beings and for organized society."[130]

The famous Scottsboro case provided artists with a new subject related to lynching. The trial involved nine young African American men who had hopped a train to Memphis in search of work in March 1931 and were accused of raping two white women on board the train. The trial began just two weeks later, and eight of the men were sentenced to death for the crime, even though one of the women eventually recanted her story. The case became a national sensation in the 1930s, underlining for many the deficiencies of the southern justice system that was the horribly warped alternative to lynching. After a series of appeals and new trials, the men served lengthy prison terms. Cartoonist Russell O. Berg submitted "Have I Been Hit?" in the January issue, showing a southerner being hit by a book that bears the legend "A New Trial for the Scottsboro Boys: U.S. Supreme Court" (fig. 38). The man represents "The

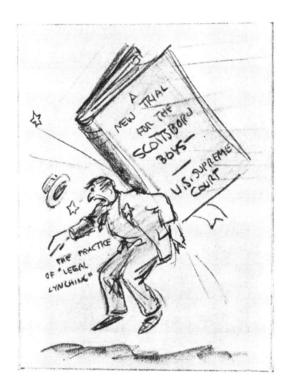

Figure 38. "Have I Been Hit?," by Russell O. Berg. Reprinted from *The Crisis*, January 1933, p. 13.

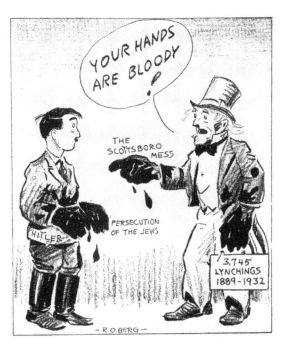

Figure 39. "Pot and Kettle Again," by Russell O. Berg. Reprinted from *The Crisis*, July 1933, p. 159.

Practice of Legal Lynching," a reference to the near-certainty that the men would be found guilty and put to death—lynching legally sanctioned by the courts. In July, Berg offered " Pot and Kettle Again," where Uncle Sam's bloodied hands are labeled with the texts "The Scottsboro Mess" and "3,745 Lynchings 1889–1932." He points accusingly at Hitler, whose hands are also bloody, and screams, "Your hands are bloody!" (fig. 39). The hypocrisy of Americans who could show outrage about the atrocities committed against innocent German Jews but did nothing to stop the atrocities at home was the central theme. Artwork which *The Crisis* had laid the groundwork for appeared over several years in support of the Scottsboro boys, much of it sponsored by the Communist Party (CPUSA), which had vied successfully with the NAACP to represent the Scottsboro boys in their trial. Although it was the CPUSA that called for artistic support, most artists who supplied artwork and support for the Scottsboro boys did so on the basis of humanitarian needs rather than for political reasons. As one artist stated, "Most of the artists, like myself, who lived in New York City, far from the South, were emotionally involved in all the horrible things that were happening to the blacks. Some of us were able to communicate our feelings in prints and paintings even though we had never seen a lynching or a beating."[131]

Other black journals periodically printed images connected with lynching, but no journal came close to the constant visual attack in *The Crisis* against lynching. Mainstream white publications occasionally included anti-lynching imagery as well, sometimes causing great furor. Cartoonist Edmund Duffy offered his "Maryland, My Maryland!" in the *Baltimore Sun* (fig. 40).[132] The cartoon was a response to the lynching of a black man accused of murdering a white businessman. It showed a lynched black man hanging from a tree, blindfolded, his fingers and toes extended freakishly in death. The figure provides a stark and disturbing silhouette against a plain sky, and the Maryland countryside stretches behind him. The cartoon was so disturbing to the *Sun's* readers that it was said to have created more furor than the actual *act* of lynching. Its publication resulted in street protests. The newspaper's delivery vans were attacked, the drivers beaten.[133] The more radical journal *New Masses* included a cartoon entitled "The Law" in the January 9, 1934, issue. It featured a building labeled "U.S. Courts," a swastika in its pediment, a lynching tree growing through its center, one branch bearing a lynched man, another branch bearing the ghost of a lynching victim (fig. 41).[134] Mexican muralist José Clemente Orozco also created his own harrowing image of lynching in 1934, a lithograph entitled "The Hanged Man (Negroes)" from the portfolio "The American Scene." He sought to create a shocking statement about the staggering statistics

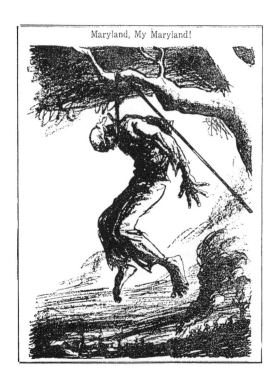

Maryland, My Maryland!

Figure 40. "Maryland, My Maryland!," by Edmund Duffy. Reprinted from the *Baltimore Sun*, December 16, 1931. Courtesy *Baltimore Sun*.

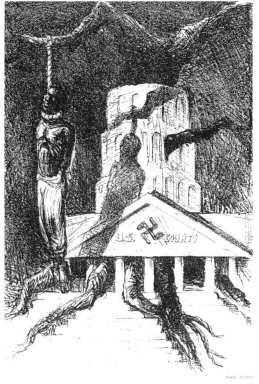

Figure 41. "The Law." Reprinted from *The New Masses*, January 9, 1934. Courtesy Communist Part USA.

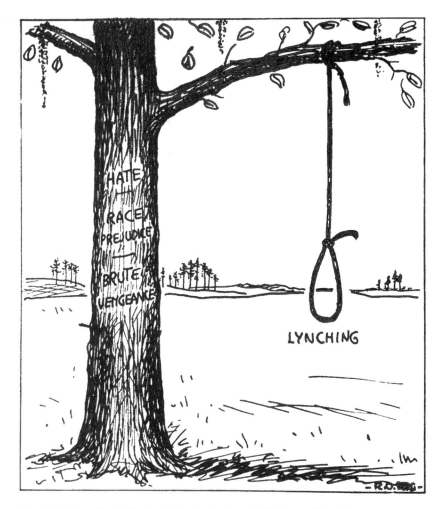

Figure 42. "The Tree and Its Fruit," by Russell O. Berg. Reprinted from *The Crisis*, February 1934, p. 30.

on lynching in the United States with the image of four skeleton-like bodies dangling from trees like a Japanese woodblock print, limbs piercing the composition. Orozco wanted to show the conflicting values of the United States, a land of the "free" where "justice" for all supposedly prevailed.

Lynching is symbolized by a tree in R. O. Berg's "The Tree and Its Fruit" in the February 1934 issue (fig. 42). Berg drew a tree with the words "Hate," "Race Prejudice," and "Brute Vengeance" carved on the trunk. A rope with the word

"Lynching" below it dangles from the branch. This cartoon appeared next to the monthly "Debit and Credit" column for 1933, with the first Debit, "Twenty-Eight Human Beings Lynched by Mobs without Trial" appearing on the left side. Du Bois used art to underline one of the most serious issues of the day, drawing the viewer into the Debit and Credit column, encouraging the reader to review the major events of the preceding year. It was terrible enough to read about the horrors of lynching, but no one could ignore the photos and the smiling crowds behind the charred bodies of the victims.

The international dimension of the anti-lynching campaign continued to influence the cartoonists of *The Crisis.* In June 1934, the Night of the Long Knives took place in Germany, when Hitler's Gestapo summarily executed members of the Sturmabteilung (SA) that Hitler thought posed a threat to his regime. The victims were arrested in the middle of the night and murdered in cold blood. In "Victims of Lynching!," Romare Bearden shows General Hugh S. Johnson delivering a speech at Waterloo, Indiana, on July 12, 1934 (fig. 43).[135] Johnson says, "A few days ago in Germany, events occurred which . . . made me . . . physically sick." He stands on a map of the southern United States, reading a speech as he faces Nazi flags, while the gravestones of victims of lynching dot the landscape all around him and vultures fly overhead. Bearden's message was clear. Johnson was sickened by the slaughter of Germans but paid no attention to the murders surrounding him in his own land, the lynchings taking place in the United States. Bearden's cartoon echoes Du Bois's searing criticism of the hypocrisy of American leaders who recognized human rights violations only when they occurred in other countries.

Bearden shows the black man finally fighting back in his cartoon "For the Children!" (fig. 44)[136] We see the heads of Klansmen appearing over the horizon. They hold the flags of lynching, peonage, and segregation as they come forward. A large muscular black man marches toward them, shotgun in hand, while a young black boy, presumably his son, walks behind him, his hand on his father's back. The gun, although it is prominent in the composition, is not poised to shoot, but it is clear that the man must face the terror and protect his own if necessary—"for the children." We feel we are a part of the scene as the man's back leads us into the composition. Bearden wants us to feel his simultaneous uncertainty and determination. The cartoon suggested a possible new motif in the imagery of African Americans on lynching—the possibility of violent resistance to this extralegal terrorism. It appeared as a part of the special annual issue devoted to children. In the South, the Depression years intensified lynching as a response to the economic crisis. However, the impact of the Depression on the rest of the nation stimulated political action against lynching.

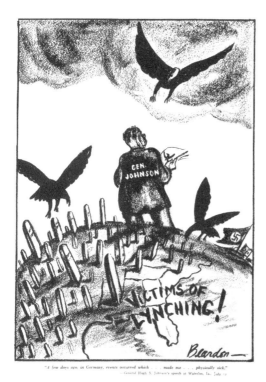

Figure 43. "Victims of Lynching!," by Romare Bearden. Reprinted from *The Crisis*, September 1934, p. 257.

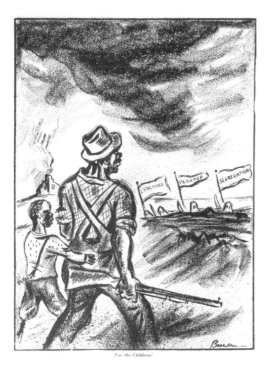

Figure 44. "For the Children!," by Romare Bearden. Reprinted from *The Crisis*, October 1934, p. 294.

LYNCHING IN PUBLIC ART SHOWS:
THE NAACP AND THE ARTISTS' UNION

Du Bois's efforts to keep lynching at the forefront of public consciousness was ultimately recognized by liberal New York literary and cultural leaders.[137] In 1935, the show "An Art Commentary on Lynching," sponsored by the NAACP, opened at the Arthur U. Newton Galleries in New York after the first venue, the Jacques Seligmann Galleries, canceled at the last minute, fearful that the content was too political and racial in nature. This brought more attention to the Newton show, which was very well attended in its two-week run in February and March.[138] Although the show debuted a few months after Du Bois stepped down as editor of *The Crisis,* it is impossible to imagine its existence without the two decades of Du Bois's work on the journal. His efforts to use visual imagery to combat lynching were vital to the success of such public art shows. This was the first exhibition devoted to issues focused on African American men, and it was the first time an exhibition tried to counter negative attitudes about black men.[139] Organized by Walter White, the NAACP's director, it was a part of the effort of the organization to bring attention to the issue of lynching and garner support for the Costigan-Wagner Bill, new anti-lynching legislation which had been introduced in Congress in 1934. Both White and James Weldon Johnson had worked closely with Du Bois and helped spearhead the NAACP's anti-lynching campaign. Walter White understood the propagandistic possibilities of such an exhibition. He solicited artists for the show and encouraged them to emphasize the "horror and pathos" of lynch violence. He sought elite support, writing to one prominent patron: "Even a morbid subject, can be made popular if a sufficiently distinguished list of patronesses will sponsor the exhibit and the right kind of publicity can be secured for it. . . . I fear that I have put this somewhat crudely and inadequately but I trust that you will be able to understand how I am trying delicately to effect a union of art and propaganda."[140]

The thirty-eight participants in the exhibition included one woman and ten blacks. White's exhibition catalogue contained the essays of two white writers, Sherwood Anderson and Erskine Caldwell, who emphasized the economic reasons behind lynching and the urgent need for anti-lynching legislation. Pearl Buck spoke at the preview of the exhibition, where she noted that every black man was a potential victim of the lynch mob, including the artists who participated in the exhibition. Because of the involvement of such prominent white artists as Thomas Hart Benton, Isamu Noguchi, George Bellows, John Steuart Curry, and Reginald Marsh, the show was covered by the white press, although it received mixed reviews.[141] Reginald Marsh offered "This Is Her First Lynch-

ing" to the show, which was published in *The Crisis* in January of 1935, the month before a version of it appeared in the exhibition. Marsh emphasized the horrifying "spectator sport" of lynching.

The Crisis used images from the exhibition in its future efforts in the fight against lynching. Art historian Margaret Vendryes noted that the exhibition was meant to show the urgency of the issue, to alarm the viewer, and to incite action to end lynching through legal channels.[142] The goals of the exhibition were much the same as those of Du Bois on the pages of *The Crisis*—to relay a sense of urgency, inspire swift legal action, and end lynching in the United States.

The NAACP exhibition also dealt with the fear of the sexual prowess of the black male and the perception that lynching was a way to control the black men's crimes against white women. One image in the show, "The Law Is Too Slow," was from a 1923 lithograph by George Bellows and was also used as the cover of Walter White's book *Rope and Faggot*. Richmond Barthé, whose work was reproduced many times in *The Crisis,* contributed the work "The Mother" of 1934, which was begun before the exhibition was put together. This piece shows a grieving mother holding her son, like the figure of the Virgin Mary holding the dead Christ. The dead man's body is depicted in the nude for impact and is shown intact, even though lynching victims were often castrated as a sign that their sexual prowess was destroyed, the ultimate emasculation.[143] The white artists in the show "fearlessly addressed the absurdities of lynching with the same open-faced audacity that their Southern brothers used to commit the crimes." White artists tended to show the victim as alive and perhaps therefore still possible to rescue, while black artists "more realistically depicted the deed as done."[144] There could be nothing more realistic than the actual "done deed" of the photographs of lynchings contained in the pages of *The Crisis.*

But what of the images of *The Crisis*? Did its photos and cartoons and drawings also support Walter White's statement that "even a morbid subject can be made popular?" Did the horrifying images unify blacks from all backgrounds against a terrible, hateful injustice? The lynching imagery in *The Crisis* had two purposes: It was meant to draw the viewers in, to engage them, and to serve as an issue that would promote collective identity. On the pages of *The Crisis,* the imagery was a response to a real threat. If there was a sense of the macabre or the sensational in the show "An Art Commentary Against Lynching," which was intended for a white audience, this was not present on the pages of *The Crisis.* Du Bois used the images to heighten the impact of his essays, to empower his words. Fully aware to the racial humiliation of lynching, he did not stoop to sensationalism.

The critics who reviewed the NAACP show understood what *The Crisis* had already understood, that a picture was worth a thousand words. The review in *Newsweek*'s "In the Arts" column seemed to echo Du Bois's understanding of the power of visual imagery to fight the battle against lynching: "The artists have depicted brutality in its most sickening form. . . . [N]o spoken or written argument against lynch law could be as hard hitting as this visual articulation."[145] It was clear from the exhibition's visibility that the visual imagery in *The Crisis* had had the very real effect of encouraging images of lynching by providing years of cartoons and photographs to the magazine's audience. *The Crisis* created a climate which made future images possible.

The day after the NAACP exhibition closed, "Struggle for Negro Rights" opened, an anti-lynching exhibition by the Artists' Union and several other leftist or Communist-affiliated organizations. This exhibition was held at the American Contemporary Gallery in Greenwich Village. The sponsors of this exhibition advocated a much more radical solution to lynching; "The Bill of Negro Rights and the Suppression of Lynching" demanded the death penalty for lynchers.[146] The Artists' Union tried to offer a more radical vision than the NAACP's approach of the use of "high art" to draw the public to the battle against lynching. It had submitted to Congress the "Bill of Civil Rights for the Negro People." The cover of the exhibition catalogue, like that of the NAACP exhibition's cover, was created by a white artist. A radical introduction gallery's catalogue was penned by Angelo Herndon, entitled "Pictures Can Fight!" Herndon was a young black Communist who had recently been sentenced to twenty years on a chain gang for organizing black and white unemployed workers; he was well known in leftist circles. Herndon suggested that only struggle could stop lynching, either through mass organization or mass defense. The group also affiliated with the leftist John Reed Club and *New Masses.*

Anti-lynching exhibitions offered artists a unique opportunity to "not only attack lynch violence but also to protest the cultural politics of racial oppression in American society."[147] Since many of the artists listed in the catalogues proved untraceable, it seems likely that many of them were students or amateurs. Once again, most participants were men; only four artists in the two shows combined were women. The backgrounds of these participants—their race (white in most cases) or gender—influenced how they depicted lynching.[148]

Only two of the seven African American artists who participated in the NAACP exhibition at Newton Galleries chose to portray explicit violence and they did so in order to show suffering. Four of the other five used images of sorrow, grieving, and religious metaphors to show the effects of lynching.[149] Clearly this imagery had an impact on their identity as African Americans. They did

not wish to show "frenzied white violence and demeaning black victimization."[150] These artists stressed the dignity of the victims and the terrible spiritual anguish felt by the black communities in which the victims lived.

The work of women artists did not illustrate lynching issues in *The Crisis*.[151] Nor did women participate substantially in the NAACP show at Newton Galleries or in the "Negro Rights" show at the ACA. The necessity of nudity in most images, the possibility of including castration in the images, and, for white artists, the black male nude figure would not allow them to maintain their positions as mothers, nurturers, and pure and loving caretakers. It was not considered proper for women in the 1930s to involve themselves in these issues.[152] This was a time when women were not participating actively in nude life drawing classes. As art historian Helen Langa has indicated, even women employed by the Federal Art Project (a division of the New Deal's Works Progress Administration) rarely depicted men as industrial laborers or in other roles that might depict physically explicit, active male bodies.[153] Therefore, it was not likely that women artists would be involved in the issues surrounding lynching, where both graphic suffering and male nudity (especially black male nudity) was called for.[154]

The two exhibitions revealed a significant difference in the propaganda styles of the NAACP and the leftists who mounted the ACA show. The NAACP show took up the idea of the connections with the crucifixion with African American E. Simms Campbell's "I Passed Along This Way," which showed the figure of Jesus carrying the weight of the cross up a hill, in shadow, with the image of a lynching victim behind him. The image united the suffering of Christ and the suffering of all lynching victims, indeed, of all African Americans. The image was reproduced in the March 1935 issue of *Crisis* in the honored position of frontispiece.

The *Amsterdam News* praised Campbell's image as one of the most moving pieces in the NAACP exhibition, but leftist critic Stephen Alexander, who wrote for *New Masses,* was opposed to connecting lynching to Christian suffering. Both leftist critics and leftist African Americans were wary of making Christian suffering a large part of the collective memory of African Americans. Alexander felt that the NAACP show pleaded for reform while the ACA's "Negro Rights" exhibition emphasized "fighting pictures." He believed that artists in neither exhibition had created works that really explained lynchings. He thought the NAACP show only "chalked up to God or human nature" the horrors of lynching, while the "Negro Rights" show only served to arouse viewers' indignation. He hoped that artists would create works that would "attack the social forces responsible for lynching" to carry the fight to "a higher political level." Helen Langa feels that his condemnatory perspective "failed to recognize

the significance of images that spoke to the grief as well as the outrage aroused by lynch violence."[155]

Artist Aaron Douglas's work spoke to that outrage. His close connection to Du Bois and to *The Crisis* magazine is reflected in the subject matter in his 1934 Works Progress Administration mural series *Aspects of Negro Life,* now at the Schomburg Center in Harlem. The mural series included "Idyll of the Deep South," which includes the image of mourners grieving for a man who has just been lynched; his whose feet dangle in the upper left hand of the composition. Mourners stand around the figure of the hanging body and one man pulls himself up to his knees and looks towards a distant ray of light which crosses the scene, perhaps in a gesture of hope. Douglas did not emphasize the lynching as his primary focus in a Public Works Administration (PWA) commission; he knew it would have brought "instant objections from [his] PWA superiors."[156] Douglas also included references to lynching in his 1929 illustration for Paul Morand's *Black Magic.* In "Charleston," Douglas shows well-dressed black clientele in a jazz club enjoying music, but all is not well. In front of the saxophone player, a noose dangles from above, and claw-like hands in the foreground seem ready to pounce on the whole scene. Terror and violence lurk close by in this seemingly jubilant all-black nightclub.

Finally, Douglas included a reference to lynching in his mock-up for a 1934 cover for the magazine *Spark!,* which was never published (fig. 45). The drawing includes a black fist in the center of the composition, strong and sure, with shackle and broken chain. The sections of the composition include a mob presumably searching for its black victim, a cityscape, battleships, soldiers, a lynched man, and a man with a swastika on his chest. In the lower right are the letters "DEMO," an allusion to unfinished, unfulfilled, or broken democracy, particularly fitting in light of the lynched man dangling above. This is a drawing of unfulfilled dreams, of mob violence and broken promises.[157]

The Crisis never watered down its treatment of lynching. Castration images were not in the forefront of its imagery, but it published graphic descriptions of actual torture and lynchings. Although it used religious symbolism which emphasized the suffering as well as the dignity of the victims, it also published actual photographs of lynchings. It published graphs, maps, statistics, political cartoons, drawings, and photographs month after month. Readers of *The Crisis* simply could not ignore the issue of lynching. Du Bois wanted art to become political tools that would call attention to an issue too long ignored. Artists needed to illustrate an act and to encourage participation in anti-lynching programs (often sponsored by the NAACP) without placing the black male in a position of servitude or victimization even when he was the victim in a terrible

Figure 45. "Spark!," ca. 1934, by Aaron Douglas. Courtesy the Schomberg Center for Research in Black Culture, New York Public Library.

act. People across the United States saw the images in the magazine; Du Bois used *The Crisis* to ensure that readers understood that all Americans were responsible to end the problem. It became more than a regional issue.

In 1999, the New-York Historical Society mounted an exhibition of lynching imagery entitled "Without Sanctuary: Lynching Photography in America" with a catalogue of the same title. The images are similar to those that appeared in *The Crisis*, but this time 100 photographs were shown at one time that documented decades of lynchings of black men and women in the South; many of them included white audiences. Now these documents are viewed as part of our past; *The Crisis* presented them as evidence of a present danger. As one editorial stated, "They can be made public again only because now we ask them to carry an utterly different meaning than they once did—an outcry against racism rather than a reinforcement of it." Some have argued that little good comes from viewing photographic horrors; that with such images loose in the culture, often with too little historical context, the ultimate effect could easily be to "normalize images that are in fact horrible."[158] That essentially, we are repeating the acts of those who took the images and distributed them in the first place.[159] For a while these images were available on the Internet as well with limited historical background for the photographs. The value of exhibiting such imagery en masse must be carefully reviewed. The 1998 murder of James Byrd, Jr., in Texas shows us that such cruelty in this country can still occur. Byrd was killed when he was dragged behind a truck in a racially motivated murder. The outcome, however, was quite different. Byrd's murderers were sentenced to death.

Du Bois used visual reminders and symbols of lynching on the pages of *The Crisis* as reminders of the atrocities and acts of violence that were still occurring against the black community. Lynching was a profoundly significant political mobilizing force. Du Bois recognized this and used the imagery to convert a shameful secret into a catalyst. Yet he went beyond merely using it as a political tool; he also used it to craft a sense of collective identity for the African American community. Lynching was an act that could unite the black community through sorrow, it was an act that needed to be owned by the black community and used as a symbol to motivate and inspire action.

4. Theories of Art, Patronage, and Audience

A COMMITMENT TO ART: THE EARLY THEORIES OF DU BOIS

W. E. B. Du Bois used the pages of *Crisis* to define a culture for African Americans in which they could take pride and engaged in an extended discussion and debate about the meaning of the art of black Americans and its significance for African American life. The arts, including drama, literature, painting, sculpture, photography, music, and folklore, were central to his program. Here we see both Du Bois's vision for the character of the Negro Renaissance and how art as propaganda could effect change in American society. Du Bois articulated the idea of a black aesthetic, or "a theory of art from the perspective of black Americans."[1] He did not clearly define his theory. As a social scientist, he considered art and literature a catalyst, a means to express new social, political, and economic ideas. Art was a vehicle, a useful tool to achieve change. Although he wanted black artists to be honest about black life, at times he grew concerned that they were overemphasizing the more lurid aspects of life and he urged more positive and culturally conservative views of black life.

Du Bois repeatedly expressed the belief that folk art was the foundation of a distinctive national and racial art. As early as 1911 he hoped for "the slow growth of a new folk drama built around the actual experience of Negro American life."[2] For the better part of his life he used the power of his writing abilities and his position at *The Crisis* to reconcile his double consciousness as a black American with his ideas on the relationship of black folk art to formal or high art. He included an art column in the first issues of *The Crisis*, which listed opportunities, achievements, and events by and for black Americans. Du Bois was impressed and moved by European high culture, but that did not preclude his appreciation of an authentic black folk art.[3]

For Du Bois, it was a struggle to reconcile folk art and high art. Some historians such as Arnold Rampersad note that Du Bois was "no champion of folk expression."[4] Was he a champion of high art? An early advocate of a black aesthetic?[5] Did Du Bois believe that only high art in the European tradition could uplift his people? Or did he think that black artists should draw on an aesthetic that was uniquely theirs, coming from their black heritage, their life experiences? Could Du Bois draw on both his own European background and black folk traditions for creative inspiration and expression?

Du Bois was always grateful that Fisk prepared him for service to his race through excellent teaching, small classes, and "a world among Negroes."[6] Although Fisk's teachers were white—except for William Morris, whom Du Bois considered as good as any of the whites—they were, in Du Bois's estimation, "men and women of character and fanatic devotion. It was a great experience to sit under their voice and influence. It was from that experience that I assumed easily that educated people, in most cases, were going out into life to see how far they could better the world."[7] Another professor, at Harvard, William James, made Du Bois realize the obligation he had as a "cultural aristocrat" to lead his people and helped him define his own position as a cultural leader and member of the Talented Tenth. Du Bois's exposure to and travel in Europe during his years of postgraduate study in Berlin created an interest in "high art" or "high culture." The influence of German philosophy, with its strong emphasis on idealism, on the young scholar was evidenced when he formally dedicated himself to "seek Truth" on his twenty-fifth birthday in Germany and to "take the work that the Unknown lay in my hands and work for the rise of the Negro people, taking for granted that their best development means the best development of the world."[8] That "best development" for Du Bois would certainly include a "school of art." Later he would write: "Whenever a great mass of millions of men have such common memories and experiences, they are bound sooner or later to express them. If allowed enough of intellectual freedom and economic wealth they will in time almost inevitably found a school of art and will in this way contribute to the great artistic wealth of the world."[9]

Bernard Bell has written that "Du Bois's theory of black art defines the role of the black formal artist as transformer of sordid fact and unrestrained folk expression into something more genteel and studied, thereby enhancing its fundamental uniqueness and splendor."[10] Du Bois struggled with the balance between expressing the unvarnished truth about black life and presenting a more "genteel and studied" view of black life. That is why Du Bois criticized Alain Locke for his thesis that beauty alone should be the object of black literature and art and emphatically disdained any art simply for art's sake. When a black artist "[does]

pretty things or things that catch the passing fancy of the really unimportant critics and publishers about him, he will find that he has killed the soul of Beauty in his art." Du Bois acknowledged the importance of beauty, but only if it served the pursuit of truth. He called himself a "humble disciple of art" and "one who tells the truth and exposes evil and seeks with Beauty and for Beauty to set the world right."[11] Du Bois wanted fiction that was "clear, realistic and frank, and yet fiction which shows the possible if not actual triumph of good and true and beautiful things. We do not want stories which picture Negro blood as a crime calling for lynching or suicide. We are quite fed up with filth and defeatism."[12]

Throughout his life, especially as editor of *The Crisis,* Du Bois's cultural elitism was in tension with his appreciation and use of black folk art. Actually, Du Bois demanded less conformity from his visual artists than he did from his writers, even though there were far fewer artists than writers participating in the Harlem Renaissance movement. The subject matter was different than that of literature and may have seemed more straightforward to him.

Du Bois asked his readers in 1925 to determine the difference between art by a Negro and Negro art. He queried "What are the unique characteristics of Negro art?" He praised significant artists such as Henry O. Tanner, Charles W. Chesnutt, and William Stanley Braithwaite, but he also argued that they had not contributed in any significant way to American Negro art. Du Bois maintained that Negro art should dramatize Negro life and portray Negro features and characteristics, "built on the sorrow and strain inherent in American slavery, on the difficulties that sprang from Emancipation, on the feelings of revenge, despair, aspirations, and hatred which arose as the Negro struggled and fought his way upward."[13] Du Bois wanted visuals to aid in the establishment of a past and history that had been lost through the ravages of slavery and racism. He believed that Beauty, Truth, and Right were inseparable in art, a point that

> is brought to us peculiarly when as artist[s] we face our own past as a people. There has come to us . . . a realization of the past, which for long years we have been ashamed, for which we have apologized. We thought nothing could come out of that past which we wanted to remember; which we wanted to hand down to our children. Suddenly, this past is taking on form, color and reality, and in a half shamefaced way we are beginning to be proud of it.[14]

Art would enable the black community to come to terms with its past and be proud of it.

Du Bois believed that all forms of black art should express the needs, feelings, hopes, and frustrations of blacks for blacks so that present and future gen-

erations of youth could better learn to cope. He hoped to develop art for a primarily black audience and inevitably develop a "distinctive racial technique and standard of art." Yet he always kept his educated white audience in mind as well; he cared about how blacks were perceived by whites. In works such as *The Souls of Black Folk* and *The Quest of the Silver Fleece,* Du Bois established that African American formal or high art becomes American and universal by building on the indigenous, authentic base of black folk art.[15]

CRITERIA OF NEGRO ART

In his famous address entitled "Criteria of Negro Art," which he delivered at the Chicago conference of the NAACP in 1926, Du Bois anticipated he might "disturb" his audience by bringing up such a subject. He knew that some of the members at this NAACP meeting would wonder why an organization which was "struggling for the right of black men to be ordinary human beings" would feel it important to bring up the subject of art. Could this be the most important issue when there were so many desperate situations to address? "After all, what have we who are slaves and black to do with Art?" queried Du Bois.[16] But Du Bois explained that a group such as black Americans, who were moving forward and upward, making progress, needed to evaluate where they were going. He asked the NAACP members, "What do we want? What is the thing we are after? Do we want simply to be Americans? . . . We who are dark can see America in a way that white Americans can not. And seeing our country thus, are we satisfied with its present goals and ideals?"[17] Du Bois believed that blacks should have a vision of "really a beautiful world."[18] Beauty was not the acquisition of the material wealth of the white world, he said: "Even as you visualize such ideals you know in your hearts that these are not the things you want."[19] He sought a world where "men create, where they realize themselves and where they enjoy life."[20] He felt that *The Crisis* could awaken beauty in the souls of its readers.

> We black folk may help for we have within us as a race new stirrings; stirrings of the beginning of a new appreciation of joy, of a new desire to create, of a new will to be; as though in this morning of group life we had awakened from some sleep that at once dimly mourns the past and dreams a splendid future; and there has come the conviction that the youth that is here today, the Negro youth, is a different kind of youth. With a new realization of itself, with new determination for all mankind.[21]

Du Bois hoped that beauty could set the world right. "That somehow, somewhere eternal Beauty and perfect Beauty sits above Truth and Right I can conceive, but here and now and in the world in which I work they are for me un-

separated and inseparable."[22] Du Bois said that art just needed to be created. "Art doesn't even care anything about nature. It doesn't even have to be beautiful. It simply has to be."[23] Art could also help the Negro become proud of a past that he was once ashamed of, "taking on form, color and reality." He asked the audience, "Of what is the colored artist capable?" In the past, both races had judged work inferior when it came from a black artist. But Du Bois noted that this was changing. The black artist was gaining respect, and with this respect, the color line was starting to disappear.

Du Bois understood the dilemma of the black artist. If black artists, who struggled so hard for financial support, accepted money from white philanthropists, they might find their ability to portray the truth as they saw it was compromised. Du Bois's hope was that the NAACP would begin to support black artists so that they could create with greater freedom.

This was the dilemma he spoke about, and why he wanted to engage the NAACP in issues of art. Du Bois said, "The ultimate judge has got to be you and you have got to build yourselves up into that wide judgment, that catholicity of temper which is going to enable the artist to have his widest chance for freedom." Through art, some of the prejudices against the black race could be addressed in new ways. It was a new challenge: "The beauty of truth and freedom which shall some day be our heritage and the heritage of all civilized men is not in our hands yet."[24] But Du Bois knew that it was something that could be realized.

Du Bois asserted that if black writers could escape from the prejudiced expectations of white audiences, they could create strong Negro drama. He wrote: "They fail to see the Eternal Beauty that shines through all Truth, and try to portray a world of stilted artificial black folk such as never were on land or sea."[25] Black actors and writers needed the opportunity to examine the full truth of their painful past. Du Bois then decided to pose a series of questions to a select group of black and white literary and intellectual figures. Although he had strong opinions, he seemed to be genuinely asking intellectuals for their views on the dilemmas that black artists faced. Du Bois asked if artists were under any obligation or limitation with regard to which characters they portrayed and how they portrayed those characters. Perhaps reflecting his own class bias, he asked what blacks could do when they were depicted at their worst and judged by the public as such. He questioned the portrayal of blacks by both races as sordid and criminal and wondered if black writers would follow the popular trend to depict the "sordid" in black life instead of the truth. The sordid, according to Du Bois, included sexual misconduct, gambling and abuse of alcohol and drugs.

Du Bois's questions would be repeatedly addressed in the pages of *The Crisis* over several months of 1926 as the responses to Du Bois's questions were

published.[26] White author Carl Van Vechten, a central figure in the Harlem Renaissance who was acquainted with many black artists, noted that "Negroes are sensitive in regard to fiction which attempts to picture the lower strata of the race . . . and heaven knows [they have] reason enough to feel sensitive," as the sensitive black artist would "see propaganda" in the fiction that depicted the lives of working-class blacks.[27] Van Vechten argued that the squalor and vice of Negro life would always be overdone by artists for an excellent reason, because such squalor and vice offered a "wealth of novel, exotic, picturesque material." Why bother with pictures of wealthy, cultured Negroes when these portraits were so uninteresting because they were virtually identical with those of whites? What was interesting about a successful cultured black man? This is not what the white audience craved.[28] The question was: "Are Negro writers going to write about this exotic material while it is still fresh or will they continue to make a free gift of it to white authors, who will exploit it until not a drop of vitality remains?"[29] Van Vechten, of course, made a free gift of such sensationalism with his book *Nigger Heaven,* in which he exploited the idea of the exotic or primitive to its breaking point.[30]

The other reactions to Du Bois's questions ranged across a spectrum of opinion, from those advocating complete artistic freedom and a color-blind standard of judgment to those concerned with the "culture" of the race who wanted any quality of authentic "black" art. The famous white cultural critic and satirist H. L. Mencken suggested that the black author should depict whites at their worst, which he noted Walter White had already done in his coverage of lynching. But he also felt that the artist was under no obligations or limitations whatsoever and that any portrait he created should be reasonably accurate, be it the best or the worst characters of a group. Poet Countee Cullen supported the idea of artistic freedom—"Let the young Negro writer, like any other artist, find his treasure where his heart lies"—but still wanted positive images of all black classes and not a single focus on aberrations.[31] Novelist DuBose Heyward, who was particularly fascinated with the Gullah people of South Carolina, noted that educated Negroes "should and no doubt will soon be producing their own authentic literature." The situation of the educated Negro must be treated "artistically. It destroys itself as soon as it is made a vehicle for propaganda. If it carries a moral or a lesson they should be subordinated to the *artistic* aim." Heyward concluded: "I feel convinced that he alone will produce the ultimate and authentic record of his own people . . . a real subjective literature must spring from the race itself."[32]

Poet Langston Hughes saw merit in writing about the good and the bad, the intelligent and the unintelligent: "[T]he true literary artist is going to write about what he chooses anyway regardless of outside opinions. . . . It is the way

people look at things, not what they look at, that needs to be changed."[33] The NAACP's Joel Spingarn said that literature could contribute to the literature of the world or the culture of a race. He felt that some black writers "should get a hearing, even if their books are comparatively poor. The culture of a race must have a beginning, however simple; and imperfect books are infinitely better than a long era of silence."[34] Walter White noted that upper-class Negroes had through struggle "sharpened their sensitiveness to the intense drama of race life in the United States." He believed that the "Negro writer, just like any other writer, should be allowed to write of whatever interests him whether it be of lower, or middle, or upper class Negro life in America; . . . and should be judged not by the color of the writer's skin but solely by the story he produces."[35]

Writer Julia Peterkin, the Pulitzer Prize–winning white southern author who wrote about plain black farming people, plantation life, and the Gullah people, expressed her views at length on the role of the black artist, stating that she was not a propagandist for or against the Negro. "I believe that the crying need among Negroes is a development in them of racial pride" and that they, and whites, should cease to "estimate their worth according to their success in imitating their white brethren." To Peterkin, blacks were racially different in many essential particulars from their fellow mortals of another color, but this difference did not mean that they lacked "racial qualifications of inestimable value without the free and full development of which a perfected humanity will never be achieved." In one of her more telling comments, Peterkin wrote: "If America has produced a type more worthy of admiration and honor than the 'black Negro Mammy' I fail to have heard of it." Peterkin was aghast that some blacks were against the erection of a monument to "mammy." She stated, "It seems to me that a man who is not proud that he belongs to a race that produced the Negro Mammy of the South is not and can never be either an educated man or a gentleman." She argued that the black artist should "demonstrate that their race has things the white race has not in equal degree and that cannot be duplicated; to magnify these things instead of minimizing them." These tokens of "racial worth" should be utilized in literature by both black and white artists. She ended with, "I write about Negroes because they represent human nature obscured by so little veneer; human nature groping among its instinctive impulses and in an environment which is tragically primitive and often unutterably pathetic."[36]

Although Du Bois sometimes praised Peterkin's work, her commentary provided a perfect example of why he needed to use *The Crisis* to promote the literature, poetry and visual arts produced by black artists. Du Bois wanted African Americans to have their *own* voice in the recollection of their own history. Whites such as Peterkin, no matter how well intentioned, remembered the

Civil War in an entirely different way than blacks. Whites looked back on slavery in the South and recalled the "positive" working environment of the slave, the "teamwork" of landowner and slave, and the relatively "happy state" of the slave. But this was a false and one-sided history and memory. Where Peterkin wanted the "Mammy" commemorated as a positive symbol of black life, black Americans needed to express the reality of their servitude and the profound effects slavery had on the Jim Crow South, a reality that every black person lived with in the early decades of the twentieth century. *The Crisis* needed to be more than a political or social tool for change. It needed to express and provide a venue for the artistic vision of the black race. In this way, it was an tool to educate the public, both the black audience and potential black patrons, and (and this was just as important) the white public or audience, including those like Peterkin and Van Vechten, who, despite their support of the black community and admiration of Du Bois, saw the "exotic" as the best side of the Negro and the side most worthy of artistic expression. Du Bois feared that the wildness that such authors conveyed was not a sincere expression of the artist but an effort to attract readers with stereotypes about blacks and their supposed primitivism.[37]

TRUTH, BEAUTY, AND GOODNESS: ART AS PROPAGANDA

As early as 1896 Du Bois wrote about the need for beauty in life, emphasizing the importance of the full-rounded development of man. In his view, three things in life awakened the human soul: the Good, the True, and the Beautiful. He recognized that mankind could not live without "the Beautiful"; it was part of the heart and the emotions.[38] The first place for such a pursuit was in the home, and this is where *The Crisis* could, eventually, participate in the pursuit of Beauty.

As Du Bois developed *The Crisis,* he continued to theorize on the role and importance of beauty, truth, and goodness. He explained it was the duty of black America to create beauty, which in turn was the embodiment of truth, the one great vehicle of universal understanding, the "highest handmaid of imagination." He recognized that goodness, which included justice, honor, and right, was the one true method of gaining sympathy and human interest. Du Bois saw the need to establish beauty through truth, even if the truth was gritty, harrowing, or upsetting. Du Bois knew that "art expression in the day of slavery had to be very limited . . . but as the Negro rises more and more toward economic freedom he is going on the one hand to say more clearly what he wants to say and do and realize what the ends and methods of expression may be."[39] In other

words, Du Bois believed that art was in fact the embodiment of freedom of expression and that through art, truth could be expressed, creating something beautiful.

Through the inclusion of art and poetry, creative writing, and photography, *The Crisis* could bring beauty into the home. As one of the great ends of life, it was something that an individual could be trained to appreciate. The first great art school, in Du Bois's mind, was nature. If the first great reservoir of beauty was nature, the second was art. A real masterpiece of art was "beautiful in proportion to what it creates, to the emotions it raises in the hearts of its beholders. Art does not imitate nature, but nature imitates art. How can beautiful things be preserved from the 'rust and decay of earthly life'?"[40] Nature preserved itself through continual renewal, helped or hindered by the hand of man. Art was a vital part of education, Du Bois had realized this since his Berlin days. He often suggested that his readers go to the art galleries to sit down and look at a beautiful picture for thirty minutes each week.

Du Bois often emphasized the need for truth in art. He did not want black audiences to shrink at truthful portrayals of themselves. Du Bois knew that African Americans were so accustomed to seeing the truth distorted that when their actual human frailties were depicted, they rebelled. Understandably, the black audience wanted everything told about them to be the best and the highest and noblest. In response to this, Du Bois argued that the black public had a right not to be judged only by their criminals—all peoples had this element—but also they had a right to receive just treatment and to show the best in human character. This was what Du Bois called "justifiable propaganda."[41] The artist should paint his subjects "whole" with the good and the bad. Du Bois feared the black public would shrink from such art, fearing it would be called "racial." "We fear our shortcomings are not merely human, but foreshadowings and threatenings of disaster and failure."[42] The audience and the artist alike had to become more highly trained.

In *The Crisis* of May 1925, he expressed his new editorial policy: "We shall stress Beauty—all Beauty, but especially the beauty of Negro life and character; its music, its dancing, its drawing and painting and the new birth of its literature. The growth which *The Crisis* long since predicted is coming to flower. We shall encourage it in every way . . . keeping all the while a high standard of merit and never stooping to cheap flattery and misspent kindliness."[43] Yet Du Bois also stressed his desire for art as "propaganda," a highly charged word which can be misunderstood out of context.

Simply telling the truth is propaganda, for when Du Bois said, "All art is propaganda, and ever must be, despite the wailing of the purists," he was equating truth and goodness with propaganda. (Du Bois used the word "propaganda"

to mean "a distinct point of view.") Showing good, the importance of a race, is a type of propaganda. Inevitably, that distortion becomes the truth and any other version is labeled propaganda, because the "cultural hegemony" of whites required "that black reality be interpreted to meet the culture's needs and not those of some abstraction called truth," as Keith Byerman notes.[44] Du Bois argued that the white audience wanted a distorted truth and would support no other depiction of black life. "The white public today demands from its artists, literary and pictorial, racial prejudgment which deliberately distorts Truth and Justice, as far as colored races are concerned, and it will pay for no other."[45] Du Bois insisted that showing only one side of black life was a distortion. Showing only the "sordid" side or only the "good" side alone distorted the truth.

Du Bois's beliefs about the role of art as propaganda were complex.[46] Du Bois returned to the idea of truth, pointing out an astonishing reality: "We can afford the Truth. White folk today cannot."[47] White America could not handle the truth about its cruelty and racism, or indeed about any of the negative aspects of white society. White patrons were willing to pay for black art only if it did not disturb their image of that society. That is why black audience and black patrons had to be cultivated.

Du Bois's images of joy and sorrow, the beauty of Africa and the pain of lynching, were both a part of the truth of black life. Slavery crushed African Americans only when they were denied the right to tell the truth or recognize an ideal of justice, when a true African American voice in its own identity and memory had been denied. Here Du Bois used his famous line, "Thus all Art is propaganda and ever must be, despite the wailing of the purists. I stand in utter shamelessness and say that whatever art I have for writing has been used always for propaganda for gaining the right of black folk to love and enjoy. I do not care a damn for any art that is not used for propaganda. But I do care when propaganda is confined to one side while the other is stripped and silent."[48]

Yet white censorship was not the only problem. Du Bois pointed out that the black middle class—his audience the night he gave the speech—also constrained the freedom of black artists. He wrote that "the young and slowly growing black public still wants its prophets almost equally unfree. We are bound by all sorts of customs that have come down as second-hand soul clothes of white patrons. We are ashamed of sex and we lower our eyes when people talk of it. Our religion holds us in superstition."[49] This was the conundrum of the black artist—if he or she accepted patronage from white philanthropists they put artistic freedom at risk. But aside from the small resources *The Crisis* could offer, there was no source of patronage in the African American community. And that community wanted only positive images of itself, fearing that anything negative would support white stereotypes. Du Bois felt that it was urgent

to cultivate a broader sense of the importance of artistic freedom among blacks. He well knew the power of art, and when freedom was constrained, power was constrained.

Du Bois explained in *The Crisis* that art was "one of the greatest expressions of the human soul in all time. . . . Black men invented art as they invented fire. . . . The essence of African culture lies in its art—its realization of beauty in folklore, sculpture, and music. All this Africa has given the modern world, together with its suffering and its woe."[50] Du Bois hoped that his audience would "come into that Birthright which so long we have called Freedom: that is, the right to act in a manner that seems to us beautiful; which makes life worth living and joy the only possible end of life. This is the experience which is Art and planning for this is the highest satisfaction of civilized needs."[51]

Much of the beauty that Du Bois showed on the pages of *The Crisis* was not very beautiful. The images of lynching were beautiful only in their truth, but that was of the utmost importance to him. Du Bois asserted that truth equals beauty equals propaganda. If that propaganda is involved in the fight for freedom and equality, it is worthy propaganda. It is the kind of propaganda that Du Bois meant when he stated: "I do not care a damn for any art that is not propaganda." It expressed the reality of Negro life and struggle, and that would assist the movement in leading to freedom and equality. Many of the pieces Du Bois featured were created to make a moral or political point. They were published as part of the campaign for black rights.

Du Bois stated to his audience that night that the ultimate judge of art "has got to be you and you have got to build yourselves up into that wide judgment, that catholicity of temper which is going to enable the artist to have his widest chance for freedom." He lamented that blacks still allowed their art to be judged by "a white jury." Blacks must "come to the place where the work of art when it appears is reviewed and acclaimed by our own free and unfettered judgment."[52] He argued for a black standard with which to judge art and rejected white standards. Du Bois used Carl Van Vechten's *Nigger Heaven* as an example of a book written by a white man who exploited the friendships of black men; Van Vechten ingratiated himself with black artists and then wrote about their community in a one-dimensional manner. The novel destroyed beauty and truth and left the black man a mere caricature. Van Vechten wished to express a wild, drunken, primitive black life. The black identity he wrote about was one created through white eyes and a white experience.

Du Bois saw the difference between a black man's and a white man's awareness of the Truth of African American life. But he also felt concerned that black authors would not write about the decent, hardworking, morally conventional blacks. Du Bois was in many ways a forerunner of the black arts movement of

the 1960s which celebrated the beauty of "blackness" and was more separatist in nature, because he believed that literature (and visual arts) must serve a function for the good of black people and that its worth should be judged by black people.

TRAINING, THE AUDIENCE, AND ISSUES OF PATRONAGE

Du Bois hoped that he could use *The Crisis* to showcase the unusual ability that existed among African Americans. Some outstanding blacks had been recognized in art, including painters and sculptors. But even elite blacks such as Carter Woodson had limited opportunities. Woodson lived in Washington, which had no theatre for Negroes. Its music was limited. There were art galleries, but in many cases, they refused to exhibit the work of Negro artists. This was the life of a prominent, educated black man in the 1920s in what was a largely black city. The challenges Du Bois faced were obvious. The critics said there were no racial distinctions in art, but Du Bois knew that this was not true. He only had to look at the discrimination African Americans who wished to become artists faced when they applied to the institutions that provided professional training. Lack of training alone was a huge limitation.

Du Bois used the example of a black woman somewhere in New York molding clay alone because there was not a single school of sculpture in that city where she was welcome. So she worked extra hard in the hope that she could get out of this country so she could get some sort of training. He gave other examples of the plight of black artists and summed up his thoughts: "Suppose the only Negro who survived some centuries hence was the Negro painted by white Americans in the novels and essays they have written. What would people in a hundred years say of black Americans?"[53] In effect, Du Bois asked, where would black history, identity, and memory have gone? Du Bois challenged the elite of the NAACP. His magazine could provide the place for expression of a black art aesthetic, for education in the arts (as well as in political and social issues) to unite blacks. It could develop black patronage and a black audience and provide a place where artists could be published and could exhibit. *The Crisis* could be the resource needed for both black artists and a black audience hungry for such material which had been denied them. It was the first national venue for the expression of a black identity, the expression of a suppressed black memory.

The Negro, in Du Bois's estimation, was essentially dramatic. His greatest gift to the world was "a gift of art, of appreciation and realization of beauty."[54] It was the duty of the black artist to "mold and weld this mighty material about us."[55] Du Bois's interest in art extended beyond his editorship at *The Crisis*. He wanted to create a quarterly arts journal as a means of encouraging research

and creative work in literature and art. He hoped that young American Negroes would attain a secure place in modern culture untrammeled by convention. Artists turned to Du Bois for help and support. Sometimes they received it; other times, he refused. Du Bois wanted only the best and the brightest to represent the race, and he felt confident that he could judge who was "the best." In fact, Du Bois would not give his stamp of approval to artists he felt were not worthy of such support. An author asked Du Bois to give sculptor Augusta Savage his support for inclusion in a book, but he replied that she was still in need of training. Du Bois did indeed appoint himself as gatekeeper to the artistic world of the African American community.

Du Bois had long been concerned with what he once called "the colored audience."[56] He hoped for a more sophisticated black audience and noted that theater audiences were often unsure about when to laugh and when to remain silent. He hoped that audiences might eventually become more learned with time. He questioned if this state of affairs was due to ignorance or thoughtlessness or perhaps a combination of both, but he felt that neither could be afforded. Black actors needed to be supported and encouraged with a sophisticated audience. "There is no truer encouragement than an intelligent appreciation," he said in 1916.[57] *The Crisis* could help in this venture by making art accessible to its readership on a regular basis, therefore creating, over time, a more knowledgeable and sophisticated audience. Exposure was the key. In 1920, Du Bois spoke proudly of the covers he had printed by artists such as Richard Brown, William Scott, William Farrow, and Laura Wheeler and the cartoons the magazine had published by Lorenzo Harris and Albert Smith.

Du Bois addressed the issues of patronage several times in his years as editor of *The Crisis*. He noted that everyone understood that an artist needed to live and eat. Yet he also noted that "we are united with a singular unity to starve colored artists."[58] He wrote, "The new and younger Negro poets and novelists are finding a distinct norm and a new set of human problems. They are hindered as yet somewhat by their audiences—their white audience which does not understand, their black audience which wants no art that is not propaganda. Despite this, however, they are pushing and pulling through."[59]

Du Bois did not blame the white public alone for its lack of support of black art. He lamented that "[t]here is a deep feeling among many people and particularly among colored people that art should not be paid for. The feeling is based on an ancient and fine idea of human freedom in the quest of beauty and on a dream that the artist rises and should rise above paltry consideration of dollars and food." This was a delusion, and Du Bois constantly stressed the need for support. Black artists, even more so than whites, were desperate for patrons, and most patrons of the arts were white. Writer Jessie Fauset, one of Du

Bois's most important assistants at *The Crisis* and one of those involved in the selection of visual arts for the magazine, supported the call for black patronage: "But above all colored people must be the buyers of these books for which they clamor. When they buy 50,000 copies of a good novel about colored people by a colored author, publishers will produce books, even those that depict the Negro as an angel on earth. . . . [M]ost best sellers are not born—they're made."[60]

Du Bois made sure that *The Crisis* served as a patron by offering prizes in the visual arts both through its own contests and by promoting other contests, such as those sponsored by the Harmon Foundation. This encouraged the creation of a black aesthetic. In February 1927, Du Bois listed several prizes, including a total of $250 in awards for cartoons. The NAACP's Amy Spingarn also offered prizes for *Crisis* covers. Spingarn stipulated that the drawings "must have some reference to colored people—that is: they must portray colored faces or suggest allusions to the history, art or experience of colored peoples."[61] Along with a select few, including Alain Locke, Du Bois became one of the great patrons of the Harlem Renaissance movement. Du Bois used his patronage to attempt to control what would be included in this movement; he supported some artists, such as Elizabeth Prophet and Richmond Barthé, and excluded others, including the sculptor Augusta Savage and poet Georgia Douglas, neither of whom, he felt, were ready yet to represent the race.[62] Despite his progressive views on women's rights, the self-appointed gatekeeper was a harsh judge of the few black women artists who were creating art.

Du Bois demanded excellence in the submissions for all these prizes. He instructed artists: "Do not however enter carelessly and send us half-finished matter. Take it seriously and do your best. We want to eliminate in this contest the half-interested trifler who sends ill-digested, carelessly written manuscripts and thus distracts needed attention from serious artists."[63] He also stated that "we trust that all entrants will remember that the prizes are the least valuable part of a prize contest. The great object of these contests is to stimulate effort, set a standard of taste and enable persons to discover in themselves capabilities. . . . [T]he renaissance of Negro art is only begun. After the first wild flush of new freedom, we must settle down to laborious, thoughtful, meticulously finished work, built on a real foundation of knowledge and taste. This is the object of *The Crisis* prizes."[64]

Artists had been denied opportunities to create, and this was a place where *The Crisis* could help. Du Bois again noted Tanner's role as a leader in the visual arts, calling him the "dean of American artists in Paris."[65] "Naturally, the full day of the Negro artist has not dawned, he is still too near his problem: his experience is too poignant, his life too tragic, his poverty too real, to leave him the

leisure and detachment which the artist demands. But there can be no doubt of the great natural gift, the emotional worth, and the marvelous experience which lies in this group, ready for the touch of the master hand."[66] He noted that the Negro's contribution to American art, including painting and sculpture, was perhaps even greater than his contribution to the growth of the nation as a laborer.[67] Henry O. Tanner, he noted, had won the French Legion of Honor. He reminded readers of *The Los Angeles Times* that in the mid-1920s, one colored artist had received three prizes at a Chicago Art Exhibition and fifty-six colored artists had received distinction in another.[68] Negro children were winning prizes, scholarships, and fellowships as well. All of this was part of the uplift of the Negro race. France had rediscovered African art and based a "new school of art upon it."[69] It was time for black America to recognize an artistic heritage of their own.

Du Bois used sculptor Meta Warrick Fuller as an example of an artist who had recently created a beautiful piece of work for a "great social movement," even though she was not paid for her work. Likewise sculptor May Howard Jackson did not receive adequate compensation for her portrait busts, nor did William Scott, whose painting, Du Bois felt, "is one of the finest things the Negro race has produced in America."[70] Through *The Crisis*, Du Bois could find, however small, some level of support for black artists, and the magazine made art a part of daily life. Du Bois understood that lack of patronage was one of the most crippling issues of the Harlem Renaissance. He worked hard to scout out and publicize opportunities for artists through philanthropic foundations. He wrote, "If the work is honorable, then pay is honorable, and what we should be afraid of is not overpaying the artist; it is underpaying and starving and killing him."[71]

When he announced the annual competition in literature and in art in the April 1927 issue, Du Bois reminded his readers of the impressive black heritage revealed in the fine arts of Ethiopia, Egypt, and the rest of Africa.[72] Du Bois praised James Weldon Johnson's *God's Trombones* for the preservation of the Negro idiom in art and for his beautiful poetry and he praised artist Aaron Douglas's wild, beautiful, unconventional, and daring drawings which were stylized to emphasize Negroid rather than Caucasian features of black figures.[73] Du Bois's position was that "the Negro artist must have freedom to wander where he will, portray what he will, interpret whatever he may see according to the great canons of beauty which the world through long experience he has laid down."[74]

Du Bois's ideas about art were complex. Although in his famous speech "Criteria of Negro Art" he argued all art was propaganda, he also wanted artists to be free to create as they saw fit. He insisted that the black community needed

to create its own standard by which to measure, judge, and appreciate art. His own preference for high art, shaped by his position in the Talented Tenth and his time in Europe, made it difficult for him to appreciate some forms of folk art. Yet he still promoted black folk art as one form of an authentic black voice that would contribute to the community's sense of identity. Art could be a tool of empowerment, a way to combat racism and discrimination.

5. Images of Africa and the Diaspora

A DEDICATION TO AFRICA

From the first days of its publication, *The Crisis* included striking images, essays, and political commentary about Africa, reflecting Du Bois's lifelong drive to reconnect American blacks to the continent and its widely dispersed people. Du Bois supported the pan-Africanist movement and paid careful attention to the culture of Africa. Pan-Africanism emphasized a shared identity between blacks in the diaspora and Africans, an interest in mutual experience and collective action. But the activities of pan-Africanists often revealed their cultural alienation from Africa and a limited understanding of the continent.[1] Du Bois realized that it was impossible for black Americans to have emerged out of slavery with their African connection intact. He recognized their dual historical and cultural experience.[2] By including essays and editorials on the major issues involving Africa and supporting them with visual images, Du Bois hoped to create and strengthen a sense of identity with contemporary Africa for his readers and to help them learn about their roots in the historically rich civilizations of Africa.

Du Bois hoped the power of images that represented moral, intellectual, and emotional symbols of Africa would become a part of his readers' visual vocabulary, increasing their personal connection with Africa and their interest in the events and circumstances relevant to African life. The greater frequency and sophistication of these visuals over time is obvious: the visuals also reflect the growth of interest among readers for these images of Africa and the slow cultivation of a group identity and even a sense of group memory of things "African." Africa provided a positive counterpoint to the terror of lynching and was tied to Du Bois's own internationalist vision of black Americans as not only black and American but also African. Many black Americans, perhaps most, felt little connection to Africa—the long years of slavery had ended that eth-

nic connection. As a result, black Americans shared a racial rather than eth-
nic identity. Their connection was one of the color line. Du Bois asserted that
American blacks could not turn their back on either their American exper-
iences or their African heritage. Both were intimately linked to a collective
identity.[3]

Black leaders before Du Bois had also embraced pan-African interests. In
the mid-nineteenth century, abolitionist Martin Delany had advocated a return
to Africa and the development of a black and African nationality. Black nation-
alist Henry Turner echoed this concept of a return to Africa, while activist-
priest Alexander Crummell embraced a pan-African Christian community.[4] All
three men saw the positive elements of Africa, but their statements were often
qualified by their belief that Africa was primitive and decadent. Both Turner
and Crummell considered slavery to be a means to bring civilization quickly to
blacks, whom they thought could learn from the culture of their masters. These
black leaders were trapped between their ultimate realization that they were
more comfortable with Euro-American culture and values than with African
culture and values and the fact that whites denied them full participation in
American society because of contempt for their African ancestry.[5]

The history of pan-Africanism is mired in contradictions and illuminates
the complex issues that identifying with Africa raised. Black American leaders
did not agree on their assessments of African peoples and culture. Some black
leaders shared the views of whites that Africa lacked history, forms of govern-
ment, and intellectual life. Others, such as Marcus Garvey, advocated that
American blacks return to Africa, seeing it as a promised land of escape from
white racism and oppression. Du Bois saw Africa as a spiritual and cultural
starting point, although he also recognized the gap that had developed between
American blacks and Africa. In the early twentieth century, Du Bois supported
the intellectual study of the historical wealth, heritage, and contributions of
blacks in Africa and abroad, as did men such as Carter G. Woodson and mem-
bers of the New Negro history movement.[6]

It was difficult to keep black American interest in pan-Africanism alive.
"American Negroes," Du Bois complained "were not interested." The resistance
that Du Bois encountered is a complex phenomena. During the 1920s even
white America was retreating inward after the exertions of the war effort. Im-
migration was restricted in 1924, and Americanization was emphasized in
schools and public forums at the expense of ethnic ties. For black Americans,
whose ties to Africa had been severed so long ago, the attempt to reconnect with
an African past required a much more profound and conscious act of imagina-
tion. Du Bois was discouraged, but he also recognized he was planting seeds
that might flower at a later time.[7]

At Fisk, Du Bois had been surrounded by a spectacular collection of African art. Fisk acquired its first African art holdings in the early 1870s, when faculty and staff serving as missionaries in Africa sent back art and artifacts to the university. This had an effect on Du Bois's growing appreciation of African culture. Du Bois acknowledged the role his time at Fisk had on his racial identity. "So I came to a region where the world was split into white and black halves, and where the darker half was held back by race prejudice and legal bonds, as well as by deep ignorance and dire poverty. But facing this was not a lost group, Fisk was a microcosm of a world and a civilization in potentiality. Into this world I leapt with enthusiasm. A new loyalty and allegiance replaced my Americanism: hence-forward I was a Negro."[8] Over time, Du Bois came to see American racial injustice as a global problem which involved all peoples of the diaspora.

When Du Bois delivered the Harvard University commencement address in 1890, he told his audience that they had a collective responsibility for the effects of slavery and racism. He completed his dissertation on the suppression of the African slave trade at Harvard in 1896. While the dissertation was primarily a legalistic discussion of efforts to end slavery, he ended on a moral tone that stressed the importance of accepting responsibility for slavery rather than dismissing it as a plague sent from God or justifying the actions of the founding fathers. He urged that the nation "face the fact that this problem arose principally from the cupidity and carelessness of our ancestors."[9] Most likely his dissertation research involved images of Africans that appeared on slave market posters and notices of runaway slaves. These demeaning images were visual evidence of a stolen past, a history and memory taken by whites. Du Bois knew the power of images in expressing the joys and sorrows of African peoples; with Africa he chose to emphasize the joys.

The work of anthropologist Franz Boas intensified Du Bois's interest in Africa. Du Bois had already shown an interest in the pan-African movement with his attendance at the first Pan-African Congress in London in 1900. In 1906, Du Bois invited Boas to speak at Atlanta University. Boas discussed the greatness of African culture and urged his audience to reclaim their African heritage. He told the group: "Say that you have set out to recover for the colored people the strength that was their own before they set foot on the shores of this continent."[10] Du Bois later recalled the significance of the Boas visit: "Franz Boas came to Atlanta University where I was teaching history in 1906 and said to a graduating class: You need not be ashamed of your African past; and then he recounted the history of black kingdoms south of the Sahara for a thousand years. I was too astonished to speak. All of this I had never heard and I came then and afterwards to realize how the silence and neglect of science can let truth utterly

disappear or even be unconsciously distorted."[11] Du Bois would continue his association with Boas; historian George Hutchinson notes that he served as "virtually the house anthropologist for *The Crisis* magazine, and greatly influenced Du Bois's ideas on race."[12] Boas also spoke at the first Pan-African Congress and was Du Bois's ally in trying to generate an anti-racist movement among social scientists.[13] Under the influence of Boas, Du Bois began to see history differently; his narrative of western civilization changed with his new emphasis on connections to Africa. He hoped to reconstruct the past and create a different future.[14] He recognized the one-sidedness of the continuing practice of white supremacy in the study of western civilization.

Du Bois began to see, more and more, the global aspects of black suffering, the international elements of slavery, and the fact that slavery was tied to the development of modernity in the United States. He began to see the connections between African Americans with their fellow Africans in Europe and still in Africa—the Black Atlantic. His view of the diaspora became much more global and transnationalist. African Americans were tied to the entire diaspora of their people in the new world.[15]

In 1903, Du Bois was already recognizing the global aspects of a post-slavery population. He wrote about this extensively in *Dusk of Dawn*, where he described Africa as his fatherland that connected all people of color:

> As I face Africa, I ask myself: what is it between us that constitutes a tie that I can feel better than I can explain? Africa is of course, my fatherland. Yet neither my father nor my father's father ever saw Africa or knew its meaning or cared overmuch for it. My mother's folk were closer and yet their direct connection, in culture and race, became tenuous; still my tie to Africa is strong. . . . [T]he mark of their heritage is upon me in color and hair. . . . [O]ne thing is sure and that is the fact that since the fifteenth century these ancestors of mine have had a common history, have suffered a common disaster, and have one long memory. . . . [T]he badge of colour [is] relatively unimportant save as a badge the real essence of this kinship is it social heritage of slavery; the discrimination and insult; and this heritage binds together not simply the children of Africa, but extends through yellow Asia and into the South Seas. It is this unity that draws me to Africa.[16]

Du Bois connected the suffering of black Americans with people of nonwhite descent everywhere, acknowledging the common enemy of discrimination and insult.

On the pages of *The Crisis,* Du Bois hoped to provide his readers with the visuals and written word to connect them more intimately with the national community in the United States, to make them aware of the issues of the day, to make them full participating citizens. Visual symbols of Africa could provide

insight into African culture and help create a collective identity for American people of African descent, a connection to each other that other ethnic groups in America had. The accomplishments of peoples of African descent had long been ignored. Du Bois planned to fight the tide of the "certain suppressions in the historical record current in our day . . . the habit, long fostered, of forgetting and detracting from the thought and acts of the people of Africa."[17] He hoped that the promises made by white society to black readers, both political and legal, would be kept. When it became obvious that these promises would not be kept, that political and educational opportunities would not improve, and he had fully recognized the "essentially illusory character" of the national community in the United States, other types of connections became more important. These included local connections and, more important, international connections, especially to Africa. The long overdue chance to be fully American led to a desire for greater global connections.[18]

AFRICA: THE IMAGES AND THEMES

What visual icons or symbols could Du Bois use to represent Africa? The appeal of Egypt was obvious, and previous black leaders had used it. (Frederick Douglass had visited Egypt in the late 1880s.) Egypt provided evidence of a great civilization, a black civilization which flourished before the time of slavery. It showed that civilization did not emanate from Greece; the path of civilization could be traced to Africa.[19] Du Bois asserted in *Black Folk: Then and Now—An Essay in the History and Sociology of the Negro Race* (1939) that northern European scholars had slowly forced upon the study of the interaction of Greece and Africa "a racist paradigm elevating Aryan culture as the source of ancient civilization."[20] He wrote, "All history, all science was changed to fit this new condition. . . . Wherever there was history in Africa or civilization, it was of white origins and the fact that it was civilization proved it was white."[21] Africa—via Egypt—was the key and could be seen as the home of western civilization.[22] Du Bois became a revisionist historian and used images to drive home this point.

Du Bois embraced the concept of the Black Athena as part of his larger mission to shape a black identity whose origins were the triumph and civilization of Egypt rather than the barbarism of slavery. In recent years, Martin Bernal has written extensively on the controversial notion that the Greek goddess Athena had black or African origins. Bernal, a linguist, found that classical Greek shared so many common words with Semitic languages that there had to have been a more substantial relationship between the Semitic peoples and

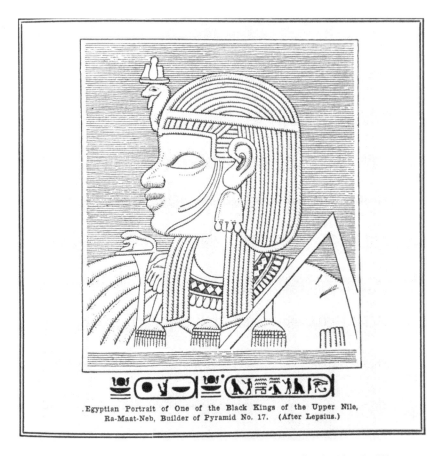

.Egyptian Portrait of One of the Black Kings of the Upper Nile,
Ra-Maat-Neb, Builder of Pyramid No. 17. (After Lepsius.)

Figure 46. "Egyptian Portrait of One of the Black Kings of the Upper Nile, Ra-Maat-Neb." Reprinted from *The Crisis*, March 1911, cover.

Greek culture. Bernal theorized that Greeks must have either had direct connection with the Canaanite people early in their history or they were actually descended from a Canaanite people. He concludes in *Black Athena* that more than one-quarter of the Greek language comes straight from Semitic roots, up to half came from Indo-European roots, and the final part of the language from Egyptian. Bernal concluded that Greek culture was ultimately African or Semitic.[23] Bernal's research is of quite recent origins, yet Du Bois believed in the African origins of western civilization in the early part of the twentieth century and used *The Crisis* to convey this view.

THE GLORY OF EGYPT/EGYPT IN AFRICA

Du Bois used images of Egyptian art with rich possibilities for the symbolism of Africa. The first African image appeared in *The Crisis* in March 1911, an unsigned drawing of "Ra-Maat-Neb" after Karl Richard Lepsius, a nineteenth-century German scholar who founded the study of Egyptology at the University of Berlin. The caption read "Egyptian Portrait of One of the Black Kings of the Upper Nile, Ra-Maat-Neb, Builder of Pyramid No. 17." The drawing (fig. 46) is a simple profile of the king in full ceremonial garb. It is a typical pharaonic portrait; the king appears to wear a nemes headdress. The top of the headdress features the uraeus rearing cobra, a symbol of sovereignty. The cobra appears in an upright position spitting fire to protect the king. The triangle in the right hand of the composition is most likely a misunderstanding of the scepter, or crook, and flail, which was often held by the pharaohs crossed against their chest. The scepter is an early symbol of authority; the crook, of rule. The king wears a beaded collar, a typical indication of wealth and power. His earring is an atypical shape.

The artist has taken some liberties with Lepsius's sketch. Most notable is the break with two-dimensional Egyptian style in the facial features. The artist who copied Lepsius's original drawing has given the nose and lips a fuller look and they are the only shadowed or modeled features on the king's face, which gives them three dimensions. The connection of Egypt to Africa was emphasized for readers of *The Crisis* regularly. The artist wanted to emphasize the African features of the king and connect him to the entire continent. Although Boas focused his own work on sub-Saharan Africa, much more was known about Egyptian art and culture than was known about sub-Saharan art and culture. Because Europeans had appropriated ancient Egyptian civilization as part of their heritage, they already recognized it as "high culture," which fit into Du Bois's idea of what African American culture should strive for.

The attempt to reconnect historical Africa with contemporary blacks was also furthered by the discovery of Tutankhamen's tomb in 1922. As Americans became fascinated with Egypt, Du Bois reiterated the tie between Egypt and African Americans. A pyramid, a sphinx, or an Egyptian king were a large part of the visual vocabulary of Africa, a language familiar to readers of *The Crisis*. The March issue included Du Bois's essay on "African Civilization," which outlined the rich discoveries made by archaeologists and explained the connection between Africa and Egypt:

> There existed, of course, until quite recent times a high civilization among the
> blacks of the upper Nile. . . . How far Egypt took its civilization from the black

Royal black Nubians sacrificing after Victory. (The victory is recorded in hieroglyphics below.) (After Lepsius.)

Figure 47. "Royal Black Nubians…." Reprinted from *The Crisis*, March 1922, p. 25.

empire and how far the two cultures originated simultaneously, from a common source, will not be decided until all the ruins have been unearthed and their records read, but it looks as if old theories were turning upside down, as if the black nations of certain regions of Africa were not races in their infancy, but the descendants of powerful civilizations broken by the slave trade and by misfortune in successive wars. . . . The Egyptians always said that their forefathers learned their arts and largely received their laws from the black people further south.[24]

The article also noted that a civilization had been found in Crete that dated to 3000 B.C., where evidence of black priestesses were found in Crete's frescoes. He concluded that there were two great early civilizations, that of the Nile, begun and largely maintained by black men, and that in Crete. A visual was included in the article, "Royal Black Nubians Sacrificing after Victory" (fig. 47).[25] The image is a traditional black-and-white Egyptian illustration, a frieze meant to represent a sculptural relief. Figures cross the top of the arched composition in strict profile or with their torsos parallel to the picture plane. Cartouches identify the figures above, bands of hieroglyphics tell their stories below. Below the image is the explanation: "The victory is recorded in hiero-

glyphics below. After Lepsius." At the top of the composition, a bird, the symbol of Amun-Ra, which consists of a solar disk and wings, reaches out over the scene. It appears to be a scene of the pharaoh and his family (the four figures on the right) worshiping gods on the left, which probably include Osiris and Amun-Ra, the creator god. Some of the headpieces and footwear are rather unusual.

Jessie Fauset, who was part of the intellectual team that worked with Du Bois, offered a lengthy article on "Nationalism and Egypt" in the April 1920 *Crisis* accompanied by two images, a wall painting, "In Ancient Egypt," and a photograph, "In Modern Egypt." Fauset provided a history of Egypt's struggle for autonomy and self-government and noted that this was nothing new; the struggle had "lain smouldering on the hearthstones of Egypt for nearly forty years."[26] The visuals encouraged the reader to investigate and reminded readers that this was *their* heritage.

The cover of the January 1921 issue featured a statue entitled "Africa" from the group at the New York Custom House, again emphasizing the strong connection of Egypt to Africa (fig. 48). It showed a somewhat defeated figure, clad from the waist down, her breasts exposed in the Hellenistic tradition. An arm rests on the head of a sphinx. The classical connotations are strong. The figure appears to be forlorn and exhausted but still holds herself up with the aid of the sphinx. Despite her fatigue she is strong (her musculature is emphasized), and her feet are planted firmly on the ground, holding her steady. Even though her head hangs down and her eyes are closed, the forceful, steady, firm profile of the sphinx remains undaunted. In this context, the image of the sphinx is the symbol of the long history of Africa that suggests that Africa will finally overcome any adversity. The connotations are clear: "Africa" may be tired from the battle, but she has not lost. Her prototype is most likely from neoclassical sculpture of the late eighteenth and early nineteenth centuries, following sculptors such as Frances Chantrey. Her face also resembles Michelangelo's *Pieta* of 1498. There are earlier prototypes, such as one at the Villa Piazza Marina in Sicily, which features a fourth-century mosaic that includes a personification of Africa, who is also half-clad.

Laura Wheeler, a frequent contributing artist to *The Crisis*, often created black-and-white drawings of African peoples for Du Bois. The April 1923 cover, "Egypt-Spring," features a young woman who is clad from the waist down, her breasts hidden by her arms, playing a harp-like instrument (fig. 49). The instrument is also a piece of sculpture; the base forms the head of a figure. Signs of spring—trees, birds, and flowers—line the composition. Harpists were common in Egyptian tomb painting of the New Kingdom, especially in banquet scenes for entertainment. The figure's face, turned toward the viewer at an

Figure 48. "Africa," from New York Customs House. Reprinted from *The Crisis*, January 1921, cover.

Figure 49. "Egypt-Spring," by Laura Wheeler. Reprinted from *The Crisis*, April 1923, cover.

angle, is not Egyptian, not parallel to the picture plane. She appears to be a con-temporary figure, and her attire is not Egyptian. The sparrows which scatter across the composition are also not Egyptian, nor is the art nouveau weeping willow which dangles above her head. The base of the harp shows a bust which wears the red crown, or deshret, of Lower Egypt. A blue lotus forms the base of the neck of the harp, which was typical in Egyptian iconography. The fragrant lotus was a typical accoutrement in the king's palace. An Egyptian-inspired deco border circles the composition. Wheeler combines various forms of Afri-can art with contemporary decorative European elements.

EGYPTIAN ART AND AFRICAN AMERICAN ARTISTS

As the Harlem Renaissance began in the mid-1920s, Du Bois's interest in seeing more artistic renderings of African themes came to fruition. The Renais-sance began at the same time as the discovery of Tutankhamen's tomb, and its artists frequently employed Egyptian iconography. The first Aaron Douglas il-lustration to be included in *The Crisis* was his "Invincible Music: The Spirit of Africa" (fig. 50),[27] a drawing specifically made for the magazine even though it was not accompanied by any text relating to the work and did not illustrate any articles. The drawing consists of one figure in silhouette, his head raised in song to the sky, his right arm holding a mallet that he uses to beat a large drum. He is in a crouching position and is clad only with a simple wrap around his waist. His position, with his shoulders parallel to the picture plane rather than reced-ing into space in correct perspective, as well as his hair and the entire profile or silhouette of his body resemble those of Egyptian art. His hair seems to be a cross between an Egyptian nemes headdress and patterned hair. Two shield-like marquis shapes are implanted in the ground behind the figure with a jagged de-sign on them that resembles African-inspired patterning. The shapes represent plant life, as do three smaller versions which look like leaves and are placed in front of the figure. The top of the drawing includes two large, jagged shapes that represent forms of energy, perhaps the sun or stars, as well as a stylized stream of smoke on the right. The bottom of the drawing includes flat papyrus plants (that resemble tulips) which appear to be inspired by the art deco movement.[28] The drawing is successful because it is very simple; its large expanses of solid black and bright white background are highlighted by grayish outlines and de-tails. The silhouette format makes it particularly forceful.

The ancient Egyptians followed the most basic rule of stylizing the body. The figure was painted as if it were being observed from several different view-points. The face was seen in profile, but the one eye shown looked straight ahead. The shoulders were shown from the front and the breast in profile, while

Figure 50. "Invincible Music: The Spirit of Africa," by Aaron Douglas. Reprinted from *The Crisis*, February 1926, p. 169.

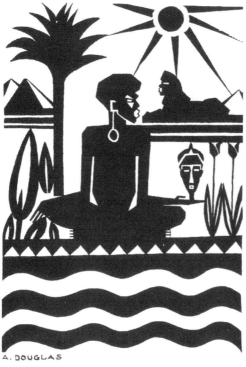

Figure 51. Poster of the Krigwa Players Little Negro Theatre of Harlem, by Aaron Douglas. Reprinted from *The Crisis*, May 1926, p. 19.

the hips were seen from a three-quarter view. The legs were depicted in profile. Douglas acknowledged his debt to Egypt: "There is one thing that I can pin down. I used the Egyptian form."[29]

Aaron Douglas's second illustration for *The Crisis* appeared in the May 1926 issue. Du Bois printed the "Poster of the Krigwa Players Little Negro Theatre of Harlem" in the issue, not attached to any particular play but rather as a type of advertisement for Du Bois's pet theatre project (fig. 51). This illustration is much more heavily influenced by Egyptian and African imagery than many of Douglas's early works. It is again in solid black and white, very boldly executed, almost resembling a woodblock print. The poster shows a single figure sitting in a cross-legged position with his or her face turned to the side in profile. The figure is very angular, a primarily rectilinear form, with exaggerated thick lips, the appearance of tribal makeup in geometric form, an Afro hairstyle, and a large hoop earring dangling from the only visible ear. Stylized plants and flowers, resembling both African motifs and art deco patterning, surround the figure, as does a palm tree.[30] The figure's left hand holds an African mask or ancestral head. Above the figure the influence of Egypt is everywhere: pyramids on the left, a sun form above, and a sphinx on the right. Wave patterns form the bottom third of the composition, perhaps representing the Nile. The obvious inspiration is Africa; regardless of the degree to which it was based on actual African imagery, the viewer can see the connections immediately. The hard-edged, woodblock-influenced style is bold and forceful.

Douglas provided the September 1927 cover, "The Burden of Black Womanhood" (fig. 52). This composition includes the figure of a woman in a long Egyptian-influenced garment. We see a side view of her hips and a silhouette of the front of her body. She holds up a round shape, "The World." She looks up, with face in profile and slit eyes that resemble African masks of the Ivory Coast, a style frequently employed by Douglas. Her lined hair recalls the headdress of the nemes. A cityscape is included below, resembling art deco drawings of skyscrapers, with the billowing smoke of industry behind it. One simple cabin, perhaps representing her humble beginnings, is on the far right. On the left, we see three pyramids and a palm tree, perhaps indicating her origins. Papyrus blossoms in outline, with a deco handling, are scattered in the composition. The woman bears the burdens of the world; the image appealed directly to the female audience of *The Crisis*.

Aaron Douglas offered his version of Africa on other *The Crisis* covers, including one with two angular, cubist-inspired hands that are opening up, revealing a powerful, jagged pyramid, with the Nile floating below and a star above. The caption reads "Princes shall come out of Egypt; Ethiopia shall soon stretch out her hand unto god." Douglas visualized Africa with Tutankhamen

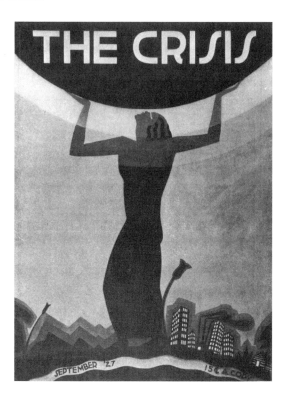

Figure 52. ""The Burden of Black Womanhood," by Aaron Douglas. Reprinted from *The Crisis,* September 1927, cover.

for the September 1928 cover, showing the outer sarcophagus of Tut. Tut had become particularly popular after his tomb was discovered in 1922.

Several other artists turned to Egyptian art for inspiration. Joyce Carrington's September 1928 cover shows a woman in an African setting, complete with palm tree, pyramid, and African necklace. She also sports a very 1920s hairstyle and what appears to be a string of beads, typical for a flapper's attire (fig. 53). She is a symbol of modern Africa, a universal woman of the diaspora. Her 1920s contemporary styling makes her accessible and familiar to readers of *The Crisis.*

Under Douglas's direction, Roscoe C. Wright offered "Negro Womanhood" as a tribute to the strength and power of black women (fig. 54). This piece is influenced by the Douglas piece above but has its own style as well. The figure of a woman reaches her hands heavenward; concentric lines of energy emanate from her body. She breaks free from the shackles of slavery. Orphist-inspired rays of light and circles form the modernist background of this composition.[31]

Figure 53. Untitled drawing of a modern African woman, by Joyce S. Carrington. Reprinted from *The Crisis*, September 1928, cover.

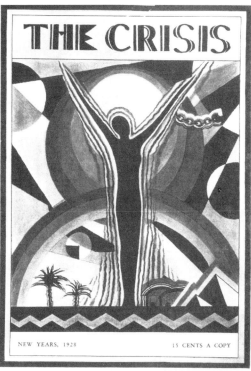

THE CRISIS

NEW YEARS, 1928 15 CENTS A COPY

Figure 54. "Negro Womanhood," by Roscoe C. Wright. Reprinted from *The Crisis*, January 1928, cover.

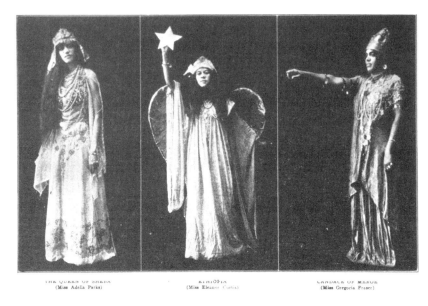

THE QUEEN OF SHEBA
(Miss Adelia Parks)

ETHIOPIA
(Miss Eleanor Curtis)

CANDACE OF MEROE
(Miss Gregoria Fraser)

Figure 55. Photos from the pageant *The Star of Ethiopia.* Reprinted from *The Crisis,* December 1915, p. 90.

Palm trees and pyramids flank her on left and right as symbols of Africa. She is in silhouette with no facial features, yet the uplifting quality of the piece is clear. A jagged line below represents the great flowing river of the Nile. The piece, in the tradition of Du Bois and Douglas, is both pan-Africanist and feminist.

ETHIOPIA

The nation of Ethiopia also figured prominently in Du Bois's understanding of Africa. An independent African black nation, Ethiopia defeated Italy at Adowa in 1896, marking the first time a nonwhite nation defeated a European nation. This success in staving off colonization was an important part of Du Bois's idea of a contemporary Africa. Du Bois was well aware of the rich artistic and political traditions of Ethiopia and noted in a March 1921 *Crisis* editorial that "[s]even hundred and fifty years before Christ the Negroes were rulers of Ethiopia and conquerors of Egypt."

The cover of December 1915 included a poster for the *Star of Ethiopia* pageant, an artistic and musical production which included hundreds of participants (fig. 55). The pageant portrayed the history of the "colored race from the time men were equal in the stone age, through the glories of the Ethiopian em-

pire, through slavery and freedom, and up to its present development in science, art and education."[32] The article that described the event referred to the African American contributions of rhythm, ragtime, and the banjo, among other artistic achievements. Photographs of pageant participants, including three attractive young women in full costume, enticed the reader to investigate the event.

The pageant was part of a exposition organized in New York by Du Bois and other leaders that was dedicated to illuminating the achievements in "Negro progress." The exposition consisted of fifteen different divisions of Negro life and labor and included a representation of the arts that emphasized Egyptian wall paintings and obelisks. *Star of Ethiopia* was written and directed by Du Bois and was performed four times during the exposition. It included six episodes of African and American history, including the "Gift of Iron" from prehistoric Africa and the "Gift of the Nile" from Egyptian civilization, slavery in America, spirituals, and the struggle for freedom. Du Bois also staged the pageant in Washington, D.C., and Philadelphia.[33]

Du Bois highlighted those few African states which had preserved the dignity of independence. The November 1917 issue included a fine drawing by John Henry Adams, formerly of the *Negro Voice,* of the "Empress Taitou, Widow of the Late Menelik II, Emperor of Abyssinia, and Mother of the Present Empress Ouizeros Zeoditu" (fig. 56). This image was intended to serve as a source of education and racial pride for the readers of *The Crisis.*[34]

THE DIVERSITY OF AFRICA

Although Africa encompassed many different cultures, Du Bois wanted to connect readers to the entire continent. This included North African and Islamic regions which also suffered under colonialism and foreign rule. The December 1924 cover features a "North African Warrior of the 15th Century," a photograph of a costumed man, proud and strong, in armor, holding a weapon in his right hand, looking off to the side (fig. 57). The unsigned photo is another reminder to the readership of the long history of Africa and the desire to claim all the continent of Africa, including its Arab North, as part of the heritage of American blacks. It is a rare cover for December; there is no religious content. Inside the issue, a history of Egypt and Abyssinia was offered by Kantiba Nerouy, who noted that the people of this region have "as much if not more Negro blood than American Negroes."[35] A map and Egyptian-inspired drawings were included.

When *The Crisis* offered lengthy discussions on Africa, either historical or political in nature, Du Bois often included visuals to accompany the text. Jessie Fauset wrote about "Dark Algiers the White" in the April 1925 issue. The essay

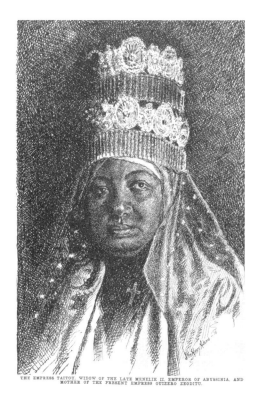

THE EMPRESS TAITOU, WIDOW OF THE LATE MENELIK II, EMPEROR OF ABYSSINIA, AND MOTHER OF THE PRESENT EMPRESS OUIZERO ZEODITU.

Figure 56. Empress Taitou, by John Henry Adams. Reprinted from *The Crisis*, November 1917, p. 25.

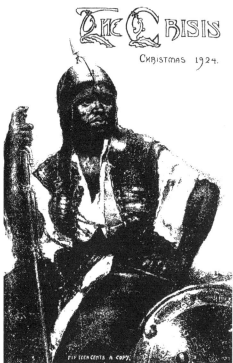

Figure 57. "North African Warrior of the 15th Century." Reprinted from *The Crisis*, December 1924, cover.

was accompanied by Laura Wheeler's drawings including one of men and women on the streets of Algiers in traditional costume, placed directly into the text which discussed the life and culture of the country. This issue had many different essays on Africa, as well as one on "Arabia." Another deco-inspired African cover by Waring appeared in September 1924, "The Strength of Africa" (fig. 58). It shows a muscular (Nubian?) man with an Egyptian-inspired headpiece, the nemes headdress of a pharaoh, yet he appears to be acting as a servant or attendant in this piece. He sports ankle bracelets, carrying the wrap of the woman he attends and covering and protecting her with his large peacock-feather fan or shade. Peacock feathers were not typically used in Egypt. His garment is not Egyptian. He follows behind her as she takes her lion for a walk, an unusual scene that is not Egyptian in origin. Laura Wheeler developed her own visual vocabulary for her composition. The woman's headdress seems derived from that of an Egyptian queen. It is vague in derivation and appears to draw its symbolism from more than one goddess. It is a vulture headdress; the vulture "sits" on her head, the wings extended. There is an exotic, almost performance element to the cover; it features a sense of pageantry and might be described as Las Vegas in contemporary terms. The wrap on her body and the diaphanous wrap which emanates from her *bustier*-styled top are not typically Egyptian. The lion is in complete silhouette; she is in profile, with a wrap on her lower body, a see-though wrap on her upper body, and a decorative headpiece in her hair. A rather exotic *bustier* covers her breasts. She too wears ankle bracelets. She again represents an exotic, primitive, decadent style; she is clearly someone of importance, perhaps royalty. The title "The Strength of Africa" forms the base of the composition and appears to be hand-lettered.

The Crisis also announced visiting African dignitaries, including the embassy from "Her Majesty Zauditu, Queen of the Kings of Ethiopia and Empress of Abyssinia."[36] *The Crisis* noted that the delegation was refused service at the National Democratic Club and the Republican Club in New York City but was received by President Wilson at the White House and by the president of France and king and queen of England. *The Crisis* included photographs of the delegation in full regalia.

In the 1920s, *The Crisis* reflected a heightened interest in Africa. Almost every month a photograph of African royalty or African dignitaries, children, or military people, was included in its pages, often accompanied by text, essays, editorials, poetry, and African folk tales. Du Bois sought to convince African Americans that their heritage had a royalty and aristocracy to rival anything from Europe. The cover of the November 1921, "Science," offered a photograph of a piece of heavily Egyptian-influenced sculpture. The caption inside reads, "Figure of Africa Typifying 'Science' in the *Palais Mondial,* Brussels, Where the

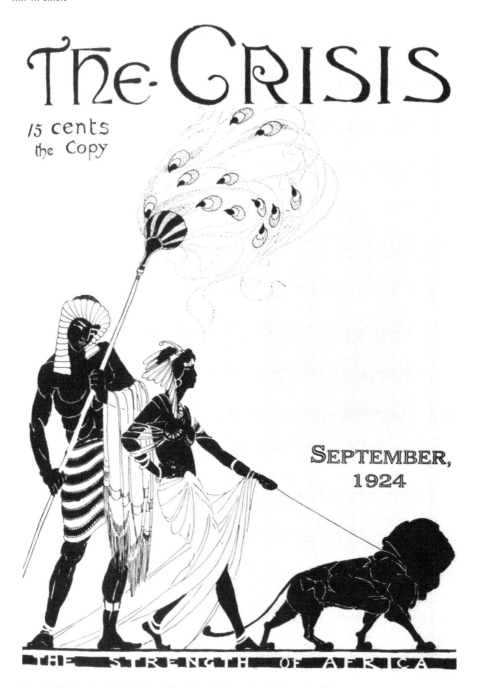

Figure 58. "The Strength of Africa," by Laura Wheeler. Reprinted from *The Crisis*, September 1924, cover.

Second Pan-African Congress was Held." The inscription reads: "I am the one that was, that is, and that shall be. No mortal may unveil my face." Inside the pages of the issue, a lengthy essay on the Second Pan-African Conference was penned by Jessie Fauset. Du Bois offered a manifesto to the League of Nations after Fauset's essay, asking that the International Bureau of Labor set aside a section to deal particularly with the needs of native Negro labor, that self-government as the ultimate aim of all men and nations be recognized, and therefore, that black people be represented by a man of Negro descent. Finally, the manifesto stated that the League of Nations should pay careful attention to the treatment of people of Negro descent.[37] He faced a constant struggle with the NAACP board for funding to attend Pan-African congresses. The NAACP believed that their limited resources should be spent on improving conditions for blacks in the United States and that Du Bois should obtain funding from the congress itself.

Du Bois's coverage of Africa was extensive. He also regularly included the opinions of Africans in the pages of *The Crisis*, a clear indication of the high regard for them he believed his readers should share. He continued to include images of royalty in Africa (who were usually wearing native regalia rather than western clothing) and the political statements they made. The June 1932 issue offered a photograph of "His Highness, Daudi Chwa, Kabaka of Buganda." Buganda was part of the Uganda protectorate, the most prosperous of its four kingdoms. Du Bois wrote of the people of the Buganda kingdom:

> After serious thinking they have come to the conclusion that the white man intends to keep them in their place of primitiveness, and that he does not wish to give them a kind of education that will make them full men and self-reliant, because if he (the white man) does so, the darker people will compete with him in all walks of life, and they will occupy all the positions of administration, with the result that the number of the unemployed people in Europe will increase. . . . The darker people have found out that only their personal efforts will bring about their salvation: and they think that to attain this end they must improve their economic conditions.[38]

The text was accompanied by the photo, a map showing the location of Uganda in Eastern Africa, and a note on Uganda by Du Bois. Du Bois wanted the message of liberation to come not only from him but from African leaders as well.

AFRICA: THE CONNECTION TO AMERICA

The desire to connect Africa to America can be seen in Laura Wheeler's "Africa in America" of June 1924 (fig. 59), which demonstrates her knowledge of Egyptian art. She uses a torso in the Armana style of the Eighteenth Dynasty

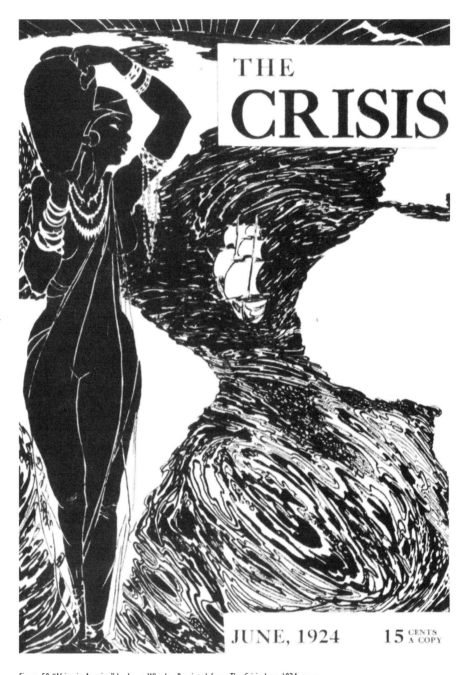

Figure 59. "Africa in America," by Laura Wheeler. Reprinted from *The Crisis*, June 1924, cover.

as the prototype for her shapely figure, a sculpture often identified as Nefertiti.[39] In the Armana-style sculptures of Nefertiti, the sculpted fabric clings to the queen's body, revealing her pubic triangle. Here, the folds are not prominent, but the diaphanous garment reveals her body in the shape of the Amarna-style sculpture, and her pubic triangle is drawn in. The numerous bracelets are not typically Egyptian, nor is her necklace, which is not the usual broad collar piece. The strands of beads around her neck are not Egyptian. Once again Wheeler combines different elements of African art and is not true to one style. In her characteristic black-and-white style, with only a few details of the human form, Wheeler creates a voluptuous woman, clad with a sheer garment that reveals all the lines of her body as if she were nude, adorned with jewelry including wrist and armbands, earrings, necklaces, and a ceremonial headpiece. The woman carries a covered urn on her shoulder. Behind her the pattern of the swirling ocean is formed with a ship crossing in full sail, a symbol of the Middle Passage and the long and harrowing journey from Africa to slavery in the Americas. The figure is strong and erect, proud and lovely. She is a symbol of Africans brought to America against their will who still retain their African heritage.

Wheeler's cover connected to a long article in which Du Bois discussed the opportunities available to black Americans who wanted to migrate to Africa. He noted that *The Crisis* periodically received requests from readers who sought advice concerning such migration. Here Du Bois recognized the hardships connected to emigration. He discouraged his readers from emigrating, including those who hoped for work, since Africa had an abundance of skilled and unskilled laborers. "There is a magnificent chance for pioneers but the point is, pioneering is a far different thing from going to work in a fully developed land," he wrote.[40] Liberia needed professionals—physicians, dentists, and nurses. The "spiritual harvest of practical missionary work would in the end be far greater than we can now dream." Du Bois also noted how polite the "natives" were to each other, both young and old. "I have often thought, when I see the awkward and ignorant missionaries sometimes sent to teach the heathen, that it would be an excellent thing if a few natives could be sent here to teach manners to black and white."[41]

AFRICA AND MODERN ART

Du Bois also promoted African art as an inspiration for the "high culture" of modern art. The May 1925 issue included excerpts from an article by Paul Guillaume, who noted that "the modern movement in art gets its inspiration undoubtedly from African art, and it could not be otherwise."[42] Guillaume had

a substantial African art collection, and he showed famed Philadelphia art collector Albert Barnes his African pieces. Barnes and Guillaume came to be considered authorities on African art. Guillaume would develop the view that African art should be analyzed on purely formal (or usual) grounds, that it was exemplary of "formal perfection," displaying the "highest degree of mastery and civilization," as one of Guillaume's followers wrote. Guillaume attempted to show how African art differed from European art, that it varied greatly in style depending on where it was made and which "tribe" made it.[43] As a Guillaume disciple wrote: "What the new generation should ask from the Negroes is a lesson in sculptural knowledge . . . a state of universality and not the exotic and savage."[44] Guillaume listed in his essay artists who took their inspiration from Africa, including Picasso, Braque, Modigliani, and others. "African art, the most modern of the arts, by this spirit is also the most ancient. In the dim, distant epochs, the men who were first active in the world after the silence of the centuries were the black men. These men were the first creators, the first warriors, the first poets; they invented art as they invented fire."[45]

An interest in modern art movements is reflected in the deco-inspired muscular figures in the style of a WPA relief sculpture or mural featured on the cover of the March 1933 issue. "A Flight into Egypt," by Zell Ingram, shows two figures in modern garb; the simple white lines on their black bodies give the impression of woodblock or linoleum-cut prints. They lunge forward in silhouette, a barren tree branch behind them (fig. 60). The title alludes to the flight into Egypt of Joseph, Mary, and Jesus to escape from Herod's threats. There is little detailing to their muscular, taut bodies, but their faces, which have the slit eyes and full lips of African masks of the Ivory Coast, were clearly inspired by artist Aaron Douglas's use of Egyptian silhouette and Dan masks of the Ivory Coast. Their wavy hair alludes to a natural hairstyle and their African origins. The simple style of the cover was quite effective, and the lettering, now typeset instead of handwritten, gave the cover a polished, clean appearance. It is symbolic of blacks freeing oppression.

Celeste Smith's deco-influenced drawing appeared inside the January 1929 issue. "Excelsior" shows a nude figure, arms reaching out, balancing on the world, standing on an outline of the continent of Africa. The influence of Aaron Douglas is obvious. Smith uses rays of light inspired by cubism, Orphism, and modernism to accentuate the figure. Two rays intersect to spotlight the figure, providing bright white light behind the body. Two shadows appear behind it in three different shades, surely indicating the many colors of African peoples, a pan-Africanist touch (fig. 61).

The frequent inclusion of work by artists such as Aaron Douglas shows an

A RECORD OF THE DARKER RACES

KARL MARX AND THE NEGRO

Figure 60. "A Flight into Egypt," by Zell Ingram. Reprinted from *The Crisis*, March 1933, cover.

Figure 61. "Excelsior," by Celeste M. Smith. Reprinted from *The Crisis*, January 1929, p. 4.

155

interest in modernist art movements and a desire to show cutting-edge movements on the pages of *The Crisis*. Douglas provides the perfect example of pan-Africanist, modernist-inspired art. He combined a use of cubism, Orphism, and African art to create a uniquely modern African-inspired art. Douglas frequently turned to the art of Ethiopia, Egypt, and the Ivory Coast, especially Dan masks, to enrich his pan-Africanist creations.

AFRICA AND MODERN POLITICS

The Crisis regularly included essays, articles, and updates on contemporary African political issues. The accompanying visuals were often cartoons, Egyptian reliefs, or photographs. Du Bois included essays on small kingdoms and successful tribes, showing them as an inspirational peoples who had to live under the worst conditions of poverty and colonization. They were the bearers of the high culture of Africa. He hoped these essays would provide inspiration for American blacks who were suffering under the conditions of racism and segregation. These essays made apparent to the readership that the people of Africa were strong and had survived the worst possible treatment. Du Bois knew that Europeans and their descendants looked to their ancestors to justify their claims of superiority and elevated status. Why should African Americans not turn to Africa for the same reasons? The rich culture of Africa had been stolen from African Americans through slavery, and it needed to be reclaimed.

Du Bois continually used the pages of *The Crisis* to keep American blacks informed of African developments. The January 1919 issue summarized Du Bois's essay on the "Future of Africa," originally published in *Atlantic Monthly*. In it, Du Bois discussed the idea that the colonies which Germany had lost in World War I should not be handed over to "any other nation of Europe, but should, under the guidance of *organized civilization,* be brought to a point of development which shall finally result in an autonomous state." The plan had met with much criticism and ridicule. The *Chicago Tribune* called the memorandum "quite utopian" and said that it had "less than a Chinaman's chance at getting anywhere at the Peace Conference" but noted that it was "nevertheless interesting."[46] He also discussed the idea of a return to Africa:

> This is not a separatist movement. There is no need to think that those who advocate the opening up of Africa for Africans and those of African descent desire to deport any large number of colored Americans to a foreign and, in some respects, inhospitable land. Once for all, let us realize that we are Americans, that we were brought here with the earliest settlers, and that the very sort of civilization from which we came made the complete adoption of western modes and customs imperative if we were to survive at all. In brief, there is

nothing so indigenous, so completely "made in America" as well. It is as ab-
surd to talk of a return to Africa, merely because that was our home 300 years
ago, as it would be to expect the members of the Caucasian race to return to
the vastness of the Caucasus Mountains from which, it is reputed, they
sprang. . . .

To help bear the burden of Africa does not mean any lessening of effort in
our own problem at home. Rather it means increased interest. For any ebulli-
tion of action and feeling that results in an amelioration of the lot of Africa
tends to ameliorate the condition of colored peoples throughout the world.
And no man liveth to himself.[47]

David Levering Lewis has described how Du Bois evinced "a tone of un-
conscious cultural superiority" and came "perilously close to imagining himself
a pan-African pro-consul" in his thinking of how American blacks might in-
volve themselves in African development.[48] Although this may be the case, Du
Bois also remained, as the quotation above represents, a fundamental critic of
any schemes to return to Africa, as if that were somehow a solution to America's
racial problems. He disagreed fundamentally with the West Indian leader Mar-
cus Garvey, founder of the Universal Negro Improvement Association, who ad-
vocated a return to Africa. Garvey worked with the Liberian government, even
buying his own cruise line, to transport African Americans back to Africa. His
movement grew rapidly in the post–World War I environment; it appealed to
many blacks, especially in Harlem, who doubted that America would ever
change and welcome their participation. At the same time, Du Bois and others
demanded self-determination for Africans against European colonialism and
self-determination for American blacks within the United States, the "father-
land for which we fought, . . . *our* fatherland."[49]

Garvey responded by bitterly criticizing Du Bois both in public speeches
and in writings, stating that Du Bois was part white in mind as well as blood
and did not know who he was or where he was. To Du Bois, Garvey was an un-
scrupulous man, whose "spinning" dreams frightened "Africans as well as Euro-
peans."[50] Lewis notes, "Whenever Du Bois wrote or spoke of Garvey there was
always the unmistakable hint of a tolerant, well-bred preceptor's exasperation
when forced to deal with a gifted, unruly, somewhat gauche parvenu—someone
woefully uninstructed in the vicarious and solemn symbolism of responsible
black leadership."[51] Du Bois was searching for a careful balance of "Negro inte-
gration" into American society, Garvey was advocating separatism. Du Bois
nurtured the image of the intelligent, reasonable, thoughtful black leader and
Garvey, Du Bois perceived, was "cutting the fool before the world."[52] Garvey
threatened the vision of pan-Africanism with his appeal to the common man to
return back to Africa. When the Third Pan-African Conference was reviewed

in the January 1924 issue, it was accompanied by a photograph of three participants, including Du Bois. The Third Pan-African Conference, which was held in London, suffered from poor representation outside the British Empire. The expectations of change its program offered were moderate in comparison with those of Garvey and his Universal Negro Improvement Association agenda.[53] A photo of the president of Liberia, whom Du Bois was visiting when the issue appeared, also accompanied the essay.[54] It ended with words that captured much of the hypocrisy of western nations who had diplomatic ties with South African prime minister Jan Smuts, who neglected blacks in his postwar agenda: "In fine, we ask in all the world that black folk be treated as men. We can see no other road to Peace and Progress. What more paradoxical figure today fronts the world than the official head of a great South African State striving blindly to build peace and Good Will in Europe by standing on the necks and hearts of millions of black Africans."[55] In October 1927, *The Crisis* reviewed the history and goals of the pan-African congresses. The hastily organized Fourth Pan-African Congress, held in New York earlier that year, ended the major phase of Du Bois's involvement with pan-Africanism, although his interest in Africa would continue until the end of his life. His disappointment in the response to pan-Africanism was reflected in a letter to Haitian diplomat Dante Bellegarde; he wrote that "until we blacks develop international interest . . . I would not undertake to push the Pan-African Congress." The next congress was not held until eighteen years later.[56]

Du Bois continued to connect the treatment of Negro peoples in Africa with the treatment of all people of African descent. He appealed to his readers to embrace the pan-African movement and to realize that the problems of Africans were similar to their own problems and that their treatment paralleled the treatment of blacks at home. He appealed to the readership to embrace the woes of Africa as their own and used the art of Africa to stress this connection. He asked the League of Nations to use its "vast moral power of world public opinion and of a body conceived to promote peace and justice among men."[57]

PRIMITIVISM AND THE ROMANTIC VIEW OF AFRICA

In April 1924, Du Bois published selections from his journal chronicling his first trip to Africa in December 1923–January 1924. The entries were personal and emotional. Indeed, Du Bois considered his meeting with the king of Liberia as one of the most important events of his lifetime and wrote about it extensively.

When shall I forget the night I first set foot on African soil—I, the sixth generation in descent from my stolen forefathers?[58]

 The spell of Africa is upon me. The ancient witchery of her medicine is burning my drowsy, dreamy blood. This is not a country, it is a world—a universe of itself and for itself, a thing Different, Immense, Menacing, Alluring. It is a great black bosom where the Spirit longs to die. It is life so burning, so fire encircled that one bursts with terrible sound inflaming life. One longs to leap against the sun and then calls, like some great hand of fate, the slow, silent, crushing power of almighty sleep—of Silence, of immovable Power beyond, within, around. Then comes the calm. The dreamless beat of midday stillness at dusk, at dawn, at noon, always. Things move—black shiny bodies, perfect bodies, bodies of sleek unearthly poise and beauty. Eyes languish, black eyes—slow, yes, lovely and tender eyes in great dark formless faces. Life is slow here. Impetuous Americans quiver in impetuous graves I saw where the ocean roars to the soul of Henry Highland Garnet. Life slows down and as it slows it deepens; it rises and descends to immense and secret places. Unknown evil appears and unknown good. Africa is the Spiritual Frontier of humankind—oh the wild and beautiful adventures of its taming! But oh! The cost thereof—the endless, endless cost! Then will come a day—an old and ever, every young day when will spring in Africa a civilization without coal, without noise, where machinery will sing and never rush and roar, and where men will sleep and think and dance and lie prone before the rising sons, and women will be happy.

 The objects of life will be revolutionized. Our duty will not consist in getting up at seven, working furiously for six, ten and twelve hours, eating in sullen ravenousness or extraordinary repletion. No—we shall dream the day away and in cool dawns, in little swift hours, do all our work.[59]

This long selection reveals that Du Bois looked at Africa with the eye of a primitivist, romanticizing the simple, sweet African customs, the slow eyes, the slow lifestyle, the ease of it all. Du Bois even sounds like the young Karl Marx in his description of an Africa which could avoid the disruptive changes brought by capitalist development. Indeed, in many ways his approach to Africa resembles the approach of whites to the work of the Harlem Renaissance, which also emphasized primitivism.[60] In many ways, his reaction to Africa is similar to the way whites reacted to the art of the Harlem Renaissance in its emphasis on "primitive" and exoticized aspects of African culture. Just as whites failed to see the full range of African American culture, Du Bois focused on images that were congruent with his romanticized view of the African continent and its people. Du Bois wrote that the African form in color and curve was the most beautiful thing on earth: "[T]he face is not so lovely, though often comely with perfect teeth and shining eyes—but the form of the slim limbs, the muscled torso, the deep full breasts!"[61]

 This primitivism also made its way into the pages of *The Crisis*. The March 1928 cover by Roscoe C. Wright, which consisted of a series of black-and-white

idols and masks, was entitled "African Witch Mask and Fetish in Design." This decorative cover, which has a deco influence in the borders that surround the captions, uses creative African-inspired lettering to evoke Africa and broken lines to connect the various figures, giving the effect of a pattern (fig. 62). It was supposed to recall the visual language of Africa, not to remind the reader of any particular African image. "A Jungle Nymph" by Allan Freelon (fig. 63), which appeared on the cover for June 1928, shows a nude young woman of African descent (indicated by her facial features and natural hair) leaning back on her arms, exposing her unclothed body, amid palms, tropical trees, dense vegetation, and a pond. The pond creates a round shape and the water is interrupted by small areas of earth and plants; the pond could represent the world. She has an Afro hairstyle, but despite her nudity, she wears earrings. Even though we observe her, she is unaware of us; the viewer is in fact a voyeur. She looks down, giving her a sense of privacy or modesty, yet her positioning resembles famous nudes of the nineteenth century who brazenly display their nudity, as in as Manet's *Olympia* of 1863. No direct gaze is provided for the viewer. The entire image is contained by a patterned border. The image fits well with Du Bois's long description of Africa previously quoted, especially his line, "The dreamless beat of midday stillness at dusk, at dawn, at noon, always. Things move—black shiny bodies perfect bodies, bodies of sleek unearthly poise and beauty. Eyes languish, black eyes—slow yes, lovely and tender eyes in great dark formless faces. Life is slow here."[62] This played to the male fantasy of the free and uninhibited "primitive" African woman.

The Crisis also evidenced a sensibility of primitivism in its more sensual covers. Because they were African, these images could exhibit imagery that was more sexual than homegrown African American covers could. Africa was *supposed* to be different, more sexually free—another fantasy. One of the more sultry covers graced the May 1925 issue. An unsigned photograph, "A Moorish Maid," shows a woman wearing an interesting metal necklace. Her hair is pulled back in a headwrap, and the image reveals a small part of her nipple, indicating that she is at least partially nude (fig. 64). This necklace was used on at least one other cover photograph the next year and must have been part of the photographer's collection used to evoke a primitive look. She looks off to the side with languid eyes and does not make visual contact with the viewer. Her face appears to have some sort of markings or scarification on it, another indication of her exoticness. This cover served to both showcase a dark-skinned woman and lure an audience—undoubtedly male—to open *The Crisis* and read on. Other African American magazines, such as the Urban League's *Opportunity,* were using similar images to attract new readers. Modern sex appeal, under the guise of the primitive, was permissible.

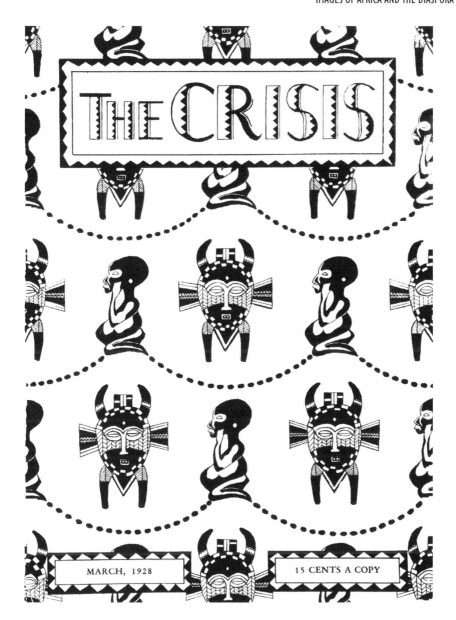

Figure 62. "African Witch Mask and Fetish in Design," by Roscoe C. Wright.
Reprinted from *The Crisis*, March 1928, cover.

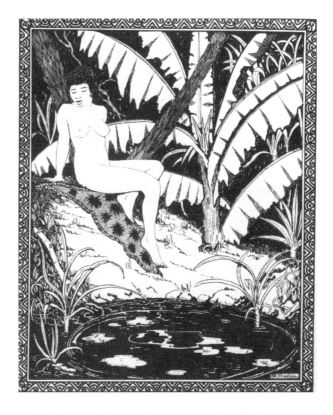

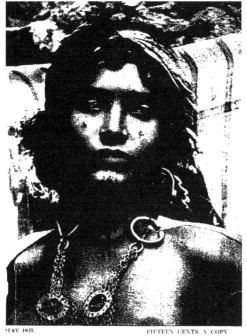

Figure 63. "A Jungle Nymph," by Alan Freelon. Reprinted from *The Crisis*, June 1928, cover.

Figure 64. "A Moorish Maid." Reprinted from *The Crisis*, May 1925, cover.

POLITICAL CRITICISM IN CARTOONS ABOUT AFRICA

Political cartoons about Africa were not common in *The Crisis.* Nevertheless, they were among the most poignant and graphic statements about the abuses Africans endured. In March 1917, E. A. Harleston provided a cartoon showing a Congolese man in tattered garment and sandals, his hands severed, facing a seated white man, Prince Albert of England. The caption read, "Voice of Congo: 'If your uncle had left us our hands, Albert, we could be of more use to you now!'" (fig. 65). This referred to the brutality suffered by the Congolese under Belgian colonization. The atrocities, including the severing of hands and feet, were well documented. A white man in military garb, sitting in front of a portrait of an elderly Leopold, King of Belgium, looks off, unconcerned with the horrors in front of him.[63]

A small cartoon by R. O. Berg was included in the November 1932 issue as an example of a typically ignorant white tourist (fig. 66). Berg shows two overweight, overindulged white people under the shade of a palm, looking at a proud black woman who is tall, slim, and strong. She is balancing a basket of goods on her head as she walks down the street. He sports a fez hat, clearly a tourist's purchase to remember his trip. The small hat provides a ridiculous contrast with his substantial girth. The man and woman exclaim: "Ain't she funny!" The irony of the two thoughtless yet ridiculous-looking Americans who consider themselves to be superior is obvious.

Among all of Du Bois's passions or the causes he championed as editor of *The Crisis,* issues surrounding Africa and the diaspora were near the top of his priorities. His lifelong passion for Africa developed and flourished on the pages of *The Crisis,* where he found a home for his opinions and a place to support his causes. He used art as an emotional, visceral support in this endeavor to tie his readers to their heritage. His use of art was not always consistent. Sometimes he turned to actual pieces of African art and to Egyptian-inspired visuals as a tangible connection to Africa's rich culture. He used photographs of ordinary people living their daily lives in Africa and photos of dignitaries and royalty. But he also included somewhat exotic or fantastic renderings of Africa that illustrate the primitivism that he cautioned against. His own description of his time in Liberia paralleled Laura Wheeler's exotic view of Africa more than the real Africa of his time.

Du Bois used art to develop his own concept of the black diaspora. By insisting that African Americans recognize their shared racial identity with Africans of all regions—not just the sub-Saharan region but also North Africa—Du Bois carved out an expansive concept of the African diaspora, developing

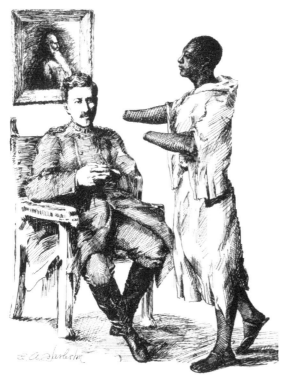

Figure 65. "Voice of Congo...," by E. A. Harleston. Reprinted from *The Crisis*, March 1917, p. 247.

Voice of Congo: "If your uncle had left us our hands, Albert, we could be of more use to you now!"

Figure 66. "Ain't she funny!," by Russell O. Berg. Reprinted from *The Crisis*, November 1932, p. 342.

"Ain't she funny!"

his own politically based collective memory. Du Bois's vision, which he amplified by artistic creations, went beyond the intellectual currents of his own time. It challenged the more provincial notions of many African Americans and laid the groundwork for future developments in the worldwide struggle for racial equality.

Du Bois spent his final years in Ghana, where he died in 1963. He wrote an undated poem, "Ghana Calls" and dedicated it to Osagyefo Kwame Nkrumah, the president of Ghana from 1957 to 1966. In its poignant words, it captures the tragedy and triumph of the black diaspora:

I was a little boy, at home with strangers.
I liked my playmates, and knew well,
Whence all their parents came;
From England, Scotland, royal France
From Germany and oft by chance
the humble Emerald Isle.

But my brown skin and close-curled hair
Was alien, and how it grew, none knew:
Few tried to say, some dropped a wondering word or stray;
Some laughed and stared
And then it came: I dreamed.
I placed together all I knew
All hints and slurs together drew.
I dreamed.

I became old; old, worn and gray;
Along my hard and weary way
Rolled war and pestilence, war again;
I looked on Poverty and foul Disease
I walked with Death and yet I knew
There stirred a doubt; Were all dreams true?
And what in truth was Africa?

I lifted up mine eyes to Ghana
And swept the hills with high Hosanna;
Above the sun my sight took flight
Till from the pinnacle of light
I saw dropped down this earth of crimson, green gold
Roaring with color, drum and song.

From reeking West whose day is done,
Who stink and stagger in their dung
Toward Africa, China, India's strand
Where Kenya and Himalaya stand
And Nile and Yang-tze roll;
Turn every yearning face of man.

Come with us, dark America:
The scum of Europe battened here
And drowned a dream
Made fetid swamp a refuge seem:

Enslaved the Black and killed the Red
And armed the Rich to loot the Dead;
Worshiped the whores of Hollywood
Where once the Virgin Mary stood
and lynched the Christ.

Awake, awake O sleeping world
Honor the sun;
Worship the starts, those vaster suns
Who rule the night
Where black is bright
And all unselfish work is right
And Greed is sin

And Africa leads on:
Pan-Africa![64]

6. Art, Political Commentary, and Forging a Common Identity

Over the years he served as editor of *The Crisis,* Du Bois developed what could be called a visual vocabulary of protest and social commentary. While images of lynching and Africa were among the most prevalent, Du Bois had many interests that were integral to the development of black identity in the United States. The issues of racism and prejudice dominated the pages of *The Crisis* for the twenty-four years he served as editor. Du Bois also considered education and fair opportunities for employment to be essential elements of complete participation in American society. On a more controversial note (within the left and progressive community, that is), Du Bois believed in supporting American involvement in World War I, but he sought to attain the best conditions possible for black members of the military. He was also a passionate supporter of women's rights and suffrage and saw the strength of the black family as paramount to the strength and security of the race. The visuals featured in *The Crisis* reflect these interests.

Symbols of these themes which had been used by other political illustrators and cartoonists in American visual history were developed in *The Crisis* as tools to show the contradictions and problems of the United States. They included symbols of patriotism, Christianity, bravery and heroism, and civilization. Du Bois was convinced that racism could be confronted intellectually to show its illogical basis and provide encouragement for supporters of African Americans. Images could do this in the most dramatic fashion. Many of the cartoonists had their own activist agenda and felt that changes should and could be made through political involvement and protest.

RACISM AND PREJUDICE

The Crisis saw each issue it addressed through the lens of racism and prejudice. Racism influenced every area of the lives of African Americans—family

life, access to education, voting rights, treatment of soldiers in wartime, and access to work and fair treatment of laborers. Du Bois also included images that dealt solely with racism based on color.

Arnold Rampersad argues that the most forceful impact of *The Crisis* came from its editorial section, usually two to four pages long, where Du Bois spoke directly to the reader. But to speak to his audience, Du Bois needed them to read his essays, and visuals could help draw them in. At times, several issues were raised in one editorial, and somewhere in the issue a photograph or drawing was offered as a support to the text. Sometimes these images were editorials unto themselves.

Du Bois first became aware of discrimination, prejudice, and racism when he went to Fisk University. Here, he "quickly understood that behind the segregation of any group was an attempt of a ruling class to put off on a defenseless or powerless group the work of their own social uplift."[1] Du Bois spoke up against discrimination in public schools in the very first issue of *The Crisis,* November 1910, where he said, "The argument, then, for color discrimination in schools and in public institutions is an argument against democracy and an attempt to shift public responsibility from the shoulders of the public to the shoulders of some class who are unable to defend themselves."[2]

One of the more poignant cartoons concerning racism and the responsibilities assigned to the races appeared in the June 1913 issue, entitled "American Logic" (fig. 67). It shows a very finely dressed white man standing next to a rough-looking white hoodlum. The caption below these two figures reads: "THIS MAN is not responsible for THIS MAN even if they do belong to the same race." On the right, a very finely dressed black man stands near a black man, who does not look as sinister as the poor white man but is leaning against a post, clearly unemployed and perhaps with trouble on the horizon. Below these two figures, the text states: "THIS MAN is responsible for all that THIS MAN does because they belong to the same race." *The Crisis* was underlining the fact that African Americans were not judged as individuals. Instead of being honored for their hard work and successes, they were automatically grouped with the least successful of their brothers. The cartoon uses a certain type of visual vocabulary that reflects assumptions about class: the bourgeois as "good" the as lower or working class as "bad."

Prejudice in national politics was featured in a political cartoon by Lorenzo Harris. It shows an ape-like nude figure with the word "prejudice" on his chest holding a giant, menacing, sharp club labeled "discrimination" in his hand. He is riding a mule, the National Democratic Party. The caption reads: "In the Saddle!" (fig. 68).[3] *The Crisis* was reminding its readers that the Democrats were in control and that they in turn were controlled by the solid "white" South. Harris

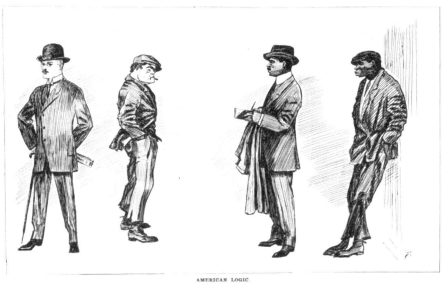

AMERICAN LOGIC.

THIS MAN is not responsible for THIS MAN
even if they do belong to the same race.

THIS MAN is responsible for all that THIS MAN
does because they belong to the same race.

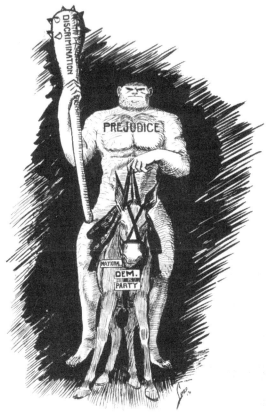

IN THE SADDLE!

Figure 67. "American Logic," by Lorenzo Harris. Reprinted from *The Crisis*, June 1913, p. 80.

Figure 68. "In the Saddle!," by Lorenzo Harris. Reprinted from *The Crisis*, January 1914, p. 119.

depicts the figure of prejudice with thick, ape-like features, a squat head, and small beady eyes set close together. Racists often depicted African Americans in drawings as ape-like, and cartoonists who fought racism turned this iconography around to depict prejudice itself as an animal-like and primitive idea.

The Crisis often included accounts of police brutality from across the country. "Our Brave Policemen" shows two huge policemen with a small, well-dressed, dejected black man between them; he is less than half the size of the officers. It is obvious this figure could offer no form of resistance against the two policemen, both of whom have square jaws and thick features. They resemble the typical depiction of barbaric "prejudice," but here they serve as an attack on the frequent hypocrisy in the language of white authority. The caption says "After a terrific struggle the burly Negro was finally subdued" (fig. 69).[4]

John Henry Adams also addressed police brutality and the unfair judicial system. His January 1919 cartoon shows a small black child, perhaps aged two or three, his wrists handcuffed together, in chains. He is presented to a white judge, who slumps over in his chair, showing no interest in the defendant, while an all-white jury listens. The caption, "Disturbing the Peace, Your Honor!" says it all. The fate of the toddler symbolizes the way in which the vague charge "disturbing the peace" was used to harass and oppress black communities, in this case, in a perfectly legal way (fig. 70).

As a statement about racism, Du Bois included James Weldon Johnson's "To America" in November 1917. The poem was accompanied by a drawing by Laura Wheeler of six youthful figures in classical chitons or togas around a statue. These figures were typically used to symbolize white European high culture, but these figures are black (fig. 71). Johnson's poem is superimposed on the image:

How would you have us, as we are
Or sinking 'neath the load we bear
Our eyes fixed forward on a star
Or gazing empty at despair?

Rising or falling? Men or things?
With dragging pace or footsteps fleet?
Strong willing sinew in your wings?
Or tightening chains about your feet?[5]

Albert Alex Smith's "The Fall of the Castle" features the word "prejudice" on a tilting castle, which is attacked by figures bearing shovels and swords as it tumbles down the hill (fig. 72). The text reads, "It was a mighty Castle, with massive towers, walls of amazing thickness, and foundations that seemed to seek the very roots of earth! It was defended by armed hosts and vast beasts of

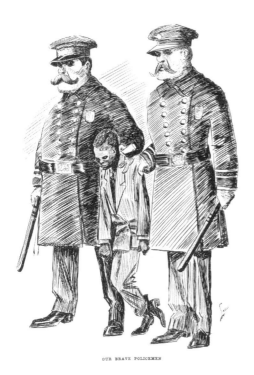

Figure 69. "Our Brave Policemen," by Lorenzo Harris. Reprinted from *The Crisis*, June 1916, p. 96.

OUR BRAVE POLICEMEN

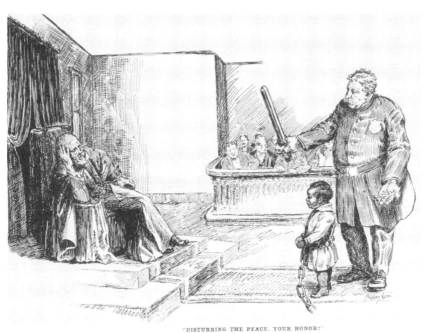

"DISTURBING THE PEACE, YOUR HONOR!"

Figure 70. "Disturbing the Peace, Your Honor!," by John Henry Adams. Reprinted from *The Crisis*, January 1919, p. 134.

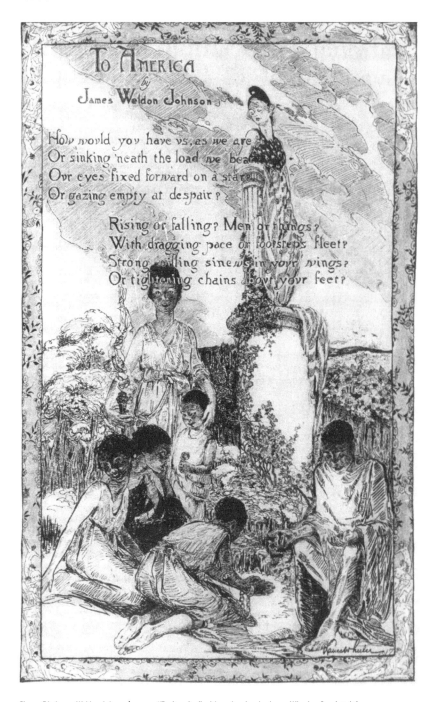

Figure 71. James Weldon Johnson's poem, "To America," with a drawing by Laura Wheeler. Reprinted from *The Crisis*, November 1917, p. 13.

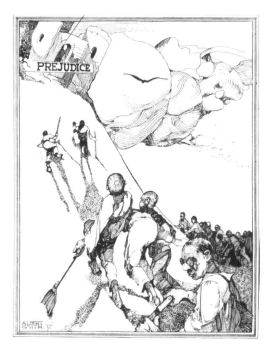

Figure 72. "The Fall of the Castle," by Albert A. Smith. Reprinted from *The Crisis*, February 1920, p. 203.

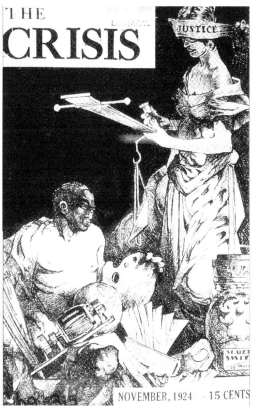

Figure 73. Justice, blindfolded, by Albert A. Smith. Reprinted from *The Crisis*, November 1924, cover.

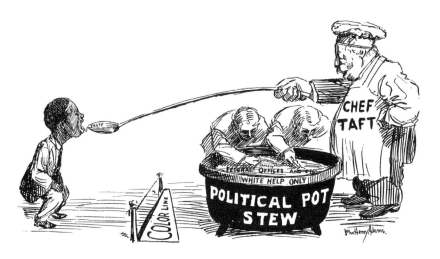

Figure 74. "Mr. Lewis Gets His!," by John Henry Adams. Reprinted from *The Crisis*, April 1911, p. 31.

the air. Men said it would never fall. They said God Himself had built it, to stand Forever and a Day. They laughed at the puny, black folk who attacked it daily, doggedly, with shovel and broom and stave. And yet—IT FELL. Why? It was built on SAND."[6] Du Bois was convinced that with enough pressure, racism could be toppled.

Drawing from his home in France, Smith had a unique insight into issues of prejudice. In an untitled cover of September 1924, Smith makes a poignant statement about American justice or, more accurately, the lack thereof. A downtrodden black man draped in a classical garment sits among symbols of art, high culture, and civilization, including a globe, an artist's palette, scientific instruments, a book, papers and scrolls which refer to literature, and architectural plans. A large classical vase or urn is next to the array of objects. Behind him, to the right, stands a blindfolded white figure of justice, clad in a classical chiton or toga, holding the scales of justice, which are completely out of balance. A hand emerges from the background, holding a blindfold with the word "justice" inscribed on it over her eyes. Even with the trappings of "culture and civilization" surrounding him, he cannot achieve justice in a society unbalanced by racism (fig. 73).

John Henry Adams's cartoon in the April 1911 related to politics and labor. "Mr. Lewis Gets His!" shows "Chef Taft" using a long spoon with the word "taste" on it feeding a black man in a suit, who stands behind the "Color Line" (fig. 74). Taft's long spoon reaches across the "Political Pot Stew" with the words

"White Help Only" on the side of the pot. Two white men eat directly from the pot. The soup is labeled "Federal Offices and etc."

The pot of stew that is "cooked" by the federal government (jobs and labor) was available only to white Americans. Black Americans were allowed only a small taste. The reference is to William H. Lewis, the first African American to hold the post of assistant attorney general; he was appointed by President Taft. The inability of Lewis, an ally of Booker T. Washington, to garner political patronage for blacks is a central point of the cartoon.[7] President William Howard Taft, who had received the votes of northern blacks, did not reciprocate with economic help from the federal government.

Although racism's illogic dismayed Du Bois, he also understood its political dimensions. The March 1913 issue offered a cartoon by Lorenzo Harris. It showed a man in a workman's costume, a porter whose job is clearly to clean. He holds a larger feather duster, and he is wearing overalls. His hat bears the words, "Negro Voter" and he holds his hand to his chin, deep in thought (fig. 75). He has just opened the door to receive a package of three boxes, labeled with "Democratic House, Dem. Senate, Dem. President." They are wrapped up and tied together with the words "Consigned to United States of America: Open after March 5th." (The new president would be inaugurated on March 4, 1913). The caption reads: "The New Porter: 'Somehow, ah cain't hep feelin' 'spicious o' dem bun'els!'" He suspects that the Democratic Party's triumph in 1912 will not help the black population. Du Bois himself had endorsed Woodrow Wilson, who won the race, only to become quickly disillusioned once he entered office.[8] It is interesting because by using this type of dialect and a porter as the main figure, the black cartoonist is playing on a black stereotype.

However, by 1930, in very different political circumstances, Du Bois could celebrate a black political victory. The July 1930 issue featured a cartoon by painter Romare Bearden, "They Voted for Judge Parker" (fig. 76). The subtitle: "Of all their titles, the best is '*Ex*-Senator'! (Apologies to Heywood Brown) [*sic*]." The cartoon showed a black man with a large smile on his face, labeled "Colored Voter," standing in a cemetery, looking with great satisfaction at a giant tombstone with the names of ten senators who had supported Judge Parker and had been voted out of office. Judge Parker's much smaller grave marker is behind the large marker in the cemetery. *The Crisis* ran a huge editorial to mark this momentous occasion when black voters finally had a say in politics, "The Defeat of Judge Parker." President Hoover had nominated John Johnson Parker of North Carolina as a Supreme Court justice. The American Federation of Labor and the NAACP protested, as did some senators, but the Senate Judiciary Committee had suggested confirmation by a vote of 10 to 6. But Parker, who had on many occasions "berated the Negro race," lost confir-

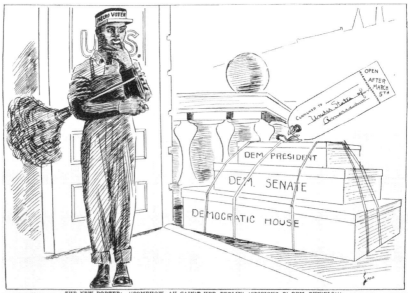

THE NEW PORTER: "SOMEHOW, AH CAIN'T HEP FEELIN' 'SPICIOUS O' DEM BUN'ELS!"

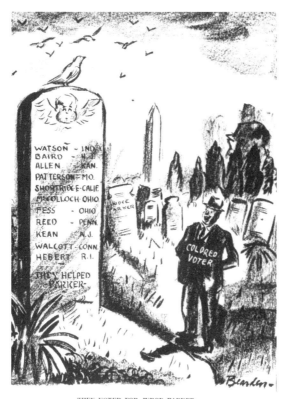

THEY VOTED FOR JUDGE PARKER
"Of all their titles, the best is 'Ex-Senator'!"
(Apologies to Heywood Broun)

Figure 75. "The New Porter...," by Lorenzo Harris. Reprinted from *The Crisis*, March 1913, p. 249.

Figure 76. "They Voted for Judge Parker," by Romare Bearden. Reprinted from *The Crisis*, July 1930, p. 362.

mation by a vote of 41 to 39. Several press agencies said that the Negro vote had been a decisive factor in his failure to be confirmed. Some papers cried out in indignation that the NAACP would influence the vote on a Supreme Court justice in any way.

While the victory was enjoyed, Du Bois noted that the criticism of the senators who opposed Parker; they were seen as "timid" and "afraid of the Negro vote." Such opinions must be "matters of grave reflection to the Negro, for they show the persistence of the extraordinary doctrine that no representative of the people has a right to defer to the wishes of his Negro constituents." Early in his career Parker had given a speech in which he stated that the Republican Party didn't want Negroes in the party and didn't want them to vote; he went so far as to imply that the participation of African Americans in party politics was "a source of evil and danger." Heywood Broun questioned Parker's integrity, asking how he could claim to have no prejudice against the Negro race if he used such words. Both the labor movement and the NAACP had opposed the Parker nomination; Du Bois felt that this presaged further political cooperation between unions and African Americans, although in this instance the American Federation of Labor was "rejoicing over the result" without mentioning the participation of blacks. Similarly, blacks claimed the victory without mentioning the contributions of the labor movement. Although the potential for collaboration existed when the right issue emerged, the two social movements had a way to go before they completely trusted each other. The cartoon offered by Bearden only offers the positive side of this situation, the defeat of the senators who supported Parker and the defeat of Parker.[9]

EDUCATION

Du Bois used *The Crisis* to express his strong support for education, which was integral to the advancement of the race and the training of the Talented Tenth. In contrast to Booker T. Washington's support of vocational training, Du Bois wanted only the finest higher education for black Americans. The discussion of education was usually a joyful celebration of the successes of individuals, educators, and schools. In the early years of *The Crisis*, photographs were most commonly used. Sometimes these would include photographs of new or improved schools, providing comparisons to inferior schools in the segregated South. Libraries with "colored reading rooms" were also depicted.

Du Bois published the names, institutions, and often the photographs of college graduates. From the first days of *The Crisis*, advertisements for colleges played a significant role in the artwork of the magazine. Du Bois urged a commitment to the finest education for black Americans.

There are people in the United States who say: "We have tried education as a solution for the race problem and failed, therefore," etc.

We cannot too often insist that it is not true. We have never tried the experiment . . . we have tried it here and there, but the United States is not today, and never has had, a complete rational system of elementary education for its myriad of black and white children, and this fact is perhaps the greatest achievement of American democracy.

Let us try education and try it on a national scale. Let us have federal aid to common school training, even if it delays our battleships and puts the annual army maneuvers out of business.[10]

Du Bois always noted how far behind the South was in spending per pupil.

Du Bois saw education as one of the most important solutions to the strict "caste system" in America that placed blacks at the bottom of the hierarchy. In the June 1912 issue, he wrote:

Consider this argument: Education is the training of men for life. The best training is experience, but if we depended entirely upon this each generation would begin where the last began and civilization could not advance. . . . [C]hildren must be trained in the technique of earning a living and doing their part of the world's work. Moreover, a training simply in technique will not do because general intelligence is needed for any trade, and the technique of trades changes.[11]

Du Bois warned that "colored people in educating their children should be careful: First: To conserve and select ability, giving to their best minds higher college training."[12] Du Bois was still addressing his old debate with Washington; he was saying that the mind needed to be trained as well as the hand. He was advocating better education for all black children, regardless of their future plans.

Du Bois was concerned that "certain folk . . . use the American public-school system for the production of laborers who still do the work they want done." These people used the public schools system to train servants, carpenters and mechanics. "They want a caste: a place for everybody and everybody in his father's place with themselves on top, and 'Niggers' at the bottom where they belong."[13] He urged, "See that your child gets, not the highest task, but the task best fitted to his ability, whether it be digging dirt or painting landscapes; remembering that our recognition as common folk by the world depends on the number of men of ability we produce—not the great geniuses, but efficient thinkers and doers in all lines. Never forget that if we ever compel the world's respect, it will be by virtue of our heads and not our heels."[14]

"Send the children to school. Do not be tempted to keep them at work because they are earning large wages. The race is to the intelligent and not merely to the busy. Wisdom is the principle thing, therefore, GET WISDOM! Hustle

the children off the farms and out of the factories and into the schools. Do not wait—do not hesitate. Our life depends upon it. Our rise is founded on the rock of knowledge. Put the children in school. Keep the children in school."[15]

The July 1912 issue included a drawing of a young black man and woman in cap and gown, proudly and confidently looking off to their future, diploma in hand (fig. 77). The essay "The Year in Colored Colleges" proclaimed that "20 colored institutions of higher training" taught 991 students, 163 of whom had graduated that year. The message of this cover was that a diploma would ensure their chance at a bright future. The two figures represent a heroic interpretation of the graduate: they look up, strong and assured. No skin color is shown, but their fuller lips and the woman's curly hair indicate their race. An architectural column behind them represents the educational institution. Below this artwork was a photo of the academic procession on graduation day at Howard University. A photo of President Taft visiting the Georgia State Industrial school was also included. July or August became the official educational issue of *The Crisis,* the month when photographs and statistics of graduates would be featured from the previous spring graduation.

Political cartoons also encouraged readers to seek out higher education in order to escape menial positions. The September 1913 issue features a cartoon by Lorenzo Harris showing a young black woman working in a kitchen, her arm grabbed firmly and forcefully by a white employer wearing a suit and bow tie and sporting a goatee (fig. 78). Here Harris employs the visual vocabulary of the southern figure that was often employed by black illustrators; He has "Confederate" attributes, including a goatee, a handlebar mustache, a long jacket, and a soft bow tie, the symbols of a southern "gentleman." He holds the woman prisoner across a kitchen table, a fierce look on his face, the knuckle of his left hand grounding his power, pushing into the table. The text reads "The New Education in the South: Domestic Science for Colored Girls Only." The implications are obvious—the South wanted to confine black women to roles of domestic servitude. If the South had its way, that would be their future, the only education worth pursuing. The reader was clearly supposed to find inspiration to escape such a fate by pursuing education.

In the July 1914 education issue, photos accompanied an editorial by Du Bois, who urged that black children be given the best possible education. "Only in the higher intellectual life of today can they hope to find that freedom, fellowship and joy which fiendish ingenuity cuts out of so much of their work, their amusements and their daily walks. . . . The colored people should strain every nerve to send their children through the best colleges. . . . Make them men even if they have to be menials. In the long run they will burst their bonds and

Figure 77. Untitled drawing of two graduates. Reprinted from *The Crisis*, July 1912, p. 133.

THE NEW EDUCATION IN THE SOUTH: "DOMESTIC SCIENCE FOR COLORED GIRLS ONLY."

Figure 78. "The New Education in the South...," by Lorenzo Harris. Reprinted from *The Crisis*, September 1913, p. 247.

be modern free men. But train them so that in the day of sundered bonds they can take their place beside their fellows and not be held back then by ignorance as they are now by prejudice." Du Bois believed so strongly in education that he advocated it for every black, regardless of their future occupation, a radical idea at this time.[16]

As a graduate of Fisk and an educator himself, Du Bois was deeply committed to the strength and independence of Negro colleges. He realized that many colleges were not strong and that their futures were not necessarily secure because so many children were being trained for menial labor through industrial training in public schools: "The result of limiting the education of Negroes under the mask of fitting them for work is the slow strangulation of the Negro college."[17] Du Bois noted that black parents were not ashamed of having their children trained to work. "But they know that if their children are compelled to cook and sew when they ought to be learning to read, write and cipher, they will not be able to enter the high school or go to the college as the white children are doing. It is a deliberate despicable attempt to throttle the Negro child before he knows enough to protest."[18] Du Bois ended his essay on a hopeful note. "Negro mothers and fathers are not being entirely deceived. They know that intelligence and self-development are the only means by which the Negro is to win his way in the modern world. They persist in pushing their children on through the highest courses. May they always continue to do so; and may the bright, fine faces on these pages be inspiration to thousands of other boys and girls in the coming years to resist the contemptible temptation so persistently laid before this race to train its children simply as menials and scavengers."[19]

Job opportunities were intimately linked with education. The black worker could not change his or her position in the labor force without proper opportunity and training. Albert Alex Smith offered his statement about the lack of opportunities offered to the black race in his untitled cartoon featured on the August 1925 cover (fig. 79). A young man, dressed in a respectable suit, stands next to a basket of cotton. A plow and an ox are nearby. Although he does not wear the attire of a farmer, the symbols of agriculture flank him, and he needs opportunities for training and advancement to change his future. He stands in a field, half-turned toward the small town in the distance. As he looks across the sweeping sky, he sees the images of six great black leaders in the clouds, their last names appearing below their portraits: abolitionist Frederick Douglass, writer Alexander Dumas, poet Paul Laurence Dunbar, composer Samuel Coleridge-Taylor, philosopher-leader W. E. B. Du Bois, and artist Henry O. Tanner. These were men that Smith greatly admired,[20] and the portraits offer a vision of hope and possibilities of change, even while the trappings of a life of

agriculture completely surround the figure. Booker T. Washington is noticeably absent from this group.

Du Bois demonstrated his interest in the Talented Tenth and high culture in the education number of August 1928. A group of men and women are featured on the cover, students of the arts—an architect with a model of a classical building, a writer with a plumed pen, a violinist, a sculptor, and a painter with a palette—all working diligently at their disciplines. Here the purpose of education is not just to find a job but to pursue liberal arts and the knowledge of and ability to create high culture. This would uplift the race.

One of the more noteworthy education covers featured a composition by Charles C. Dawson (fig. 80). It shows two figures. One is a young black man wearing a mortar board and carrying the banner of *The Crisis* with an American flag partially exposed behind it. In front of him is a young woman in Egyptian dress with the nemes headdress, holding a torch. She ties the student to the past of African history and culture via Egypt and leads him to the future. A traditional classical vase flanks the right side of the page and several buildings, presumably institutions of higher education, make up the background of the piece. Here the artist is saying that African American young people needed to be grounded in their cultural roots as well as formal education.

Du Bois continued to emphasize inequality in education and the need for change. He realized that the best education was available in white schools, and he advocated that black children attend those schools whenever possible. Regardless of what type of school a child attended, at some point he or she would have to enter the harsh white-dominated world. Du Bois wrote to parents that the homes they provided for their children would be their mainstay as they made this difficult transition, whether it took place in childhood or later in life:

> Schooling is still our grave problem. The colored child in the mixed public school has for the most part a hard road to travel. But he will be often stronger and sturdier for the experience, if he pulls through. The colored child in the better colored public schools has also the difficulty of contact with masses who have had small opportunity in this world. It frightens the careful mother and father to know what their children must meet here. . . . At least in your home you have a chance to make your child's surroundings of the best: books and pictures and music; cleanliness, order, sympathy and understanding; information, friendship and love,—there is not much of evil in the world that can stand against such home surroundings.[21]

The Crisis was ever critical of segregated schools and criticized them relentlessly for the second-rate education they offered African American children. Lorenzo Harris created the "The Argument for 'Jim Crow' Schools" for the Oc-

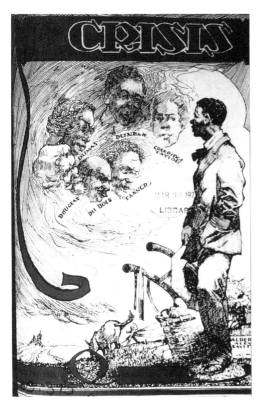

Figure 79. Untitled young man, by Albert A. Smith. Reprinted from *The Crisis*, August 1925, cover.

Figure 80. Untitled education cover, by Charles C. Dawson. Reprinted from *The Crisis*, August 1927, cover.

tober 1926 issue (fig. 81). A black woman labeled "Nearsighted Race Leaders" pulls reluctant black children toward a "lamb," saying, "Come now, play with the nice pretty little lamb that someone has sent to you." The lamb is a wolf in sheep's clothing. His name is "Separate School" and the words "Neglected Jim Crow School," "A Few Jobs for Colored Teachers" adorn his body. An ape-like figure, "Prejudice," hides behind the door. The cartoon includes subtleties. There is a class difference between the teacher and her students. The teacher is wearing an out-of-date, country-style plaid dress, not the streamlined clothing favored by middle-class women of 1926. The children, by contrast, are dressed in middle-class contemporary clothing and are groomed and neat. The teachers face is in caricature, with heavily exaggerated features; the children are fine-featured, although their skin is dark. The children sense the danger of the wolf —the boy stands up to him, the girl recoils—while the teacher is unaware. This cartoon reminds parents to be mindful of the quality of their schools and encourages them to take action. And it criticizes black educators who accept segregated schools in the Jim Crow South.[22]

For the August 1934 issue, Romare Bearden drew "Little Man, What Now?" showing a graduate in cap and gown, his back to us, holding his diploma, wondering what his future holds (fig. 82). The words "College Graduate" are written on the back of his gown. The landscape looks vast and bleak at the same time, a commentary on the America of the Great Depression.[23] The contrast with the optimism of the 1920s that blacks felt regarding the opportunities education would create for them is palpable.

Although earlier issues of *The Crisis* attacked school segregation, Du Bois later came to an opposite conclusion. In the February 1934 issue he called for the discussion of a segregation program. Some of his ideas about separate schools were controversial, and these ideas developed in front of his audience's eyes over the years on the pages of *The Crisis*. He wrote of his theories of separate schools in 1935, a year after he resigned his post as editor. He noted that much had been said "about the special aesthetic ability of the Negro race," including a "tremendous psychic history of the American and West Indian groups [that] has made it possible for the present generation to accumulate a wealth of material which, with encouragement and training, could find expression in the drama, in color and form, and in music."[24] But where could the Negro student receive proper training, thoughtful education? Du Bois felt this training could be better pursued in separate Negro schools under competent and intelligent teachers. These teachers would be truly dedicated to the finest level of education. Instead of schools being "simply separate schools, forced on us by grim necessity" they could become centers of excellence, of a "new and beautiful effort at human education."[25] He wanted the control of teachers and textbooks to be

Figure 81. "The Argument for 'Jim Crow' Schools," by Lorenzo Harris. Reprinted from *The Crisis*, October 1926, p. 116.

Figure 82. "Little Man, What Now?," by Romare Bearden. Reprinted from *The Crisis*, August 1934, p. 237.

placed in the hands of black Americans to ensure the correct politics and attitudes and, therefore, excellence in education.

His larger point is about the self-esteem of African Americans. He wanted African Americans to believe in themselves and in their abilities. The cultural context for this is specific historically. Because so many whites, even scientists, were proclaiming that African Americans were inferior mentally, using all kinds of troubling arguments, the black community was left with very little room for maneuver. They felt that they continually had to prove themselves against a white standard.

> There was a time when the ability of Negro brains to first-class work had to be proven by facts and figures, and I was a part of the movement that sought to set the accomplishments of Negro ability before the world. But the world before which I was setting this proof was a disbelieving white world. I did not need the proof for myself. I did not dream that my fellow Negroes needed it; but in the last few years, I have become curiously convinced that until American Negroes believe in their own power and ability, they are going to be helpless before the white world, and the white world, realizing this inner paralysis and lack of self-confidence, is going to persist in its insane determination to rule the universe for its own selfish advantage.[26]

Having black teachers teach black children would be one of the best ways to help them believe in themselves: "A separate Negro school, where children are treated like human beings, trained by teachers of their own race . . . is infinitely better than making our boys and girls doormats to be spit and trampled upon and lied to by ignorant social climbers, whose sole claim to superiority is [the] ability to kick 'niggers' when they are down." Du Bois also noted that "certain studies and discipline necessary to Negroes can seldom be found in white schools."[27] Du Bois saw the need for separate schools as both an indictment of the white race for its failure to educate its fellow human beings and as a cultural haven where black children could learn about their culture in an environment that fostered healthy self-esteem.

Yet he understood that the issue was very complex. A "mixed school," as he called schools with both black and white students, might offer more educational opportunities, and in that sense, might look like the best choice. But if the teachers and the public were hostile and unsympathetic to African American students, then perhaps the best choice was a segregated school. But that option carried the possibility that teachers might be "ignorant placeholders" and that lack of funding would compromise the quality of education. In the end, it came down to one clear issue: "The Negro needs neither segregated schools nor mixed schools. What he needs is Education. . . . There is no magic, either in mixed schools or in segregated schools."[28]

In March 1934, Du Bois supported segregation in subsistence homestead colonies, which were designed to develop racial solidarity and economic cooperation during the Depression, a measure introduced by the federal government. The August 1934 cover was particularly striking: it shows a silhouette of a man shackled. The chains between his wrists span the composition as his long arms reach out. He resembles muscular WPA sculpture (fig. 83). Black figures create a band, or frieze, at the base of the composition; they include a sailor, a farmer with his pitchfork, a woman doing laundry with a washboard and tub, a fleeing figure who represents a slave trying to escape to freedom, and a carpenter with his tools. They all look toward or reach toward a figure in cap and gown. The figure of education has his chains are attached to him, but he holds a diploma and surges forward. The message is undeniable: education was the only way out of the effects of slavery and discrimination. The most elevated figure in the composition is the graduate, who will escape the fate of his ancestors. The irony in this cartoon is that it seems to highlight Du Bois's insistence on higher education as a solution the race problem and his support for all-black colleges, but inside, an essay by Langston Hughes contrasts sharply with Du Bois's position. In "Cowards from the Colleges," he offers a searing condemnation of black colleges for their accepting and even participating in segregation.[29]

Du Bois was committed to education as the way out of the vicious cycle of racism and lost opportunities. It was one of the more significant, encouraging, and upbeat messages *The Crisis* would relay to its audience.

LABOR

Labor and economic issues were integral to the advancement of the race.[30] The role of African Americans in what had become an industrialized and modern economy was intimately connected to their political situation. The issue of lost economic opportunities for the black worker crossed all political boundaries and appealed to the entire readership. Du Bois often discussed the training of black workers as well as the closed doors they faced in the marketplace. Over time, the emphasis became more clearly focused on using the growing economic power of African Americans to promote change. Du Bois understood the need for unions to organize black labor; he saw unionization as a potential politicizing tool. "Lynching, segregation and mob violence still oppress and crush black America but education and organized social political power begin to point the way out," he wrote.[31] Du Bois did not emphasize class difference between the black bourgeoisie and the black worker—he was more interested in promoting race solidarity despite his own personal class biases.

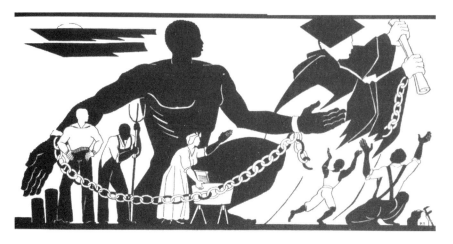

Figure 83. Untitled shackled man, by Prentiss Taylor. Reprinted from *The Crisis*, August 1934, cover.

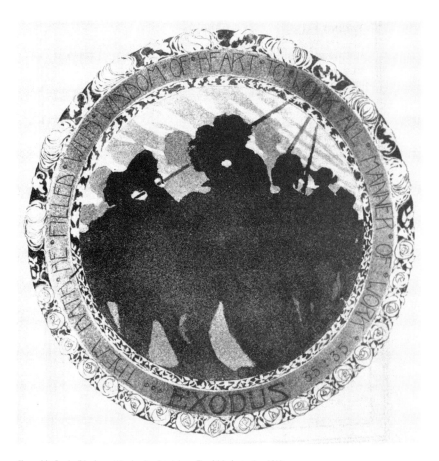

Figure 84. "Exodus," by Laura Wheeler. Reprinted from *The Crisis*, September 1919, cover.

A special labor number commenced in September 1919. The cover featured the profiles of black workers, layered in silhouette, tools slung over their shoulders, almost "marching" to work. The word "Exodus," a biblical reference and a reference to the black exodus from the rural South to the North, appears at the base of Laura Wheeler's drawing (fig. 84). The words "Them hath he filled with wisdom of heart to fill all manner of work" surround the round image, paying homage to the black worker, once again referencing the Bible. Du Bois provided the text "Labor Omnia Vincit" for this special labor issue, in which he wrote, "Labor conquers all things—but slowly, O, so slowly. . . . In this fight for Justice to Labor the Negro looms large. In Africa and the South Seas, in all the Americas and dimly in Asia he is a mighty worker and potentially, perhaps, the mightiest. But of all laborers cheated of their just wage from the world's dawn to today, he is the poorest and the bloodiest."[32]

Discrimination and prejudice continued to limit progress for black laborers. Du Bois pointed out that white laborers were not sure they wanted black laborers as fellow workers. He believed that they had some common interests but that racism divided them. They were not ready to accept black laborers into unions.[33] He wrote: "And there lies the most stupendous labor problem of the twentieth century—transcending the problem of Labor and Capital, of Democracy, of the Equality of Women—for it is the problem of the Equality of Humanity in the world as against white domination of black and brown and yellow serfs."[34]

Albert Alex Smith's "The Haunting Ghost of Negro Labor" of June 1925 shows an ignorant, muscular laborer in the foreground holding a large mallet, ready to crush the products of Negro labor illustrated in the front of the composition, which include a factory and a bridge (fig. 85). He does not want the black laborer to participate in the economic system. This is a recurring theme in *Crisis,* the desire of working-class whites to keep blacks from joining their unions, achieving economic success, a goal that was carried out through violence.[35] A strong, tall, erect figure of black labor looms in the background, undaunted by the crushing blows of white labor.

The cartoon "The Financial Stage of America" by Cornelius Johnson was included as a frontispiece and won a Krigwa first prize supplied by African American banks and insurance companies (fig. 86).[36] Full of racial stereotypes, it shows a theater-like setting, with steps leading up to wealth. At the base of the steps are the words "Good Times," then the riser of each step bears, in ascending order, "Education," "Patience," "Ambition," "Confidence," "Sacrifice," "Insurance," "Banking," "Finance," "Investments," "Business." At the top of the staircase is a white figure standing on mountains of money. Figures line the stairs on the way to the top, but only the white man makes it to the top—the rest only attempt it. This was the clear message of many of Du Bois's images and essays.

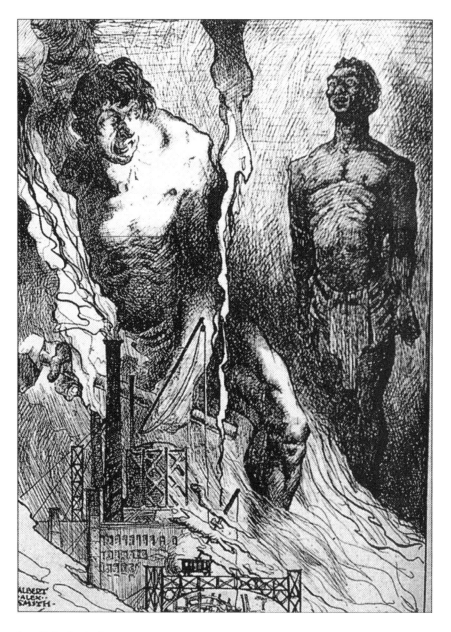

Figure 85. "The Haunting Ghost of Negro Labor," after an etching by Albert A. Smith. Reprinted from *The Crisis*, June 1925, p. 76.

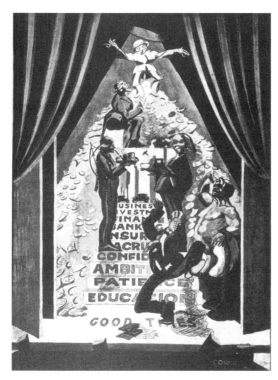

Figure 86. "The Financial Stage of America," by Cornelius W. Johnson. Reprinted from *The Crisis*, June 1929, p. 188.

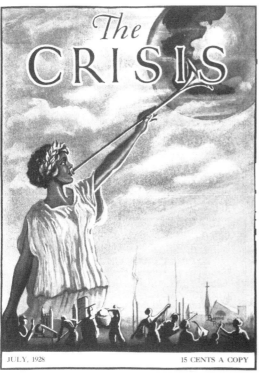

Figure 87. "Progress," by Bernie Robynson. Reprinted from *The Crisis*, July 1928, cover.

Whites dominated the economic world, blacks were shut out. But Du Bois's text is more hopeful than the visual imagery. In his text, he urges hard work, perseverance, and economic organization; in other words "Organize and fight back!" Johnson said he was quoting Shakespeare's "All the world's a stage." He said his cartoon could be described as follows: "On this stage, are all of the races in America; Jew, Caucasian, Indian, Mongolian and last but not least the Negro."[37]

Bernie Robynson's July 1928 cover "Progress" is pierced by a classically clad trumpeter with a laurel leaf wreath on her head; the trumpet and her outstretched arm cross the composition (fig. 87). A frieze of laborers forms a band across the base of the cover, including woodworkers, construction and agriculture workers, a soldier, a writer, and a musician. A figure in cap and gown is also included in the productive group. Behind the frieze stands the achievement of the black workers: a cathedral, a skyscraper, a factory, a school, and a small church. Robynson is employing heroic visual vocabulary to personify "progress" in the black community, achieved through education.

In April 1933, Du Bois wrote one of his more forceful columns about possible responses to the closed doors African American workers faced; he called it "The Right to Work." Du Bois noted that because of rapidly changing techniques in industry, it was practically impossible for "Negro industrial schools to equip themselves so as to train youth for current work." And with shops and apprentice systems closed to black Americans, the door of opportunity closed. The white industrial system in the United States was changing, and black laborers had to prepare for "a new organization and a new status, new modes of making a living, and a new organization of industry."[38] The only option left was economic self-sufficiency in the form of economic cooperation along racial lines. This was a radical proposition. It was also a somewhat bitter proposition—after decades of searching for allies, for a way to pressure white society to change its racist attitudes, Du Bois concluded that organization along racial lines was the only viable solution if change were to happen. He wrote

> Negro American consumers co-operation will cost us something. . . . It will mean years of poverty and sacrifice, but not aimless, rather to one great end. . . . But if we succeed, we have conquered a world. No future revolution can ignore us. No nation, here or elsewhere, can oppress us. . . . We open the gates, not only to our own twelve millions, but to five million West Indians, and eight million black South Americans, and one hundred fifty million more Africans. We stretch hands and hands of strength and sinew and understanding to India and China, and all Asia. We become in truth, free.[39]

Here he is advocating economic segregation, if you will—withdrawing black economic resources from white society and using them to build up black communities, both in the United States and abroad.

Du Bois's ideas about public ownership and state control of the economy became increasingly radical over time. Blacks needed to have power and learn the secret of economic organization. Having survived slavery, poverty, lynching, and other atrocities, black Americans remained in "good health and strength. We have brains, energy, even taste and genius. . . . Negro literature and art has been distilled from our sweat. There is no way of keeping us in continued industrial slavery, unless we continue to enslave ourselves, and remain content to work as servants for white folk and dumb driven laborers for nothing." His answer? "We can work for ourselves. We can consume mainly what we ourselves produce, and produce as large a proportion as possible of that which we consume." He encouraged black Americans to "establish a progressively self-supporting economy that will weld the majority of our people into an impregnable, economic phalanx."[40]

The motive for black Americans was a strong one. "We are fleeing, not simply from poverty, but from insult and murder and social death. We have an instinct of race and a bond of color, in place of a protective tariff for our infant industry."[41]

Du Bois related economics to every other problem that blacks suffered, and he covered all these issues in *The Crisis*. Art which referred to economic slavery was related to almost every other issue, including education, women's rights, poverty, lynching, and racism. Freedom could not be achieved without economic opportunity.

The November 1933 issue of *The Crisis* featured a cover that paid tribute to the "Black Miner" (fig. 88). Mining was one of the most physically demanding and dangerous jobs any man could do. The cover shows a simple woodblock-style cutout of a miner in silhouette. He leans on his mallet, deep in thought, exhausted and dejected. Bright light from his cap is used to emphasize the folds of his clothes, his arms, and his profile as he looks down. The outline of his body is echoed four times in the background in alternating black and gray shadows, a technique often employed by former *Crisis* art director Aaron Douglas. The only details offered are the folds on his garment, his facial features, and his ear. African American coal miners were fiercely loyal union members, even in the face of discrimination from union leadership. They were important to the mining industry in the South.[42]

The Depression brought an increase in pages devoted to labor in *The Crisis* and an increase in political cartoons and photographs featuring successful black laborers and black businessowners. Although all workers suffered during the hardships of the economic crisis, black workers, who already had many doors closed to them, faced nearly insurmountable obstacles. The American Federation of Labor, one of the strongest unions in the country with over 1 million

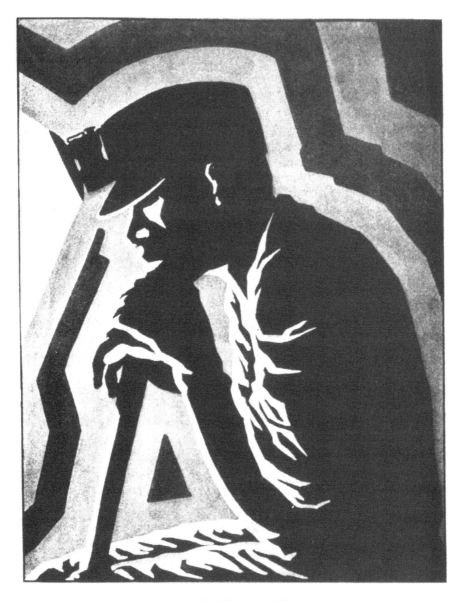

Figure 88. "Black Miner," by J. E. Dodd. Reprinted from *The Crisis*, November 1933, cover.

members, organized along craft lines; that is, it organized skilled workers. Du Bois wrote in 1933: "It is a petty bourgeois organization, with all the ideals of the small capitalists and with the desire and program to increase the wages of a small class of skilled and favorably situated laborers at the expense of the mass of the working people."[43] Unskilled workers were left to find their own way in the new industrial economy until the birth and phenomenal growth of the Congress of Industrial Organizations.[44]

The AFL insisted that it did not discriminate against blacks, a claim Du Bois exposed as "a flat and proven falsehood. . . . They keep Negroes out of every single organization where they can. . . . Their officials have repeatedly refused to sit down with black men and discuss ways and means by which race prejudice within the labor movement could be abated. Whenever any trade union within the A. F. of L. does receive Negro laborers, it does so against the policy of the . . . leaders, and it is encouraged to discriminate against the Negroes."[45] The March 1934 issue illustrates this reality with a giant figure, a labor leader labeled "A.F. of L.," holding puppet-like workers by strings, "The Trade Unions," who are jeering at a black worker, a carpenter who likely is a skilled laborer who would be technically eligible to join their union (fig. 89). The black worker is dressed in overalls, ready to work, a full toolbox in his hand, but he is shut out by the white unions. The white workers who symbolize the trade unions are depicted as children; they stick out their tongues and thumb their noses at the black laborer, who is shown as dignified and patient. The union members hold a shovel with the word "Ritual" on it and a document, "By-Laws," in their hands; their behavior makes a mockery of the "official" policies of the union. The labor leader, who indulgently chides "Boys—Remember Our Constitution!" while doing nothing to stop the behavior of the rank and file.

Accompanying the cartoon was an article about Boulder Dam (later renamed Hoover Dam) written by Leland Stanford Hawkins, an African American man in Los Angeles, California. Construction of the dam was one of the largest federal public works projects of the Depression years, and thousands of unemployed workers flocked to the site, hoping for employment. Almost all the blacks who went were turned away; only after pressure did the construction consortium, Six Companies, hire a token number of thirty African Americans among the thousands of whites.[46] Hawkens wrote that the massive project was not a symbol of industrial development; rather, it was a symbol of race prejudice. The black laborers couldn't even live in Boulder City, the housing provided for workers. The supervisor who managed the few blacks said he was going to put "darkies to work when jobs occur where they won't come in contact with the white men," and he put them to work in the harshest conditions. He gave them

Figure 89. "Boys—Remember Our Constitution!" Reprinted from *The Crisis*, March 1934, p. 73.

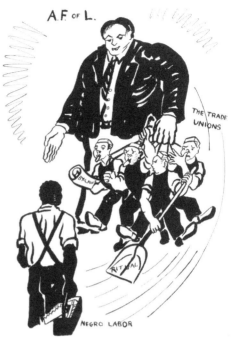

Figure 90. "No Help Wanted," by Romare Bearden. Reprinted from *The Crisis*, April 1934, p. 105.

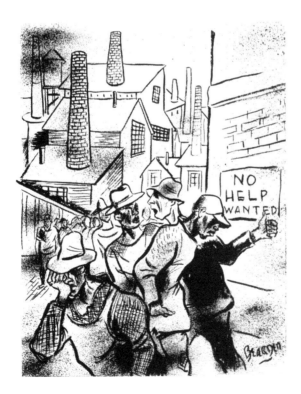

bagged water so they wouldn't use the drinking fountains, separate toilets, a separate truck to ride in, and a separate dormitory where the conditions were deplorable. The black laborers were forced to join the "Negro Laborers' Protective Association," a company union at a cost of $12 if they wanted to work on the dam. The project directors denied any discrimination, stating they would have been happy to employ such labor, since "Negro, Coolie or peon labor would be preferred not only because it is the cheapest labor but also the least troublesome."[47]

An April 1934 cartoon drawn by Romare Bearden shows a long line of black workers and a simple sign posted on the wall to which a white man in a suit points: "No Help Wanted" (fig. 90). Dejected workers hold their faces in despair, their eyes downcast. By 1934, a staggering 21.6 percent of the labor force was unemployed, but African Americans were hit even harder.[48] Their unemployment rate was approximately 50 percent nationwide.[49] The final labor cartoon under Du Bois's editorship was another Bearden cartoon published in July 1934, "The Picket Line" (fig. 91). Instead of merely recording the economic distress of his community, Bearden suggests action. The cartoon shows a collage of headlines: "Owners Tell Minister They Will Not Employ Negroes As Clerks," "Admit 75 Per Cent of Trade Is Derived from Colored Patronage," "The Jobless Negro," and more. Bearden drew a huge group of black protesters holding signs that said "Begin to Trade Where You Can Also Find Work," "Give Us a Job!" and "Negro Consumers." Here the picket line is not one of striking workers; these picketers are African American consumers who refuse to buy goods from businesses that will not hire them. It is interesting to note that even though women were the primary consumers, men were depicted as the visible leaders in these images. This is early evidence of the strategy of the consumer boycott that Martin Luther King, Jr., would use so effectively decades later in the civil rights movement.

The Crisis offered columns of statistics on wages, types of work offered, photographs of unemployed workers, and success stories, including a growing interest by some companies in the "Negro market." Du Bois became an increasingly militant supporter of the black laborer on the pages of *The Crisis*. He hoped his essays and the visuals could address the black laborer's exclusion from work while highlighting successful black businesses as a form of inspiration.[50]

WAR AND THE MILITARY

One of the most controversial positions W. E. B. Du Bois ever took as editor of *The Crisis* was his full support for American involvement in World War I.

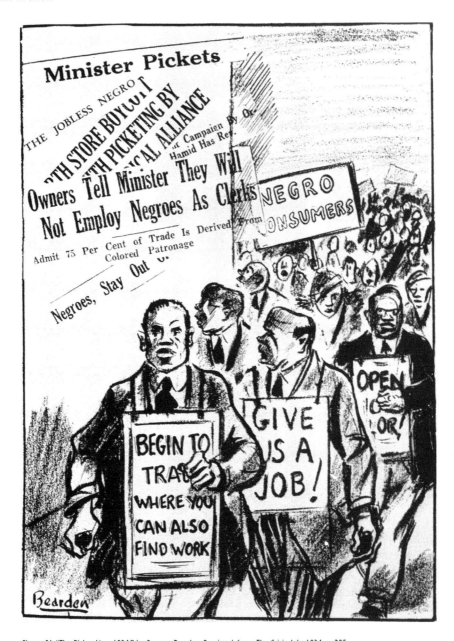

Figure 91. "The Picket Line, 1934," by Romare Bearden. Reprinted from *The Crisis*, July 1934, p. 205.

As did contemporary observers, historians still bitterly debate Du Bois's "Close Ranks" editorial in July 1918, which urged that blacks "forget [their] special grievances and close ranks" with white Americans and the Allies for the duration of the war.[51] David Levering Lewis, who does not doubt that Du Bois believed in the importance of an Allied victory, thinks he wrote the editorial to gain an army commission.[52] Historian Mark Ellis strongly criticizes Du Bois's position, arguing it was "serious misjudgment" that "harmed the struggle for equal rights."[53] William Jordan defends Du Bois, arguing that he took a "pragmatic" stance and that "Du Bois was not simply hopeful about what would happen if blacks supported the war unconditionally, he was also fearful of what would happen if they took any other course of action."[54] The imagery in *The Crisis* supports Jordan's perspective, reflecting both the support Du Bois gave to the war effort and his hope for change in America as a result of the war. The magazine had reached its sought-after monthly circulation of 50,000, and the threat of wartime censorship and restriction was certainly apparent.[55] Theodore Kornweibel's recent study highlights the degree to which the Bureau of Investigation (an early name for the FBI) began scrutinizing *The Crisis* in late 1917; some agents believed that "every word is loaded with sedition."[56] In May 1918, Du Bois told the NAACP board that "the Department of Justice has warned us against the tone of some of the articles in Crisis."[57]

In reality, government authorities would by late summer 1918 conclude that *The Crisis* was "the most well-balanced and sane" of the black periodicals. Perhaps one factor in their thinking was its visual representation of both soldiers and the war. The images Du Bois chose to use emphasized his view that black patriotism and loyalty to the war effort would be rewarded with an end to segregation and discrimination.[58] Even before the war, images of soldiers appeared frequently in *The Crisis*. The first soldier to appear on the cover was a photograph of army captain Charles Young in February 1912.[59] Young was handsome, educated, and articulate and one of Du Bois's first real male friends. He was the son of slaves and the third African American graduate of West Point.[60] Du Bois was his ardent supporter. In the early years of *The Crisis,* images of soldiers usually appeared in the form of photographs (that included both soldiers in the United States and around the world), sometimes as a part of the "Man of the Month" column. Unlike some progressives who abhorred military service, Du Bois had no qualms about honoring black participation in the peacetime military, even though it remained strictly segregated.

After America's entry into the war in April 1917, Du Bois sought to ensure black participation. When it appeared that black men might not be serving on the battlefront and for the first time since the founding of the Republic would

not be allowed the "privilege of dying alongside" white soldiers, Du Bois became committed to ensuring a place for black officers in the war effort.[61] The army leadership had "profound hostility" to the idea of a black officer group, and it required political pressure from the NAACP to ensure that some blacks would serve as officers.[62] (Du Bois's own father had served in the Union army, although without distinction.[63]) Du Bois also hoped to achieve better conditions for soldiers, and despite his opposition to segregation, he ultimately supported the creation of such a segregated camp for black soldiers. Conditions in the segregated camps were particularly bad in the South, where black troops endured poor clothing and inferior dining, housing, and working conditions.[64] Yet in Du Bois's view, all that was surely preferable to being denied participation. David Levering Lewis has noted that Du Bois was expected to cry "racism" and to fight against a separate camp, but instead "his very powers as propagandist appear to have pushed him in the other direction, as if to preclude the possibility that his renown might be exploited in order to stigmatize African Americans as whining, divisive and unpatriotic." Du Bois planned to take up the cause for complete integration of African American soldiers once the war was over.[65]

Although *The Crisis* had been sharply critical of the mistreatment of blacks within America, Du Bois now chose images that affirmed African American loyalty to the United States. As historian Mark Lewis's recent study makes clear, the belief that "blacks were a weak link in the political, economic, and military cohesion required for total war" was widely shared within Woodrow Wilson's administration.[66] Government spying and surveillance of black leaders and organizations was intensified because of fears of pro-German or pacifist sentiments among blacks.

The Crisis countered this fear, though not without some ambiguity. One striking example was the cartoon by Lorenzo Harris, "In Spite of Submarines" (fig. 92), which appeared in June 1917.[67] A giant warship, occupying three-quarters of the composition, was shown floating with a submarine beside it. Three scuba divers attached to the submarine are diving under water; they are labeled "Prejudice," "Lynch Law," and "Segregation." The giant warship is labeled "US Negro. Patriotism and Loyalty." The artist is comparing prejudice, lynch law, and segregation to the most feared new weapon of warfare in World War I, the U-boat. Divers are drilling holes in the side of the ship. The cartoon is saying that black patriotism must constantly face the assault of racism.

Several covers depicted African American soldiers in battle in a heroic, patriotic, and highly masculine context. The July 1917 cover showed a drawing of African American soldiers behind their machine guns and bayonets, one soldier

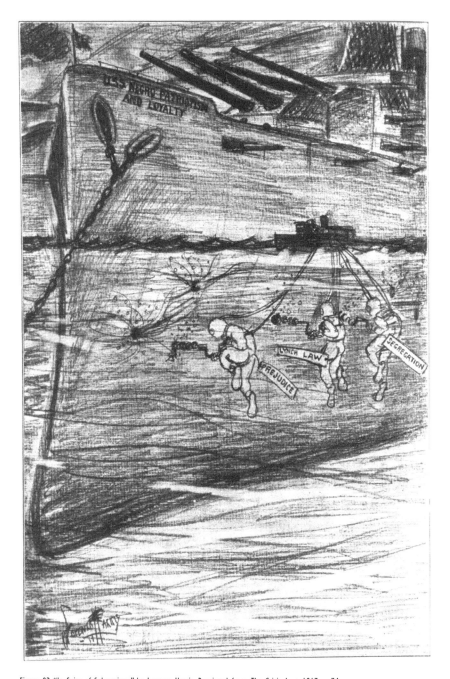

Figure 92. "In Spite of Submarines," by Lorenzo Harris. Reprinted from *The Crisis*, June 1917, p. 74.

searching for the enemy with binoculars, proud and determined, fearlessly serving under a large American flag waving in the breeze (fig. 93). The three soldiers lead us back in traditional perspective to the flag; a wave of the flag touches the third soldier's hat. Explosions sound in the background, but the soldiers are not afraid. Although U.S. soldiers were not engaged in combat until later in the year, they were already conducting training exercises. The cover meant to make readers aware of the well-trained, proud, and brave African American soldiers who would serve their country in battle. In sharp contrast to images of war that were then prevalent in Europe, which emphasized the brutality and mutilation of war, images of war in *The Crisis,* indeed most American images of war, emphasized bravery, patriotism, and loyalty;[68] American soldiers had not yet experienced the trench warfare and bitter realities the Europeans had. These images fit in well with Du Bois's desire to show the best and the brightest of African Americans.

These patriotic images were further amplified by their connection to traditional gender roles. In the September 1917 issue Jessie Fauset provided a poem, illustrated by Laura Wheeler, about the "women left behind" (fig. 94). A young woman, formally attired in a long gown with pearls around her neck, her hair swept up in a chignon, sits all alone on a bench in the garden, thoughtful and silent. Fauset's poem reads:

> Again it is September!
> It seems so strange that I who
> made no vows
> Should sit here desolate this
> golden weather
> And wistfully remember—
>
> A sigh of deepest yearning,
> A glowing look and words that
> knew no bounds,
> A swift response, an instant
> glad surrender,
> To kisses wild and burning!
>
> Ay me!
> Again it is September!
> It seems so strange that I who
> kept those vows
> Should sit here lone, and spent,
> and mutely praying
> That I may not remember![69]

Some 400,000 blacks had entered the military; 200,000 were sent to France and 30,000 were on the front lines.[70] This type of romantic war imagery, depict-

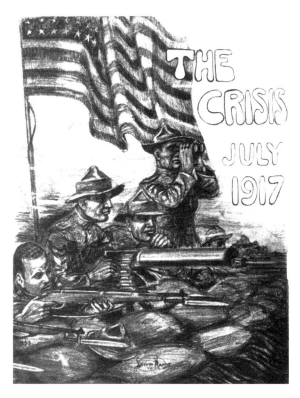

Figure 93. Untitled soldiers in battle, by Lorenzo Harris. Reprinted from *The Crisis*, July 1917, cover.

Figure 94. Untitled drawing by Laura Wheeler. Reprinted from *The Crisis*, September 1917, p. 248.

ing the woman left behind who awaits the return of her man, could be shared by blacks and whites alike and foreshadows, at least symbolically, the "'closed ranks" of Du Bois's editorial. It underlines the emotional depth of his commitment to the war effort and the degree to which he was willing to take a more accomodationist stance during the conflict.

But *The Crisis* did not wholly lose its critical edge during the war. In June 1918, Du Bois introduced a yearly magazine number dedicated to soldiers. In these special issues, wartime concerns were often tied to issues of freedoms denied at home. In the 1918 issue, "War, the Grim Emancipator" the silhouetted outline of a soldier, "War," holds his weapon as he faces the reader (fig. 95). A black man is on the left hand of the composition, holding his hammer/mallet in his hand, moving forward, standing on the rock of "Economic Slavery." A broken shackle of slavery dangles from his wrist. Behind him, "The War" holds the knife of "War Work" which severs his shackles. The war had increased black income and economic power temporarily, yet *The Crisis* recognized that the transformation in African American lives had been paid for by a huge cost in black lives.

William Edward Scott's, "At Bay" of November 1918 shows a black soldier with pistol in hand, fallen but still holding the American flag. Even with pain crossing his face, he is proud and brave (fig. 96). The wrist which holds his pistol is bandaged. The barbed wire of the European trenches divides the composition behind him, and soldiers are in the background still fighting. The barbed wire represents trench warfare and the realities of war, including the suffering of the wounded and sacrifice of lives. The wire isolates the soldier in the front of the composition, thereby emphasizing him. Scott depicts the patriotic, heroic masculine black American soldier, willing to sacrifice his life to serve his country. It reflects an imagery central to American civic religion, later enshrined in the flag-raising statue of Iwo Jima and even the post-9/11 actions of firefighters at the World Trade Center.

However, the end of hostilities in November 1918 brought a gradual shift in Du Bois's perspective. The great hopes that he and other black leaders had that the war to make the world safe for democracy would bring democracy to America were bitterly disappointed. The violence in northern cities, epitomized by the Chicago race riots of 1919, was paralleled by an upsurge in lynching in the South; ten of the victims were returning black veterans.[71] Despite considerable examples of heroism and significant casualties in France, black soldiers were smeared by some white army officers as cowardly and their achievements denigrated.[72] As Emmett Scott, an African American official in the War Department put it, "As one who recalls the assurances of 1917 and 1918 . . . I confess personally a deep sense of disappointment, of poignant pain that a great coun-

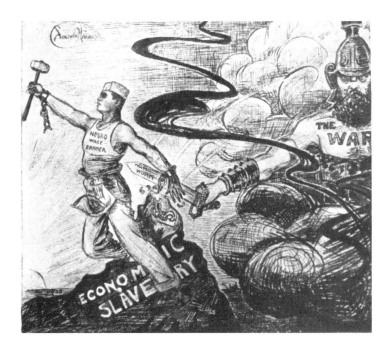

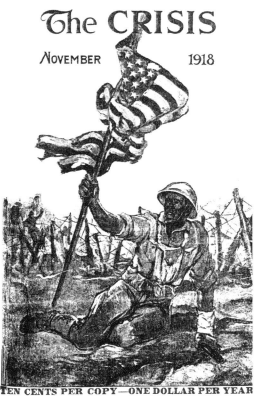

The CRISIS

NOVEMBER 1918

TEN CENTS PER COPY—ONE DOLLAR PER YEAR

Figure 95. "War, the Grim Emancipator," by Lorenzo Harris. Reprinted from *The Crisis*, June 1918, p. 72.

Figure 96. "At Bay," by William Edward Scott. Reprinted from *The Crisis*, November 1918, cover.

try in time of need should promise so much and afterward perform so little."[73] Du Bois shared these sentiments of disappointment and betrayal, and the imagery he chose reflected these views. The May 1919 cover of *The Crisis* featured a Lorenzo Harris work depicting bravery in action with his African American soldier lunging forward with a knife in one hand, his bayonet leaning against a giant crest behind him. The crest, which the soldier is engraving, reads "The American Negro's Record in the Great World War: Loyalty, Valor, Achievement." His figure echoes this sentiment. The soldier's face is in profile, and his body is parallel to the picture plane, highlighting his uniform and strong build. An American flag is draped over the crest and an eagle graces the top of it. He is brave, strong, and aggressive in battle (fig. 97). The image was accompanied by an editorial by Du Bois on "Returning Soldiers." The cover was meant to draw the reader in, to note the loyalty and bravery of black soldiers, and then to absorb the results of this loyalty, through the eyes of Du Bois, inside the issue. This was at the height of *The Crisis's* circulation, which reached over 100,000 in August of 1919; both blacks and liberal whites would see this image and read Du Bois's editorial.

The editorial and the cartoon refuted the libels against black soldiers and to renewed Du Bois's call for action:

> We are returning from war! The Crisis and tens of thousands of black men were drafted into a great struggle. . . . [W]e fought gladly and to the last drop of blood; for America and her highest ideals, we fought in far-off hope; for the dominant southern oligarchy entrenched in Washington, we fought in bitter resignation. For the America that represents and gloats in lynching, disfranchisement, caste, brutality and devilish insult—for this, in the hateful upturning and mixing of things, we were forced by vindictive fate to fight, also.[74]
>
> But today we return! We return from the slavery of uniform which the world's madness demanded us to don to the freedom of civil garb. We stand again to look America squarely in the face and call a spade a spade. We sing: This country of ours, despite all its better should have done and dreamed, is yet a shameful land.

Du Bois didn't regret the decision to fight:

> But by the God of Heaven, we are cowards and jack-asses if now that the war is over, we do not marshal every ounce of our brain and brawn to fight a sterner, longer, more unbending battle against the forces of hell in our own land.
> We return.
> We return from fighting.
> We return fighting.
> Make way for Democracy! We saved it in France, and by the Great Jehovah, we will save it in the United States of America, or know the reason why.[75]

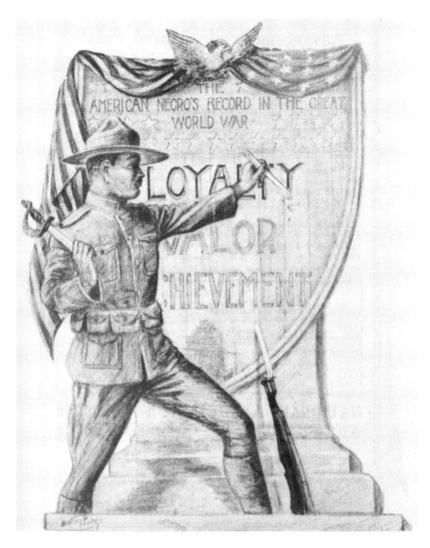

Figure 97. "The American Negro's Record . . . ," by Lorenzo Harris. Reprinted from *The Crisis*, May 1919, cover.

Yet Du Bois would remain disappointed; the war seemed to yield little in the way of improvement in the status of African Americans.

A January 1920 cartoon sums up these feelings, showing a fat white patriot (or a European caricature of an excessive American) dressed in flag-inspired attire turning to a wounded black soldier who has exaggerated features (fig. 98).

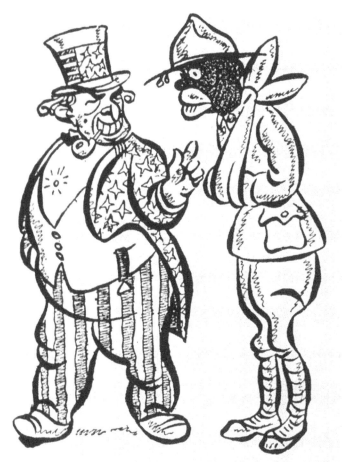

"JOHNATHAN: It's very simple, Bill; in war-time you must rush ahead; now you stay in the rear."

From *Lustige Blaetter*, Berlin;
also copied in *Le Rire*, Paris

Figure 98. Untitled cartoon from Lustige Blaetter (Berlin) and Le Rire (Paris). Reprinted from *The Crisis*, January 1920, p. 143.

He is tired and dejected. The white man explains: "It's very simple, Bill; in war-time you must rush ahead; now you stay in the rear." The cartoon was reprinted from Berlin's *Lustige Blaetter* paper and also appeared in *Le Rire* in Paris. The European artist used caricature for both figures, a fat white racist and a black soldier with full lips and very dark skin. The Germans were noting the hypoc-

risy of Paris, London, and Washington. Europeans had to deal with the fact that they had used African soldiers and promised reforms in arrangements with their colonies. Du Bois reprinted the cartoon, recognizing that Europeans better understood better than most Americans the predicament of African American soldiers and recognized that promises made to them had been broken.

For the rest of his life, Du Bois would note again and again that few advances were achieved by black military participation. After Pearl Harbor, as Lewis notes, Du Bois had no desire to recapture the moment of "Close Ranks." He regretted the war with Japan, opposed the internment of Japanese Americans, and made only a subdued call to duty: "We fight not in joy but in sorrow with no feeling of uplift; but under the sad weight of duty and in part, as we know to our sorrow, because of the inheritance of a slave psychology which makes it easier for us to submit rather than to rebel. Whatever our mixed emotions, we are going to play the game."[76] Du Bois had hoped that through military service, black Americans would be welcomed back as full participating members in American society, as equals. He hoped their valor and hard work would pay off in tangible improvements in daily life. The images he used in *The Crisis* affirm the strength of his conviction, emphasizing a very traditional and patriotic vision of wartime sacrifice. The harsh disappointment of his hopes, the reality that "we saved democracy in France" but could not bring it back to the United States, make his embrace of such traditional images all the more ironic. Du Bois had closed ranks but, like black veterans, faced rejection from the very country he wanted to defend.

WOMEN, THE FAMILY, AND CHILDREN

W. E. B. Du Bois was a lifetime supporter of women's rights in the public arena. He wrote essays, books, editorials, and reviews and gave numerous speeches that featured arguments supporting equal rights for women in their daily lives and the right for women to vote. As historian Bettina Aptheker has pointed out, Du Bois was not unique among black men in his efforts to humanize women.[77] Pride in womanhood was an important part of the black experience, and tributes to black women were common in the latter part of the nineteenth century.[78] Du Bois and other black intellectuals understood that the abuse suffered by black women under slavery, including sexual abuse, formed a large part of the black experience in the United States and needed to be understood. In one of his most famous books, *Darkwater,* Du Bois wrote passionately that while he could "forgive" the South its "so-called 'pride of race,'" the "one thing I shall never forgive, neither in this world or the world to come: its wanton and continued and persistent insulting of the black womanhood which

it sought and seeks to prostitute to its lust."[79] Du Bois knew black minister Alexander Crummell well and greatly admired his lectures on the abuses that black women suffered under slavery. Crummell spoke of the black woman's loss of innocence, the sexual abuse she suffered and the fact that she was used as a breeder of slaves for field labor and for the auction block.

Du Bois's youth profoundly affected his view of women. Shanette Harris has noted that early in his childhood Du Bois was placed in the role of caretaker for his mother and was expected to carry out this job in an adult manner. There was tremendous pressure on the young man to succeed and to please his family. His desire to succeed and excel was influenced by his distant mother and by his experiences of powerlessness and rejection by classmates in his youth.[80] This was underlined by an incident when Du Bois sought to exchange calling cards with a young white girl but found that she had rejected his card. This young woman was another reason he realized that he was shut out of the white world by a "vast veil"; the incident may have influenced his future dealings with women. As David Levering Lewis has documented, Du Bois was a chronic womanizer. His affairs were frequent and were not well concealed. At home, his publicly expressed view of women as equals who bore the burden of racism and sexism was not practiced; his wife, Nina, played the part of "effaced and dutiful wife," as per Du Bois's expectations, and his daughter, Yolande, was largely controlled by her father, whose hopes for her were "exalted and unrealistic."[81] Yolande also carried the burden, as the only surviving child, of the loss of her parents' first-born child. Du Bois expected that his wife, although college educated, would take care of his needs above all else. Many similarly educated African American women chose to teach African American children, to help uplift the race.[82] Nina was not given this option; her place was as a homemaker who cared for her husband and child.

Du Bois's contribution to the struggle for women's emancipation has been described as threefold: he originated theoretical ideas on the nature of woman's oppression and liberation, he gave practical and consistent support to the woman's rights movement, and he focused special attention on the particular suffering of black women.[83]

Du Bois could be a highly controlling individual, both at home and in the workplace. He ran a very tight ship at *The Crisis,* and although prominent women in his editorial offices, such as Jessie Fauset, had important responsibilities, he did not regard them as equals. His relationship with women poses a paradox. In his own home, he maintained the late Victorian posture of the controlling patriarch, but at the same time he was publicly a strong advocate of women's rights.

Du Bois supported the education of women, the right to vote, and the right to have a choice of career. He even supported women's right to choose motherhood or opt not to have children through birth control. Du Bois hoped that men could achieve liberation from the "freedom" to dehumanize and plunder woman. He understood the painful irony that black women had achieved an unprecedented equality with men in slavery by laboring next to them in the fields and enduring the same harsh punishments. Such life experiences placed black women in a position to provide good leadership for woman's emancipation and could have a vast influence on the women's movement. While Du Bois was not totally successful in showing black men the plight of black women with the same clarity as he did when he discussed racism,[84] he was still successful in bringing some of the major issues of the day confronting women to the forefront.

Suffrage

Through his efforts to support woman's suffrage, Du Bois tried to develop a relationship with the organized women's rights movement; he wanted to make links between the struggle to free black people and the struggle to get the vote for women.[85] The greatest obstacle to this was white racism within the women's movement, which attempted to prevent black men from voting for women's suffrage.[86]

Many white suffragettes opposed black women's suffrage in order to gain political support for their cause from the South. Some arguments for women's suffrage stated that if black men and paupers were allowed to vote, why not educated women?[87] This was the kind of racist argument that might garner support from white southern men. Du Bois believed that all people had the right to vote, not merely the educated. Some of Du Bois's suffrage speeches were published by the National American Woman Suffrage Association. Du Bois understood that many supporters of the movement, both men and women, only supported a white woman's right to vote. He maintained strongly, "Let every black man and woman fight for the new democracy which knows no race or sex."[88]

Du Bois devoted two issues of *The Crisis* to suffrage. He often included editorials urging black men to support a woman's right to vote.[89] He explicitly rejected the view that men were superior to women. Yet he also accepted the social stereotype of women as a civilizing force.

> The ancient idea that boys are intrinsically and naturally better than girls is a relic of barbarism that dies a hard death. We must, however, insist on reminding ourselves that the idea is uncivilized and pre-historic and rooted in a day when women were owned and men their owners by force or theft. Many

things still remind us of that stage of culture: the loss of a woman's name by her marriage; the persistent idea that a married woman should not have a career; and the older opposition to women suffrage. In other words, the continued inferiority of women in work and wage and certain phases of social esteem is at the bottom of this supposed preference for boy children. And this is especially pronounced among primitive and ignorant people.

On the other hand there are certain distinct advantages in girls. They contribute to the home, in the first ten or fifteen fateful years, far more than boys. They become the intimate and loving part of its organism, its work and play and decoration. They are educated and trained in the home by parents and chosen guests, while the boy, despite every effort, gets his chief training on the streets and even in the gutter. The girl stays tame while the boy wanders wild and even in the re-creation of life; it is the Mother and not the Father who counts most and this all ancient civilizations—Egypt, Indian and West Africa—knew.[90]

Du Bois knew that the suffrage movement for women was connected to racism and prejudice, and he confronted his readers with this confluence. Some black male leaders, as David Levering Lewis has pointed out, "connected the issue of votes for women with the unhappy memories of their nineteenth-century collaboration."[91] Many men felt that the nineteenth-century collaboration with white women suffragists had not been a smooth partnership. And white women suffrage leaders did not make it any easier to contemplate alliance in the twentieth century. Anna Howard Shaw, president of the National American Woman Suffrage Association, was quoted in the October 1911 *Crisis* as stating: "Do not touch the Negro problem. It will offend the South."[92] In other words, she wanted people to work for *white* women's votes, not black, since including blacks in the equation might weaken political support for white women's suffrage, or so the argument went. Du Bois feared that the battle cry was rapidly becoming "Votes for White Women Only."[93] Yet even in the face of such racism, he would not abandon the cause; it mattered deeply to him and he continued to include it in the pages of *The Crisis,* showing his sizeable readership the duplicity of white leaders in the suffrage movement.[94] Five years later, Shaw reversed her opinion and supported all women's right to vote. Du Bois published this, too, in *The Crisis.*

The August 1915 issue featured Lincoln as a symbol of freedom that could only be achieved through the vote (fig. 99). An elderly Sojourner Truth, her hair wrapped in a kerchief and shawl over her shoulders, a symbol of the strong black woman, is sitting in front of an open book, her hand reaching out as if to present the book to us. Behind her is the image of Abraham Lincoln, looking down, his hand on the pages of the book. This is related to Du Bois's effort in 1911–1912 to revive the alliance between "women and Negroes."[95] Abraham

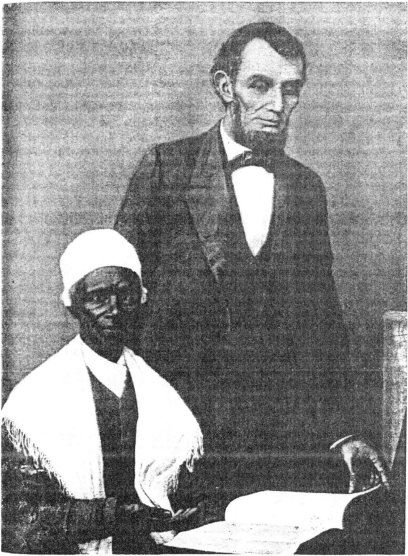

AUGUST
1915

THE CRISIS

AUGUST
1915

VOTES FOR WOMEN

Figure 99. "Votes for Women." Reprinted from *The Crisis*, August 1915, cover.

Lincoln's image was a common symbol of emancipation in the visual arts. It recalls Henry O. Tanner's famous portrait of two elderly people looking at the portrait of Lincoln. Tanner's painting shows Lincoln watching over black Americans; he is an icon of freedom and emancipation. Inside the issue, Du Bois's text showed the commitment of black leaders to women's rights.

The Family

The NAACP received numerous requests in the early years of the publication of *The Crisis* to establish a children's department, and accordingly, the NAACP established a committee to review the possibilities. In the interim, Du Bois established special annual issues devoted to children's issues: the children's number, the education number, and, later, the *Brownies' Book. The Crisis* included information important for growing families and for children. He recognized the unique problems faced by the parents of black children in a racist society and offered both warnings and solutions to parents. Du Bois featured, for example, in October 1911 a "Children's Number" for the "true brownies." This interest in children Du Bois felt, "makes the widest appeal to our readers."[96] Du Bois wanted to build an audience from the ground up and was always mindful of the youngest members of his readership. He wanted to educate children, to encourage them to care for others and not learn hatred for other races. Visual images in these special issues were uplifting and positive reminders of the importance of children and the duties of parenthood.

The first issue of *The Crisis,* November 1910, with its image of the child with the hoop and stick, announced a visible interest in children. Du Bois worried considerably about how to present the issues of racism and discrimination to African American children. Later he wrote: "To none can this be truer than to the children of the darker world who hold in their little hands so vast a destiny. They will look back some day in wonder at their files of *The Crisis* and say, can these things be true? Was not this exaggerated? Little realizing that the editor must palliate and soften the awful truth even for his darkest readers less they sicken and fail and die."[97]

Du Bois used *The Crisis* to celebrate children and to discuss issues important to them, his "Children of the Sun." He also often included examples of the horrors which children suffered, reminding his readers in *The Crisis* of the plight of black children. Usually these statements did not include commentary, they just stated the facts.[98] The December 1910 issue, the second issue published, featured a drawing of a child, this time in the hands of its mother, by John Henry Adams, who had illustrated *Negro Voice* in Atlanta. Both look out at the viewer.

The Crisis tried to show its readership that involvement in the important political issues of the day was a step toward creating a bright future for their children, a future that was in jeopardy in the political and social environment of the day. But it also recognized the intractable character of racism, as evidenced by "The Drop Sinister," one of the more interesting images reproduced in *The Crisis* (fig. 100). At first glance, the painting by Harry W. Watrous, which was exhibited in 1915 at the New York Academy of Design, seems to show a family at a dinner table. Two parents sit at the table, the father deep in thought while he reads the newspaper *The Christian.* A golden-haired child stands beside her mother's chair, looking up at her as if to question her. The mother does not meet her child's gaze; she stares straight ahead in abstraction. A portrait of Lincoln hangs behind them on the wall. On the mantle over the fireplace is the biblical text "And God said, Let us make them in our image after our likeness." Lest the reader confuse the meaning of the cartoon, Du Bois explained "The Drop Sinister." "The people in this picture are all 'colored;' that is to say the ancestors of all of them numbered among them full-blooded Negroes. These 'colored' folk married and brought to the world a little golden-haired child: today they pause for a moment and sit aghast when they think of this child's future. What is she? A Negro? No, she is 'white.' But *is* she white? The United States Census says she is a 'Negro.'"[99] "What earthly difference does it make what she is, so long as she grows up a good, true, capable woman? But her chances for doing this are small! Because 90,000,000 of her neighbors, good, Christian, noble, civilized people, are going to insult her, seek to ruin her and slam the door of opportunity in her face the moment they discover *The Drop Sinister.*"[100] The painting is particularly moving to the viewer because the purpose of it is not obvious until the text is read, making it more shocking. Although it appears to be just an average family portrait, the deeper meaning of the painting is quite profound and tragic.

The Crisis also paid tribute to motherhood with a photo of a young mother holding her baby on her shoulder in a loving pose, reinforcing the woman's position as main caregiver of the family. Yet Du Bois also understood the pressures of motherhood, both physical and mental, and encouraged careful family planning. This insistence was related to the high infant mortality rate among blacks. Du Bois lamented the unnecessary death of so many infants in the black community. "The remedy is, first, care and forethought in bringing children into the world and, second, pure food and air for them when they come."[101]

The idea of the mother as a protector is particularly poignant in John Henry Adams's cartoon, "Woman to the Rescue!" in the May 1916 issue (fig. 101). A woman raises a large club while her two young children, a boy and girl, cling to her long skirts. The club, labeled "Federal Constitution," is swinging at horrible

Figure 100. "The Drop Sinister," after the painting by Harry W. Watrous. Reprinted from *The Crisis*, October 1915, pp. 286–287.

Figure 101. "Woman to the Rescue!," by John Henry Adams. Reprinted from *The Crisis*, May 1916, p. 43.

birds swooping down to attack her and her children. She attempts to beat off the advances of "Jim Crow Law," "Segregation," "Grand-Father Clause," "Seduction," and "Mob." A black man in a traditional southern suit and top hat runs away. He states, "I don't believe in agitating and fighting. My policy is to pursue the line of least resistance. To h— with Citizenship Rights. I want money. I think the white folk will let me stay on my land as long as I stay in my place . . . (Shades of Wilmington, N.C.)"[102] The good whites ain't responsible for bad administration of the law and lynching and peonage, let me think awhile, er—." The black woman battles the forces of evil alone, with no support from the black male. She will fight her own battle to the end.

Albert Alex Smith drew the June 1925 *Crisis* cover "Negro Family under the Protection of the NAACP." The NAACP figure, who has wings and laurel leaves in her hair, provides a protective arm around a child, who is held also by her mother. The father sits at the base of the group. The figures are linked together, and the viewer follows the angel-like, perhaps white, allegory of the NAACP, down through child, mother, and father. The placement of the group on a black background gives the drawing emphasis (fig. 102).

Du Bois was proud of his children's number, but he realized that this popular yearly issue of *The Crisis* was not enough. He lamented that he also had to record the horrors committed against the black race in nearly every children's number. It was "inevitable" for *The Crisis* to record such events, but he worried about the effects it would have on the children who read it. He wondered if it would educate them in human hatred.

Vivian Schuyler provided the cover for the "Childrens' Number" in the October 1929 issue. It showed the profile of three children, one playing with a bubble pipe, one eating ice cream, one playing with a doll (fig. 103). This portrait shows the joys of the innocence of childhood. The black child had the same right to an innocent, sweet childhood as the white, which they were often denied.

With the help of art, both drawings and photographs, W. E. B. Du Bois underlined the points he considered to be most important to women. The material in *The Crisis* that dealt with women and children was uplifting and supportive; it celebrated the role of women in society, the all-important need to educate women, and the great importance of the role of the mother in black society. On a personal level, Du Bois presents a paradox—controlling and demanding both at home and at the office with the women with whom he spent most of his time, yet in public presenting to his readership at *The Crisis* a progressive stance on issues involving women's suffrage, rearing children, prejudice toward women, and family issues in a bold, dynamic, and forceful way.

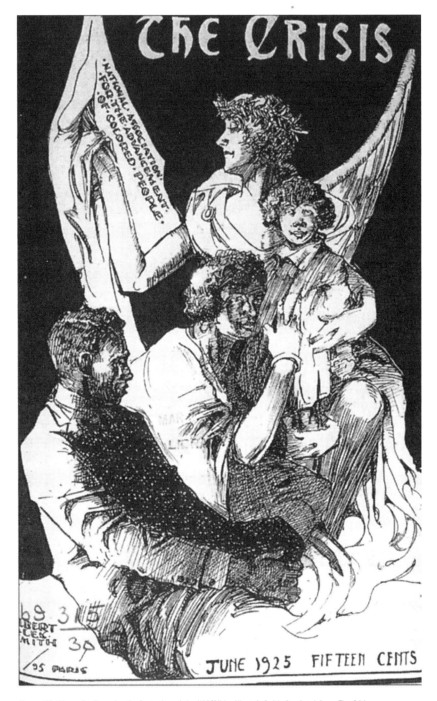

Figure 102. "Negro Family under the Protection of the NAACP," by Albert A. Smith. Reprinted from *The Crisis*, June 1925, cover.

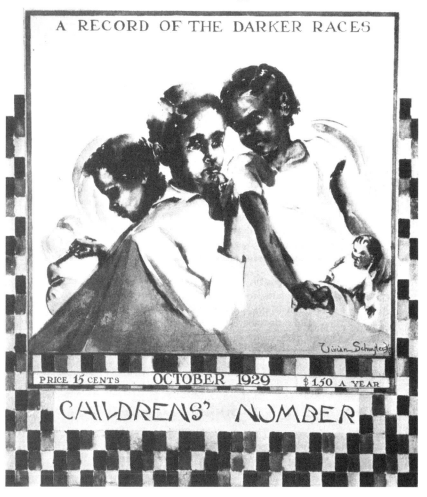

Figure 103. Untitled drawing of three children for "Childrens' Number," by Vivian Schuyler Key. Reprinted from *The Crisis*, October 1929, cover.

As the first national black journal in the United States to achieve a wide readership, *The Crisis* disseminated important information to its readers, information vital to the success of the black race and to inclusion in American life, education, society, and the workforce. By constantly addressing the problems black Americans faced in the labor force, in education, within the family, in the military, and the prejudice they dealt with in daily life, he could unite and strengthen a growing black middle class and strengthen a strong sense of collective identity among his readers.

Conclusion

The May 1934 issue of *The Crisis* featured a political cartoon that was both racial and Marxist. It features a heavyset white man dressed as a guardian angel. He holds his arms across his big belly, his hands clasped, his eyes closed in a sainted style, a halo over his head (resembling a coin) and wings on his back. His vest has a dollar sign on it. "The Guardian Angel" by Romare Bearden (fig. 104) watches over Literature, Education Research, Religion, Art, and Music. But he is a guardian for white folk, not black Americans. His own financial gain is his only real interest. All culture is supported by capitalist interests. Black Americans will not be allowed to participate and enjoy the fruits of their hard work. This image summarized, in essence, Du Bois's understanding of how black Americans were treated in a white-dominated society.

In the same issue, Du Bois offered an essay on segregation. A young girl questioned Du Bois after a lecture, arguing that because he was no longer fighting segregation, he was too willing to compromise. Du Bois explained that he was always willing to compromise and that he would take would he could get but would always want more. "Moreover, I fight Segregation with Segregation, and I do not consider this compromise, I consider it common sense." He made reference to a terrible slum which provided substandard housing for 5,000 African Americans but soon would be bulldozed and replaced with new housing for these people. While it wasn't ideal and it was "segregation by the US government," Du Bois noted that it was far better to get a decent segregated development than none at all. "The advantage of decent homes for five thousand colored people outweighs any disadvantage which will come from this development."

He wrote, "I say again, if this is compromise; if this is giving up what I have advocated for many years, the change, the reversal, bothers me not at all. But Negro poverty and idleness, and distress, they bother me, and always will."[1] Al-

Figure 104. "The Guardian Angel," by Romare Bearden. Reprinted from *The Crisis*, May 1934, p. 137.

though he opposed racial segregation early in his career, as early as 1917 Du Bois speculated about the possibility that under specific conditions there might be a need for a "new and efficient industrial machine" within the black community that might require a type of separatism. During the years of the Great Depression, Du Bois came to believe that the only hope "lay in the use of self-segregation against the fact of imposed segregation."[2] The idea that an oppressed group needed to separate itself in order to develop and mature would be articulated later by the Black Power movement; Du Bois was ahead of his time.

In fact, the entire issue in which this cartoon and essay appeared focused on the issue of segregation. It printed a proposal from Du Bois to the board of directors of the NAACP, modification of the proposal by the board's Committee of Administration, and the final resolution passed by the board. Du Bois was advocating a type of economic, political, and social separatism, "voluntary segregation," that was an affront to the integrationist philosophy of the NAACP.[3] Du Bois questioned the resolution, which read in part: "Thus both principle and practice necessitate unyielding opposition to any and every form of enforced segregation." Du Bois responded: "It would be interesting to know what the Board means by its resolution. Does is mean it does not approve of the Negro church or believe in its segregated activities in its 26,000 edifices where most branches of the NAACP meet and raise money to support it? . . . Does it believe in 200 Negro newspapers which spread NAACP news and propaganda? . . . Does it believe in Negro business enterprise of any sort? Does it believe in Negro history, Negro literature and Negro art? . . . Does it believe in Negro spirituals? *And if it does believe in these things is the Board of Directors of the NAACP, afraid to say so?*"[4] Du Bois's strident challenge indicated where his mind now was. On May 31, 1934, Du Bois resigned as editor and submitted this letter to NAACP president Joel Spingarn:

> My dear Spingarn,
>
> I have considered very carefully and painfully the suggestions of you and your brothers. I cannot comply. I know in my soul that the time has come for complete severance. It is not easy. I am twice losing a first born child and I am cutting my self off from old and good friends, but Gott helfe mich, ich kann nicht anders. I appreciate your friendship and your many efforts in my behalf.[5]

Du Bois refused to compromise about his stance on separatism in the pages of *The Crisis.*

Du Bois had changed. His interest in racial separatism clashed with the integrationist philosophy of the NAACP and resulted in his resignation from *The Crisis.* Du Bois concluded that voluntary black self-segregation was the only answer to several things: the segregation that was white imposed, particularly in

the South; the failure of the American capitalist system to provide for the needs of black Americans (which was particularly poignant during the Depression); white racism; the new industrial technology which undermined the development of a classical education and the talents of skilled artisans, hurting employment opportunities for African Americans; and an education system that had failed blacks.[6] Du Bois discussed these issues on the pages of *The Crisis* between 1930 and 1934.[7] It was a new form of black nationalism. His assessment that the Communist Party USA had failed to help the Scottsboro boys and failed to acknowledge the power of white racism further supported his views that self-segregation was the answer for African Americans seeking a better life.

DU BOIS'S CHANGED VIEW OF ART
AFTER THE HARLEM RENAISSANCE

Du Bois was reluctant to criticize black writers during the final years of the Harlem Renaissance. He continued to stress that "all art is propagandabut also, that all propaganda is not art." He felt that "criticisms should be aimed at the incompleteness of art expression—at the embargo which white wealth lays on full Negro expression—and a full picturing of the Negro soul."[8] America was mired in the Great Depression. There was much less funding for art and literature. Some key players were gone, such as writer/editor Wallace Thurman, who had died. "Night had fallen on the heyday of the Harlem Renaissance."[9] Du Bois had come to the conclusion that black independence and black control had to be extended to the entire spectrum of black existence in America: black people needed to develop and control strong black institutions for the good of black people.

In 1939, Du Bois, who had left *The Crisis* five years earlier, expressed his belief in the *Journal of Negro Education* that a racial technique in art and propaganda was inevitable.[10] Du Bois wanted black artists to create primarily for a black audience, opposing many of his former allies who still believed that Negro art should seek a white audience. Du Bois thought otherwise, and he had used *The Crisis* to make advances in the important issues of patronage of black artists and cultivation of a black audience for the work those artists produced. "Why not see Negro literature in terms of the Negro audience: as a means of expression of their feelings and aspiration; as a picture painted for their own enlightenment of the vast tragedy of their life, and the comedy of their very frustrations? This is possible; but only possible as a buying Negro clientele is deliberately and consciously built up to support such art. In the end such literature and only such will be authentic and true enough to join the Art Universal." Du Bois was committed to the project of developing an educated, enlightened, so-

phisticated audience that contained individuals who would become the future patrons of black art. Du Bois wanted to encourage "the varying but persistent development of a literature of expression and of a Negro-American art."[11] He wrote: "A racial technique in art is inevitable . . . but here too is opportunity: our Art can make black beautiful. It can be, not simply a 'contribution to American culture' but a contribution to our own culture, which is and long will be a thing largely segregated and apart, despite all we think."[12] In the years after Du Bois left *The Crisis* and resigned from the NAACP, he had only grown in his commitment to black art for black Americans. Du Bois's dream that the best in black literature and art would be created about blacks by blacks, read and bought by blacks, was unrealized, in his estimation. He wrote that the Harlem Renaissance was brief because it was "transplanted and exotic . . . for the benefit of white people. . . . [I]t did not grow out of the inmost heart and frank experience of Negroes: on such an artificial basis no real literature can grow." The output of writers such as James Baldwin, Richard Wright, Ralph Ellison, and Zora Neale Hurston demonstrated that Du Bois was too pessimistic in his assessment.[13]

In *Dusk of Dawn,* Du Bois established himself as a progenitor of a black arts movement.[14] He summed up his *Crisis* writings on an African heritage when he wrote that creative art was essential to the development and transmission of new ideas among blacks. "The communalism of the African clan can be transferred to the Negro American group. . . . The emotional wealth of the American Negro, the nascent art in song, dance and drama can all be applied, not to amuse the white audience, but to inspire and direct the acting Negro group itself. I can conceive no more magnificent or promising crusade in modern times."[15] Here is where his interest in some form of segregation comes into play, to create art for a *black* audience. "There has been a larger movement on the part of the Negro intelligentsia toward racial grouping for the advancement of art and literature. There has been a distinct plan for reviving ancient African art through an American Negro art movement, and more specially a thought to use the extremely rich and colorful life of the Negro in America and elsewhere as a basis for painting, sculpture, and literature."[16] These artists needed support from other blacks who were deliberately schooled and trained in art appreciation, a more sophisticated, educated audience. Some have argued that Du Bois experienced difficulty in shaping a black aesthetic because he was unable to "harmonize his awareness of the utilitarian value of literature for a specific group with his concern for the creation of Truth and Beauty, his fallacious assumption that his aesthetic was necessarily the aesthetic of most black people."[17] In truth, Du Bois was ahead of his time. He wanted artists to express a truthful black life experience, but one that contained beauty and illuminated the best of black life

too. Du Bois looked ahead to the controversies of the black arts movement of the 1960s, which would demand a racial, politically expressive art of its participants and would face many of the same challenges, dilemmas, and opportunities that Du Bois faced early in the twentieth century.

IDENTITY AND MEMORY

Over his twenty-three years as editor of *The Crisis*, W.E.B. Du Bois used visual imagery to shape a collective identity for African Americans and create a new collective memory. He carefully placed illustrations and cartoons in the magazine to support the causes he publicly advocated. At a time when the social realist movement was developing in the United States, *The Crisis* offered its own realism—brutally honest statements about African American life and the "American dream" that was never extended to Black Americans. Often the artists turned to traditional iconography for their prototypes, using established symbols such as the Statue of Liberty and relying heavily on traditional Christian iconography.

Du Bois wanted to reconstruct the past by asserting a history in *The Crisis* that refuted dominant white culture and by creating a visual vocabulary that would enhance a new black collective memory. He wanted to confront the race problem on the pages of *The Crisis*, not hide from it. In *The Crisis*, a journal edited by an African American and largely controlled by blacks for a predominantly black audience, black achievement could be celebrated.

Du Bois conceived of *The Crisis* as a journal that would disseminate information and could serve as a tool to educate his readers. On its pages, Du Bois reclaimed a lost history. But he controlled that history with words and art that told the story he wanted blacks to absorb. *The Crisis* told the story from the top down, from the pens and brushes of the Talented Tenth. Du Bois created a place and power for blacks to fight white distortions of history and preserve African American history. Where black newspapers in limited markets featured only minimal visuals, *The Crisis* reached a national audience and made visual imagery an integral part of the journal.

The artists whose work Du Bois published faced the obstacles of limited training, limited exhibition venues, and limited chances for patronage, and they welcomed Du Bois's support and the opportunity to create community and a visual vocabulary. Du Bois used art as an audience-building tool. Art could draw readers into an issue, could entice them to read on, could give a message when an issue was too painful to read about. It increased the number of subscribers and encouraged a reader to buy the journal at a newsstand. These artists were able to create art as social protest that would cut to the essence of an issue in sec-

onds. As Du Bois saw it, through the art in *The Crisis,* the best and brightest of the race would serve to enlighten readers and encourage involvement in the pressing issues of the day. After Du Bois's departure, the use of art in *The Crisis* rapidly diminished. The year 1936 saw a marked decline, and by 1937, very little original art was used. Instead, art was reprinted from other journals. *The Crisis* was no longer in the business of commissioning art. By the years 1938–1939, its use of art had diminished even further, and photographs had become the primary source of visuals in the magazine. Du Bois's use of art was consistent, strong, and unique to the early decades of the journal.

The white media was one sided in its coverage of lynchings. Even the most respected white newspapers, including the *New York Times,* covered the crimes with a bias and assumed the guilt of the black victims. Some lynchings would never have been recorded if it were not for the actions of *The Crisis* and the NAACP. Accusations of sex crimes, fear of miscegenation, and the presumed primitive sexuality of black men were used as rationalizations for lynchings. Historians now assess the real issues as fear of black economic advancement and the loss of black labor. Where white journals revealed only a narrow perspective on lynchings, the whole story, with photographs, was included in *The Crisis.* When a subscriber couldn't bear a sixteen-page account of the Waco atrocities, the photos compelled an acknowledgment of racial terror and encouraged participation in the fight against lynching.

The artists used Christian iconography, particularly images of the crucified Christ, to emphasize the un-Christian character and sheer evil of lynching. In early-twentieth-century America, a Christian and church-going society, the images they created sought to shame Americans. They emphasized the depraved aspect of the "entertainment value" of lynchings for southerners, hoping that civilized Americans could be motivated to act against such barbarism in their communities. They asserted an image of lynchings that countered the postcard images of actual lynchings sold as souvenirs on site. *The Crisis* appropriated those images as evidence of the terror and used them as the inspiration for political cartoons that addressed the issues. The facts about lynchings had been suppressed, the events were lied about, and the details twisted to support a white viewpoint of the events. Du Bois used art and editorials as publicity to encourage his readers, legislators, and the courts to take action. Symbols of lynchers were developed in the guise of the barbarian and the devil to attack the uncivilized and un-Christian behavior of the perpetrators. The artists and essayists showed the hypocrisy of a country that could send its men to war to fight atrocities abroad but ignore murder and terror at home. To use the old cliché, one picture could be worth a thousand words, and Du Bois understood the power of the image. He used that power skillfully to proclaim that lynching was not a

southern problem; it was a problem that all blacks, indeed all Americans, had to face.

Deeply concerned with identity formation, Du Bois focused much of his energy on forging a relationship between his readers and Africa. The joyfulness and racial pride that images that elicited Africa created were just as important to the artists of *The Crisis* as the sorrow imagery of lynching evoked. Du Bois understood the global implications of slavery and wanted to forge a greater sense of the Black Atlantic and of a truly pan-Africanist view of the diaspora. Modern artists including Picasso and Braque had appropriated African art for their own artistic and creative successes; why shouldn't African Americans do the same? Du Bois's trip to Africa in 1924 solidified his relationship to the continent, one that would continue until his death in Ghana in 1963.

Social realist, cubist-inspired, art deco and modernist art appeared on the pages of the magazine. The artists of *The Crisis* were not merely illustrators; many were fully engaged in modernist movements. Du Bois openly dealt with the issues of racism, education, labor, war, and women's issues with rich visuals to elucidate the magazine's political agenda.

Through the art and the written word in *The Crisis,* Du Bois would hammer home to his readers the need for a strong sense of identity and the need to record history accurately, to take the power of history-telling away from the white majority. Unless history was told accurately, the mistakes of the past would be repeated. As Du Bois said, "One is astonished in the study of history at the recurrence of the idea that evil must be forgotten, distorted, skimmed over. . . . The difficulty of course, with this philosophy is that history loses its value as an incentive and example; it paints perfect men and noble nations, but it does not tell the truth."[18]

The artists of *The Crisis* undertook the telling of truth under the direction and inspiration of Du Bois, joining readers through common hope and common sorrow in a collective African American identity and creating their own authentic historical memory. It was a singular and important achievement, a tribute to the man David Levering Lewis has called an "avatar of the race." As Du Bois himself put it 1921, "We Americans have settled the race problem and will not have our settlement tampered with. The truth of Art tampers. That is its mission."[19]

Notes

INTRODUCTION

1. *The Crisis,* November 1910, 10.

2. Leon F. Litwack, "The Birth of a Nation," in Mark C. Carnes, ed., *Past Imperfect* (New York: Henry Holt, 1995), 136.

3. David W. Blight, "W. E. B. Du Bois and the Struggle for American Historical Memory," in Geneviève Fabre and Robert O'Meally, eds., *History and Memory in African-American Culture* (New York: Oxford University Press, 1994), 46.

4. Du Bois, "Criteria of Negro Art," *The Crisis,* October 1926, 290.

5. David Levering Lewis, *W. E. B. Du Bois: The Fight for Equality and the American Century, 1919–1963* (New York: Henry Holt, 2000), 175. I use the term "Negro" to refer to the African American race in the context of the time period when Du Bois was editor of *The Crisis*.

I. W. E. B. DU BOIS AND AFRICAN AMERICAN MEMORY AND IDENTITY

1. David W. Blight, "W. E. B. Du Bois and the Struggle for American Historical Memory," in Geneviève Fabre and Robert O'Meally, eds., *History and Memory in African-American Culture* (New York: Oxford University Press, 1994), 45.

2. W. E. B. Du Bois, *The Souls of Black Folk,* ed. David Blight (1903; reprint, Boston: Bedford Books, 1997), 111.

3. David Thelen, "Memory and American History," *Journal of American History* 75, no. 4 (March 1989): 1119.

4. Michael Frisch. "The Memory of History," in Susan Porter Benson, Steven Brier, and Roy Rozenzweig, eds., *Presenting the Past: Essays on History and the Public* (Philadelphia: Temple University Press, 1986), 10–11.

5. David Levering Lewis, "Du Bois and the Challenge of the Black Press," available online at http://www.thecrisismagazine.com/his_dll.htm.

6. David Levering Lewis, *W. E. B. Du Bois: Biography of a Race, 1868–1919* (New York: Henry Holt, 1993), 30.

7. Ibid., 250.

8. Blight, "W. E. B. Du Bois and the Struggle for American Historical Memory," 58.

9. Quoted in ibid., 49.

10. Amy Kirschke, "The Intersecting Rhetorics of Art and Blackness in the *Souls of Black Folk*," in Dolan Hubbard, ed., *The Souls of Black Folk One Hundred Years Later* (Columbia: University of Missouri Press, 2003), 172–188.

11. W. E. B. Du Bois, "The Shadow," *The New Republic,* February 23, 1921.

12. David Levering Lewis and Deborah Willis, *A Small Nation of People: W. E. B. Du Bois and African-American Portraits of Progress* (New York: Amistad Press, 2003), 30.

13. Shawn Michelle Smith, *Photography on the Color Line: W. E. B. Du Bois, Race, and Visual Culture* (Durham, N.C.: Duke University Press, 2004), 148.

14. David Levering Lewis, *W. E. B. Du Bois: The Fight for Equality and the American Century, 1919–1963* (New York: Henry Holt, 2000), 2.

15. There were exceptions to the negative depictions of blacks by white artists. Winold Reiss depicted blacks with respect and sensitivity. Art historian Sydelle Rubin has noted that "Du Bois had so much respect for Reiss's artwork that he asked Reiss to judge several art contests for *The Crisis.*" According to Aaron Douglas, it was Reiss's recommendation that warmed up Du Bois's opinion of him; Du Bois in turn invited Douglas to become a frequent contributor to *The Crisis.* Aaron Douglas to Alta Sawyer, n.d., Box 1, Folder 8, Aaron Douglas Papers, Schomburg Center for Research in Black Culture, New York Public Library. See Rubin Sydelle Iris. "Emigration in Harlem: New Perspectives on Miguel Covarrubias and Winold Reiss (Ph.D. diss., Boston University, 2002), 295.

16. Bethany Johnson, "Freedom and Slavery in *The Voice of the Negro*: Historical Memory and African-American Identity, 1904–7," *Georgia Historical Quarterly* 84, no. 1 (2000): 58. Johnson explains that elite clubwomen hoped for the material and moral improvement of their poorer, rural sisters but invoked class privilege in the process of campaigning for these changes.

17. These cases are discussed in Chapter 3.

18. Johnson, "Freedom and Slavery," 49.

19. Both *Voice of the Negro* and *The Crisis* employed John Henry Adams as an illustrator. The magazines had other illustrators in common as well.

20. Johnson, "Freedom and Slavery," 55–57.

21. Ibid., 33.

22. Villard was the grandnephew of the great abolitionist William Lloyd Garrison. He helped found the NAACP, eventually serving as chairman.

23. Mary White Ovington, "How the National Association for the Advancement of Colored People Began," *The Crisis,* August 1914, 187–188.

24. Lewis, *W. E. B. Du Bois: Biography of a Race,* 409–410. The board members included Villard, Kelly Miller, Max Barber, William Stanley Braithwaithe, and Mary Dunlop McClean.

25. Lewis, *W. E. B. Du Bois: Biography of a Race,* 411.

26. *The Crisis,* November 1910; Lewis, *W. E. B. Du Bois: Biography of a Race,* 411.

27. Lewis, *W. E. B. Du Bois: Biography of a Race,* 416.

28. In 1916, a pamphlet Du Bois had written was published by the NAACP that restated the organization's reason for being and reported recent lynching statistics (2,812 in the previous thirty years) and the total disfranchisement of three-fourths of black voters. *The Crisis,* Du Bois proudly stated, had become self-supporting in just five years, beginning on January 1, 1916. Readership of *The Crisis* passed the 30,000 mark in 1916. Lewis, *W. E. B. Du Bois: Biography of a Race,* 513.

29. For Du Bois's beliefs about *The Crisis* and its potential, see Lewis, *W. E. B. Du Bois: Biography of a Race,* 408–434.

30. From *Two Addresses Delivered by Alumni of Fisk University, in Connection with the Anniversary Exercises of Their Alma Mater, June, 1898* (Nashville: Fisk University, 1898), 1–14.

31. *Booklovers' Magazine,* July 1903, 2–15.

32. Ibid.

33. Du Bois, "Black America," in Herbert Aptheker, ed., *Writings by W. E. B. Du Bois in Non-Periodical Literature Edited by Others* (Millwood, N.Y.: Kraus-Thomson, 1982), 170. Originally published in *New Republic,* 33 (January 3, 1923).

34. Du Bois, "The Negro in Literature and Art," *Annals of the American Academy of Political and Social Science* 49 (September 1913): 233–237. In 1941, four years after Tanner's death, Du Bois was still referring to him as the best example of a black painter, even though he was mentoring living artists, including sculptor Elizabeth Prophet and *Crisis* illustrator Aaron Douglas. "The Negro in America, 1941," *Encyclopedia Americana* (New York and Chicago: Americana Corp., 1943), 20:47–52. An almost identical essay appeared in the 1932 edition.

35. Du Bois, "The Contribution of the Negro to American Life and Culture," in Aptheker ed., *Writings by W. E. B. Du Bois in Non-Periodical Literature Edited by Others.* Originally from *Pacific Review* 2 (June 1921): 127–132.

36. Du Bois, "The Negro as a National Asset: IV, As an Artist," in Herbert Aptheker, ed., *Writings by W. E. B. Du Bois in Periodicals Edited by Others,* vol. 2, *1910–1934* (Millwood, N.Y.: Kraus-Thomson, 1982), 205. Originally published in *Homiletic Review* 86 (July 1923): 52–58. Du Bois is quoting Natalie Curtis Burlin, *Negro Folk Songs* (New York: G. Schirmer, 1918).

37. Thelen, "Memory and American History," 1117–1118; Rebecca Kook, "The Shifting Status of African Americans in the American Collective Identity," *Journal of Black Studies* 29, no. 2 (November 1998): 159.

38. Blight, "W. E. B. Du Bois and the Struggle for American Historical Memory," 53.

39. Ibid., 56.

40. For discussion of the significance of Du Bois's book, see Eric Foner, *Reconstruction: America's Unfinished Revolution, 1863–1877* (New York: Harper & Row, 1988), xx.

41. Arnold Rampersad, *The Art and Imagination of W. E. B. Du Bois* (Cambridge, Mass.: Harvard University Press, 1976), 34, 37.

42. David W. Blight, "Fifty Years of Freedom: The Memory of Emancipation at the Civil War Semicentennial, 1911–1915," *Slavery and Abolition* 21, no. 2 (2000): 120.

43. *Baltimore Afro-American Ledger,* July 5, 1913, quoted in David W. Blight, "'What Will Peace among the Whites Bring?' Reunion and Race in the Struggle over the Memory of the Civil War in American Culture," *Massachusetts Review* 34, no. 3 (1993): 404.

44. Du Bois, *Souls of Black Folk,* 45.

45. Blight, "Fifty Years of Freedom," 126.

46. Ibid., 127.

47. Quoted in Blight, "Fifty Years of Freedom," 128–129.

48. Pierre Nora has written extensively on "*lieux de memoire,*" or sites of memory. "A process of interior decolonization had affected ethnic minorities, families and groups

that until now have possessed reserves of memory but little or no historical capital. We have seen the end of societies that had long assured the transmission and conservation of collectively remembered values." Sites of memory were "sometimes constructed by one generation in one way and then reinterpreted by another . . . *lieux de memoire* are constantly evolving new configurations of meaning, and . . . their constant revision makes them part of the dynamism of the historical process."

Nora seeks to build a theoretical apparatus to help scholars develop useful descriptions of the cultural processes that make up African American life. These help the scholar attend to the various ways in which historical actors refract knowledge and culture through particular sites. Over time, these sites of memory become prisms, consolidating and then dispersing meaning and knowledge. Pierre Nora, "Between Memory and History: Les Lieux de Memoire," in Geneviève Fabre and Robert O'Meally, eds., *History and Memory in African American Culture* (New York: Oxford University Press, 1994), 285.

49. Thelen, "Memory and American History," 1123.

50. Foucault states that history is the passion and violence of cultural conflict about memory; this cultural struggle is a "hazardous play" of "endlessly repeated dominations." A domination becomes "fixed throughout its history in rituals and meticulous procedures that impose rights and obligations. It establishes marks of its power and engraves memories on things and even within bodies." Blight, "W. E. B. DuBois and the Struggle for Historical Memory," 51. "Problematic and incomplete" in Nora, "Between Memory and History," 285.

51. Du Bois, *Black Reconstruction: An Essay toward a History of the Part Which Black Folk Played in the Attempt to Reconstruct Democracy in America, 1860–1880* (New York: Harcourt, Brace and Co, 1935), 726.

52. Blight, "W. E. B. Du Bois and the Struggle for American Historical Memory," 51.

53. Thelen, "Memory and American History," 1124.

54. Mitch Kachun, "Before the Eyes of All Nations: African American Identity and Historical Memory at the Centennial Exposition of 1876," *Pennsylvania History* 65, no. 3 (1998): 321–322.

55. Du Bois, *The Souls of Black Folk*, 38–39. This concept of "twoness" can also be found in Du Bois's address "The Conservation of Races," which he presented to the American Negro Academy (1897); in two subsequent essays in *American Negro Association Occasional Papers* (1897); and in "Strivings of the Negro People" in *The Atlantic Monthly* (1897).

56. Blight, "W. E. B. Du Bois and the Struggle for American Historical Memory," 49–50.

57. Ibid., 50.

58. Johnson, "Freedom and Slavery," 62.

59. Kachun, "Before the Eyes of All Nations," 303.

60. Ibid., 312.

61. David W. Blight, "'For Something Beyond the Battlefield': Frederick Douglass and the Struggle for the Memory of the Civil War," *The Journal of American History* 75, no. 4 (March 1989): 1156–1178.

62. Ibid., 1159.

63. Blight, "'What Will Peace among the Whites Bring?'" 405.

64. Blight, "For Something Beyond the Battlefield," 1158.

65. Quoted in ibid.

66. Du Bois quoted in ibid., 1161.

67. Ibid.

68. Quoted in ibid., 1175.

69. Du Bois, *Black Reconstruction,* 727.

70. Blight, "W. E. B. Du Bois and the Struggle for American Historical Memory," 59.

71. Blight, "For Something Beyond the Battlefield," 1164.

72. Ibid., 1173.

73. Du Bois, *Black Reconstruction,* 722.

74. Blight, "For Something Beyond the Battlefield," 1174.

75. Du Bois, "History of the Black Artisan from African to Emancipation," in Julius Lester, ed., *The Seventh Son: The Thought and Writings of W. E. B. Du Bois,* vol. 1 (New York: Random House, 1971), 335.

76. Du Bois, "The Negro in Literature and Art," 233–237.

77. Bruce Harvey, *American Geographics: U.S. National Narratives and the Representation of the Non-European World, 1830–1865* (Stanford, Calif.: Stanford University Press, 2001), 207–208. See the discussion of Delaney, whom Harvey calls the "most stalwart exemplar of minority separatist politics in the nineteenth century" (194–195).

78. Ibid., 210–211.

79. Du Bois, "Social Origins of American Negro Art," *Modern Quarterly* 3 (Autumn 1925): 11.

80. Ibid.

81. Ibid.

82. Maurice Maeterlinck et al., *What Is Civilization?* (New York: Durfield, 1926), 43–57.

83. Ibid., 43–57.

84. Du Bois, "Elizabeth Prophet, Sculptor," *The Crisis,* December 1929, 407, 427, 429.

85. Ibid.

86. W. E. B. Du Bois to Elizabeth Prophet, November 20, 1934, in Herbert Aptheker, *Correspondence of W. E. B. Du Bois,* vol. 2, *1934–44* (Amherst: University of Massachusetts Press, 1976), 40.

87. Henry Lee Moon, *The Emerging Thought of W. E. B. Du Bois* (New York: Simon and Schuster, 1972), 51.

88. Ibid.

89. Du Bois, "H. L. Mencken," *The Crisis,* October 1927, 276.

90. Du Bois, "The Negro College," *The Crisis,* August 1933, 177.

91. W. E. B. Du Bois, *Autobiography of W. E. B. Du Bois: A Soliloquy on Viewing My Life from the Last Decade of Its First Century* (New York: International Publishers, 1968), 256.

92. Blight, "W. E. B. Du Bois and the Struggle for American Historical Memory," 52.

2. A HISTORY OF BLACK POLITICAL CARTOONS AND ILLUSTRATION

1. Stephen Hess and Sandy Northrop, *Drawn and Quartered: The History of American Political Cartoons* (Montgomery, Ala.: Elliot & Clark, 1996), 76.

2. Quoted in Barbara E. Lacey, "Visual Images of Blacks in Early American Imprints," *William and Mary Quarterly,* 3rd series 53, no. 1 (January 1996): 158–159.

3. This book was published in Hartford, Connecticut, in 1790.

4. Hess and Northrop, *Drawn and Quartered,* 17.

5. Lacey, "Visual Images of Blacks in Early American Imprints," 144–145.

6. Hess and Northrop, *Drawn and Quartered,* 18.

7. Shawn Michelle Smith, *Photography on the Color Line: W. E. B. Du Bois, Race, and Visual Culture* (Durham, N.C.: Duke University Press, 2004), 82.

8. "Barsqualdi's Statue: Liberty Frightening the World" (Thomas Worth, 1884). In Roger A. Fisher, "Oddity, Icon, Challenge: The Statue of Liberty in American Cartoon Art, 1879–1986," *Journal of American Culture* 9, no. 4 (1986): 63.

9. Steven Loring Jones, "From 'Under Cork' to Overcoming: Black Images in the Comics," in Charles Hardy and Gail Stern, eds., *Ethnic Images in the Comics* (Philadelphia: Balch Institute for Ethnic Studies, 1986), 21.

10. Ibid., 24.

11. Lacey, "Visual Images of Blacks in Early American Imprints," 175.

12. Hess and Northrop, *Drawn and Quartered,* 20.

13. Honoré Daumier is known for his depictions of King Louis Philippe in 1831. Daumier and Charles Philipon illustrated for *Le Charivari* in Paris, where they fine-tuned the art of political satire. Daumier's biting satire addressed such issues as freedom of speech. In "You Have the Floor, Explain Yourself" of 1835, drawn for the journal *La Caricature,* Daumier pictured a cynical, smirking judge offering a defendant, who is held back by the members of the defense team, gagged, and unable to defend himself, the right to speak. His "defense" appears below, torn into shreds. Daumier believed that the French justice system did not offer members of the lower classes the chance to defend themselves: he conveyed this belief in his series *Les Gens de Justice.*

14. Rebecca Zurier, *Art for the Masses: A Radical Magazine and Its Graphics, 1911–1917* (Philadelphia: Temple University Press, 1988), 148.

15. Ibid., 151.

16. "Cartoons by the Late Ollie Harrington Tell Us Like It Was—and Is," *Ebony,* February 1996, 122.

17. Quoted in Hardy and Stern, *Ethnic Images in the Comics,* 12. See also Martin Sheridan, *Comics and Their Creators: Life Stories of American Cartoonists* (Boston: R. T. Hale & Company, 1942).

18. Ruth Thibodeau, "From Racism to Tokenism: The Changing Face of Blacks in *New Yorker* Cartoons," *Public Opinion Quarterly* 53 (Winter 1989): 486. The NAACP mounted a campaign in the 1940s against ethnic stereotyping in the comics, which gained momentum in the civil rights era. Eventually, African Americans virtually disappeared from the comics in any form. A study conducted in 1962 found that between 1943 and 1958, only one black and no Jews appeared among 532 cartoon characters. Ethnicity did not seem to sell comics. A study of *New Yorker* cartoons between 1946 and 1955 found that blacks (including peoples of the diaspora) constituted only 1.37 percent of all figures drawn.

19. This refusal of admission is according to Smith's father, Alfred Renforth Smith, in a biography of his son submitted to the Harmon Foundation. Harmon Foundation Papers, Box 49, Manuscript Division, Library of Congress.

20. Amy Spingarn, who was married to the NAACP's Joel Spingarn, was an arts advocate. David Levering Lewis, *W. E. B. Du Bois: Biography of a Race, 1868–1919* (New York: Henry Holt, 1993), 486.

21. Theresa Leininger-Miller, *New Negro Artists in Paris: African American Painters and Sculptors in the City of Light, 1922–1934* (New Brunswick, N.J.: Rutgers University Press, 2001), 202.

22. *La Revue Moderne Illustrée des Arts et de la Vie,* 15 Juillet 1938.

23. Albert Alex Smith to Mr. and Mrs. Alfred Renfrow Smith, January 7, 1935, Harmon Foundation Papers, Box 80.

24. Arthur Schomburg to George Haynes, September 2, 1929, Harmon Foundation Papers, Box 49.

25. *Opportunity: Journal of Negro Life* was a rival publication edited by Charles S. Johnson. For more information on the rivalry between *The Crisis* and *Opportunity,* see David Levering Lewis, *W. E. B. Du Bois: The Fight for Equality and the American Century, 1919–1963* (New York: Henry Holt, 2000), 155–159.

26. Alfred Renforth Smith to George E. Haynes, October 11, 1928, Harmon Foundation Papers, Box 49.

27. Jean McGleughlin, Obituary of Albert Alexander Smith, *Opportunity Magazine,* July 1940, 208.

28. Cornelius Johnson, Harmon Foundation application, 1933, Harmon Foundation Papers, Box 76.

29. Ibid.

30. Laura Wheeler Waring, artist's statement for a Guggenheim Fellowship, November 12, 1928, Harmon Foundation Papers, Box 45.

31. Ibid.

32. Waring was concerned because the pay was very low and she had not received any money for some illustrations she provided. She noted the cost of postage and paper and expressed her discomfort about telling Du Bois this information. Laura Wheeling Waring to W. E. B. Du Bois, October 1, 1923, W. E. B. Du Bois Papers, Library of Congress. Clearly *The Crisis* was working on a tight budget. Thanks to Theresa Leininger-Miller for this letter and information on their dinner, obtained from her work on Waring's "Blue Diary."

33. Laura Wheeler Waring, artist's statement for a Guggenheim Fellowship, November 12, 1928.

34. Laura Wheeler Waring to William E. Harmon, January 26, 1928, Harmon Foundation Papers, Box 45.

35. George E. Haynes, support letter for Laura Wheeler Waring for a Guggenheim Fellowship, November 12, 1928, Harmon Foundation Papers, Box 43.

36. Elmer Simms Campbell, undated press release, ca. 1931, Harmon Foundation Papers, Box 44.

37. Obituary: Elmer Simms Campbell, *New York Times,* January 29, 1971, 40.

38. Ibid.

39. He eventually lost the case.

40. Charles Dawson, biographical statement, March 21, 1935, Harmon Foundation Papers, Box 74.

41. Ibid.

42. For more on the Krigwa Award, see Lewis, *W. E. B. Du Bois,* 2:205–207.

43. *Chicago Daily News,* August 18, 1934.

44. Charles Dawson to the Harmon Foundation, March 21, 1935, Harmon Foundation Papers, Box 74.

45. Aaron Douglas to Alta Sawyer, 1925, Box 1, Folder 1, Aaron Douglas Papers, Schomburg Center for Research in Black Culture, New York Public Library.

46. See Amy Helene Kirschke, *Aaron Douglas: Art, Race, and the Harlem Renaissance* (Oxford: University Press of Mississippi, 1995).

47. Bernie Robynson, biographical statement, 1930, Harmon Foundation Papers, Box 79.

48. George E. Haynes was a Talented Tenth economist.

49. James Lesesne Wells, biographical statement, 1930, Harmon Foundation Papers, Box 81.

50. Vivian Schuyler Key, biographical statement, 1930, Harmon Foundation Papers, Box 48.

51. The International House was built by Mr. and Mrs. John D. Rockefeller to foster appreciation and understanding of non-U.S. cultures.

52. Bearden created several important cartoons under Du Bois's editorship and several after Du Bois resigned as editor in August 1934.

53. Dagmar Grimm, "George Grosz," in Stephanie Barron, ed., *Degenerate Art: The Fate of the Avant-Garde in Nazi Germany* (New York: Abrams, 1991), 286.

54. M. Bunch Washington, *The Art of Romare Bearden: The Prevalence of Ritual* (New York: Abrams, 1973), 16; and Robert Douglas, "From Blues to Protest/Assertiveness in the Art of Romare Bearden and John Coltrane," *International Review of African American Art* 1, no. 2 (1988): 30.

55. Romare Bearden, "The Negro Artist and Modern Art," *Opportunity: Journal of Negro Life,* December 1934, 231–232.

56. For more information on the political cartoons of Romare Bearden, see Amy Kirschke, "Bearden in *Crisis:* Illustrating Identity and Political Action," in Ruth Fine, ed., *Romare Bearden: Studies in the History of Art* (Washington, D.C.: National Gallery of Art, 2005).

3. THE "CRIME" OF BLACKNESS

1. Robert Zangrando, *The NAACP Crusade against Lynching, 1909–1950* (Philadelphia: Temple University Press, 1980), 6–7.

2. David Levering Lewis, *W. E. B. Du Bois: Biography of a Race, 1868–1919* (New York: Henry Holt, 1993), 226.

3. "Militia Guarding a Georgia Jail," *New York Times,* April 24, 1899.

4. W. E. B. Du Bois, *Autobiography of W. E. B. Du Bois: A Soliloquy of Viewing My Life from the Last Decade of Its First Century* (New York: International Publishers, 1968), 222.

5. Dominic J. Capeci Jr., and Jack C. Knight, "Reckoning with Violence: W. E. B. Du Bois and the 1906 Atlanta Race Riot," *Journal of Southern History* 62, no. 4 (1996):

733; W. Fitzhugh Brundage, *Lynching in the New South: Georgia and Virginia, 1880–1930* (Urbana: University of Illinois Press, 1993), 204.

6. Capeci and Knight, "Reckoning with Violence," 733.

7. The Niagara Movement would lead Du Bois to more speaking engagements and involvement in leadership, including participation in a second annual meeting in West Virginia in August of 1906.

8. Washington advocated a policy of conciliation and accommodation and advised black Americans to seek practical vocational education rather than a college education.

9. The most complete account of the Atlanta riots can be found in Mark Bauerlein, *Negrophobia: A Race Riot in Atlanta, 1906* (San Francisco: Encounter, 2001).

10. Du Bois, *Autobiography of W. E. B. Du Bois,* 286.

11. Capeci and Knight, "Reckoning with Violence," 746; Du Bois, "Looking Seventy-Five Years Backward," *Phylon* 3, no 2 (1942): 245. For more on the public's reaction to Du Bois's inaction following the riots, see Capeci and Knight, "Reckoning with Violence," 740–752.

12. Capeci and Knight, "Reckoning with Violence," 751.

13. Lewis, *W. E. B. Du Bois: Biography of a Race,* 228.

14. Du Bois, *Darkwater: Voices within the Veil* (1920; reprint, Millwood, N.Y.: Kraus-Thomson, 1975), 9; Capeci and Knight, "Reckoning with Violence," 761.

15. Du Bois, "Looking Seventy-Five Years Backward," 244.

16. Ben Tillman, "The Black Peril, 1907," in William Chace and Peter Collier, eds., *Justice Denied: The Black Man in White America* (New York: Harcourt, Brace, 1970), 181–182.

17. Zangrando, *The NAACP Crusade against Lynching,* viii.

18. Capeci and Knight, "Reckoning with Violence," 759.

19. Charlotte Wolf, "Constructions of a Lynching," *Sociological Inquiry* 62, no. 1 (1992): 83.

20. James E. Cutler, *Lynch-Law: An Investigation into the History of Lynching in the United States, 1905* (1905; reprint, New York: Negro Universities Press, 1969), 116.

21. Katherine Stovel, "Local Sequential Patterns: The Structure of Lynching in the Deep South, 1882–1930," *Social Forces* 79, no. 3 (2001): 852, 858.

22. Vincent Vinikas, "Specters in the Past: The Saint Charles, Arkansas, Lynching of 1904 and the Limits of Historical Inquiry," *Journal of Southern History* 65, no. 3 (1999): 543.

23. Christopher Waldrep, "The War of Words: The Controversy over the Definition of Lynching, 1899–1940," *Journal of Southern History* 66, no. 1 (2000): 75.

24. Roy Nash, "Memorandum for Mr. Phillip G. Peabody on Lynch-Law and the Practicability of a Successful Attack Thereon," May 22, 1916, NAACP Papers, Reel 1, Manuscript Division, Library of Congress, Washington, D.C.

25. Mary Church Terrell, "Lynching from a Negro's Point of View," *North American Review* 178 (June 1904): 853.

26. Richard M. Perloff, "The Press and Lynchings of African Americans," *Journal of Black Studies* 30, no. 3 (2000): 318–319.

27. For information on the press and lynching, see Richard M. Perloff, "The Press and Lynchings of African Americans," *Journal of Black Studies* 30, no. 3 (2000): 318–319.

28. Stewart E. Tolnay, Glenn Deane, and E. M. Beck, "Vicarious Violence: Spatial Effects on Southern Lynchings, 1890–1919," *American Journal of Sociology* 102, no. 3 (1996): 789.

29. Ibid.

30. Ibid., 791–792.

31. Wolf, "Constructions of a Lynching," 87.

32. James W. Clark, "Without Fear or Shame: Lynching, Capital Punishment and the Subculture of Violence in the American South," *British Journal of Political Science* 28, no. 2 (1998): 271.

33. Waldrep, "The War of Words," 78.

34. Sometimes those numbers differed from Work's because the two did not agree about whether an event was a lynching. Here, the definition of lynching came into play.

35. Tolnay, Deane, and Beck, "Vicarious Violence," 794.

36. Stovel, "Local Sequential Patterns," 851; and Tolnay, Deane, and Beck, "Vicarious Violence," 1195.

37. W. E. B. Du Bois, *Souls of Black Folk,* edited by David Blight and Robert Gooding-Williams (1903; reprint, New York: Bedford Books, 1997), 142.

38. Michael D. Webb, "'God bless you all—I am innocent': Sheriff Joseph F. Shipp, Chattanooga, Tennessee, and the Lynching of Ed Johnson," *Tennessee Historical Quarterly* 58, no. 2 (1999): 157, 170.

39. Clark, "Without Fear or Shame," 281.

40. Tolnay, Deane, and Beck, "Vicarious Violence," 799.

41. Patrick J. Huber, "'Caught Up in the Violent Whirlwind of Lynching': The 1885 Quadruple Lynching in Chatham Country, North Carolina," *North Carolina Historical Review* 75, no. 2 (1998): 137.

42. Jacqueline Dowd Hall quoted in Vinikas, "Specters in the Past," 556.

43. Brundage, *Lynching in the New South,* 162.

44. Richard Wright, *Black Boy: A Record of Childhood and Youth* (New York: Harper & Row, 1966), 190.

45. Ibid., 85; Charles S. Johnson, *Growing Up in the Black Belt: Negro Youth in the Rural South* (Washington, D.C.: American Council on Education, 1941).

46. Vinikas, "Specters in the Past," 557.

47. Lawrence Edward Kight, "'The State Is on Trial': Governor Edmund F. Noel and the Defense of Mississippi's Legal Institutions against Mob Violence," *Journal of Mississippi History* 60, no. 3 (1998): 192.

48. *The Crisis,* December 1910, 15.

49. Waldrep, "The War of Words," 76; Ida B. Wells, *Southern Horrors: Lynch Law in All Its Phases* (New York: New York Age Print, 1892).

50. Wolf, "Constructions of a Lynching," 87.

51. Joel Williamson, "Wounds Not Scars: Lynching, the National Conscience, and the American Historian," *Journal of American History* 83, no. 4 (1997): 1237–1239.

52. Ibid., 1242.

53. Ibid., 1253.

54. Trudier Harris, *Exorcising Blackness: Historical and Literary Lynching and Burning Rituals* (Bloomington: Indiana University Press, 1984), 22.

55. The social roles of women were changing too. In the next decade women would gain the vote. Many would change their clothing and hairstyles and participate in the

sexual and social freedoms of the jazz age. Many white men felt threatened by these changes. The sexual and racial hierarchy of the South put white women on a pedestal as the icons of sexual purity and chastity. In such a system, a white woman could easily empower herself as an oppressor by claiming that a black man had made unwanted advances or assaulted her. Each time a black man's path crossed that of a white woman, he was at her mercy and his life was potentially in danger.

56. Du Bois, "On Being Ashamed of Oneself: An Essay on Race Pride," *The Crisis,* September 1933, 200.

57. "Editorial: Lynching," *The Crisis,* August 1911, 158–159.

58. "Along the Color Line," *The Crisis,* September 1911, 185.

59. Lewis, *W. E. B. Du Bois: Biography of a Race,* 426.

60. Quoted in ibid., 426.

61. "Editorial: Triumph," *The Crisis,* September 1911, 195.

62. W. E. B. Du Bois, "Jesus Christ in Georgia," *The Crisis,* December 1911, 70–74.

63. Clark, "Without Fear or Shame," 281.

64. Grace Elizabeth Hale, *Making Whiteness* (New York: Pantheon Books, 1998), 203.

65. The practice of proudly sending postcards with brutal imagery was not confined to Americans. In the early twentieth century, French troops fighting in Indochina sent postcards with the pictures of the severed heads of Vietnamese rebels to their friends at home. "Vietnam: A Television History," Part I (PBS, 1983).

66. John Holmes, "Holmes on Lynching," *The Crisis,* January 1912, 110–111.

67. "Colored Men Lynched without Trial," *The Crisis,* March 1912, 208–209.

68. Ibid.

69. "Editorial: Lynching," *The Crisis,* March 1914, 239.

70. Ibid.

71. Du Bois, "The Lynching Industry," *The Crisis,* February 1915, 196, 198.

72. Ibid.

73. *The Crisis,* June 1915, 96.

74. *The Crisis,* February 1915, 197.

75. "Opinion: Lynching," *The Crisis,* October 1914, 279.

76. Ibid.

77. "The Burden," *The Crisis,* January 1916, 145.

78. "Peonage," *The Crisis,* April 1916, 302–303.

79. Ibid., 304.

80. Ibid., 305.

81. "The Waco Horror," Special Supplement to *The Crisis,* July 1916, 4.

82. Lewis, *W. E. B. Du Bois: Biography of a Race,* 514. Lewis has noted that "The Waco Horror" (reported in June and July in *The Crisis*) broke new ground in lynching journalism.

83. "The Waco Horror," 8.

84. Giotto used this technique to include the viewer in the crowd in his frescoing of Enrico Scrovegni's Arena Chapel in Padua by placing a figure with his back to the viewer in a crowd scene, notably in the *Lamentation* (1306). The artist in this cartoon is clearly familiar with Christian iconography and symbolism.

85. "Editorial: The Lynching Fund," *The Crisis,* December 1916, 61–62.

86. Du Bois, "The Looking Glass," reprinted from the *San Francisco Bulletin* in *The Crisis,* July 1917, 134–135.

87. Du Bois, "The Lynching at Memphis," *The Crisis,* August 1917, 187. The effort to obtain an image of a murder victim is a plot element in Thomas Dixon's 1905 novel *The Clansmen,* the book that spawned the movie *Birth of a Nation.* My thanks to Cary Wintz for this insight.

88. Ibid., 188.

89. Lewis, *W. E. B. Du Bois: Biography of a Race,* 539. Martha Gruening, with whom Du Bois collaborated, was the older sister of Ernest Gruening, an anti-imperialist and one of the foremost among progressive voices in the U.S. Senate. He was one of two senators to vote against the Gulf of Tonkin Resolution. See the impressive study by Robert D. Johnson, *Ernest Gruening* (Cambridge, Mass.: Harvard University Press, 1998).

90. Lewis, *W. E. B. Du Bois: Biography of a Race,* 536–537.

91. Du Bois, "Awake America," *The Crisis,* September 1917, 216–217.

92. James Madison, *A Lynching in the Heartland: Race and Memory in America* (New York: Palgrave for St. Martin's Press, 2001), 37.

93. Du Bois, "The Work of a Mob," *The Crisis,* September 1918, 222. This terrible lynching would inspire sculptor Meta Vaux Warrick Fuller to create a sculpture of Mary Turner.

94. "Mob Action," speech delivered by President Woodrow Wilson, July 26, 1918, recorded in *Washington Bee,* August 3, 1918, 1. *The Crisis* reprinted the speech as "President Wilson's Crusade against Lynching," *The Crisis,* January 1919, 227.

95. Zangrando, *The NAACP Crusade against Lynching,* 21.

96. *Thirty Years of Lynching in the United States, 1888–1918* (New York: NAACP, 1919).

97. For more information on the Dyer Anti-Lynching Bill, see Zangrando, *The NAACP Crusade against Lynching,* 44–45.

98. Waldrep, "The War of Words," 80.

99. Brundage, *Lynching in the New South,* 361.

100. Walter White would become the executive secretary of the NAACP in 1931. He investigated lynchings throughout the South, writing both a novel and a book about the issue. He also spearheaded a federal anti-lynching legislation campaign.

101. "Diary of Journey" (1921), Series 3/C, Folder no. 5515, 6–7, Unpublished Articles, W. E. B. Du Bois Papers, University of Massachusetts, Amherst.

102. Du Bois, "The Social Equality of Whites and Blacks," *The Crisis,* November 1920, 16.

103. *The Crisis,* January 1922, 124. The February issue included another map of the lynchings. The NAACP took out a full-page advertisement in the November 23, 1922, issue of the *New York Times* that prominently featured lynching statistics from NAACP studies ("3436 People Lynched 1889 to 1922") and encouraged readers to contact their senators to urge passage of the Dyer Anti-Lynching Bill.

104. Speech of Moorhouse Storey, June 1922, quoted in *The Crisis,* August 1922, 165.

105. "The Shame of America," *The Crisis,* February 1923, 168–169.

106. This iconography of the mourning mother can be found in such famous works as Giotto's *Crucifixion* and *Lamentation* (both in 1306), Cappella degli Scrovegni, Padova, where the intense pain and suffering of the Virgin Mary is emphasized.

107. *The Crisis,* May 1923, 37.

108. *The Crisis,* February 1924, 169.

109. *The Crisis,* February 1924, cover.

110. *The Crisis,* February 1927, 180. The cartoon won an honorable mention in a 1926 *Crisis* contest.

111. "Opinion: Lynching," *The Crisis,* February 1927, 180. Zangrando states that there were thirty lynchings in 1926 and seventeen in 1925. The numbers are slightly different, but the fact that there was an increase was accurate.

112. This is clearly a reference to Du Bois's *Souls of Black Folk.*

113. "Postscript: Lynchings," *The Crisis,* August 1927, 203.

114. *The Crisis,* September 1928, 312.

115. Zangrando, *The NAACP Crusade against Lynching,* 90. White was a unique figure in the anti-lynching movement. He was able to investigate lynchings for the NAACP and then for *The Crisis* because as a very light skinned, blond, blue-eyed man, he was able to hide his blackness. He knew that revealing his race would place him in danger of being lynched himself, something he almost fell victim to in 1919. White would investigate some forty-one lynchings in his career.

116. Walter Francis White, *Rope and Faggot* (1929; reprint, New York: Arno, 1969), 40. The indifference of Christian churches in the South to the crime of lynching offers a chilling parallel to the indifference of European Christianity to the Holocaust.

117. Waldrep, "The War of Words," 86–87.

118. White, *Rope and Faggot,* 245, 248–249.

119. For more about White's investigation, see Madison, *A Lynching in the Heartland.*

120. Ibid., 11.

121. Ibid., 71, quoting the *Marion Chronicle,* August 8, 1930.

122. "Postscript: Marion," *The Crisis,* October 1930, 353.

123. Madison, *A Lynching in the Heartland,* 113.

124. Ibid.

125. First published under the title "Bitter Fruit" in *The New York Teacher* (January 1937). See Peter Daniels, "'Strange Fruit': The Story of a Song," available online at http://www.wsws.org/articles/2002/feb2002/frut-f08.shtml.

126. *Strange Fruit,* California Newsreel, 1999, Joel Katz, producer/director/filmmaker.

127. Madison, *A Lynching in the Heartland,* 121.

128. Quoted in ibid., 124.

129. "Postscript: Lynchings," *The Crisis,* February 1932, 58.

130. Ibid.

131. Lynn Barstis Williams, "Images of Scottsboro," *Southern Cultures* 6, no. 1 (2000): 51.

132. *Baltimore Sun,* December 16, 1931.

133. Stephen Hess and Sandy Northrop, *Drawn and Quartered: The History of American Political Cartoons* (Montgomery, Ala.: Elliott and Clark Publishing: 1996), 99.

134. *New Masses,* January 9, 1934, 7.

135. *The Crisis,* September 1934, 257.

136. Josephine Schuyler, "The Slaughter of the Innocents," *The Crisis,* October 1934, 295.

137. The NAACP remained involved in the battle to end lynching. Walter White tried to help get the Costigan-Wagner Bill passed in both 1934 and 1935 and even enlisted the help of Eleanor Roosevelt. But as Robert Zangrando explained: "No less than

in the days of the Dyer bill, the Costigan-Wagner measure and its later counterparts suffered from southern intransigence and from the higher priorities that national leaders accorded to other aspects of America's domestic and foreign policies." Zangrando, *The NAACP Crusade against Lynching*, 129.

138. Margaret Rose Vendryes, "Hanging on Their Walls: A Commentary on Lynching, the Forgotten 1935 Exhibition," in Judith Jackson Fossett and Jeffrey A. Tucker, eds., *Race Consciousness* (New York: New York University Press, 1997), 154.

139. Ibid., 153.

140. Marlene Park, "Lynching and Antilynching: Art and Politics in the 1930s," *Prospects: An Annual of American Cultural Studies* 18 (1993): 324; Walter White to Mrs. George Bellows, December 13, 1934, NAACP Papers, Manuscript Division, Library of Congress, Washington, D.C.

141. One of the more prominent participants, Isamu Noguchi, based his piece on a photograph that Walter White had helped him secure that was dated 1930. Vendryes, "Hanging on Their Walls," 157.

142. Vendryes, "Hanging on Their Walls," 168.

143. Ibid., 168.

144. Ibid., 172.

145. "Art: Lynching Show Opens in Spite of Opposition 'Outburst,'" *News-Week*, February 23, 1935, 19.

146. This is discussed in detail by Helen Langa, in "Two Antilynching Art Exhibitions: Politicized Viewpoints, Racial Perspectives, Gendered Constraints," *American Art* (Spring 1999): 13–14.

147. Ibid., 17.

148. Citing the research of Trudier Harris, art historian Helen Langa has noted that most artists chose not to show castration. Harris said that castration was the symbolic extreme of lynching's unmanning of black victims. Most artists seemed to see this level of dismembering, of bloody violence, as too graphic and too offensive to include in their images. This was also the case in *The Crisis*. (Few artists in the NAACP exhibition showed this aspect of lynching. The exceptions are Noguchi's sculpture, José Clemente Orozco's lithograph, and Harry Sternberg's lithograph, which actually showed the aftermath of castration, with splashed blood in the area of removed genitals.) Descriptions of lynchings in *The Crisis* did not refer to castration and no drawings or photographs made castration clear to the viewer, reflecting perhaps Victorian mores about sexuality. The artists of *The Crisis* did not believe castration imagery was necessary to achieve the goal of reaching readers, and in an age of much greater visual restraint in the depiction of violence and sexual themes, they were undoubtedly right. (No doubt graphic castration photos would have risked government censorship and would have offended the readers as well.)

White artists in the exhibition tended to picture heroically masculine black men who had been forcefully subdued by constraint, violation, and castration. Langa feels these images give a mixed message. The artists hoped to show them as symbols of masculine potency and beauty. Their muscular bodies could be likened to the powerful proletarian workers evoked by leftist painters in the 1930s. They could also be viewed as idealized male athletes in the tradition of classical sculpture. Yet, Langa explains, these idealized yet powerless representations that emphasized victimhood unmanned those whose rights they were supposed to defend. They were still racially subordinated because they

had been removed of all power, noble yet helpless. Langa, "Two Antilynching Art Exhibitions," 23, 26–27.

149. Ibid., 28.

150. Langa, "Two Antilynching Art Exhibitions," 28.

151. Laura Wheeler's February 1924 image "Lest We Forget" is the exception to this generalization.

152. For more on this, see Langa, "Two Antilynching Art Exhibitions," 35.

153. Ibid.

154. Ibid., 54.

155. Ibid., 29.

156. T. R. Poston, "Murals and Marx," *New York New Amsterdam News,* November 24, 1934.

157. Kirschke, *Aaron Douglas.* Douglas's years of working for Du Bois affected his subject matter and brought him to lynching imagery. He had not tackled the subject before he worked for Du Bois at *The Crisis.*

158. Brent Staples, "Editorial Observer: The Perils of Growing Comfortable with Evil," *New York Times,* April 9, 2000.

159. Ibid.

4. THEORIES OF ART, PATRONAGE, AND AUDIENCE

1. Darwin Turner, "W. E. B. Du Bois and the Theory of a Black Aesthetic," in William L. Andrews, ed., *Critical Essays on W. E. B. Du Bois* (Boston: G. K. Hall, 1985), 74.

2. Quoted in Bernard Bell, "W. E. B. Du Bois's Struggle to Reconcile Folk and High Art," in Andrews, ed., *Critical Essays on W. E. B. Du Bois,* 118.

3. Ibid., 106.

4. Arnold Rampersad, *The Art and Imagination of W. E. B. Du Bois* (Cambridge, Mass.: Harvard University Press, 1976), 74. See also Bell, "W. E. B. Du Bois's Struggle to Reconcile Folk and High Art," 106–122.

5. For more on Du Bois's experiences in Germany, see Kenneth Barkin, "W. E. B. Du Bois' Love Affair with Imperial Germany," *German Studies Review* 28, no. 2 (May 2005): 284–302.

6. "A South of Slavery, Rebellion, and Black Folk," in David Levering Lewis, *W. E. B. Du Bois: Biography of a Race, 1868–1919* (New York: Henry Holt, 1993), 55.

7. Quoted in ibid., 110.

8. Quoted in ibid., 109–110. See also Barkin, "W. E. B. Du Bois' Love Affair with Imperial Germany."

9. Du Bois, "Social Origins of American Negro Art," *Modern Quarterly* 3 (Autumn 1925): 54.

10. Bell, "W. E. B. Du Bois's Struggle to Reconcile," 112.

11. "Our Book Shelf," *The Crisis,* January 1926, 141.

12. "Books," *The Crisis,* March 1931, 102.

13. Du Bois, "Social Origins of American Negro Art," 53.

14. Du Bois, "Criteria of Negro Art," in Herb Aptheker, ed., *Selections from* The Crisis, vol. 1, *1911–1925* (Millwood, N.Y.: Kraus-Thomson, 1983), 446. Originally published in *The Crisis,* October 1926.

15. Bell, "W. E. B. Du Bois's Struggle to Reconcile," 120.

16. Du Bois, "Criteria of Negro Art," 444.

17. Ibid.

18. Ibid., 445.

19. Ibid.

20. Ibid.

21. Ibid.

22. Ibid., 446.

23. W. E. B. Du Bois to Anne F. Jenkins, April 17, 1926, microfilm reel 19, frame 26, W. E. B. Du Bois Papers, University of Massachusetts, Amherst.

24. Ibid., 447.

25. Du Bois, "Negro Art," in Aptheker, ed., *Selections from* The Crisis, 1:301. Originally published in *The Crisis,* June 1921.

26. Du Bois posed the questions and printed the first solicited response beginning in the February 1926 issue; responses continued to be published in every month (except July and October) through November 1926. The "Criteria" speech was then published in *The Crisis* near the end of the symposium.

27. Cary Wintz, *The Harlem Renaissance 1920–1940: The Critics and the Harlem Renaissance* (New York: Garland Publishing, 1996), 349; and Du Bois, "The Negro in Art: How Should He Be Portrayed?" *The Crisis,* March 1926, 219.

28. Du Bois, "The Negro in Art," 216. See also Turner, "W. E. B. Du Bois and the Theory of a Black Aesthetic," 85.

29. Du Bois, "The Negro in Art," 219.

30. "Books," *The Crisis,* December 1926, 81–82.

31. Quoted in "Response to Criteria of Negro Art," *The Crisis,* August 1926, 194.

32. Quoted in Du Bois, The Negro in Art," *The Crisis,* March 1926, 220.

33. Quoted in ibid., 278.

34. Quoted in ibid., 279.

35. Quoted in ibid., 279–280.

36. Quoted in Du Bois, "Negro Art," *The Crisis,* September 1926, 238–239.

37. Darwin Turner also argues this point. Turner, "W. E. B. Du Bois and the Theory of a Black Aesthetic," 79.

38. Du Bois, "The Art and Galleries of Modern Europe," 1896, speech delivered at Wilberforce University. Quoted in Herbert Aptheker, *Against Racism* (Amherst: University of Massachusetts Press, 1985), 34.

39. Du Bois, "The Social Origins of American Negro Art," *Modern Quarterly,* 3 (Oct.–Dec., 1925, found in Aptheker ed., *Writings by W. E. B. Du Bois in Non-Periodical Literature Edited by Others,* 270

40. Du Bois, "Negro Art," *The Crisis,* June 1921, 36.

41. Ibid., 55–56.

42. Ibid.

43. Du Bois, "The New Crisis," *The Crisis,* May 1925, 8.

44. Keith E. Byerman, *Seizing the Word: History, Art, and Self in the Work of W. E. B. Du Bois* (Athens: University of Georgia Press, 1994), 105. I have drawn extensively on Byerman's work.

45. Du Bois quoted in Nathan Huggins, *Harlem Renaissance* (New York: Oxford, 1971), 101.

46. See Byerman, *Seizing the Word,* esp. 100–101.

47. Du Bois, "Criteria of Negro Art," 449.

48. Ibid., 448.

49. Ibid., 449.

50. "Editorial: Reconstruction and Africa," *The Crisis,* February 1919, 165–166.

51. Commencement Address at Talladega College, Talladega, Alabama, June 5, 1944. In *Talladegan* 62 (November 1944): 1–6.

52. Du Bois, "Criteria of Negro Art," 449.

53. Ibid., 447–448.

54. Du Bois, "The Drama among Black Folk," *The Crisis,* July 1916, 169.

55. Du Bois, "The Younger Literary Movement," *The Crisis,* February 1924, 161.

56. Du Bois, "The Colored Audience," *The Crisis,* September 1916, 217.

57. Ibid.

58. "Art for Nothing," *The Crisis,* May 1922, 8–9.

59. Ibid.

60. Jessie Fauset, "The Negro in Art," *The Crisis,* June 1926, 72. Fauset's precise contribution is unclear, although surely it is significant. I base my judgment on a conversation with David Levering Lewis, April 2002.

61. *The Crisis,* February 1927, 191–193.

62. Discussion of Elizabeth Prophet, Richmond Barthé, Augusta Savage, and Georgia Douglas in Du Bois to Alexander Alland, March 14, 1949, in Aptheker, ed., *Correspondence of W. E. B. Du Bois,* vol. 2: *1934–44* (Amherst: University of Massachusetts Press, 1976), 221. He noted that Savage was a hardworking artisan but scarcely a first-class sculptor.

63. "Krigwa, 1927," *The Crisis,* February 1927, 191–193.

64. Ibid.

65. He also mentioned William Scott and William Harper.

66. Du Bois, "The Negro as a National Asset," in Aptheker ed., *Writings by W. E. B. Du Bois in Non-Periodical Literature Edited by Others,* 206. Originally published in *The Homilectic Review,* 86 (July 1923), 52–58.

67. Herbert Aptheker, *Literary Legacy of W. E. B. Du Bois* (White Plains, N.Y.: Kraus International Publications, 1989), 171.

68. *Los Angeles Times,* June 14, 1925, pt. 3, 26–27.

69. Ibid.

70. Ibid.

71. Ibid.

72. Du Bois set up a literary prize in April 1931 in part to wean writers from Van Vechten and McKay. My thanks to Cary Wintz for this point.

73. "The Browsing Reader," *The Crisis,* July 1927, 159.

74. Turner, "W. E. B. Du Bois and the Theory of a Black Aesthetic," in Andrews, ed., *Critical Essays on W. E. B. Du Bois,* 86.

5. IMAGES OF AFRICA AND THE DIASPORA

1. Tunde Adeleke, "Black Americans and Africa: A Critique of the Pan-African and Identity Paradigms," *International Journal of African Historical Studies* 31, no. 3 (1998): 517.

2. Ibid., 525.

3. Leo Marx, "American Studies: A Defense of an Unscientific Method," *New Literary History* 1 (1969): 86.

4. Adeleke, "Black Americans and Africa," 513. Delany grew to see Africans as barbaric; Crummell saw them as violent and crude. Turner, too, grew to see imperialism and colonialism as necessary to efforts to civilize Africa.

5. Tunde Adeleke, "Who Are We? Africa and the Problem of Black American Identity," *Canadian Review of American Studies* 29, no. 1 (1999): 77.

6. Adeleke, "Black Americans and Africa," 514.

7. Arnold Rampersad, *The Art and Imagination of W. E. B. Du Bois* (Cambridge, Mass.: Harvard University Press, 1976), 162–163.

8. W. E. B. Du Bois, *Autobiography of W. E. B. Du Bois* (New York: International Publishers, 1968), 122.

9. W. E. B. Du Bois, "Jefferson Davis as a Representative of Civilization," Commencement Address, Harvard University, 1890, in W. E. B. Du Bois, *Writings* (New York: Library of America, 1986), 811–814; David Blight, "W. E. B. Du Bois and the Struggle for American Historical Memory," in Geneviève Fabre and Robert O'Meally, eds., *History and Memory in African-American Culture* (New York: Oxford University Press, 1994), 47–49.

10. Quoted in Melville Herskovits, *Franz Boas: The Science of Man in the Making* (New York: Scribner's, 1953), 111.

11. W. E. B. Du Bois, *Black Folk Then and Now* (1939; reprint, Millwood, N.Y.: Kraus-Thomson, 1975), vii; George Hutchinson, *The Harlem Renaissance in Black and White* (Cambridge, Mass.: Belknap Press of Harvard University Press, 1995), 63.

12. Hutchinson, *The Harlem Renaissance in Black and White*, 63.

13. David Levering Lewis, *W. E. B. Du Bois: The Fight for Equality and the American Century, 1919–1963* (New York: Henry Holt, 2000), 472.

14. Michael Frisch, "The Memory of History," in Susan Porter Benson, Steven Brier, and Roy Rozenzweig, eds., *Presenting the Past: Essay on History and the Public* (Philadelphia: Temple University Press, 1986), 6.

15. My argument owes a great deal to Paul Gilroy, *The Black Atlantic* (Cambridge, Mass.: Harvard University Press, 1993), esp. 113, 121–145.

16. Du Bois, *Dusk of Dawn: An Essay toward an Autobiography of a Race Concept,* in Du Bois, *Writings,* 639–640.

17. W. E. B. Du Bois, *The World and Africa: An Inquiry into the Part Which Africa Has Played in World History* (New York: International Publishers, 1947), 1–2; Blight, "W. E. B. Du Bois and the Struggle for American Historical Memory," 53.

18. Gilroy, *The Black Atlantic,* 123.

19. Ibid., 60.

20. Quoted in Lewis, *W. E. B. Du Bois: The Fight for Equality and the American Century,* 457.

21. Ibid. Melville Herskovits reviewed *Black Folk: Then and Now* in the *New Republic* and argued that the first half of the book was lacking in recent sources on Egypt and flawed in its romanticization of contemporary struggles. His assessment was not unique. The whole idea of a connection between African peoples, the emphasis on a nonexistent harmony and consensus, on glorious accomplishments rather than on the contradictions and problems, was romantic, and Du Bois was guilty of this romanti-

cization. But he was using Africa to connect a people; he did not have illusions about a unified Africa.

22. Much of his use of African history, although it is fragmentary, can be traced back to *Souls of Black Folk.* Here Du Bois claimed that the problem of race was a "problem of the color line," but he was not just talking about race in the United States; he meant the global issues of the diaspora, a transnationalist point of view. He wanted black Americans to see their links with the past so they could connect their contemporary suffering with other African peoples in the world. See Gilroy, *The Black Atlantic,* 127.

23. See Martin Bernal, *Black Athena: The Afroasiatic Roots of Classical Civilization* (New Brunswick, N.J.: Rutgers University Press, 1987).

24. Du Bois, "African Civilization," *The Crisis,* March 1922, 25.

25. Ibid.

26. Ibid. For more on Fauset and Du Bois, see Lewis, *W. E. B. Du Bois: The Fight for Equality and the American Century,* 49–50. Fauset was romantically linked with Du Bois.

27. Aaron Douglas, Drawing, "Invincible Music: The Spirit of Africa," *The Crisis,* February 1926, 169. This drawing gives the illusion of a cutout black-and-white silhouette with wavy lines of gray tones.

28. This flower design, like others Douglas used in his illustrations, is similar to one found in Theodore Menten, *Art Nouveau and Early Art Deco Type and Design* (New York: Dover, 1972), 9.

29. Aaron Douglas interview by L. M. Collins, July 16, 1971, Black Oral Histories, Special Collections, John Hope and Aurelia E. Franklin Library, Fisk University, Nashville, Tenn.

30. Again, these plants, which are repeated throughout Douglas's illustrations, are clearly influenced by art nouveau and early art deco patterning and can be found in Menten, *Art Nouveau and Early Art Deco Type and Design,* 9, 15.

31. Orphism, an offshoot of cubism, was also known as synchronism.

32. "Opinion: The Gifts of Ethiopia," *The Crisis,* December 1915, 75.

33. David W. Blight, "Fifty Years of Freedom: The Memory of Emancipation at the Civil War Semicentennial, 1911–1915," *Slavery and Abolition* 21, no. 2 (2000): 130–131.

34. *The Crisis,* November 1917, 25. Abyssinia was an ancient name for Ethiopia. Menelik II married Empress Taitou (sometimes spelled "Taytu"), a noblewoman of imperial blood, in 1883. They had no children.

35. "Opinion: On Migrating to Africa," *The Crisis,* June 1924, 68.

36. Zauditu was the daughter of Menelik II. Haile Selassie, who was her close advisor, succeeded her at her death in 1916.

37. "Manifesto to the League of Nations," *The Crisis,* November 1921, 18.

38. Du Bois, "A Message from the King of Buganda to American Negroes," *The Crisis,* June 1932, 183–184.

39. The woman's body was emphasized in the Armana period. Tightly wrapped sheer fabric outlined the shape of the body and revealed the stomach, the thighs, and the pubic area.

40. "Opinion: On Migrating to Africa," 58.

41. Ibid.

42. Quoted in Du Bois, "African Art," *The Crisis,* May 1925, 39.

43. Hutchinson, *The Harlem Renaissance in Black and White,* 427.

44. Ibid.

45. Quoted in Du Bois, "African Art," 39.

46. David Levering Lewis, *W. E. B. Du Bois: Biography of a Race, 1868–1919* (New York: Henry Holt, 1993), 577.

47. Du Bois, "The Future of Africa," *The Crisis,* February 1919, 165–166.

48. Lewis, *W. E. B. Du Bois: Biography of a Race,* 119–120.

49. "Opinion: Returning Soldiers," *The Crisis,* May 1919, 13–14.

50. Quoted in Nathan Huggins, *Harlem Renaissance* (New York: Oxford University Press, 1971), 46.

51. Lewis, *W. E. B. Du Bois: Biography of a Race,* 73.

52. Quoted in Huggins, *Harlem Renaissance,* 47.

53. Lewis, *W. E. B. Du Bois: The Fight for Equality and the American Century,* 112–117.

54. Liberia was recognized by the United States in 1862. It was never colonized by a European power. The American Colonization Society became interested in Liberia in 1816, and the first freed slaves from the United States set foot on Liberian soil in 1822.

55. W. E. B. Du Bois, "Report: The Third Pan-African Congress," *The Crisis,* January 1924, 122.

56. Lewis, *W. E. B. Du Bois: The Fight for Equality and the American Century,* 211.

57. Du Bois, "The Pan-African Congresses," *The Crisis,* October 1927, 263–264.

58. "Opinion: Africa," *The Crisis,* April 1924, 248.

59. Ibid., 274. This parallels nineteenth-century Marxist imagery of what the world would look like after the revolution took place. Henry Highland Garnet was a black abolitionist of the nineteenth century.

60. Primitivism is the romantic notion that black Americans lived a wild, unrefined, simple, and pure life.

61. "Opinion: Africa," 273.

62. Ibid., 274.

63. *The Crisis,* March 1917, 247. In World War I, the British sought help from the Congolese. See Samuel H. Nelson, *Colonialism in the Congo Basin, 1880–1940* (Athens: Ohio University Press, 1994), 124–125.

64. W. E. B. Du Bois, "Ghana Calls," to Osagyefo Kwame Nkrumah, n.d., from *Selected Poems* (Accra: Ghana Universities Press, n.d.), 37–40.

6. ART, POLITICAL COMMENTARY, AND FORGING A COMMON IDENTITY

1. Daniel Walden, *W. E. B. Du Bois: The Crisis Writings* (Greenwich, Conn.: Fawcett, 1972), 85.

2. "Segregation," *The Crisis,* November 1910, 10–11.

3. *The Crisis,* January 1914, 119.

4. *The Crisis,* June 1916, 96.

5. *The Crisis,* November 1917, 13.

6. *The Crisis,* February 1920, 203.

7. David Levering Lewis, *W. E. B. Du Bois: Biography of a Race, 1868–1919* (New York: Henry Holt, 1993), 107, 167.

8. Ibid., 424.

9. "The Defeat of Judge Parker," *The Crisis,* July 1930, 225–227, 248.

10. "Editorial: Education," *The Crisis,* May 1912, 25–26.

11. "Editorial: Education," *The Crisis,* June 1912, 74.

12. Ibid.

13. Ibid., 75.

14. Ibid., 76

15. "Editorial: School," *The Crisis,* October 1918, 267. Many progressives sought to restrict child labor, but their focus was on white children, the children of immigrants from Europe. Du Bois wanted black children to have the same consideration.

16. "Editorial: College Education," *The Crisis* July 1914, 128.

17. "Editorial: Education," *The Crisis,* July 1915, 133.

18. Ibid., 136.

19. Ibid.

20. Theresa Leininger-Miller, *New Negro Artists in Paris: African American Painters and Sculptors in the City of Light, 1922–1934* (New Brunswick, N.J.: Rutgers University Press, 2001), 221–222.

21. "Opinion: Crisis Children," *The Crisis,* October 1926, 283.

22. *The Crisis,* April 1926, 116.

23. The cartoon appeared in October 1934, the first issue of *The Crisis* published after Du Bois's departure.

24. Du Bois, "Does the Negro Need Separate Schools?" in Herbert Aptheker, ed., *Writings by W. E. B. Du Bois in Periodicals Edited by Others,* vol. 3, *1935–1944* (Millwood, N.Y.: Kraus-Thomson, 1982), 13. Originally published in *Journal of Negro Education* (July 1935).

25. Ibid.

26. Ibid., 11.

27. Ibid., 14.

28. Ibid.

29. Du Bois, "Postscript," *The Crisis,* March 1934, 85–86.

30. For the role of African Americans in the labor movement, see Philip Foner, *Organized Labor and the Black Worker, 1619–1973* (New York: Praeger, 1974), 86, 88, 92ff.; and Bruce Nelson, *Divided We Stand: American Workers and the Struggle for Black Equality* (Princeton, N.J.: Princeton University Press, 2001).

31. Du Bois, "The Pan-African Congresses," *The Crisis,* October 1927, 264.

32. Du Bois, "Labor Omnia Vicit," *The Crisis,* September 1919, 231–232.

33. Nell Irvin Painter, "Black Workers from Reconstruction to the Great Depression," in Paul Buhle and Alan Dawley, eds., *Working for Democracy: American Workers from the Revolution to the Present* (Urbana: University of Illinois Press, 1985), 63–71.

34. Du Bois, "Labor Omnia Vicit," 232.

35. See Daniel Letwin, *The Challenge of Interracial Unionism: Alabama Coal Miners* (Chapel Hill, University of North Carolina Press, 1998), 153–156.

36. *The Crisis,* June 1929, 189.

37. Du Bois, "Along the Color Line," *The Crisis,* June 1929, 197.

38. Du Bois, "The Right to Work," in Aptheker, ed., *Selections from* The Crisis, vol. 2, *1926–1934* (Millwood, N.Y.: Kraus-Thomson, 1983), 692. Originally published in *The Crisis,* April 1933, 93–94.

39. Ibid., 694 Du Bois asked, "What then, shall we do? What can we do? Parties of reform, of Socialism and Communism beckon us. None of these offers us anything concrete or dependable." They too were designed to lift white producers and consumers,

"leaving the black man and his peculiar problems severely alone." Du Bois wrote that so-cialists and communists assumed that state control of industry would in some way mag-ically abolish race prejudice and wanted Negroes to assume on faith that this would be the result. But nothing in the history of American socialism gave them the slightest as-surance on this point. Communism, Du Bois argued, "led by a group of pitiable mental equipment," only wanted to use Negroes as shock troops. "To raise hell on any and all occasions, these offer in reality nothing to us except social equality in jail." Du Bois would change his mind later.

40. Ibid., 693.

41. Ibid., 694.

42. Letwin, *The Challenge of Interracial Unionism,* 105–107.

43. Du Bois, "The A. F. of L.," *The Crisis,* December 1933, 292.

44. The CIO was formed in 1935 by mine workers; by 1938, nearly 4 million un-skilled workers belonged to the new union.

45. Du Bois, "The A. F. of L, 292."

46. See "Hoover Dam," available online at http://www.arizona-leisure.com/hoover-dam-men.html.

47. Leland Stanford Hawkins, "Boulder Dam," *The Crisis,* March 1934, 77–78.

48. U. S. Bureau of the Census, *Historical Statistics of the United States, Colonial Times to 1957* (Washington, D.C.: Government Printing Office, 1960), 70.

49. Robert McElvaine, *The Great Depression, 1929–1941* (New York: Times Books, 1993), 187.

50. See David Levering Lewis, *W. E. B. Du Bois: The Fight for Equality and the American Century, 1919–1963* (New York: Henry Holt, 2000), 305–306.

51. Mark Ellis, "'Closing Ranks' and 'Seeking Honors': W. E. B. Du Bois in World War I," *The Journal of American History* 79, no. 1 (June 1992): 96.

52. Lewis, *W. E. B. Du Bois: Biography of a Race,* 553–555.

53. Mark Ellis, "'Closing Ranks,'" 120–124.

54. William Jordan, "The Damnable Dilemma: African-American Accommoda-tion and Protest during World War I," *Journal of American History* 81, no. 4 (March 1995): 1564.

55. These circulation figures come from Lewis, who noted that *The Crisis* increased its circulation from its April 1912 figure of 22,500 to over 50,000 by January 1918. Lewis, *W. E. B. Du Bois: Biography of a Race,* 416, 544.

56. Theodore Kornweibel, Jr., *Investigate Everything: Federal Efforts to Compel Black Loyalty during World War I* (Bloomington: Indiana University Press, 2002), 132.

57. Ibid., 140.

58. Du Bois was acting in the same spirit as suffragists of the time; he was a strong supporter of women's suffrage and doubtless had ties to strategists in the movement. In both Europe and the United States, there was a widespread belief among suffragists in the early decades of the twentieth century that if they were politically mature, capable, and showed self-sacrifice, their efforts would lead to greater equality and ultimately suf-frage. This seemed even more logical concerning military service and war and the possi-ble loss of life. See Nancy Cott, *The Grounding of Modern Feminism* (New Haven, Conn.: Yale University Press, 1987), 59–60.

59. Du Bois often featured images of the African American military during the first decade of the magazine. The May 1911 issue included a photograph of the officers of

the 8th Regiment, Illinois National Guard, and noted that Colonel Marshall was attending maneuvers in Texas. "Along the Color Line," which appeared in the October 1911 issue, included a photograph of the Knights of Pythias in Indianapolis, dated August 1911 (228). The cover of the September 1915 issue included a soldier in full dress uniform. Inside this special Chicago issue, in the column "Colored Chicago," photographs of officers in the armed forces, including black captains and three majors, were included. The November 1915 issue included a photograph of the Veterans of Foreign Service of Pittsburgh, Pennsylvania, Post No. 46, the only colored post on parade at the national convention at Detroit. The November 1916 issue included the photograph of the First Colored Regiment.

60. Lewis, *W. E. B. Du Bois: Biography of a Race,* 176.

61. Ibid., 530. For more on the effects of service in the war on political rights in an international context, see Nicoletta F. Gullace, *"The Blood of Our Sons": Men, Women, and the Renegotiation of British Citizenship during the Great War* (New York: Palgrave Macmillan, 2002).

62. Arthur E. Barbeau and Florette Henri, *The Unknown Soldiers: Black American Troops in World War I* (Philadelphia: Temple University Press, 1974), 58. This is the best account of the role of African American soldiers in World War I.

63. Lewis, *W. E. B. Du Bois: Biography of a Race,* 530.

64. Barbeau and Henri, *The Unknown Soldiers,* 50.

65. Lewis, *W. E. B. Du Bois: Biography of a Race,* 532.

66. Mark Ellis, *Race, War and Surveillance: African Americans and the United States Government during World War I* (Bloomington: Indiana University Press, 2001), xvi.

67. *The Crisis,* June 1917.

68. Ernst Friedrich, *Krieg dem Kriege! = Guerre à la guerre! = War against War!* (Berlin: Freie Jugend, 1926).

69. *The Crisis,* September 1917, 248.

70. See Barbeau and Henri, *The Unknown Soldiers*; and Lewis, *W. E. B. Du Bois: Biography of a Race,* 574.

71. James R. Grossman, "A Chance to Make Good, 1900–1929," in Robin Kelley and Earl Lewis, eds., *To Make Our World Anew* (New York: Oxford University Press, 2000), 400.

72. These achievements are discussed in Barbeau and Henri, *The Unknown Soldiers,* 111–163.

73. David M. Kennedy, *Over Here: The First World War and American Society* (New York: Oxford University Press, 1980), 284.

74. Du Bois is defending his support of the war and his brief dalliance with a military commission by stating that *The Crisis* was drafted into service as well. Du Bois, "Returning Soldiers," *The Crisis,* May 1919, 13; and Du Bois, *Writings,* 1181.

75. Du Bois, "Returning Soldiers," *The Crisis,* May 1919, 14.

76. Lewis, *W. E. B. Du Bois: Biography of a Race,* 470.

77. Bettina Aptheker, "W. E. B. Du Bois and the Struggle for Women's Rights, 1910–1920," *San Jose Studies* 1, no. 2 (1975): 7.

78. Ibid., 8.

79. W. E. B. Du Bois, *Darkwater: Voices from Within the Veil* (New York: Harcourt Brace, 1921), 172. In his essay in the book titled "The Damnation of Women," Du Bois offered his most elegant and direct argument for the equality of the sexes.

80. Shanette M. Harris, "Constructing a Psychological Perspective: The Observer and the Observed in the Souls of Black Folk," in Dolan Hubbard, ed., *The Souls of Black Folk One Hundred Years Later* (Columbia University of Missouri Press, 2003), 226–228.

81. Lewis, *W. E. B. Du Bois: Biography of a Race,* 435 and 451.

82. Rufus Burrow, Jr., "W. E. B. Du Bois and the Intersection of Race and Sex in the Twenty-First Century," in Hubbard, *The Souls of Black Folk One Hundred Years Later,* 135.

83. Bettina Aptheker, "W. E. B. Du Bois and the Struggle for Women's Rights," 8.

84. Burrow, "W. E. B. Du Bois and the Intersection of Race and Sex," 130.

85. Bettina Aptheker, "W. E. B. Du Bois and the Struggle for Women's Rights," 11.

86. Glenda Gilmore, *Gender and Jim Crow: Women and the Politics of White Supremacy in North Carolina, 1896–1920* (Chapel Hill: University of North Carolina Press, 1996), 211–212.

87. Ibid., 11.

88. Editorial, "Womens Suffrage," *The Crisis,* May 1913, 29.

89. Bettina Aptheker, "W. E. B. Du Bois and the Struggle for Women's Rights," 11.

90. Irene Diggs, "DuBois and Children," *Phylon* 36, no. 4 (1976): 386–387.

91. Lewis, *W. E. B. Du Bois: Biography of a Race,* 417.

92. Du Bois, "Forward, Backward," *The Crisis,* October 1911, 244.

93. Ibid., 418.

94. Ibid.

95. Jean Fagan Yellin, "Du Bois' *Crisis* and Woman's Suffrage," *Massachusetts Review* 14, no. 2 (1973): 370; Bettina Aptheker, "W. E. B. Du Bois and the Struggle for Women's Rights," 11–12.

96. *The Crisis,* March 1925, 285–286.

97. "Editorial: The Immortal Children," *The Crisis,* October 1916, 267–268; Diggs, "DuBois and Children," 390.

98. This is well documented in Diggs, "Du Bois and Children," 370–399.

99. "The Drop Sinister," *The Crisis,* October 1915, 286–287.

100. Ibid., 286.

101. "Editorial: The Slaughter of the Innocents," *The Crisis,* October 1918, 267.

102. John Henry Adams, "Woman to the Rescue," *The Crisis,* May 1916, 43. "Wilmington, N.C." refers to the overthrow of an elected black government and to the brutal attack on black businessowners in Wilmington, North Carolina, in 1898. Businesses were destroyed and many blacks were forced out of town or chose to flee to avoid more terror. The African American writer Charles W. Chesnutt wrote an account of the Wilmington terror in his second novel, *The Marrow of Tradition* (1901; reprint, Boston: Bedford/St.Martin's, 2002).

CONCLUSION

1. "Postscript: The Board of Directors on Segregation," *The Crisis,* May 1934, 149.

2. Ibid.

3. David Levering Lewis, *W. E. B. Du Bois: The Fight for Equality and the American Century, 1919–1963* (New York: Henry Holt, 2000), 343.

4. *The Crisis,* May 1934, 149.

5. W. E. B. Du Bois to Joel Spingarn, May 31, 1934, James Weldon Johnson Papers, Box 11, Beinecke Rare Book and Manuscript Library, Yale University, New Haven, Connecticut.

6. For more on Du Bois's philosophy of separatism, see Lewis, *W. E. B. Du Bois: The Fight for Equality and the American Century,* 302–348.

7. Arnold Rampersad, *The Art and Imagination of W. E. B. Du Bois* (Cambridge, Mass.: Harvard University Press, 1976), 162–163.

8. Du Bois, "Dramatis Personae," *The Crisis,* May 1930, 162.

9. Darwin Turner, "W. E. B. Du Bois and the Theory of a Black Aesthetic," in William L. Andrews, ed., *Critical Essays on W. E. B. Du Bois* (Boston: G. K. Hall, 1985), 88–89; quote on page 88.

10. Du Bois, "The Position of the Negro in the American Social Order: Where Do We Go from Here?" *Journal of Negro Education* 8 (July 1939): 551.

11. Ibid.

12. Ibid., 562.

13. *The Crisis,* August 1933, 176.

14. Turner, "W. E. B. Du Bois and the Theory of a Black Aesthetic," 74.

15. Perhaps Du Bois's effort at separatism in art/literature was ultimately as wrong-headed as his concept of a social-economic-political separatism based on the model of the African clan as a model for twentieth-century African Americans. W. E. B. Du Bois, *Dusk of Dawn* (New York: Harcourt, 1940), 219.

16. Ibid., 202.

17. Turner, "W. E. B. Du Bois and the Theory of a Black Aesthetic," 91.

18. Du Bois, *Black Reconstruction: An Essay toward a History of the Part which Black Folk Played in the Attempt to Reconstruct Democracy in America, 1860–1880* (New York: Harcourt, Brace and Co., 1935), 722.

19. W. E. B. Du Bois, "The Shadow," *New Republic,* February 23, 1921.

Bibliography

UNPUBLISHED SOURCES/ARCHIVES

Arts Students League Archives. New York, New York.

Aaron Douglas Papers. John Hope and Aurelia E. Franklin Library, Special Collections, Fisk University, Nashville, Tennessee.

Aaron Douglas Papers. Schomburg Center for Research in Black Culture, New York Public Library, New York, New York.

W. E. B. Du Bois Papers. W. E. B. Du Bois Library, University of Massachusetts, Amherst.

Harmon Foundation Papers. Manuscript Division, Library of Congress, Washington, D.C.

Charles S. Johnson Papers. Beinecke Rare Book and Manuscript Library, Yale University, New Haven, Connecticut.

James Weldon Johnson Memorial Collection of Negro Arts and Letters Papers. Beinecke Rare Book and Manuscript Library, Yale University, New Haven, Connecticut.

NAACP Papers. Manuscript Division, Library of Congress, Washington, D.C.

INTERVIEWS

Interview with Stephanie Cassidy, archivist, Arts Student League, New York, December 17, 2003.

Conversation with David Levering Lewis. April 2002, Nashville, Tennessee.

Interviews with Laura Manos, Christiana Cunningham-Adams, and George Adams, art conservators, Nashville, Tennessee, June 2 and 4, 2003.

PUBLISHED WRITINGS OF W. E. B. DU BOIS

Articles

"Does the Negro Need Separate Schools?" *The Journal of Negro Education,* July 1935, 335.

"Looking Seventy-Five Years Backward." *Phylon* 3, no. 2 (1942): 245.

"The Negro in Literature and Art." *Annals of the American Academy of Political and Social Science* 49 (September 1913): 233–237.

"The Shadow." *The New Republic*, February 23, 1921.
"Social Origins of American Negro Art." *Modern Quarterly* 3 (Autumn 1925).

Books

Autobiography of W. E. B. Du Bois: A Soliloquy of Viewing My Life from the Last Decade of Its First Century. New York: International Publishers, 1968.

Black Folk: Then and Now—An Essay in the History and Sociology of the Negro Race. 1939; reprint, Millwood, N.Y.: Kraus-Thomson, 1975.

Black Reconstruction: An Essay toward a History of the Part Which Black Folk Played in the Attempt to Reconstruct Democracy in America, 1860–1880. New York: Harcourt, Brace and Co., 1935.

Darkwater: Voices within the Veil. 1920; reprint, Millwood, N.Y.: Kraus-Thomson, 1975.

Dusk of Dawn. New York: Harcourt, 1940.

Selected Poems. Accra: Ghana Universities Press, n.d.

The Souls of Black Folk. Edited by David Blight. Boston: Bedford Books, 1997.

W. E. B. Du Bois: The Crisis Writings. Edited by Daniel Walden. Greenwich, Conn.: Fawcett, 1972.

The World and Africa: An Inquiry into the Part Which Africa Has Played in World History. New York, 1947.

Writings. New York: Library of America, 1986.

Edited Works

Aptheker, Herbert, ed. *Correspondence of W. E. B. Du Bois.* Vol. 1, *1877–1934.* Amherst: University of Massachusetts Press, 1973.

——. *Correspondence of W. E. B. Du Bois.* Vol. 2, *1934–1944.* Amherst: University of Massachusetts Press, 1976.

——. *Correspondence of W. E. B. Du Bois.* Vol. 3, *1944–1963.* Amherst: University of Massachusetts Press, 1978.

——. *Writings in Periodicals Edited by W. E. B. Du Bois: Selections from the Brownies' Book.* Millwood, N.Y.: Kraus-Thomson, 1980.

——. *Selections from* The Crisis. Vol. 1, *1911–1925.* Millwood, N.Y.: Kraus-Thomson, 1983.

——. *Selections from* The Crisis. Vol. 2, *1926–1934.* Millwood, N.Y.: Kraus-Thomson, 1983.

——. *Writings by W. E. B. Du Bois in Periodicals Edited by Others.* Vol. 1, *1891–1909.* Millwood, N.Y.: Kraus-Thomson, 1982.

——. *Writings by W. E. B. Du Bois in Periodicals Edited by Others.* Vol. 2, *1910–1934.* Millwood, N.Y.: Kraus-Thomson, 1982.

——. *Writings by W. E. B. Du Bois in Periodicals Edited by Others.* Vol. 3, *1935–1944.* Millwood, N.Y.: Kraus-Thomson, 1982.

——. *Writings by W. E. B. Du Bois in Periodicals Edited by Others.* Vol. 4, *1945–1961.* Millwood, N.Y.: Kraus-Thomson, 1982.

——. *Creative Writings by W. E. B. Du Bois: A Pageant, Poems, Short Stories, and Playlets.* White Plains, N.Y.: Kraus-Thomson, 1985.

————. *Newspaper Columns by W. E. B. Du Bois.* Vol. 1, *1883–1944.* White Plains, N.Y.: Kraus-Thomson, 1986.

————. *Pamphlets and Leaflets by W. E. B. Du Bois.* White Plains, N.Y.: Kraus-Thomson, 1986.

Weinberg, Meyer, ed. *W. E. B. Du Bois: A Reader.* New York: Harper & Row, 1970.

————. *The World of W. E. B. Du Bois: A Quotation Sourcebook.* London: Greenwood Press, 1992.

PRIMARY SOURCES—PUBLISHED

Barnes, Albert C. "Negro Art in America." *Survey Graphic* 6 (March 1925): 668–669.

————. "Negro Art: Past and Present." *Opportunity* 4, no. 21 (May 1926): 148–149, 168–169.

Bearden, Romare. "The Negro Artist and Modern Art." *Journal of Negro Life,* December 1934.

Friedrich, Ernst. *Krieg dem Kriege! = Guerre à la guerre! = War against war!* Berlin: Freie Jugend, 1926.

Locke, Alain. "Art or Propaganda?" *Harlem,* November 1924, 12.

————. "Legacy of the Ancestral Arts." In Alain Locke, ed., *The New Negro.* 1925; reprint, New York: Atheneum, 1980.

————. "African Art in America." *The Nation,* March 16, 1927, 290.

————. "The African Legacy and the Negro Artist." In *Exhibition of the Works of Negro Artists,* 10–12. New York: Harmon Foundation, 1931.

McGleughlin, Jean. Obituary of Albert Alexander Smith. *Opportunity Magazine,* July 1940, 208.

Schomburg, Arthur. "The Negro Digs Up His Past." In Alain Locke, ed., *The New Negro,* 231–237. 1925; reprint, New York: Atheneum, 1980.

Terrell, Mary Church. "Lynching from a Negro's Point of View." *North American Review* 178 (June 1904).

White, Walter Francis. *Rope and Faggot: A Biography of Judge Lynch.* 1929; reprint, New York: Arno, 1969.

SECONDARY SOURCES

Adeleke, Tunde. "Black Americans and Africa: A Critique of the Pan-African and Identity Paradigms." *The International Journal of African Historical Studies* 31, no. 3 (1998): 505–536.

————. "Who Are We? Africa and the Problem of Black American Identity." *Canadian Review of American Studies* 29, no. 1 (1999): 49–86.

Allen, James. *Without Sanctuary: Lynching Photograph in America.* Santa Fe: Twin Palms, 2000.

Andrews, William L., ed. *Critical Essays on W. E. B. Du Bois.* Boston: G. K. Hall & Co., 1985.

Aptheker, Bettina. "W. E. B. Du Bois and the Struggle for Women's Rights, 1910–1920." *San Jose Studies* 1, no. 2 (1975): 7–16.

Aptheker, Herbert. *Against Racism.* Amherst: University of Massachusetts Press, 1985.

———. *Literary Legacy of W. E. B. Du Bois.* White Plains, N.Y.: Kraus International Publications, 1989.

Barbeau, Arthur, and Florette Henri. *The Unknown Soldiers: Black American Troops in World War I.* Philadelphia: Temple University Press, 1974.

Barkin, Kenneth. "W. E. B. Du Bois' Love Affair with Imperial Germany." *German Studies Review* 28, no. 2 (May 2005): 284–302.

Barron, Stephanie, ed. *Degenerate Art: The Fate of the Avant-Garde in Nazi Germany.* New York: Abrams, 1991.

Bauerlein, Mark. *Negrophobia: A Race Riot in Atlanta, 1906.* San Francisco: Encounter Books, 2001.

Bernal, Martin. *Black Athena: The Afroasiatic Roots of Classical Civilization.* New Brunswick, N.J.: Rutgers University Press, 1987.

Blight, David. "'For Something Beyond the Battlefield': Frederick Douglass and the Struggle for the Memory of the Civil War." *The Journal of American History* 75, no. 4 (March 1989): 1156–1178.

———. "'What Will Peace among the Whites Bring?': Reunion and Race in the Struggle over the Memory of the Civil War in American Culture." *Massachusetts Review* 34, no. 3 (1993): 393–410.

———. "W. E. B. Du Bois and the Struggle for American Historical Memory." In Geneviève Fabre and Robert O'Meally, eds., *History and Memory in African-American Culture.* New York: Oxford University Press, 1994.

———. "Fifty Years of Freedom: The Memory of Emancipation at the Civil War Semicentennial, 1911–1915." *Slavery and Abolition* 21, no. 2 (2000): 117–134.

———. *Race and Reunion: The Civil War in American Memory.* Cambridge, Mass.: Belknap Press of Harvard University Press, 2001.

Brundage, W. Fitzhugh. *Lynching in the New South: Georgia and Virginia, 1880–1930.* Urbana: University of Illinois Press, 1993.

———. *Under Sentence of Death: Lynching in the South.* Chapel Hill: University of North Carolina Press, 1997.

Byerman, Keith E. *Seizing the Word: History, Art, and Self in the Work of W. E. B. Du Bois.* Athens: University of Georgia Press, 1994.

Capeci, Dominic J., Jr., and Jack C. Knight. "Reckoning with Violence: W. E. B. Du Bois and the 1906 Atlanta Race Riot." *Journal of Southern History* 62, no. 4 (1996): 727–766.

"Cartoons by the Late Ollie Harrington Tell Us Like It Was—and Is." *Ebony* 51, no. 4 (February 1996): 122–127.

Clark, James W. "Without Fear or Shame: Lynching, Capital Punishment and the Subculture of Violence in the American South." *British Journal of Political Science* 28, no. 2 (1998): 269–289.

Cott, Nancy F. *The Grounding of Modern Feminism.* New Haven, Conn.: Yale University Press, 1987.

Cutler, James E. *Lynch-Law: An Investigation into the History of Lynching in the United States.* 1905; reprint, New York: Negro Universities Press, 1969.

Diggs, Irene. "Du Bois and Children." *Phylon* 36, no. 4 (1976): 370–399.

Douglas, Robert. "From Blues to Protest: Assertiveness in the Art of Romare Bearden and John Coltrane." *International Review of African American Art* 1, no. 2 (1988): 28.

Ellis, Mark. *Race, War and Surveillance: African Americans and the United States Government during World War I.* Bloomington: Indiana University Press, 2001.

Fabre, Geneviève, and Robert O'Meally, eds. *History and Memory in African American Culture.* New York: Oxford University Press, 1994.

Fields, Karen. "What One Cannot Remember Mistakenly." In Geneviève Fabre and Robert O'Meally, eds., *History and Memory in African American Culture*, 150–163. New York: Oxford University Press, 1994.

Fisher, Roger A. "Oddity, Icon, Challenge: The Statue of Liberty in American Cartoon Art, 1879–1986." *Journal of American Culture* 9, no. 4 (1986): 63–81.

Foner, Eric. *Reconstruction: America's Unfinished Revolution, 1863–1877.* New York: Harper & Row, 1988.

Fontenot, Chester W., and Mary Alice Morgan, eds. *W. E. B. Du Bois and Race: Essays Celebrating the Centennial Publication of the Souls of Black Folk.* Macon, Ga.: Mercer University Press, 2002.

Fossett, Judith Jackson, and Jeffrey A. Tucker, eds. *Race Consciousness.* New York: New York University Press, 1997.

Franklin, Vincent P. "W. E. B. Du Bois and the Education of Black Folk." *History of Education Quarterly* 16 (1976): 11–18.

Frisch, Michael. "The Memory of History." In Susan Porter Benson, Steven Brier, and Roy Rozenzweig, eds., *Presenting the Past: Essays on History and the Public*, 5–17. Philadelphia: Temple University Press, 1986.

Gilmore, Glenda Elizabeth. *Gender and Jim Crow: Women and the Politics of White Supremacy in North Carolina, 1896–1920.* Chapel Hill: University of North Carolina Press, 1996.

Gilroy, Paul. *The Black Atlantic: Modernity and Double Consciousness.* Cambridge, Mass.: Harvard University Press, 1993.

Ginzburg, Paul. *One Hundred Years of Lynchings.* Baltimore: Black Classic Press, 1988.

Hale, Grace Elizabeth. *Making Whiteness: The Culture of Segregation in the South, 1890–1940.* New York: Pantheon Books, 1998.

Hall, Jacquelyn Dowd. *Revolt against Chivalry. Jessie Daniel Ames and the Womens Campaign against Lynching.* New York: Columbia University Press, 1993.

Hardy, Charles, and Gail Stern, eds. *Ethnic Images in the Comics.* Philadelphia: Balch Institute for Ethnic Studies, 1986.

Harris, Shanette M. "Constructing a Psychological Perspective: The Observer and the Observed in the Souls of Black Folk." In Dolan Hubbard, ed., *The Souls of Black Folk One Hundred Years Later.* Columbia University of Missouri Press, 2003

Harris, Trudier. *Exorcising Blackness: Historical and Literary Lynching and Burning Rituals.* Bloomington: Indiana University Press, 1984.

Hartigan, Lynda Roscoe. *Sharing Traditions: Five Black American Artists in Nineteenth-Century America.* Washington, D.C. National Museum of American Art, 1985.

Harvey, Bruce A. *American Geographics: U.S. National Narratives and the Representation of the Non-European World, 1839–1865.* Stanford, Calif.: Stanford University Press, 2001.

Herskovits, Melville. *Franz Boas: The Science of Man in the Making.* New York: Scribner's, 1953.

Hess, Stephen, and Sandy Northrop. *Drawn and Quartered: The History of American Political Cartoons.* Montgomery, Ala.: Elliot & Clark, 1996.

Hubbard, Dolan, ed. *The Souls of Black Folk: One Hundred Years Later.* Columbia: University of Missouri Press, 2003.

Huber, Patrick J. "'Caught up in the Violent Whirlwind of Lynching': The 1885 Quadruple Lynching in Chatham Country, North Carolina." *North Carolina Historical Review* 75, no. 2 (1998): 134–160.

Huggins, Nathan. *Harlem Renaissance.* New York: Oxford, 1971.

Hutchinson, George. *The Harlem Renaissance in Black and White.* Cambridge, Mass.: Belknap Press of Harvard University Press, 1995.

Johnson, Bethany. "Freedom and Slavery in the Voice of the Negro: Historical Memory and African-American Identity, 1904–7." *Georgia Historical Quarterly* 84, no. 1 (2000): 29–71.

Johnson, Charles S. *Growing Up in the Black Belt: Negro Youth in the Rural South.* Washington, D.C.: American Council on Education, 1941.

Jones, Steven Loring. "From 'Under Cork' to Overcoming: Black Images in the Comics." In Charles Hardy and Gail Stern, eds., *Ethnic Images in the Comics.* Philadelphia: Balch Institute for Ethnic Studies, 1986.

Kachun, Mitch. "Before the Eyes of All Nations: African American Identity and Historical Memory at the Centennial Exposition of 1876." *Pennsylvania History* 65, no. 3 (1998): 300–323.

Kight, Lawrence Edward. "'The State Is on Trial': Governor Edmund F. Noel and the Defense of Mississippi's Legal Institutions against Mob Violence." *Journal of Mississippi History* 60, no. 3 (1998): 191–222.

Kirschke, Amy Helene. *Aaron Douglas: Art, Race, and the Harlem Renaissance.* Oxford: University Press of Mississippi, 1995.

———. "The Intersecting Rhetorics of Art and Blackness in the *Souls of Black Folk.*" In Dolan Hubbard, ed., *The Souls of Black Folk One Hundred Years Later.* Columbia: University of Missouri Press, 2003.

Klein, Kirwin Lee. "On the Emergence of Memory in Historical Discourse." *Representations* 69 (Winter 2000): 127–150.

Kook, Rebecca. "The Shifting Status of African Americans in the American Collective Identity." *Journal of Black Studies* 29, no. 2 (November 1998): 154–178.

Kornweibel, Theodore, Jr. *Investigate Everything: Federal Efforts to Compel Black Loyalty during World War I.* Bloomington: Indiana University Press, 2002.

Lacey, Barbara E. "Visual Images of Blacks in Early American Imprints." *William and Mary Quarterly*, 3rd series, 53, no. 1 (January 1996): 137–180.

Langa, Helen. "Two Antilynching Art Exhibitions: Politicized Viewpoints, Racial Perspectives, Gendered Constraints." *American Art* (Spring 1999): 11–39.

Leininger-Miller, Theresa. *New Negro Artists in Paris: African American Painters and Sculptors in the City of Light, 1922–1934.* New Brunswick, N.J.: Rutgers University Press, 2001.

Lenthall, Bruce. "Outside the Panel: Race in America's Popular Imagination—Comic Strips Before and After World War II." *Journal of American Studies* 32 (1998): 1, 39–61.

Lester, Julius. *The Seventh Son: The Thought and Writings of W. E. B. Du Bois.* Vol. 1. New York: Random House, 1971.

Letwin, Daniel. *The Challenge of Interracial Unionism: Alabama Coal Miners, 1878–1921.* Chapel Hill: University of North Carolina Press, 1998.

Lewis, David Levering. *W. E. B. Du Bois: Biography of a Race, 1868–1919.* New York: Henry Holt, 1993.

———. "Du Bois and the Challenge of the Black Press." *Crisis* 104, no. 1 (July 1997): 43–44.

———. *W. E. B. Du Bois: The Fight for Equality and the American Century, 1919–1963.* New York: Henry Holt, 2000.

———. and Deborah Willis. *A Small Nation of People: W. E. B. Du Bois and African-American Portraits of Progress.* New York: Amistad Press, 2003.

Litwack, Leon F. "The Birth of a Nation." In Mark C. Carnes, ed., *Past Imperfect.* New York: Henry Holt, 1995.

Madison, James H. *A Lynching in the Heartland: Race and Memory in America.* New York: Palgrave for St. Martin's Press, 2001.

Maeterlinck, Maurice, et al. *What Is Civilization?* New York: Durfield, 1926.

Marx, Leo. "American Studies: A Defense of an Unscientific Method." *New Literary History* 1 (1969): 75–90.

McElvaine, Robert S. *The Great Depression: America, 1929–1941.* Toronto: Times Books, 1984.

Menten, Theodore. *Art Nouveau and Early Art Deco Type and Design.* New York: Dover, 1972.

Messinger, Lisa Mintz. *African-American Artists, 1929–1945: Prints, Drawings, and Paintings in the Metropolitan Museum of Art.* New York: Metropolitan Museum of Art, 2003.

Moon, Henry Lee. *The Emerging Thought of W. E. B. Du Bois.* New York: Simon and Schuster, 1972.

Nelson, Samuel H. *Colonialism in the Congo Basin, 1880–1940.* Athens: Ohio University Press, 1994.

Nora, Pierre. "Between Memory and History: Les Lieux de Memoire." In Geneviève Fabre and Robert O'Meally, eds., *History and Memory in African American Culture*, 150–163. New York: Oxford University Press, 1994.

Painter, Nell Irvin. "Black Workers from Reconstruction to the Great Depression." In Paul Buhle and Alan Dawley, eds., *Working for Democracy: American Workers from the Revolution to the Present.* Urbana: University of Illinois Press, 1985.

Park, Marlene. "Lynching and Antilynching: Art and Politics in the 1930s." *Prospects: An Annual of American Cultural Studies* 18 (1993): 311–365.

Perloff, Richard M. "The Press and Lynchings of African Americans." *Journal of Black Studies* 30, no. 3 (2000): 315–330.

Philippe, Robert. *Political Graphics: Art as Weapon.* New York: Abbeville Press, 1980.

Porter, James. *Modern Negro Art.* 1943; reprint, New York: Arno Press, 1969.

———. *In Memoriam: Laura Wheeler Waring, 1887–1948—An Exhibition of Paintings.* Washington, D.C.: Howard University Gallery of Fine Arts, 1949.

Posnock, Ross. "The Distinction of Du Bois: Aesthetics, Pragmatism, Politics." *American Literary History* 7, no. 3 (1995): 500–524.

Powell, Richard. *To Conserve a Legacy: American Art from Historically Black Colleges and Universities.* Cambridge, Mass.: MIT Press, 1999.

Rampersad, Arnold. *The Art and Imagination of W. E. B. Du Bois.* Cambridge, Mass.: Harvard University Press, 1976.

Sims, Lowery. *Challenge of the Modern: African American Artists, 1925–1945.* New York: Studio Museum, 2003.

Smith, Shawn Michelle. *Photography on the Color Line: W. E. B. Du Bois, Race, and Visual Culture.* Durham, N.C.: Duke University Press, 2004.

Stovel, Katherine. "Local Sequential Patterns: The Structure of Lynching in the Deep South, 1882–1930." *Social Forces* 79, no. 3 (2001): 843–880.

Thelen, David. "Memory and American History." *Journal of American History* 75, no. 4 (March 1989): 1117–1129.

Thibodeau, Ruth. "From Racism to Tokenism: The Changing Face of Blacks in *New Yorker* Cartoons." *Public Opinion Quarterly* 53 (Winter 1989): 483–494.

Thompson, Shirley. "'*Ah Toucoutou, ye conin vous*': History and Memory in Creole New Orleans." *American Quarterly* 53, no. 2 (June 2001): 232–266.

Tillman, Ben. "The Black Peril." In William Chace and Peter Collier, eds., *Justice Denied: The Black Man in White America,* 180–185. New York: Harcourt, Brace, 1970.

Tolnay, Stewart E., Glenn Deane, and E. M. Beck. "Vicarious Violence: Spatial Effects on Southern Lynchings, 1890–1919." *American Journal of Sociology* 102, no. 3 (1996): 788–815.

Tolnay, Stewart E., and E. M. Beck. *A Festival of Violence: An Analysis of Southern Lynchings, 1882–1930.* Urbana: University of Illinois Press, 1995.

Vendryes, Margaret Rose. "Hanging on Their Walls: A Commentary on Lynching, the Forgotten 1935 Exhibition." In Judith Jackson Fossett and Jeffrey A. Tucker, eds., *Race Consciousness.* New York: New York University Press, 1997.

Vinikas, Vincent. "Specters in the Past: The Saint Charles, Arkansas, Lynching of 1904 and the Limits of Historical Inquiry." *Journal of Southern History* 65, no. 3 (1999): 535–564.

Waldrep, Christopher. "The War of Words: The Controversy over the Definition of Lynching, 1899–1940." *Journal of Southern History* 66, no. 1 (2000): 75–100.

Washington, M. Bunch. *The Art of Romare Bearden: The Prevalence of Ritual.* New York: Abrams, 1973.

Webb, Michael D. "'God bless you all—I am innocent': Sheriff Joseph F. Shipp, Chattanooga, Tennessee, and the Lynching of Ed Johnson." *Tennessee Historical Quarterly* 58, no. 2 (1999): 156–179.

Wells, Ida B. *Southern Horrors: Lynch Law in All Its Phases.* New York: New York Age Print, 1892.

Wiegman, Robyn. "Anatomy of a Lynching." In *American Anatomies: Theorizing Race and Gender.* Durham, N.C.: Duke University Press, 1995.

Williams, Lynn Barstis. "Images of Scottsboro." *Southern Cultures* 6, no. 1 (2000): 50–67.

Williamson, Joel. "Wounds Not Scars: Lynching, the National Conscience, and the American Historian." *Journal of American History* 83, no. 4 (1997): 1221–1253.

Wintz, Cary. *The Harlem Renaissance, 1920–1940: The Critics and the Harlem Renaissance.* New York: Garland Publishing, 1996.

Wolf, Charlotte. "Constructions of a Lynching." *Sociological Inquiry* 62, no. 1 (1992): 83–97.

Wolters, Raymond. *Negroes and the Great Depression: The Problem of Economic Recovery.* Westport, Conn.: Greenwood Publishing Corporation, 1970.

Wright, Richard. *Black Boy: A Record of Childhood and Youth.* New York: Harper & Row, 1966.

Yellin, Jean Fagan. "Du Bois' *Crisis* and Woman's Suffrage." *Massachusetts Review* 14, no. 2 (1973): 365–375.

Zangrando, Robert. *The NAACP Crusade against Lynching, 1909–1950.* Philadelphia: Temple University Press, 1980.

Zurier, Rebecca. *Art for the Masses: A Radical Magazine and Its Graphics, 1911–1917.* Philadelphia: Temple University Press, 1988.

NEWSPAPERS AND POPULAR MAGAZINES

Baltimore Sun
Chicago Daily Sun
The Crisis
Harper's Weekly
Horizon Magazine
La Revue Moderne Illustrée des Arts et de la Vie
Leslie's Weekly
Marion Chronicle
The Masses
Negro Voice
New Amsterdam News
New York Herald Tribune
New York Times
Opportunity
San Francisco Bulletin

Index

Italicized page numbers indicate illustrations.

Adams, John Henry: "Disturbing the Peace, Your Honor," 170, *171;* drawing of a child, 214; "Empress Taitou," 147, *148;* "Mr. Lewis Gets His!," *174,* 174–175; "The National Pastime," 57–59, *58;* "1900," 60, *61;* "1910," 60, *61;* poem about black men, 9; portrait of Du Bois, 9, *10;* in *Voice of the Negro,* 10; "Woman to the Rescue!," 215–217, *216,* 252n102

Africa, 131–166; art of (*see* African art); Boas and, 137; cartoons about, 163, *164;* connection to America, 151–153; *Crisis* essays/articles about, 147–151, 156; Du Bois on, 134, 159, 160; emigration to, 153; Pan-African Congress, First (1900), 7, 133; Pan-African Congress, Second, 151; Pan-African Congress, Third, 157–158; Pan-African Congress, Fourth, 158; pan-Africanism, 7, 24, 131; return to, 132, 156–157; romantic view of, 158–162, *161; 162,* 246n21; self-determination for, 157; sub-Saharan art and culture, 137

"Africa" (photograph of statue), *140*

"Africa in America" (Wheeler), 151–153, *152*

African American newspapers, 226

African Americans: Africa and, 131–132; black nationalism, 224; Blue-Gray Reunion (1913), 16; Bryan on, 88; collective/historical identity of, 3, 6, 20, 114, 132, 226; double/dual consciousness of, 20, 115, 131; Du Bois on, 14–15, 20–21, 50, 118, 122, 124–125, 131, 134, 137, 157, 182, 186; in 18th- and 19th-century cartoons, 29–31; Great Depression, 41, 193–195; history of, 5–6, 19; images/representations of, 2–3, 7–9, 15, 17, 26, 29–33, 40; middle-class, 124–125; migration from rural South to urban North, 84; in the military in World War I, 202; *New Masses,* 8, 15; opportunities for, 181–182; pan-Africanism, 132; patriotism and loyalty to World War I effort, 199–201, *201, 202, 203, 205,* 206–209, *207, 208;* pride in womanhood, 209–210; self-determination, 157; sexuality and spontaneity, 8; Talented Tenth, 5; whites' treatment of, 221; whites' view of, 55–56, 59–60; Wilson and, 70; World War I, 200

African art: Armana period, 151–153, 247n39; Douglas (Aaron) and, 40, 156; modern art, 153–156. *See also The Crisis:* art in, African-inspired

"African Civilization" (Du Bois), 137–138

"African Witch Mask and Fetish in Design" (Wright), 159–160, *161*

"Ain't she funny" (Berg), 163, *164*

Amy Helene Kirschke is Assistant Professor in the Art & Art History Department at the University of North Carolina–Wilmington.